Expressions of Place
The Art of William Stanley Haseltine

Wm S. Haseltine

Expressions of Place
The Art of William Stanley Haseltine

Marc Simpson

Andrea Henderson

Sally Mills

The Fine Arts Museums of San Francisco
Distributed by Hudson Hills Press, New York

This catalogue has been published in conjunction with the exhibition
Expressions of Place: The Art of William Stanley Haseltine.

The Fine Arts Museums of San Francisco
M.H. de Young Memorial Museum
20 June – 20 September 1992

Brandywine River Museum
Chadds Ford, Pennsylvania
20 January – 18 April 1993

The exhibition has been organized by The Fine Arts Museums of San Francisco
and is made possible by The Henry Luce Foundation, Inc. Additional support
was provided by the National Endowment for the Arts, a Federal agency, and
the Sumner Gerard Foundation.
 Presentation of the exhibition in San Francisco is further underwritten
by generous gifts from Barbro and Bernard Osher and the Ednah Root Foundation.
 Presentation of the exhibition at the Brandywine River Museum is made
possible by support from an anonymous donor.

The clothbound edition is distributed throughout the world by
Hudson Hills Press, Inc., Suite 1308, 230 Fifth Avenue, New York, NY 10001-7704.
 In the United States, its territories and possessions, Canada, Mexico,
and Central and South America via National Book Network, Inc.
 In the United Kingdom and Eire via Shaunagh Heneage Distribution.
 In Japan via Yohan (Western Publications Distribution Agency).
Editor and Publisher: Paul Anbinder

The diary of John Taylor Johnston is quoted from in Sally Mills's essay and in the
Chronology by permission of The Metropolitan Museum of Art, New York.
Material in the Chronology based on William Stanley Haseltine's time at Harvard
is cited by permission of the Harvard University Archives. Letters by Elizabeth
Herriman to George Henry Yewell are quoted by permission of the University of
Iowa Libraries (Iowa City).

Library of Congress Cataloging-in-Publication Data
Simpson, Marc.
 Expressions of Place: The Art of William Stanley Haseltine/
 Marc Simpson, Andrea Henderson, Sally Mills.
 Catalogue of exhibition held : June 20-Sept. 20, 1992, at The Fine Arts Museums
of San Francisco, M.H. de Young Memorial Museum.
 Includes bibliographical references and index.
 ISBN 0-88401-070-8 : $35.00. – ISBN 0-88401-071-6 : $50.00
 1. Haseltine, William Stanley. 1835-1900 – Exhibitions. 2. Landscape in art –
Exhibitions. I. Haseltine, William Stanley, 1835-1900. II. Henderson, Andrea.
III. Mills, Sally. IV. The Fine Arts Museums of San Francisco. V. Title.
ND237.H344A4 1992 92-7266
759.13 – dc20 CIP
H — S

Cover: William Stanley Haseltine, *Ruins of the Roman
Theatre at Taormina, Sicily* (detail), 1889, pl. 61.

Contents

Lenders to the Exhibition

American Express Company

Amon Carter Museum, Fort Worth

The Art Museum, Princeton University

Bowdoin College Museum of Art, Brunswick, Maine

The Brooklyn Museum

The Butler Institute of American Art, Youngstown, Ohio

The Carnegie Museum of Art, Pittsburgh

Cooper-Hewitt, National Museum of Design, Smithsonian Institution,
 New York

The Corcoran Gallery of Art, Washington, D.C.

Cummer Gallery of Art, Jacksonville, Florida

The Currier Gallery of Art, Manchester, New Hampshire

Davenport Museum of Art, Davenport, Iowa

The Detroit Institute of Arts

The Downtown Club, Birmingham, Alabama

The Fine Arts Museums of San Francisco

Henry Melville Fuller

The Georgia Museum of Art, The University of Georgia, Athens

Ben Ali Haggin, New York

The High Museum of Art, Atlanta

Hirschl & Adler Galleries, Inc., New York

Krannert Art Museum and Kinkead Pavilion,
 University of Illinois, Champaign

Rob and Mary Joan Leith

The Mariners' Museum, Newport News, Virginia

Mellon Bank Corporation, Pittsburgh

Memphis Brooks Museum of Art, Memphis, Tennessee

The Metropolitan Museum of Art, New York

Milwaukee Art Museum

Montgomery Museum of Fine Arts, Montgomery, Alabama

Museum of Fine Arts, Boston

National Gallery of Art, Washington, D.C.

National Museum of American Art, Smithsonian Institution,
 Washington, D.C.

David Nisinson

North Carolina Museum of Art, Raleigh

Phoenix Art Museum, Phoenix, Arizona

Portsmouth Abbey, Portsmouth, Rhode Island

Princeton University

Private Collections

Julian Wencel Rymar

The Saint Louis Art Museum

Smith College Museum of Art, Northampton, Massachusetts

Dr. H.J. Smokler

Terra Museum of American Art, Chicago

Wadsworth Atheneum, Hartford, Connecticut

Walker Art Center, Minneapolis

D. Wigmore Fine Art, Inc., New York

The William Benton Museum of Art,
 The University of Connecticut, Storrs

Mr. Graham Williford

Dr. Richard P. Wunder

Directors' Foreword

The early works of William Stanley Haseltine are among the handsomest landscapes painted in America during the 1860s. The later European scenes use a calm and precise monumentality as an armature for exploring the light effects that came ever more to preoccupy artists throughout America and Europe. As a whole, the artist's career offers insights into major issues of aesthetic and cultural history. We therefore take great pleasure in organizing *Expressions of Place: The Art of William Stanley Haseltine.*

The Fine Arts Museums of San Francisco is a logical institution to generate a Haseltine retrospective. It has three paintings by the artist in its permanent collection – a large, classic New England coastal scene from 1863, a jewel-like view of Mont Saint Michel from about 1868, and an epic view of the Roman ruins at Taormina with Mount Ætna in the distance dated 1889. Two of the three have been acquired within the past seven years, clearly indicating the Museums' commitment to the artist and belief in his importance. It was while doing research in preparation for the acquisitions, in fact, that it was first realized how much work remained to be done to document Haseltine's career and to examine the development of his style and imagery.

The Brandywine River Museum is proud to bring an extensive selection of Haseltine's art to the Delaware Valley. He was born and educated in Philadelphia and trained, worked, and exhibited there. In 1854, Haseltine remarked on the "affection and pride which I shall always entertain for my native city." This exhibition brings the artist nearly home. The Brandywine River Museum has a long-standing interest in Haseltine. Two of his drawings were given to the permanent collection by his grandson, Marshall Haseltine, and the collection also contains a recent portrait of Marshall Haseltine by George A. Weymouth. The exhibition complements the Museum's nineteenth-century landscape collection and fits well into its program of presenting important American art and the results of scholarly research that enlarge art history.

We could not have prepared this exhibition without the informed and effective support of The Henry Luce Foundation, Inc., which with its grant and fellowship program has made such great strides in furthering the understanding and enjoyment of American art. This is the third major exhibition in a decade at The Fine Arts Museums for which they were principal funders, following *Venice: The American View, 1860-1920* (which included two works by Haseltine), and *Winslow Homer: Paintings of the Civil War.* Our sincerest thanks are due the foundation officers, especially Henry Luce III, Robert E. Armstrong, and Mary Jane Crook. Barbro and Bernard Osher, as well, have been major contributors to American art projects at The Fine Arts Museums, including both of the exhibitions just mentioned. It is with heartiest thanks that we record their enabling participation in *Expressions of Place.* We also owe our thanks to the Ednah Root Foundation that has in this, as with all projects in American art at The Fine Arts Museums, been a major contributor. We are grateful to the trustees of the foundation, Robert A. Mills and Robert A. Schlesinger, for their continuing support and good will. Likewise, the National Endowment for the Arts has been a significant and consistent supporter of our exhibition efforts, and we are grateful for its aid. We also appreciate additional support for the exhibition from the Sumner Gerard Foundation. An anonymous donor and trustee of the Brandywine River Museum made possible the presentation in Chadds Ford. His support for both the artist and the Museum is a source of pride and is received with much gratitude.

The entire staff of The Fine Arts Museums has worked hard to bring this exhibition into being. We especially note the contributions of Marc Simpson, who conceived and ably directed the project, and Sally Mills, who has since returned to graduate school at Princeton University. Together with their colleague Andrea Henderson they have brought a central figure of nineteenth-century American landscape painting to renewed and well-merited prominence.

Harry S. Parker III
Director of Museums

James H. Duff
Director, Brandywine River Museum

Acknowledgments

One of the truest pleasures of a project like *Expressions of Place: The Art of William Stanley Haseltine* is the opportunity to thank the many people who have made it possible. The exhibition and catalogue would never have moved beyond the stage of dream were it not for the support of The Henry Luce Foundation, Inc., and its effort to foster an ever-deepening appreciation and knowledge of American art. All of us involved in the project are grateful to Henry Luce III, President, as well as Robert E. Armstrong and Mary Jane Crook for their enthusiasm and interest in Haseltine's work. In addition, the National Endowment for the Arts, a Federal agency, granted valued financial support for the exhibition, while Andrew Oliver, Jr., Director of the agency's Museum Program, materially assisted in research. Our thanks are also due to the Sumner Gerard Foundation. A generous gift from Barbro and Bernard Osher and the steady support of the trustees of the Ednah Root Foundation have made the enterprise possible in San Francisco. The Brandywine River Museum has been able to present the exhibition because of a generous anonymous contribution and because of a specific commitment by its trustees.

Without the sacrifice of the lenders of Haseltine's paintings and drawings, listed elsewhere in this catalogue, the exhibition could not take place. A special note of thanks must be given to Ben Ali Haggin, not only as a lender but as a devoted advocate of Haseltine's works for most of the past decade. The Haseltine family has been particularly gracious in sharing with us their works, providing access to invaluable documentation. We extend our thanks to Carla Haseltine Browne, Marshall Haseltine, Leslie Middleton, Lord Plowden, William Plowden, Mrs. Janos Scholz, Contessa Helen Haseltine Toggenburg, Mrs. Charles Towers, Louise Butler Uhl, and Penelope Vaux.

Within The Fine Arts Museums this enterprise has provided the opportunity for a truly collaborative effort. Particular thanks are due: Harry S. Parker III, Director; Steven A. Nash, Chief Curator; Debra Pughe, Director of Exhibitions; Bill White, Exhibition Designer; Connie King, Senior Graphic Designer; James Forbes, Deputy Director for Development; Debbie Small, Manager of Government and Foundation Relations; Therese Chen, Director of Registration; Jerry Smith, Librarian; Ann Karlstrom, Director of Publications; Mardi Leland, Photo Services Coordinator; Joseph MacDonald, Photographer; Pamela Forbes, editor of *Triptych*; and, last but not least, the technicians, art handlers, and engineers who are responsible for actually placing the exhibition before the public. We also wish to express our appreciation to the Board of Trustees, and to the Docent Council and the Volunteer Council of the Museums. The catalogue's clarity and direction are largely attributable to the editorial skills of Karen Kevorkian.

Within the Museums' American Art Department, Jane Glover efficiently oversaw many of the details relating to the exhibition and catalogue. Derrick Cartwright showed his usual discernment in critiquing catalogue essays, and diligence in ferreting out data for the chronology. Nancy McBean provided hard work in San Francisco and, along with Peter McBean, much-appreciated hospitality in Newport; Lauren Smith, a student from the University of Michigan, provided days of assistance and fact-checking with exhibition histories.

At the Brandywine River Museum our thanks are due: James H. Duff, Director; Gene E. Harris and Virginia H. O'Hara, curators; Jean A. Gilmore, Registrar; Suzanne DeMott, Preparator; Victor T. Razze and his staff; Lucinda Laird, Director of Public Relations; Mary Cronin, Supervisor of Education; Donna Kimmel, Coordinator of Volunteers; and the volunteers themselves.

Many people and organizations assisted us in the gathering of material on Haseltine over the past three years. Noteworthy among them: Accademia Nazionale di San Luca (Rome); Adams Davidson Galleries; Susannah H. Michalson, Allen Memorial Art Museum, Oberlin College; Altman/Burke Fine Arts Inc.; Patricia Weaver, American Academy in Rome; Diane C. Bliss, American Express Company; Jan Keene Muhlert, Doreen Bolger, Sarah Cash, and Melissa G. Thompson, Amon Carter Museum; Lee B. Anderson; William D. Antrim, Jr.; Archives of American Art, Smithsonian Institution; Archivio Capitolino (Rome); Suzanne Folds McCullagh, The Art Institute of Chicago; Damon Ball; Joan Barnes; Madeleine Fidell Beaufort; Bruce Weber, Berry-Hill Galleries, Inc.; Biblioteca Universitaria Alessandrina (Rome); Bibliotheca Hertziana (Rome); John Wetenhall and Melissa Falkner, Birmingham Museum of Art; John Bockstoce; Katherine J. Watson, Donald A. Rosenthal, John W. Coffey, and Mattie Kelly, Bowdoin College Museum of Art; Morton C. Bradley, Jr.; Robert T. Buck, Linda S. Ferber, Barbara Dayer Gallati, and Karen Tates, The Brooklyn Museum; Norma Broude; Jeffrey R. Brown and Kathy Corbin, Brown-Corbin Fine Art; John Burrows; Louis A. Zona and Clyde Singer, The Butler Institute of American Art; Phillip M. Johnston, Louise Lippincott, Monika Tomko, Cheryl A. Saunders, and William Stover, The Carnegie Museum of Art; Alessandra Pinto Surdi, Centro di Studi Americani (Rome); Jonathan Harding, The Century Association; Debra Force, Christie's; H. Nichols B. Clark, The Chrysler Museum; Millard F. Rogers, Jr., John Wilson, Kristin L. Spangenberg, and Susan Holmberg Currie, Cincinnati Art Museum; E. Bruce Robertson, William Talbot, Kenneth Bé, and Henry Hawley, The Cleveland Museum of Art; Coe Kerr Gallery, Inc.; Columbia University's Avery and Butler libraries; Thomas Colville; Diane H. Pilgrim, Marilyn F. Symmes, Elaine Evans Dee, Megan Smith, Cordelia Rose, and David Black, Cooper-Hewitt, National Museum of Design,

Smithsonian Institution; David C. Levy, William B. Bodine, Jr., and Linda Crocker Simmons, The Corcoran Gallery of Art; Robert W. Schlageter and Vance Schrum, Cummer Gallery of Art; Marilyn F. Hoffman and Michael Komanecky, The Currier Gallery of Art; Mark Towner, Brady Roberts, and Patrick Sweeney, Davenport Museum of Art; Annabel Solomon, David David, Inc.; Peter H. Davidson & Co., Inc.; Cecily Langdale, Davis & Langdale Company, Inc.; Dominique H. Vasseur, The Dayton Art Institute; Terry De Lapp Gallery; Samuel Sachs II, Nancy Rivard Shaw, James W. Tottis, and Michele Peplin, The Detroit Institute of Arts; Nicholas di Benedetto; Lauretta Dimmock; Dean Stuart and Wanda Smith, The Downtown Club, Birmingham, Alabama; Paul Dumont; Massimo Elser; Free Library of Philadelphia; Mr. and Mrs. Alan R. Freedman; Freeman Fine Arts of Philadelphia, Inc.; Frick Art Reference Library; Gabinetto Comunale delle Stampe e Disegni (Rome); Galleria Nazionale d'Arte Moderna (Rome); Jane K. Bledsoe, Patricia Phagan, and Lynn Bowenkamp, The Georgia Museum of Art, The University of Georgia; James Gerard; Andrea Keogh, Godel & Co., Inc.; Harvard University Archives; G. H. Laing, Haverhill Public Library; Gudmund Vigtel, Judy L. Larson, Jody Cohen, and Ashley A. Clark, The High Museum of Art; Stuart Feld, Susan Menconi, M.P. Naud, and Sandra Feldman, Hirschl & Adler Galleries, Inc.; David Cassedy, Janice Dockery, and the librarians of the Historical Society of Pennsylvania; Inventories of American Paintings and Sculpture, Smithsonian Institution; Irma Jaffe; Mr. and Mrs. George Kauffman; F. Frederick Bernaski, Kennedy Galleries, Inc.; Melissa De Medeiros, Knoedler Gallery, Inc.; Paul Kossey; Stephen S. Prokopoff, Krannert Art Museum and Kinkead Pavilion, University of Illinois; Michael A. Latragna Fine Paintings; Anne M. Bolin, Lockwood-Mathews Mansion Museum; Michael Quick, Los Angeles County Museum of Art; David McCarthy; Mrs. David McGiffert; Andrea Mariani; William D. Wilkinson, Lisa Royse, and Richard C. Malley, The Mariners' Museum; Colleen Schafroth, Maryhill Museum of Art; Lauren Kintner, Mellon Bank; Patricia P. Bladon and Laura Richens, Memphis Brooks Museum of Art; Phillipe de Montebello, John K. Howat, Marceline McKee, Peter M. Kenny, and the librarians of The Metropolitan Museum of Art; Robert Peter Miller and Wendy Williams, Robert Miller Gallery; Russell Bowman, Leigh Albritton, Ariana Huggett, and Peggy Mead, Milwaukee Art Museum; J. Brooks Joyner, Margaret Lynn Ausfield, Pamela Bransford, and Alice Carter, Montgomery Museum of Fine Arts; Neil Morris; Gemma di Domenico Cortese, Museo di Roma; Alan Shestack, Sue Reed, Barbara Stern Shapiro, Clifford S. Ackley, Theodore Stebbins, Carol Troyen, Erica Hirschler, Jessica Murray, and Karen L. Otis, Museum of Fine Arts, Boston; Stanley C. Paterson and Calantha Sears, Nahant Historical Society; Douglas Cisney, Nahant Public Library; Barbara S. Krulik, National Academy of Design; J. Carter Brown, Nicolai Cikovsky, Jr., Franklin Kelly, Carlotta Owens, Nancy Anderson, Lisa E. Mariam, and the librarians of the National Gallery of Art; Elizabeth Broun, Charles J. Robertson, William H. Truettner, Joann Moser, Kristin Austin, and Kimberly Cody, National Museum of American Art; Robert G. Stewart, National Portrait Gallery; Henry Adams and Margaret C. Conrads, The Nelson-Atkins Museum of Art; New York Public Library; Richard S. Schneiderman, Anthony F. Janson, Peggy Jo D. Kirby, and William Holloman, North Carolina Museum of Art; Dr. Peter Riser and Dr. Patricia Morse, Northeastern University's Marine Science Center at East Point, Nahant; Alfred C. Harrison, Jr., The North Point Gallery; Alicia Longwell, The Parrish Art Museum; Susan Danly and Margaret McCarthy, Pennsylvania Academy of the Fine Arts; The Gerald Peters Gallery; Morris Goldsmith, Philadelphia Sketch Club; James K. Ballinger, Jennifer M. Kratz, and Suzanne Gainer, Phoenix Art Museum; Father Peter Sidler, Portsmouth Abbey; John Preston; Allen Rosenbaum, Betsy Rosasco, Maureen McCormick, and Norman Muller, The Art Museum, Princeton University; Radcliffe College's Schlessinger Library; Remak Ramsay; Cheryl L. Robledo; James D. Burke, Sidney M. Goldstein, and Michael Shapiro, The Saint Louis Art Museum; Frank S. Schwarz & Son; Andrew Shahinian; Kara Dey, C.G. Sloan & Company, Inc.; Charles Parkhurst, Linda Muehlig, Michael Goodison, and Louise LaPlante, Smith College Museum of Art; Regina Soria; Peter Rathbone, Sotheby's; Sunne Savage Gallery; Spanierman Gallery; Victor Spark; Joy Sperling; Mr. and Mrs. Jack Steadman; Diana Strazdes; Sutro Library, San Francisco, California State Library System; Taggart & Jorgenson Gallery; Harold P. O'Connell, Jr., D. Scott Atkinson, and Jayne Johnson, Terra Museum of American Art; Joan Hendrix, Union League of Philadelphia; the Libraries of the University of California, Berkeley; Thomas P. Bruhn and George Mazeika, University of Connecticut, Storrs; Charles Eldredge, Marilyn Stokstad, and Tracey Cady, University of Kansas; Dr. William Dennen, University of Kentucky; Robt S. Cox, the University of Michigan's William L. Clements Library; Patrick McCaughey, Linda Ayres, and Mary C. Schroeder, Wadsworth Atheneum; William Vance; William R. and Allison Vareika, William R. Vareika Fine Arts; Robert Vose III, Vose Galleries; R. Morrie Lord and Alice H. Payne, Vulcan Materials Company; Kathy Halbreich, Laura E. Tanner, and Tom Westbrook, Walker Art Center; Eda Martin, Adam A. Weschler & Son; Deedee Wigmore, D. Wigmore Fine Art, Inc.; Professor John Wilmerding; Mr. and Mrs. William D. Wixom; Mrs. Norman B. Woolworth; Susan E. Strickler, Worcester Art Museum; Paul Worman; Richard Field, Yale University; Richard York and Eric Widing, Richard York Gallery; Mary Zlot, Mary Zlot & Associates.

What virtues are to be found herein result from the good will and professionalism of these many working together. As for the faults, we take the responsibility with the hope that we have inspired interest sufficient to generate another book that will correct them.

M.S., A.H., S.M.

Introduction

After a full and productive life, William Stanley Haseltine died in Rome in 1900. His eulogist summarized the landscapist's five-decade career by writing:

He belonged to that set of American artists, who, although they pass the greater part of their life "abroad," still preserve to the end the characteristics of their race; rapid conception of ideas, accurate reproduction of what they see, and a thorough knowledge of what they undertake. . . . [W]e find three elements in the character of Haseltine's paintings: Anglo-Saxon precision, French love of atmosphere and light, and German romanticism.[1]

The internationalism noted by the critic aptly summarizes Haseltine's career. A Harvard-educated young man, he studied painting in Düsseldorf and traveled throughout Germany, Switzerland, and Italy with Albert Bierstadt, Emanuel Leutze, and Worthington Whittredge. The year after his return to the United States in 1858, he established himself in New York where he was elected an Associate of the National Academy in 1860 and elevated to Academician status in 1861. In 1866 the artist and his family moved to Europe, traveling throughout France and Italy before settling in Rome. With the exception of extended tours both in Europe and America, Haseltine lived there for the rest of his life, painting sites in Europe, principally those of Italy.

In spite of the favorable critical response to his work of the early 1860s – Henry Tuckerman praised him at length in *Book of the Artists: American Artist Life*, 1867 – when Haseltine moved to Europe his public profile faded. By 1900

very few recognized his importance as an artist – probably because he worked solely for the sake of his work – invited no criticisms, and asked for no praise.[2]

This relative neglect has continued through our time, although there have been efforts to explore portions of his career. In 1947 his daughter, Helen Haseltine Plowden, published the artist's biography, *William Stanley Haseltine: Sea and Landscape Painter (1835-1900)*, which remains the standard source on him. Before then, with Plowden's assistance the Doll & Richards Gallery of Boston held a one-man show in 1937 devoted to the painter's work, followed by an exhibition of his watercolors in 1938 at the Phillips Academy. The next twelve years saw a hiatus of activity. Then in quick succession his works were shown at, among other places, again the Doll & Richards Gallery (1950, 1954, and 1958), The University of Georgia in Athens (1952), the Isaac Delgado Museum in New Orleans (1952), the Maryhill Museum of Fine Arts in Goldendale, Washington (1953), the Mint Museum of Art in Charlotte, North Carolina (1957), the Brooks Memorial Art Gallery in Memphis (1957), the Cooper Union Museum for the Arts of Decoration (1958),

and the Albany Institute of History and Art (1958). These smaller projects coalesced in a major showing of over one hundred sixty works at the National Academy of Design in New York in late 1958. Unfortunately, none of these exhibition ventures were accompanied by a major catalogue. In 1983, Davis & Langdale Company, Inc., in association with Ben Ali Haggin, brought together an exhibition of Haseltine's drawings and published an essay on the works by John Wilmerding. In this essay Wilmerding felt constrained to write, "Alone among the central figures associated with the mature Hudson River school and the luminists, W.S. Haseltine has yet to receive full scholarly investigation."[3]

And yet the quality of Haseltine's work has been acknowledged repeatedly in recent years, with drawings and paintings playing key roles in ever more museum collections and important thematic exhibitions.[4] From these enterprises, it is clear that Haseltine was singularly effective in working in the cultural milieu of his age. His landscapes of the New England shore number among the precise and light-filled visions that are key to understanding American artistic accomplishment at the mid-century; his later works and his very life are models of the expatriate experience so crucial to the century's closing decades. The fact that Haseltine's brothers were also involved in the art world, filling positions ranging from sculptor to dealer, places him as a model for exploring the enterprise that was so important a part of an artist's career at the time.

There are difficulties endemic to the study of Haseltine's work. First, many of the paintings for which he was best known in his day have yet to come to light or be identified. The *Amalfi, Coast of Naples*, that was so successful in the National Academy of Design exhibition in 1862, for example, must have been stunning. And the *Ruins of a Roman Theatre, Sicily*, chosen to be included at the Centennial Exposition was most likely an ambitious and successful example of his work. But these and a host of major exhibition paintings are not now known, and their absence undoubtedly skews the perception of the painter.

Among those works that are known, many have become detached from their nineteenth-century history of exhibition and ownership. Close reading of contemporary critical texts and the process of elimination can lead to informed guesses, but a real lack of firm documentation, coupled with Haseltine's habit of working in closely related views of the same site, lends a tentative note to almost every attempt to link a work to a specific nineteenth-century exhibition or review. Complicating this exercise is the confusion between the sites where Haseltine most often worked, which leads in turn to a welter of inappropriate titles; Nahant and Narragansett scenes have been often confused in

the literature, for example, as have depictions of Capri and Sicily, France and the United States. Unless there is a clearly identifiable landmark in a work, the simple nature of Haseltine's motifs make absolute identifications difficult even for the scholars and residents of the artist's haunts. This is especially the case in those areas where the present coastline is different from the one scrambled over by Haseltine – Nahant's Pulpit Rock, for example, is no more. A complicating factor is the fact that the dates and locales that Plowden inscribed on many of her father's works, seeking to impose order, were deduced retroactively from spotty data.

A further difficulty in assessing the whole of Haseltine's career arose from the noblest of intentions. In the 1960s, Plowden asked that the National Academy of Design assist her in disseminating the works of her father throughout America. This the Academy did with admirable diligence, placing more than ninety works in collections across the country. The goal was to share Haseltine's accomplishment with as many museums and communities as possible. The nearly even distribution of works, however, has meant that there is no one public institution where a concentration of Haseltine's paintings and drawings can be seen together.

But for all these difficulties, Haseltine's works have provided more than adequate compensation. There is in these drawings and paintings a truth of light and atmosphere that has brought smiles of wonder to all of us who have been involved in this project. "That is what it looks like," say admiring viewers, marveling not only that Haseltine is able to prompt recognition, but as well to inspire the same feelings of awe and pleasure that nature itself provokes. At the same time, the views are so strongly composed that simple geometry provides satisfaction. The tools with which Haseltine worked were recognized by his contemporaries. His colleague, Worthington Whittredge, wrote to Helen Haseltine (later Plowden):

I would sum up your father's excellencies as an artist, with three phrases. He was from the very beginning a superior draughtsman. He was a good colorist. He had sentiment coupled in unusual degree with strength and frank expression.

The works gathered together for the retrospective exhibition, *Expressions of Place: The Art of William Stanley Haseltine*, testify to the aptness of this praise. They reveal Haseltine's power as a draftsman and colorist, and his poetic, direct response to the landscape of Europe and America.

M.S.

Notes

1. Diego Angeli in *Il Giorno*, trans. in "The Late Mr. William Stanley Haseltine," *Evening Post* (New York), 28 April 1900.

2. Angeli, "The Late Mr. William Stanley Haseltine."

3. *William Stanley Haseltine: Drawings of a Painter*, exh. cat. (New York: Davis & Langdale, 1983), n.p.

4. *The Düsseldorf Academy and the Americans* (The High Museum of Art, 1972), *Seascape and the American Imagination* (Whitney Museum of American Art, 1975), *American Master Drawings and Watercolors* (The Drawing Society, 1976), *American Expatriate Painters of the Late Nineteenth Century* (The Dayton Art Institute, 1976), *Hudson and the Rhine: Die amerikanische Malerkolonie in Düsseldorf im 19. Jahrhundert* (Kunstmuseum Düsseldorf, 1976), *American Light: The Luminist Movement, 1850-1875* (National Gallery of Art, 1980), *Next to Nature: Landscape Paintings from the National Academy of Design* (The National Academy of Design, 1980), *Venice: The American View, 1865-1920* (The Fine Arts Museums of San Francisco, 1984), *American Artists Abroad: The European Experience in the Nineteenth Century* (Nassau County Museum of Art, 1985), *The New Path: Ruskin and the American Pre-Raphaelites* (The Brooklyn Museum, 1985) and *The Eden of America: Rhode Island Landscapes, 1820-1920* (Museum of Art, Rhode Island School of Design, 1986).

Expressions of Place

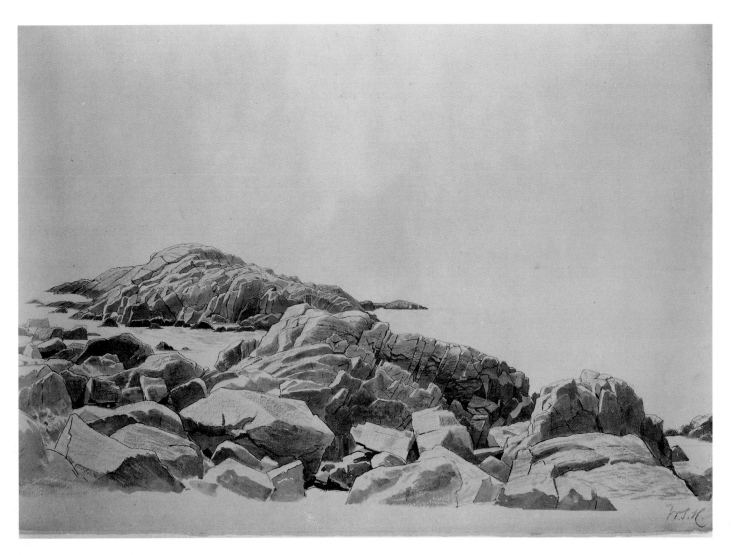

fig.5 William Stanley Haseltine, *New England Coast*
[Indian Rock], ca. 1862/63. Ink over graphite on
paper, 15¼ x 22⅛ in. The Metropolitan Museum of Art,
New York. John G. Agar Fund, by exchange, 1982 (1982.124).

Noble Rock Portraits: Haseltine's American Work

Marc Simpson

William Stanley Haseltine drew and painted one portion of the American landscape more than any other during his relatively few mature years in this country – scenes of New England's shore. His focus was not exclusive. During the months surrounding his first marriage in October 1860, for example, he sketched along the Hudson, Pequest, and Delaware rivers (*figs.1 & 2*), all within a short distance of his New York studio, as well as in the Berkshire Mountains in western Massachusetts (*fig.3*). While his wife waited to "shed her first born"[1] in the summer of 1861, he distracted himself by sketching at Cold Spring on the Hudson (*pl.16*).

Even with these exceptions, however, it is striking how congenial the artist found an equitable focus on land and salt water. Haseltine's record of exhibited American scenes reveals a sensibility akin to that of the poet and essayist Henry David Thoreau, who wrote:

> *My years are like a stroll upon the beach,*
> *As near the ocean's edge as I can go.*[2]

From Maine's Mount Desert Island south approximately three hundred miles to Rhode Island's Point Judith, Haseltine, too, repeatedly traveled "as near the ocean's edge" as he could go, recording the wonders of the shore in crisply detailed drawings and careful oil studies. These, and the paintings derived from them, are among the artist's most original and memorable works.

Haseltine's American coastal views are the work of an accomplished and well-educated artist just setting out on his career. His depictions of specific rock formations and particular light conditions frequently prompted enthusiastic recognition of a favored spot by critics and, presumably, patrons. Further, his contemporaries were able to find some of the most important movements of the age reflected in these works: the belief that art's purpose was best expressed through the accurate depiction of nature and the recognition of geology as a science with the authority to rival scriptural accounts of the earth's creation. Both the recognizability and the resonance of his art grew from Haseltine's choice of elemental subjects observed closely and recreated faithfully. In his best American paintings – pared-down visions of rock, sea, and sky – the land formations speak with geological truthfulness, the waves break convincingly, and a palpable atmosphere suffuses the whole. The image simulates observed nature; the viewer, subscribing at least momentarily to the truth of the work, uses the painting to

fig.1 William Stanley Haseltine, *Near Hyde Park, Hudson River*, 3 July 1860. Wash on paper, 14⅝ x 21⅝ in. Museum of Fine Arts, Boston. M. and M. Karolik Collection.

fig.2 William Stanley Haseltine, *Delaware River*, ca. 1860. Ink and wash over graphite on paper, 14¾ x 22 in. Worcester Art Museum, Worcester, Massachusetts. Gift of Helen Haseltine Plowden.

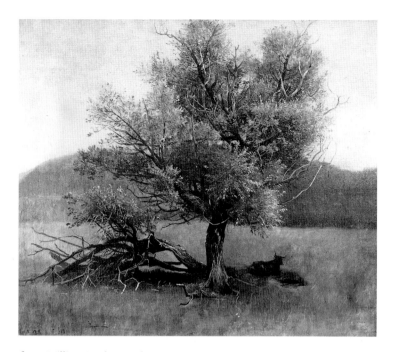

fig.3 William Stanley Haseltine, *Tree, Lenox, Massachusetts*, 1860. Oil on canvas, 16 x 18¼ in. The Dayton Art Institute, Dayton, Ohio. Gift of Mrs. Helen Haseltine Plowden (61.47).

prompt the same meditations on universal issues that would arise at the shore.

Indian Rock, Narragansett, Rhode Island (*pl.22*),[3] is one such painting, stark in the massing of its carefully detailed forms and surfaces, yet provocative. This, or a work very like it, prompted the foremost art-chronicler of the 1860s, Henry T. Tuckerman, to praise Haseltine's "remarkable accuracy" and the "emphatic beauty" of "these noble rock portraits set in the deep blue crystalline of the sea."[4]

Haseltine accomplished his "remarkable accuracy" through intense study on site. He then in his studio worked over the surfaces of such exhibition canvases as *Indian Rock, Narragansett, Rhode Island*, with minute brushstrokes, changing tone and color almost imperceptibly in his attempt to remove all overt trace of his hand from the painting. Yet he prevented these highly finished renderings from taking on an enameled hardness by permitting the texture of their underlying ground to show through the thinly applied paint. The gesso's even stipple catches and diffuses the light, casting an atmospheric veil across the scene. The artist was thus able to work in his most detailed and objective manner, predominantly in the striking color complements of blue and orange, while the physical characteristics of the paint aided him in suggesting a scene filled with air and light.

Tuckerman praised the topographical, geological, and meteorological accuracy of Haseltine's works:

The waves that roll in upon his Rhode Island crags look like old and cheery friends to the fond haunters of those shores in summer. The very sky looks like one beneath which we have watched and wandered; while there is a history to the imagination in every brown angle- projecting slab, worn, broken, ocean-mined and sun- painted ledge of the brown and pictur-esquely-heaped rocks, at whose feet the clear, green waters plash.[5]
These were crucial components in many mid-nineteenth-century critics' favorable responses to landscape paintings.[6] Ralph Waldo Emerson's epiphany before a pristine landscape – "I become a transparent eye-ball; I am nothing; I see all; the currents of the Universal Being circulate through me; I am part or particle of God" – became the model of objective achievement held up to the artist.[7]

Throughout the country by mid-century, as well, the writings of the English critic and philosopher John Ruskin spawned an American landscape school devoted to the closest replication of nature's details. Ruskin urged that the artist be "a glass of rare strength and clearness too, to let us see more than we could ourselves, and bring nature up to us and near to us."[8] Haseltine's good friend and colleague, Worthington Whittredge, later reminisced:
Ruskin, in his "Modern Painters," just out then and in every landscape painter's hand, had told these tyros nothing could be too literal in the way

of studies, and many of them believed Ruskin. The consequence was that many of them made carefully painted studies of the most commonplace subjects without the slightest choice or invention, and exhibited them as pictures.[9]

Even those who doubted Ruskin's infallibility, such as Whittredge, were touched by an increasing urge to specificity in their studies and compositions.

Haseltine's own sensibility and training would further have inclined him to a close study of nature. While at Harvard – B.A. 1854, M.A. 1858 (degrees of distinction in light of how few American landscape painters before him possessed advanced educational degrees) – he was a member of the Natural History Club, presided over by Alexander Agassiz, son of the Harvard professor Louis Agassiz, who was then the foremost geologist active in America. In addition to whatever science he imbibed while a student, along with remnants of heady transcendentalism, his painting studies in Philadelphia with the German-trained Paul Weber in 1854-1855 and his sojourn in Düsseldorf also would have instilled in him a reliance on observable fact.[10]

The contemporary critics who reviewed Haseltine's early exhibited works reinforced this inclination when in 1857 they held up the close study of nature as the touchstone of landscape painting:[11]

Mr. Hazeltine exhibits several landscapes . . . they show power which only needs to be influenced by an untrammelled study of Nature.[12]

By the time he began to regularly exhibit his New England views in the early 1860s, most critical voices praised his works' veracity, claiming them as "admirably faithful representations of delicate and too often unstudied water effect,"[13] or reflecting "a rare fidelity to Nature."[14] Referring to one Rhode Island painting a critic wrote:

We have seldom, if ever, seen a stronger piece of painting. It belongs to the class of work that the Germans call objective – that is, work unaffected by emotion or mental peculiarity. It is the strongest way of rendering the fact of the subject.[15]

Tuckerman summed up the consensus when he observed, "Few of our artists have been more conscientious in the delineation of rocks; their form, superficial traits, and precise tone are given with remarkable accuracy."[16]

As with any great portrait or comparable depiction of observed fact, Haseltine's views reveal not simply a likeness, but also clues to the character of what is portrayed, especially traces of past action and present status. Thus critics saw much more than mere surface effects in Haseltine's rendering of coastal scenery:

Hazeltine exhibited two American coast views, with the same evidence of filial study of nature, the same intelligent and spirited painting of water effects, and the same capital rock drawing, which have so often proved to

us that he takes an interest in the formative laws no less than the external appearance of scenery.[17]

The phrase "formative laws" makes overt reference to the geological work of scholars such as the elder Agassiz, who had turned attention to the coastal rock formations near Nahant, a site north of Boston that Haseltine would eventually paint, to further his studies of marine life and for support of his glacial theory of land formation.[18] Class lists apparently do not exist for Agassiz's lectures in the early 1850s, so we cannot prove that Haseltine attended such course offerings as an 1853 lecture series on the geology of the Ice Age.[19] Still, art critics of the 1860s sometimes articulated a link between geologist and painter:

Agassiz pronounces the rocks of Nahant to be the oldest on the globe, and that they are of volcanic origin. Mr. Haseltine fully conveys their character in his pictures.[20]

Great praise went to the artist who not only looked at nature, but studied it with the methods of a scientist and could infuse an image with the resulting knowledge.[21]

Every inch of [Haseltine's] "Indian Rock" tells a story in the most idiomatic language of nature. The staircased mass of red granite bears reminiscences all over it of a fiery birth and trial through cycles under the Thor hammer of the sea. If the water were at its wildest we question whether more oceanic force could be suggested than speaks from that sharply fractured, chinked and squared-blocked mass of finely variegated stone.[22]

As Haseltine himself is reported as saying, "Every real artist is also a scientist . . . not satisfied until his work is a true expression of what he feels to be real."[23]

Haseltine's "rock portraits," to use Tuckerman's stylization, were ideally suited to appeal to an American audience gone "geology crazy."[24] That science, in part due to the dynamic teaching and popularizing lectures of Agassiz, was at the center of social, scientific, and religious debate.[25] Even the readers of *Moby-Dick*, what few of them there were in the 1850s, were expected to know of Agassiz and his theories:

I should say that those New England rocks on the sea-coast, which Agassiz imagines to bear the marks of violent scraping contact with vast floating icebergs – I should say, that those rocks must not a little resemble the Sperm Whale in this particular.[26]

Thus the praise later recounted by the artist's daughter, that Haseltine "was often asked if he had studied geology,"[27] served not only to emphasize the artist's detailed rendering of a given site, but also to place him at the nexus of concerns and theories then pervading Western culture, including catastrophism, uniformitarianism, and the debate concerning the geologic chronology of the earth. The years around 1860 were filled with tremendous achievements in the study of the earth's surface

and the age of mankind – Alexander von Humboldt's five volumes of *Cosmos* appeared between 1845 and 1862; Matthew Fontaine Maury set forth the first edition of his *The Physical Geography of the Sea* in 1855; Charles Darwin published *On the Origin of the Species by Natural Selection* in 1859; the archaeopteryx fossil – the feathered dinosaur – was discovered in 1861; T. H. Huxley's *Evidence as to Man's Place in Nature* and Charles Lyell's *The Antiquity of Man* both appeared in 1863. Haseltine's images of rock and ocean would prompt his acute viewers to reflect on these scholarly accomplishments. As Tuckerman, again, wrote of the paintings, "they speak to the eye of science of a volcanic birth and the antiquity of man."[28] Oliver Wendell Holmes' nearly contemporary apostrophe of the ocean is, in this context, suggestive. He called it:

the great liquid metronome . . . steadily swinging when the solo or duet of human life began, and . . . just as steadily after the human chorus has died out and man is a fossil on its shore.[29]

Aside from its pursuit of scientific accuracy, Haseltine's faithfulness to nature apparently also addressed the buying public's reception of his works. The nineteenth century saw the increase of leisure time, and with it the resultant growth of vacation spots. These popular resorts provided the vast majority of his exhibition paintings with their subjects and titles. It seems likely that at least a portion of his patronage throughout his career, both in America and later in Europe, developed in response to his patrons' need for mementoes of a given spot, either often-visited or frequently dreamed of. Tuckerman claimed that the artist's works would "distinctly and, as it were, personally, appeal to the lover of nature for recognition or reminiscence."[30] All three sites of Haseltine's principal American campaigns – Maine's Mount Desert, the western shore of Rhode Island's Narragansett Bay, and Nahant just north of Boston – were favorite destinations of tourists.[31]

On first glance, then, these three sites would appear a logical set of destinations for most landscape artists of the time. Yet the exclusivity of Haseltine's choice places him at odds with almost all the other comparably well-traveled painters of his generation, notably his friends from Europe (and fellow residents at the Tenth Street Studio Building), Whittredge, Sanford R. Gifford, and Albert Bierstadt. Whittredge later wrote pointedly of the difficulty faced by these artists who had the experience of both European art and landscape to overcome in their search for originality:

It was impossible for me to shut out from my eyes the works of the great landscape painters which I had so recently seen in Europe, while I knew well enough that if I was to succeed I must produce something new and which might claim to be inspired by my home surroundings. I was in despair. Sure, however, that if I turned to nature I should find a friend,

I seized my sketch box and went to the first available outdoor place I could find. . . . But how different was the scene before me from anything I had been looking at for many years! . . . I think I can say I was not the first or by any means the only painter of our country who has returned after a long visit abroad and not encountered the same difficulties in tackling home subjects.[32]

For many of this generation, the difficulties in "tackling home subjects" forced them to quest for new lands and visions. Central and South America, Newfoundland and the Arctic, and the Far West soon came to be seen as the hunting ground for a generation of American artist-explorers. William Bradford, Frederic Edwin Church, Martin Johnson Heade, Louis Mignot, and Thomas Moran among many others joined Whittredge and Bierstadt in exploring the extremes of the Western Hemisphere, staking artistic claims as interpreters of a given region, finding originality not so much in style as in subject matter.[33] As a writer for the *Cosmopolitan Art Journal* wrote in 1860:

Our artists are quite generally "out of town" – which means gone to the antipodes, or anywhere else that a good sketch can be had. The hope of that great picture, of which every artist dreams, sends him into every imaginable locality in quest of the sketch. They straddle mountains, ford rivers, explore plains, dive into caves, gaze inquisitively into the clouds (not always, we are sorry to say, into Heaven), sail seas, run into icebergs, scald themselves in Amazonian valleys – always returning safely home in the golden October, with a lean pocket and plethoric portfolio, ready for commissions and praise.[34]

Haseltine did not follow the lead of these friends and colleagues to combine the role of explorer with that of artist. When he went in search of American scenery, he instead trod in domestic, east-coast-bound footsteps. The great achievement of his American works lay in his consistently wringing a distinctive and resonant art from this continued confrontation with the familiar.

Haseltine's first professional summer on the American coast was in 1859, when in the company of painter Charles Temple Dix he summered on Mount Desert, Maine.[35] The island, described somewhat contradictorily by one writer in 1860 as both a "wild and unfrequented vicinity" and "a paradise of painters,"[36] had provided material for artists from the early years of the century. Its first notable painter was Thomas Cole, who visited the island in 1844 with artist Henry Cheever Pratt.[37] Bradford, Benjamin Champney, Church, Thomas Doughty, John F. Kensett, John LaFarge, Fitz Hugh Lane, and many others soon followed. In 1859 William Hart was on the island with Haseltine and Dix, as was the young Alfred Bricher, who "fell in company with William Stanley Haseltine and . . . Charles Temple Dix [and] derived great benefit from their kindly advice."[38] What drew them all was the

majesty of the island's rocky coastline. A writer in 1862 noted,

A summer trip to Mount Desert has of late been a pleasant treat to American landscape painters. . . . The vigorous and varied rock-bound coast of New England can be nowhere seen to greater advantage.[39]

A decade later another visitor wrote:

In all my wanderings I remember no place where the lover of the beautiful, the romantic, and the more sublime elements of nature will find so much that will fascinate and captivate him as here.[40]

It was while on Mount Desert, in the careful drawings that document sites scattered across the island, that Haseltine found his mature voice. Amid the panoramic vistas reminiscent in format of his earlier European and American inland work, such as *Eagle Cliff from Northeast Harbor across Somes Sound* (*pl. 10*), are such detailed studies of the rocky coast as *Near Otter Cliffs, Mount Desert* (*pl. 13*). This magical drawing, with a spareness and elegance almost like a Chinese ink painting, is among the earliest works by Haseltine to focus solely on the three elements of sea, rock, and sky. The attention he lavishes on each facet of the cliff convincingly conveys its weight and structure. The tonal range exploited in its depiction, from unmodulated passages of dark ink wash to thin edges of bare paper, testifies further to close and accurate study. Haseltine balances the dark wedge of the cliff with an equal portion of untouched paper; only a ruler-thin horizon line breaks sky from sea. A few dancing strokes indicate reflections in the water and a ruff of foliage atop the cliff. Haseltine concentrates wholly on providing a stark, effective rendering of the rocks and their elemental drama with the sea.

The island could apparently inspire this concentration in artists as diverse as Cole (*Frenchman's Bay, Mt. Desert Island, Maine*, 1845, Albany Institute of History and Art, New York), Church (*Coast Scene, Mount Desert*, 1863, Wadsworth Atheneum, Hartford, Connecticut), or William Hart (*Pools by the Seaside*, 1861, Albright-Knox Art Gallery, Buffalo, New York). For these artists, the starkness of the work on Mount Desert provided an atypical note in the outline of their careers. But Haseltine succumbed to it fully, finding a pattern to shape much of his work over the next five years. This could be a disposition in part prepared by his friendship in the 1850s with, and lifelong admiration of the work of, Andreas Achenbach. The German painter was well known in both Europe and America for his dramatic seascapes.[41]

Over the winter of 1859-1860, Haseltine developed at least one exhibition painting from the Maine trip.[42] He apparently continued to mine the studies during the next two years, generating exhibition paintings without, so far as we know, returning to Mount Desert.[43] One of the finest paintings to result from this focus was *A View from Mount Desert* (*pl. 14*), very likely the same work shown at the National

Academy of Design exhibition in 1862 as *Mt. Desert Island*. Marked as the work of "a young artist who has an ambition to improve, and who is destined, we think, to make his mark in the meritorious school of landscape which is rapidly growing up among us,"[44] the painting was part of a highly successful exhibition for the newly elected National Academician. His *Amalfi, Coast of Naples* (location unknown), was accorded much favorable attention and sold from the walls of the show. *Mt. Desert Island* was noted as having "much local characterization," and was further described in detail:

Pine trees and boulders, on a slope that edges away down to the sea, are combined with a wide ocean expanse which glitters in a very strong light peering forth from behind dark clouds. There is severity predominant and in keeping throughout, while the good drawing and the indescribable sense of air and space make this also an attractive picture.[45]

But the same writer did find a cause for concern with *Mt. Desert Island*: "[L]et Mr. Hazeltine beware of mistaking white pigment for light. It is an easy substitute, but passable only where the spectator is remote perforce and where effect alone is consequently studied." The critic's warning about viewing a work from too near holds true for almost all of Haseltine's painted oeuvre. Most frequently, in works of any significant scale, the artist seeks to establish the atmosphere of a specific place; this is also true of Bierstadt, Gifford, Bradford, and any number of other landscape painters of the time. Their success in this quest can best be perceived when their works are seen from a distance. Crawling around the perimeter of a room, as is the habit of many museum- and gallery-goers today, denies the art its evocative power, substituting felicities of surface handling for the achievement of light and air. Paintings such as *A View from Mount Desert* must be seen from a distance to transmit the "indescribable sense of air and space" that is their aim.

Mount Desert remained a sympathetic locale in Haseltine's mind. He again visited the island in 1893 and then stayed there for the summer of 1895. The sixty-year-old artist continued to sketch and paint, most often choosing the contained subjects more readily encompassed by his late watercolor technique, as in *Seal Harbor, Mount Desert, Maine* (*pl. 71*).

Haseltine probably attained his greatest fame, however, with views of a more southerly coastline, that of Narragansett, Rhode Island. Unlike Newport, its fashionable neighbor to the east – where, according to Thoreau, one "thinks more of the wine than the brine"[46] – Narragansett Pier was just barely establishing itself as a summer resort in the early 1860s.[47] Patronized in particular by Philadelphians, Narragansett Pier built its first hotel in 1856. A second was not erected until 1866.[48] Thus when Haseltine first arrived for the summer of 1862,

he probably found the place relatively still and solitary. To augment
this solitude, he turned his attention away from the sandy beach to
focus instead on the five-mile stretch of rocks that run south from
Narragansett Pier to Point Judith. Great chunks of reddish granite,
smooth-faced blocks and huge inclined slabs, here push the sea back
from the land. Their irregular massing and jumbled appearance,
speaking of immense forces at work in their placement, provided the
artist with a bounty of views.[49]

Haseltine took full advantage of the possibilities offered to him.
Drawings in various media – graphite, ink, and colored washes –
reveal that he prowled along the giant rock faces (*pls.17 & 18*). Sketches,
whether full sheet or in a sketchbook, were clearly done with composi-
tions of paintings in mind (*fig.4*). The point that most fixed his atten-
tion along the Narragansett shore was a jutting mound of reddish rock,
one of the distinctive landmarks of the place, called Indian Rock, a
squarish pile of jagged blocks surrounded almost wholly by the sea.
Haseltine examined Indian Rock, so-called because its color was said
to be the stain of Native-American blood that the ocean could not
wash away,[50] from both near and far (*figs.5 & 6*). Moving around it,
concerned not only with its most characteristic physiognomy (*pl. 20*)
but also with its many guises when seen from different points of view,
Haseltine was clearly fascinated by the site, making there some of his

most complex plein-air drawings to date.

When he returned to New York after his first summer at Narragansett,
Indian Rock and its neighbors provided the motif for a number of
paintings noted by critics who praised his "fine feeling for bold coast
and untamed water,"[51] and his "filial study of nature."[52] The most
important of the paintings resulting from the summer's work was
Indian Rock, Narragansett (*pl. 21*), probably one of the two Narragan-
sett paintings, both of them already sold, that constituted his National
Academy of Design acceptances for the 1863 spring annual. The critic
for the *Evening Post* wrote that "In drawing light and shade and color it
is one of the truest and strongest pieces of rockwork in the exhibition."[53]

The success of the works from early 1863 inspired Haseltine to
return to Rhode Island for at least part of that next summer and to
focus his attentions during the winter of 1863-1864 on further recre-
ations of the scene:

*W. S. Haseltine has returned to his studio after a busy summer on the
sea-shore, and is at work again upon those sunny red rocks and blue
waters which render his pictures so attractive and characteristic. His new
sketches embrace some of the most interesting scenery to be found on our
Atlantic coast, particularly along the rocky shores of Narragansett Bay, in
the vicinity of Point Judith. . . . To those who have sailed or strayed along
the sea-coast of Rhode Island, opposite to Newport, the striking character*

of the scenery and remarkable tint of the rocky ledges, particularly in the afternoon sunlight, must be peculiarly interesting. To others, not familiar with that bold and beautiful coast, the sketches of this artist will be none the less valuable as presenting a phrase of scenery not exceeded in nature's attractions anywhere in this country. The pictures are painted with great boldness of effect, and the sharp irregular angles of the rocky red ledges contrast forcibly and pleasingly with the bright blue waters which circle and spread around them, and the calm, cloudless azure which bends serenely above.[54]

Probably referring to such closely related works as *Indian Rock, Narragansett, Rhode Island,* and *Rocks at Narragansett* (also known as *Rocks at Nahant*) (*pls. 22 & 23*),[55] these two paintings are among the artist's most concentrated, distilled portrayals of the elemental trinity of rock, sea, and sky. Haseltine here portrays no fishermen or strollers to give scale or allow the viewer an empathetic association. Only the yachts at the horizon reveal the transitory presence of humanity on this coast.

Haseltine's Rhode Island views proved to be exceedingly popular. They joined distinguished collections, were widely exhibited, and most often prompted favorable reviews. One result of this popularity, however, was a cautionary notice: the critic for the *Post* wrote, "The success which has attended Hazeltine's efforts in this way has induced him to confine his brush for the present upon similar views."[56] People began to wonder if the painter could do more varied work. In February 1864, one writer thought it important to warn the young artist about working too much along one line:

Mr. Hazeltine's two pictures in the gallery of the "Century" are perhaps an advance in certain qualities; but they are so strong and marked in style, so unmistakably Mr. Hazeltine's work that a few words of criticism are called for. They are justly appreciated and well understood; so much so that Mr. Hazeltine is threatened with . . . martyrdom to a specialty. . . . It is a great injustice to an artist to encourage him in one direction at the expense of versatility. Most of all so when a specialty is not one of sentiment, but of subject-matter – rocks, water, and sky.[57]

Haseltine did not immediately heed the warning, however, and continued to put visions of the rocks at Narragansett before the public. In late 1864 Goupil & Co. announced that it was preparing an engraving of the site "after a recently-painted picture by Haseltine. It will prove an acceptable companion to Kensett's 'Noon on the Seashore,' and Casilier's [*sic*] 'Lake George.' "[58] The engraving would eventually appear in the 19 June 1869 issue of *Appleton's Journal* as part of "not only a varied series of illustrations of our mountain, river, and coast scenery, but a choice gallery of American art."[59] The graphic reached its most distinguished audience three years later when it was included

fig.6 William Stanley Haseltine, *Indian Rock with Distant Clouds, Narragansett Bay, Rhode Island,* ca. 1862/63. Ink and wash over graphite on paper, 15¼ x 22³⁄₁₆ in. Daniel J. Terra Collection, Terra Museum of American Art, Chicago.

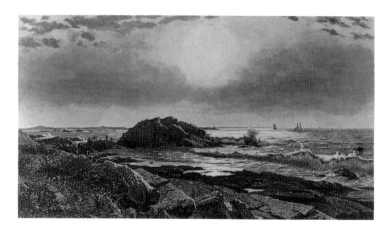

fig.7 Samuel Valentine Hunt (1803-1893), *Indian Rock, Narragansett, after W. S. Haseltine.* Steel engraving. Published in William Cullen Bryant, ed., *Picturesque America,* 2 vols. (New York: D. Appleton & Co., 1872-1874).

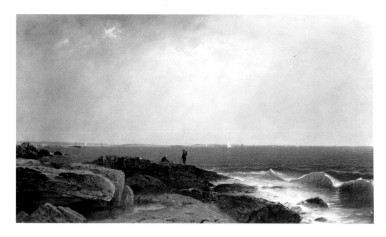

fig.8 John F. Kensett (1816-1872), *Narragansett Bay*, 1861. Oil on canvas, 14 x 24 in. Private collection.

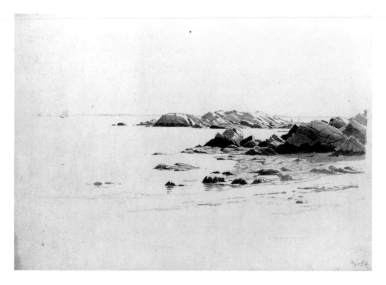

fig.9 William Stanley Haseltine, *Rocklined Beach with Distant Boats* [Pea Island, Nahant], ca. 1864. Ink and wash over graphite, 15¼ x 21 ⅞ in. National Gallery of Art, Washington, D.C. Ailsa Mellon Bruce Fund.

as an illustration in William Cullen Bryant's *Picturesque America* (fig.7).

One possible reason that Haseltine did not at first respond to the warning about a close focus on views of Narragansett rocks was the positive and comparable example provided by one of the best-loved of American landscape painters, John F. Kensett. Critics had frequently associated the two men: "From present appearances, Hazeltine's red rocks are likely to become as popular and as individualized as are the mottled and somber gray ones of Kensett, so well known to all lovers of marine paintings."[60] Indeed, in both his choice of locale and in the concentration on a few simple elements, Haseltine seems to follow in the footsteps of Kensett, who had earlier gained fame for a similar reductionist aesthetic in such paintings as *Narragansett Bay* (fig.8). The points that underscored Kensett's success during the 1860s – Tuckerman wrote that "his coast scenes are so popular they find purchasers before they leave the easel"[61] – had to do with their accuracy and the demand for faithful representations of the familiar, the very elements that sparked contemporary critics to praise Haseltine.

Given the questions of his versatility, however, it is significant that during the summer of 1864 Haseltine did not return to Narragansett. Perhaps the critical warnings of repetition finally had an effect. It certainly seems likely that the traumatic death of his wife and newborn child in June would have required him to make a change from routine. Yet he did not abandon the coast. Instead he was drawn north, to another, more active leisure resort, the small peninsula of Nahant just outside Boston.

The vital community at Nahant would have offered a striking contrast to the relative quiet of Narragansett. Already by 1840 there was an established and active resort on the site, and the spot was advertised in promotional literature that suggested converging artistic and geologic concerns, as well as those of the nation's emerging leisure class, as a watering place "of interest to all, and especially to the curious, the scientific and the romantic."[62] Its proximity to Boston and Cambridge encouraged many members of that social and intellectual community to establish summer homes there. Thoreau called it, somewhat scornfully, "the resort of all the fashion of Boston."[63] The authors Henry Wadsworth Longfellow and John Greenleaf Whittier,[64] the historians John Lothrop Motley and William H. Prescott, and Cornelius Felton, president of Harvard College, among many other notables, resided there over various summers in the 1850s and 1860s.[65] This coterie of Boston literati had earlier attracted the painter Kensett – Haseltine's exemplar – to the area of Boston's North Shore.[66] Its great attraction, in addition to the intellectual society, was the pounding sea that ringed the peninsula's rocky cliffs and beaches. As Oliver Wendell Holmes, another summer resident, wrote of the place, "if you would

enjoy Nahant, you must have an ocean in your soul."[67]

Nahant's cliffs and promontories had an expert advocate in Louis Agassiz, who spent his summers on the site. The noted geologist wrote: *[Nahant's] features warrant a minute study of months, or even years, for we should constantly find new subjects of interest. To the student of nature, Nahant is a geological museum in miniature, in which he may examine on a small scale all the great features of the globe.*[68] Agassiz, in his writing, teaching, and lecturing, made such frequent reference to the spot that one recent writer has posited that to an audience in the 1860s mere mention of Nahant would conjure the presence of Agassiz as surely as Mount Vernon brings to mind George Washington.[69] Over the very summer when Haseltine was at Nahant, the *Atlantic Monthly* carried Agassiz's article, "The Ice-Period in America," which included citations of the area.[70] It certainly seems possible that scientist and painter, who was during the early 1860s faithfully attending his Harvard reunions, came into contact over the summer of 1864.

The art press reported on Haseltine's stay at Nahant, aptly mentioning both art and society as occupations: "Haseltine divides his time between fashion and the sea at Nahant."[71] The same periodical, *Watson's,* praised the results of his summer's work when he had returned to the studio later in the fall:

Haseltine, who passed the summer months at Nahant, has brought back many admirable studies of the scenery of that neighborhood.... It is within three years that Mr. Haseltine has come into notice as a painter of coast scenes, and so marked has been his success, that his prominence and superiority in the portrayal of the rocky shores of Nahant and Narragansett are by all fully acknowledged.[72]

The summer's work included such characteristic drawings as *Rocklined Beach with Distant Boats* and *Shag Rocks, Nahant (fig. 9 & pl. 26).* Most dramatic of the extant drawings probably done from that summer is *Rocky Coastline, New England (pl. 24)* – the Boston steamer in the distance helps identify the site, as do the rocks which seem similar to East Point formations.[73] This provides a richly faceted counterpoint to the artist's earlier *Near Otter Cliffs, Mount Desert.* Haseltine uses the same basic technique as five years earlier; he reinforces his pencil contours with ink, using washes of varying densities to suggest angles and shadows while leaving touches of bare paper for highlights. But there is, if possible, an even greater fluency and bravura in the brushwork of this later drawing.

Along with works on paper, critics visiting the studio also saw small paintings that were presumably done on site. *After a Shower, Nahant, Massachusetts (pl. 27),* painted thinly so that the twill of the canvas is still evident, and *Coast of New England (fig. 10),* showing the no-longer

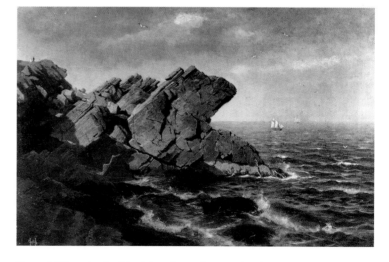

fig. 10 William Stanley Haseltine, *Coast of New England* [Pulpit Rock, Nahant], ca. 1864. Oil on canvas, 15 x 23 in. Bowdoin College Museum of Art, Brunswick, Maine. Gift of Helen Haseltine Plowden.

extant Pulpit Rock, are perhaps examples of the scale and finish that so impressed writers:

Many of his studies are as elaborate in their completeness as finished pictures – the rocks, water, and sky being painted with such a closeness and fidelity to nature as to leave little for the artist to add when he comes to use them in large works. . . . [N]o one who has wandered over those huge masses of rough red rock, and watched the waves breaking against them, could fail to locate, from his studies, the very spot he has delineated.[74]

As in previous years, Haseltine was soon at work on large exhibition paintings based on his summer's rambles; such was his status that reports on his progress in the Tenth Street studio appeared in print.[75] The most impressive work Haseltine began over the winter was *Nahant Rocks (pl. 32)*, among the painter's largest efforts to date. This was probably well underway by mid-February, when a writer for the art press noted:

Haseltine has a large marine view of a rocky coast near Nahant, with Castle Rock in the middle distance, jutting out into the water. A fine effect of sunlight and shadow on the rocks is obtained by the artist, and the character of the water and the sky is truthfully presented.[76]

Castle Rock, on the northeastern side of Nahant, was one of the popular landmarks of Nahant (as Haseltine documented in a close-up view of the site [*fig.11*]), profiled in tourists' reports and guidebooks throughout the century. Its blocky structure and moated site created a scene that "might almost be taken for a savage fortress . . . with battlements, embrasures, buttresses, and turrets, the only kind of counterpart to the castle ruins which so richly deck European scenes that our new America affords."[77]

But occupying as much space as either rock or sea in the painting, Haseltine fills the canvas with a compellingly clear blue sky – the ethereal but crucial capping of the work. Here he effectively captures the singular clarity of shore light, proving it to be equally worthy of attention and study as rocks or sea. As one writer had earlier observed of Nahant's skies:

But he is a Tyro in the observation of nature, who does not know that, by the sea, it is the sky-scape and not the landscape in which enjoyment lies. . . . [F]or the sea and sky are exhaustless in interest as in beauty, while, in comparison, you soon drink up the little drop of satisfaction in fields and trees.[78]

When Haseltine's painting was shown at the National Academy of Design spring exhibition, along with another Castle Rock painting and a view of Nahant's Pulpit Rock, it was praised as, "one of the best that we have seen of his many groups of bold, dark rocks, edged by a bright, blue sea."[79]

Sadly, however, if the change of venue away from Narragansett and a shift in scale were elements of a conscious effort on Haseltine's part

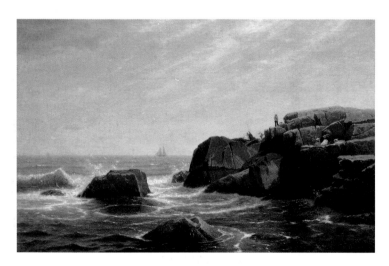

fig.11 William Stanley Haseltine, *Castle Rock, Nahant*, 1865. Oil on canvas, 24 x 38 in. The Corcoran Gallery of Art, Washington, D.C. Gift of Helen Haseltine Plowden.

to appease the critics' complaints of sameness in his work, they did not succeed. Responses to the National Academy show were consistent in urging the need of more drastic change, one citing *Castle Rock, Nahant*, as "another of Mr. W. S. Haseltine's carefully manufactured articles in stone-ware and water,"[80] and a different one saying bluntly, "Admirable as [this] is, there is too much repetition of former things in the same line."[81] Perhaps the most wounding charge came as a general attack: "It would be a relief if Mr. Haseltine would go to work at once and paint a quarry. He might in such wise get over it, and become as surfeited as the rest of the public."[82]

These negative responses to Haseltine's works reveal the quandary often faced by artists. Professional commentators, espousing views sometimes at odds with one another, urge change and reform; the buying public, anxious to take part in previous successes, rewards consistency. Thus all three works at the National Academy, and the majority of those exhibited elsewhere in 1865, had been sold before the shows' catalogues were printed. More importantly, such works as *Castle Rock, Nahant*, do not exhibit any sign of the artist losing interest in the subject matter, for their formal strengths are considerable and his manner of capturing light and air effective.

Yet Haseltine, whether or not prompted by critical urging (for he did not apparently need to sell his works to survive),[83] did tackle a series of different challenges later in 1865. During the summer, for example, he returned to Europe for the first time since his student days, searching for new motifs in the Old World. His works from the next fall and winter included a high ratio of Italian subjects, including many coastal views featuring the rocky coastline of Capri. At about this same time he also undertook at least one collaborative venture, working with the figure painter William J. Hennessy to paint a Narragansett scene with relatively large-scale figures scrambling over the rocks – very likely the painting *Rocks at Narragansett* (*fig.12*).[84]

A significant personal change also took place; the successful conclusion of his courtship of Helen Marshall with a wedding, his second, held in February 1866. After an April auction of thirty-four paintings from his studio, he and his family departed for Europe, anticipating a stay of about two years.[85] It would prove to be much longer. With the exception of brief interludes, in fact, he largely withdrew from the United States, neither living nor exhibiting there but rarely over the next thirty-five years. European subjects, with their own distinctive rocks, ruins, and monuments, dominated the remainder of his career.

For far less than a decade, then, Haseltine worked along the eastern seaboard. Other gifted painters of his generation followed him to the American shore – Bierstadt, Bricher, Whittredge – as did fellow Philadelphians Thomas Moran, William Trost Richards, and Alexander

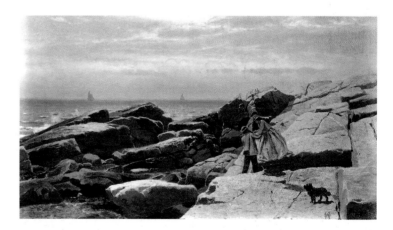

fig.12 William Stanley Haseltine and William J. Hennessy (1839-1917), *Rocks at Narragansett*, ca. 1865. Oil on canvas, 12 x 22 in. Vulcan Materials Company, Birmingham, Alabama.

Harrison, among many others.[86] The greatest of these others was Winslow Homer. Just a few years after Haseltine had moved to Europe, Homer began to paint views of oceanside resort life, as in *Long Branch, New Jersey* (1869, Museum of Fine Arts, Boston). In this painting, as in his Gloucester works of the 1870s and even in the darkening ocean views portraying the coasts of England and Maine in the 1880s, Homer most frequently concentrated his energy on depicting the people who live by the water; their enjoyment of, or struggles against, the sea provides the works' drama. Only in 1890, in a major exhibition painting, *Sunlight on the Coast* (*fig.13*),[87] did Homer shift focus away from mankind to the elements of rock, sea, and sky.

At first glance, it is hard to imagine two more disparate works than Haseltine's *Indian Rock, Narragansett, Rhode Island* (*pl.22*), and Homer's *Sunlight on the Coast*, done over twenty-five years later. The most immediate difference is the threat implicit in the later work, a consequence not only of the lowering weather and oncoming darkness but also the scale of the wave, the high horizon line, and Homer's decision to suspend the viewer above the water – formal choices that conspire to unsettle. Homer also simplified the surfaces of his subjects, releasing the viewer from the responsibility of observing facts closely. As if he were trying to simulate the dash of the waves, he pushed his paint across the canvas with vigorous strokes and daubs, leaving the track of an agitated, exuberant hand throughout; the act of painting becomes the work's subject.[88]

This contrast in tone and manner between the two paintings, in addition to marking the distinct personalities of Haseltine and Homer, reflects changes in the art world occurring in the twenty-seven years that separate their making. Expectations about landscape painting's style had changed radically. Critics in the 1860s had lauded accurate depictions of the world, demanding that painters demonstrate a scientist's objectivity. Praise accorded Haseltine was most often based on this criterion, and what harsh criticism he received grew from perceived failings in this regard.[89] How different was the sensibility of the next generation, whose members proclaimed that a "work of art is not a scientific statement."[90] As one recent scholar has noted, even as early as the 1870s "to paint geologically had come to signify that one was out of date. . . . To be literal and factual in paintings suggested to many a lack of artistic imagination."[91]

Of even greater importance in marking the change between the two works is the shift in the expectation of how a painter should use the landscape. In paintings of the 1850s and 1860s, ranging from the quiet visions of Fitz Hugh Lane to the grandiloquent declamations of Albert Bierstadt, nature was most often presented as beneficent – a striking contrast to the manmade ravages of expanding urban sprawl,

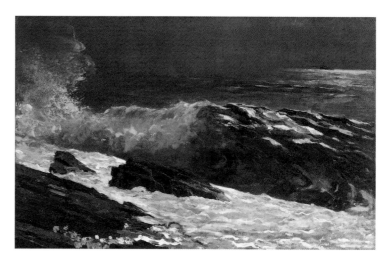

fig.13 Winslow Homer (1836-1910), *Sunlight on the Coast*, 1890. Oil on canvas, 30¼ x 48½ in. The Toledo Museum of Art, Toledo, Ohio. Gift of Mr. and Mrs. Edward Drummond Libbey.

industrialization, and the American Civil War that surrounded the artists and their patrons. By the 1890s, in contrast, views of nature more often reflected the interior world of the individual artist, functioning as mirrors to the emotions and perceptions of their creators.[92]

Homer, although he was just eight months younger than Haseltine, moved in the prevailing direction of the times and, with his seascapes of the 1890s, created images of immense abstract and symbolic power. Haseltine followed a different course during the last quarter of the century, never abandoning the objective ideals of his early maturity in his search for the beautiful and magnificent in nature.

Yet in spite of the differences between *Indian Rock, Narragansett, Rhode Island,* and *Sunlight on the Coast* that were imposed by the sensibilities of the artists and the times of their creation, the two paintings also reveal marked similarities. In both the painters use like compositional structures to organize their wide horizontal formats: the land mass fills the diagonal across one lower corner while bubbling white foam fills the other; one breaking wave runs nearly parallel to the horizon and dominates the middle ground; a boat at the horizon serves as a visual balance to the foreground rocks. Moreover, contemporary critics of both works appreciated the accuracy, albeit defined differently and achieved through different technical means, of the artists' observation of locale, light, and weather.[93] Both works make manifest the artists' rapt attention to wave and rock, and their attempt to capture a single moment – individual yet characteristic – split from the continuum of ebb and flow.

There is at least one further consideration that connects Haseltine's *Indian Rock, Narragansett, Rhode Island,* to Homer's *Sunlight on the Coast* – the representative role each plays both in the artists' careers and in the history of American marine painting. Each painter turned to the subject repeatedly during an extended portion of his career, ringing close variants of the theme with ever-growing conviction. In this sense the two painters partook of the seascape's fascination for America's artists since the founding of the union, offering "a shape for their feelings about the location of the physical universe and its relation to our metaphysical quest for ultimate meaning."[94] For the nation's painters, as well as Americans in general, the shore fosters contemplation. Questions beyond those of human society – creation, destruction, infinity – seem naturally to arise there:

The sea drowns out humanity and time; it has no sympathy with either; for it belongs to eternity, and of that it sings its monotonous song forever and ever.[95]

Herman Melville put it succinctly: "as every one knows, meditation and water are wedded for ever."[96]

Haseltine's apparently accurate, geologically precise portrayals

open the door to these mysteries. Because of the close observation that underlies them, and the skill with which they are constructed, they are able to project the wonder and mystery of being at the shore. But the works do not rely solely on the viewers' reminiscence for their power. They instead provide a heightened, accentuated view of nature that subtly departs from the realities of vision: the intensity of their colors beggars daily experience; their overall focus across the width of the canvas exceeds the workings of the human eye; the placement of the horizon is generally higher than one would see it if walking along the rocks.[97] Haseltine also arranges his canvas so that, even more than at the shore, the disorienting question of the scale of the objects portrayed comes to the fore.[98] All these departures from observed reality provide the works with a power that makes them appropriate vehicles for our ineluctable fascination with those dramatic boundaries "near the ocean's edge" where solid land, fluid sea, and a sky that extends forever are joined.

Notes

This essay could not have been written without the dedicated and longstanding research efforts of Andrea Henderson. She, Sally Mills, Derrick Cartwright, and Fronia Simpson have all read versions of the paper and made fruitful suggestions for which I am grateful.

1. James Suydam to John F. Kensett, Cold Spring, N.Y., 7 August 1861, Kensett Papers, Archives of American Art, Smithsonian Institution, roll N68-85, frame 307. Earlier, in 1854 and 1855 while Haseltine sought parental approval for study abroad, views of the Juniata and Delaware rivers near his Philadelphia home occupied his time.

2. Henry David Thoreau, "The Fisher's Son," *Collected Poems of Henry Thoreau*, ed. Carl Bode (Chicago: Packard and Co., 1943), 122.

3. Although the painting shows the area adjacent to Indian Rock and should probably be called simply *Narragansett*, we here maintain its traditional title.

4. Henry T. Tuckerman, *Book of the Artists: American Artist Life* (1867; New York: James F. Carr, 1967), 556-557.

5. Tuckerman, *Book of the Artists*, 557.

6. One of the most insightful readings of this aspect of American culture is found throughout Barbara Novak's *Nature and Culture: American Landscape and Painting, 1825-1875* (New York: Oxford University Press, 1980). See also the discussions of individual works in *Next to Nature: Landscape Paintings from the National Academy of Design*, exh. cat. (New York: National Academy of Design, 1980).

7. "Nature" [1836], *Ralph Waldo Emerson: Essays & Lectures* (New York: Library of America, 1983), 10.

8. John Ruskin, *Modern Painters I* (1843), reprinted in Robert Herbert, ed., *The Art Criticism of John Ruskin* (Garden City, N.Y.: Anchor Books, 1964), 30. For full studies of Ruskin's influence in America, see Roger B. Stein, *John Ruskin and Aesthetic Thought in America, 1840- 1900* (Cambridge: Harvard University Press, 1967); and Linda S. Ferber and William H. Gerdts, *The New Path: Ruskin and the American Pre-Raphaelites*, exh. cat., The Brooklyn Museum (New York: Schocken Books, Inc., 1985).

9. Worthington Whittredge, *The Autobiography of Worthington Whittredge, 1820-1910*, John I. H. Baur, ed. (1942; New York: Arno Press, 1969), 55.

10. See *The Düsseldorf Academy and the Americans*, exh. cat. (Atlanta: The High Museum of Art, 1972); Wend von Kalnein, *The Hudson and the Rhine: Die amerikanische Malerkolonie in Düsseldorf im 19. Jahrhundert*, exh. cat. (Düsseldorf: Kunstmuseum Düsseldorf, 1976); Elayne Genishi Garrett, *The British Sources of American Luminism*, Ph.D. diss. (Case Western Reserve University, 1982); Brucia Witthoft, *American Artists in Düsseldorf: 1840-1865*, exh. cat. (Danforth, Mass.: Danforth Museum, 1982); Lynda Joy Sperling, *Northern European Links to Nineteenth Century American Landscape Painting: The Study of American Artists in Duesseldorf*, Ph.D. diss. (University of California, Santa Barbara, 1985).

11. To be fair, critics were themselves urged to comparable accomplishments: "[The critic] should have above all things a familiar and intimate knowledge of nature, and not only a practical knowledge to be gained by observation and experience but also a scientific knowledge. Geology and Botany will never come amiss when added to knowledge" ([Russell Sturgis], "Art Criticism," *New Path* 1, no. 12 [April 1864]: 154; quoted in John P. Simoni, *Art Critics and Criticism in Nineteenth Century America*, Ph. D. diss. [Ohio State University, 1952], 37).

12. *Crayon* 4, no. 6 (June 1857): 186.

13. "Fine Arts. The Studio Pictures," *Evening Post* (New York), 5 February 1863.

14. "Brooklyn Art Association: Annual Reception at the Academy," *Brooklyn Daily Eagle*, 4 March 1863.

15. "Artists' Studios," *Round Table* 1, no. 2 (26 December 1863): 27.

16. Tuckerman, *Book of the Artists*, 556. Of course, not all critics subscribed to this view of Haseltine's works. Clarence Cook, critic for the *New-York Daily Tribune* and chief spokesman for the American Pre-Raphaelites, twice launched tirades against one of Haseltine's National Academy of Design paintings of 1864, *Iron-Bound, Coast of Maine* (probably either *pl. 15* or the work auctioned at Christie's, 1 December 1989). See "Fourth Artists' Reception," *New-York Daily Tribune*, 26 March 1864 (here attributed to Cook) and "National Academy of Design. The Thirty-ninth Exhibition," *New-York Daily Tribune*, 7 May 1864. Cook particularly railed against the American artists who had studied in Düsseldorf – Emanuel Leutze, Worthington Whittredge, Albert Bierstadt, and Haseltine. See Simoni, *Art Critics*, 279-280. A year later another writer took aim at Haseltine from the pages of the *New Path*, the leading Ruskinian periodical of the time: "Hazeltine has painted a number of pictures which have for subject ledges of the siennite rock which seems to constitute the greater part of this Gloucester coast. I do not know where he found the rocks he has painted ("Leaves from a Note-Book [dated September 1865]," *New Path* 2, no. 11 [November 1865]: 181).

17. "Fine Arts. The Brooklyn Artist's Reception," *Evening Post* (New York), 5 March 1863.

18. The most useful biography on Agassiz is Edward Lurie, *Louis Agassiz: A Life in Science* (Chicago: University of Chicago Press, 1960). See also Rebecca Bailey Bedell, *The Anatomy of Nature: Geology and American Landscape Painting, 1825-1875*, Ph.D. diss. (Yale University, 1989), 127-150, 185-186; Charles Frederick Holder, *Louis Agassiz: His Life and Work* (New York: G. P. Putnam's Sons, 1893).

19. Bedell cites the lecture series, noting that attendance records for the class are not extant (*The Anatomy of Nature*, 154).

20. "Among the Studios," *Watson's Weekly Art Journal* 1, no. 24 (8 October 1864): 372.

21. As early as 1845 one New York critic would write: "An artist should be something of a geologist to paint rocky scenes correctly, as he should be a botanist to paint flowers, and an anatomist to paint the human form" ("Twentieth Annual Exhibition of the Academy of National Design," *Broadway Journal*, 3 May 1845; quoted in Ellwood C. Parry III, *The Art of Thomas Cole: Ambition and Imagination* [Newark: University of Delaware Press, 1988], 308). Another wrote of Aaron D. Shattuck's *Study of Rocks* as "small, but decidedly rocky. A geologist would know how to prize it" ("The National Academy of Design, III," *New-York Daily Tribune*, 19 April 1856; quoted in Simoni, *Art Critics*, 7.) For other examples, see Bedell, *The Anatomy of Nature*, 35- 37, 51-62.

22. "The National Academy of Design. Its Thirty-Eighth Annual Exhibition," *Evening Post* (New York), 13 May 1863.

23. Helen Haseltine Plowden, *William Stanley Haseltine: Sea and Landscape Painter (1835-1900)* (London: Frederick Muller, Ltd., 1947), 168.

24. Bedell summarizes the fashionability of the science, highlighting its practical, recreational, intellectual, nationalistic, and religious appeal (*The Anatomy of Nature*, 1-13). See also Paul Shepherd, Jr., "Paintings of the New England Landscape: A Scientist Looks at Their Geomorphology," *College Art Journal* 17, no. 1 (Fall 1957): 30-42; and Virginia L. Wagner, "Geological Time in Nineteenth-Century Landscape Paintings," *Winterthur Portfolio* 24, nos. 2-3 (Summer/Autumn 1989): 153-163.

25. See "Relation Between Geology and Landscape Painting," *Crayon* 6 (1859): 255-256; and *Geology and Its Teaching, Especially as it relates to the Development Theory as Propounded in "Vestiges of Creation," and Darwin's "Origin of the Species"* (London: Houlston and Wright, 1861).

26. Herman Melville, *Moby-Dick: or, The Whale* (1851; Berkeley, Los Angeles, London: University of California Press, 1983), 315. Actually, Melville misinterprets Agassiz's theory of glaciation, citing instead the contemporary belief that sought to reconcile the record of ice's shearing action with the biblical account of the flood. More than two decades later, the populist poet John Greenleaf Whittier, a distant relation of Haseltine who lived in the painter's ancestral town of Haverhill, Mass., would write of the geologist as one searching for the divine "thought which underlies/Nature's masking and disguise" through his study of rocks ("The Prayer of Agassiz," *The Poetical Works of Whittier*, Cambridge Edition [Boston: Houghton Mifflin, 1975], 450-451). Henry Wadsworth Longfellow and others wrote in praise of Agassiz.

27. Plowden, *Haseltine*, 83.

28. Tuckerman, *Book of the Artists*, 557.

29. Oliver Wendell Holmes, *The Autocrat of the Breakfast Table; Every Man his own Boswell* (1858; Boston: Houghton, Mifflin and Company, 1891), 265.

30. Tuckerman, *Book of the Artists*, 557.

31. Roger Stein discusses the lure of the sea and the development of the fashionable watering-place in mid-nineteenth-century America in his *Seascape and the American Imagination*, exh. cat. (New York: Clarkson N. Potter in association with the Whitney Museum of American Art, 1975), 87-102. See also Russell Lynes, "At the Water's Edge: Changing Perspectives on the Beach," in *At the Water's Edge: 19th and 20th Century American Beach Scenes*, exh. cat. (Tampa, Fla.: Tampa Museum of Art, 1989), 17-23. Whittier, whose popular verses made famous the town of Haverhill, Mass., which Haseltine's ancestors had settled, also found solace at the sea: "Good-by to Pain and Care! I take/Mine ease to-day:/Here where these sunny waters break" ("Hampton Beach," *The Poetical Works*, 142).

32. Whittredge, *Autobiography*, 42.

33. A limited selection of recent publications treating this phenomenon includes: Katherine Manthorne, *Tropical Renaissance: North American Artists Exploring Latin America, 1839-1879* (Washington, D.C.: Smithsonian Institution Press, 1989); Gerald L. Carr, *Frederic Edwin Church: The Icebergs* (Dallas: Dallas Museum of Fine Arts, 1980); Patricia Trenton and Peter H. Hassrick, *The Rocky Mountains: A Vision for Artists in the Nineteenth Century* (Norman: University of Oklahoma Press, 1983).

34. "Art Gossip," *Cosmopolitan Art Journal* 4, no. 3 (September 1860): 126.

35. For discussions of Mount Desert in the nineteenth century, see "Mount Desert," *Harper's New Monthly Magazine* 45, no. 267 (August 1872): 321-341; Samuel Adams Drake, *Nooks and Corners of the New England Coast* (New York: Harper & Brothers, 1876), 28-57; and for an overview of the island, Samuel Eliot Morison, *The Story of Mount Desert Island, Maine* (Boston: Little, Brown, and Co., 1960).

36. "Art Gossip," *Cosmopolitan Art Journal* 4, no. 3 (September 1860): 126.

37. For a thorough discussion of Cole's work in Maine, see John Wilmerding, "Thomas Cole in Maine," *Record of The Art Museum, Princeton University* 49, no. 1 (1990): 3-23.

38. "Art Gossip," *Cosmopolitan Art Journal* 4, no. 3 (September 1860): 126, which says "William Hart and Church go, or have gone, to Mount Desert, on the coast of Maine, where Mr. H. spent last summer"; "American Painters. – Alfred T. Bricher," *Art Journal* (New York) 1, no. 11 (November 1875): 340.

39. T. Addison Richards, *Appletons' Illustrated Hand-Book of American Travel* (New York: D. Appleton & Co., 1862), 57.

40. "Mount Desert," *Harper's*, 331.

41. *Clearing Up, Coast of Sicily* (1844, Walters Art Gallery, Baltimore, Maryland) was but one of Achenbach's works most familiar to artists in America due to its inclusion at exhibitions in New York through the 1850s. For a discussion of the work and its importance in the career of Frederic Church, see Franklin Kelly, *Frederic Edwin Church and the National Landscape* (Washington, D.C.: Smithsonian Institution Press, 1988), 35. Other German painters working in a comparable vein include Fritz Hildebrandt (1819-1855), Friedrich Preller (1804-1878), and Rudolf Schick (1840- 1887).

42. One such he sold to the important Philadelphia collector J. L. Claghorn. Claghorn's *Mount Desert* was then included in the 1860 spring exhibition of the Pennsylvania Academy of the Fine Arts. Dix, too, worked his studies into exhibition paintings, showing in January 1860 *Mt. Desert Island*, characterized as "a noble marine," at a reception of the Allston Association in Baltimore (G.B.C., letter from Baltimore in "Sketchings: Domestic Art Gossip," *Crayon* 7, no. 3 [March 1860]: 82-83).

43. Perhaps he felt constrained to stay within easy reach of New York due to his domestic situation – his engagement over the summer of 1860, and the birth of his first child in August 1861.

44. "The Academy of Design. Second Notice. The Large Room," *Evening Post* (New York), 17 April 1862.

45. "Fine Arts. National Academy of Design. Second Notice," *Albion* 40, no. 19 (10 May 1862).

46. Henry David Thoreau, *Cape Cod* (1865), in *Henry David Thoreau* (New York: Library of America, 1985), 1039.

47. Haseltine, however, very likely spent some time during the summer of 1862 in Newport. The *Newport Daily News* of 9 July announced the arrival there of his colleague Mauritz F. H. De Haas; on 31 July William Bradford arrived. In early August both Haseltine's cousin, Frank Haseltine, and his youngest brother, Albert Chevalier, were there ("Arrivals at the Hotels," *Newport Daily News*, 9 July 1862; 31 July 1862; 2 August 1862; 12 August 1862 [as "A.C. Plaseltine" of

Philadelphia]; 22 August 1862 [as "A.C. Haseltone" of Philadelphia]).

48. Thereafter a boom followed, so that a writer in 1869 could note: "Until a comparatively recent date this place was a waste, and occupied only by a few fishermen's houses, but a strange change has now come over the scene. A thousand bathers may now be seen, on a warm summer day, crowding the beach that was once so still and solitary; and not fewer than eighteen hotels and boarding-houses have been erected upon the shore, some of them elegant and costly and of vast dimensions" (T. M. Clarke, "Providence and Vicinity," *Picturesque America; or The Land We Live In*, William Cullen Bryant, ed., 2 vols. [New York: D. Appleton & Co., 1872-1874], 1:509). See also: Irving Watson, *Narragansett Pier as a Fashionable Watering Place and Summer Residence* (Providence, R.I.: A. Crawford Greene, 1873); *American Seaside Resorts; A Hand-book for Health and Pleasure Seekers* (New York: Taintor Brothers, Merrill & Co., 1877); Edgar Mayhew Bacon, *Narragansett Bay* (New York: G. P. Putnam's Sons, 1904); Rhode Island Historical Preservation Commission, *Narragansett Pier, Narragansett, Rhode Island, Statewide Historical Preservation Report W-N-I* (February 1978).

49. Many painters soon followed: "A few years ago, and only here and there a traveller had ever heard of the place.... But now how changed! Umbrella'd artists plant their easels here and there, and dash away with their ochres, and chromes, and bistres, and tell you that there are no rocks on our coasts so rich and varied in their coloring as these" ([T. M. Clarke], "Indian Rock," *Appleton's Journal* 1, no. 12 [19 June 1869]: 375). For two fine surveys of the landscape artists who worked in the area, including Kensett, Lane, Heade, Whittredge, Bierstadt, Suydam, and LaFarge, see Robert G. Workman, *The Eden of America: Rhode Island Landscapes, 1820-1920*, exh. cat. (Providence: Museum of Art, Rhode Island School of Design, 1986); and *The Artistic Heritage of Newport and the Narragansett Bay*, exh. cat. (Newport: William Vareika Fine Arts, 1990).

50. [Clarke], "Indian Rock": 375.

51. "Fine Arts. The Studio Pictures," *Evening Post* (New York), 5 February 1863.

52. "Fine Arts. The Brooklyn Artist's Reception," *Evening Post* (New York), 5 March 1863.

53. "The National Academy of Design. Its Thirty-Eighth Annual Exhibition," *Evening Post* (New York), 13 May 1863.

54. "Fine Arts," *Evening Post* (New York), 3 December 1863.

55. Many of Haseltine's works have become unhinged from their original titles and now bear descriptive titles given by recent owners and dealers. Scenes of Nahant and Narragansett have thus become mixed. Real similarities between these sites, as well as the difficulty of locating the artist's precise vantage points along miles of changing coastline, further complicate the correct identification of the North American works. Haseltine's work is not alone in fostering this confusion. For an excellent unraveling of a similar puzzle, see Kathleen Motes Bennewitz, "John F. Kensett at Beverly, Massachusetts," *American Art Journal* 21, no. 4 (1989): 46-65.

56. "Fine Arts," *Evening Post* (New York), 3 December 1863.

57. "Art and the Century Club," *Round Table* 1, no. 9 (13 February 1864): 139.

58. "Fine Art Items," *Watson's Weekly Art Journal* 2, no. 1 (5 November 1864): 20. Unless the engraver, Samuel Valentine Hunt, took considerable liberties, the original painting has not yet come to light.

59. *Appleton's Journal* 1, no. 6 (8 May 1869): 185. In that same year a painting of Indian Rock by Mauritz F.H. DeHaas also inspired an engraving from the firm of William Pate. I am grateful to William Vareika for sharing with me a photograph of the DeHaas engraving.

60. "Fine Arts," *Evening Post* (New York), 3 December 1863. In addition to the critic from the *Post*, writers from the *Albion* and *Watson's Weekly Art Journal* associated the two men – see Chronology, this volume, for 10 May 1862, 5 November 1864, and 17 December 1864. Moreover in 1865 Kensett acquired a work by Haseltine, whereas the younger man was among those who paid tribute to Kensett after his early death in 1872.

61. Tuckerman, *Book of the Artists*, 512. Kensett's friends had tried to lure him away from the coast: "Now do come and leave those Old rocks and water scapes and try us here for a little while. I know you will come back to the stern Mountains with pleasure after getting tired of the monotony of the Old Ocean" (Benjamin Champney to Kensett, 3 September 1854, Kensett Papers, Archives of American Art, Smithsonian Institution, roll 1533, no frame no.). But he, like Haseltine, remained loyal to the thin border between land and sea throughout the remainder of his career.

62. Alonzo Lewis, *The Picture of Nahant* (Lynn, Mass.: Thos. Herbert, 1855), 3-4; see also, Wm. W. Wheildon, *Letters from Nahant, Historical, Descriptive and Miscellaneous* (1838; Bunker-Hill Aurora, 1842), 3-6, 20-27; John Hayward, *New England Gazetteer* (Boston: John Hayward, 1841); *Nahant: and What is to be Seen There* (Boston: Adams & Co., 1868); S. A. Drake, "Coast Rambles in Essex," *Harper's New Monthly Magazine* 56, no. 336 (May 1878): 811-815. It should be noted that the grand hotel of the peninsula, The Nahant, burned to the ground in 1861; it was not rebuilt.

63. *The Maine Woods* (1864) in *Henry David Thoreau*, 710.

64. Whittier wrote of Nahant, simply, as "New England's Paradise!" (quoted in Henry Cabot Lodge, *An Historical Address* [Nahant, Mass.: Town of Nahant, 1904], 16).

65. S. A. Drake, "Coast Rambles in Essex," 812.

66. John Paul Driscoll and John K. Howat, *John Frederick Kensett: An American Master*, exh. cat., Worcester Art Museum (New York: W. W. Norton & Co., 1985), 34. Other artists recorded as earlier working at Nahant include Christopher P. Cranch, Thomas Doughty, Alvan Fisher, and Robert Salmon.

67. Holmes, *Autocrat*, 265.

68. Agassiz, lecturing at Nahant in 1854, quoted by Cornelius C. Felton in the *Boston Advertiser* and compiled *in Nahant: A Collection from Sundry Sources of Some Noteworthy Descriptions of the Town* (Lynn, Mass.: John Macfarlane & Co., 1899), 43. The writer for *Picturesque America* characterized the area: "The rocks are torn into such varieties of form, and the beaches are so hard and smooth, that all the beauty of wave-motion and the whole gamut of ocean-eloquence are here offered to eye and ear. All the loveliness and majesty of the ocean are displayed around the jagged and savage-browed cliffs of Nahant" (2:399).

69. Bedell, *The Anatomy of Nature*, 159.

70. July 1864; quoted in Bedell, *The Anatomy of Nature*, 157.

71. "Movements of Artists," *Watson's Weekly Art Journal* 1, no. 14 (30 July 1864): 213.

72. "Among the Studios," *Watson's Weekly Art Journal* 1, no. 24 (8 October 1864): 372.

73. I would like to thank Stanley Paterson for his help, in consultation with Dr. Peter Riser, Dr. Patricia Morse, and Dr. William Dennen, in identifying probable sites of Haseltine's work on Nahant.

74. "Among the Studios," *Watson's Weekly Art Journal* 1, no. 24 (8 October 1864): 372.

75. See, for example, "Among the Studios," *Watson's Weekly Art Journal* 2, no. 6 (3 December 1864): 83.

76. "A Visit to the Studios. What the Artists are Doing," *Evening Post* (New York), 16 February 1865. This is probably the work referred to on 4 February 1865: "Haseltine is engaged on a large marine view, which gives promise of becoming one of his best and most effective works. . . . Haseltine is occupied on a large coast view" ("Among the Studios," *Watson's Weekly Journal* 2, no. 15 [4 February 1865]: 227). On 18 February, *Watson's* again reported on a studio visit, this time highlighting a large view of *White Cliff, Portland* (location unknown), implying that work on the Castle Rock painting was largely complete.

77. "The Eastern Shore," *Picturesque America*, 2:401. See also, *Picture of Nahant*, 5, ill. on 7; Joseph H. Bragdon, *Seaboard Towns: or, Travellers Guide Book from Boston to Portland* (Newburyport, Mass.: Moulton & Clark, 1857), 35.

78. George William Curtis, "Nahant," *Lotus-Eating* (1852; reprinted in *Nahant: A Collection from Sundry Sources*), 16.

79. "Fine Arts. The National Academy of Design. Fourth Notice," *Albion* 43, no. 22 (3 June 1865): 261.

80. "National Academy of Design, South Room," *New-York Times*, 13 June 1865.

81. "Fine Arts. The National Academy of Design. Fourth Notice," *Albion* 43, no. 22 (3 June 1865): 261.

82. "National Academy of Design, North Room," *New-York Times*, 29 May 1865.

83. Whittredge wrote to Helen Haseltine after her father's death that "the most noble thing to me in your father's character was his unaffected devotion to art. He was not obliged to paint for a livelihood, yet he was [one] of the most industrious students I ever knew. He was as much elated as any of us when he sold a picture, but this was because it was a recognition of his work, far more than because he cared for the money it brought" (Whittredge to Helen Haseltine, 5 May 1900, William Stanley Haseltine Papers, Archives of American Art, Smithsonian Institution, roll D295, frame 457).

84. The cypher used to sign this work is seen but rarely, and then on works datable to about 1865 – a study of Capri (ex. coll. American Academy in Rome), *Coast of New England* (*fig.10*), and *After a Shower Nahant, Massachusetts* (*pl.27*). The collaborative work was sold by Samuel P. Avery on 4 February 1867, with the catalogue listing "*Narragansett Rocks.* (figures by W. J. Hennessy)"; the painting fetched $120 and was sold to "Alcott" (Madeleine Fidell Beaufort to Andrea Henderson, 26 January 1988). This identification was first proposed by Andrea Henderson in "William Stanley Haseltine," M. A. essay, 1984, Columbia University, 22.

85. "Addresses of Artists," *Round Table* 3, no. 37 (19 May 1866): 311.

86. For a range of examples, see Stein, *Seascape and the American Imagination*; and John Wilmerding, *American Marine Painting* (1968; New York: Harry N. Abrams, 1987).

87. Recent publications on this aspect of Homer's work include Bruce Robertson, *Reckoning with Winslow Homer: His Late Paintings and Their Influence*, exh. cat. (Cleveland: The Cleveland Museum of Art, 1990); *Winslow Homer in the 1890s: Prout's Neck Observed*, exh. cat. (New York: Hudson Hills Press in association with the Memorial Art Gallery of the University of Rochester, 1990). Homer did experiment earlier with private works that show the sea without figures; see, for example, *Rocky Coast and Gulls*, 1869 (Museum of Fine Arts, Boston), and four drawings dating to about 1884 in the Cooper-Hewitt (1912-12-90, 1912-12- 91, 1912-12-187, and 1912-12-188).

88. David Tatham, "Winslow Homer and the Sea," in *Winslow Homer in the 1890s*, 67.

89. See especially the negative reviews of *Iron-Bound, Coast of Maine* (1864) in the *New-York Daily Tribune* of 26 March 1864 and 7 May 1864, and the summary condemnation "Leaves from a Notebook," published in the *New Path* in November 1865; reproduced in the Chronology.

90. Bruce Crane, "Landscape Sketching and Painting" (1895); quoted in Bruce Webber and William H. Gerdts, *In Nature's Ways: American Landscape Paintings of the Late Nineteenth Century*, exh. cat. (West Palm Beach, Fla.: Norton Gallery of Art, 1987), 9.

91. Wagner, "Geological Time," 162.

92. For an extended discussion of the development of the landscape aesthetic at the end of the nineteenth century, see Weber and Gerdts, *In Nature's Ways*.

93. For responses to Homer's work, see Gordon Hendricks, *The Life and Work of Winslow Homer* (New York: Harry N. Abrams, 1979), 204-205.

94. Stein, *Seascape and the American Imagination*, 130.

95. Holmes, *The Autocrat of the Breakfast Table*, 264.

96. Melville, *Moby-Dick*, 3.

97. The position of the horizon line is clearly crucial to the reading of the pictures. In the drawings, it is often a ruler-sharp divider between water and sea; the paintings can either show a hazy blur or a crystalline line "where the blue of heaven on bluer/wave shuts down!" as Whittier wrote ("Hampton Beach," *The Poetical Works*, 142).

98. Thoreau, America's great observer of nature, noted the surprise afforded by the smallest object varying from these limitless horizontals: "Objects on the beach, whether men or inanimate things, look not only exceedingly grotesque, but much larger and more wonderful than they actually are. Lately, when approaching the sea-shore . . . I saw before me, seemingly half a mile distant, what appeared like bold and rugged cliffs on the beach, fifteen feet high, and whitened by the sun and waves; but after a few steps it proved to be a low heap of rags, – part of the cargo of a wrecked vessel, – scarcely more than a foot in height" (*Cape Cod*, 923-924).

fig.1 William Stanley Haseltine, *Via Flaminia
near the Porta del Popolo*, ca. 1857/58. Oil on canvas,
13⅜ x 22⅛ in. Museo di Roma.

Haseltine in Rome

Andrea Henderson

No place ever took so strong a hold of my being as Rome, nor ever seemed
so close to me and so strangely familiar. I seem to know it better than my
birthplace and to have known it longer.
> Nathaniel Hawthorne, The Italian Notebooks

He grew passionately, unreasoningly fond of all Roman sights and sensations,
and to breathe the Roman atmosphere seemed a needful condition of being.
> Henry James, Roderick Hudson

For Hawthorne and James, as for other nineteenth-century Americans
of creative temperament, a Roman pilgrimage became indeed "a need-
ful condition of being." Although the descriptions of their encounters
with the sights, smells, people, politics, religious traditions, and living
conditions of Rome range in tone from hellish to Edenic, Americans
were firm in their opinion that no education was complete without
an expedition to Italy. With the increased ease of transatlantic travel,
Americans followed in the Grand Tour footsteps of the English, whose
longstanding interest in Italy grew out of their familiarity with classical
literature, as well as with the great Romantic triumvirate – Byron,
Shelley, and Keats – who celebrated Italy's charms and whose words
were knowingly invoked at appropriate places and times.[1]

William Stanley Haseltine, like many before and after him, found
that Rome offered "inspiration in the atmosphere" (*fig.1*).[2] After his
first Italian sojourn as a student-painter in the late 1850s, Haseltine
returned to America to enjoy considerable artistic success in New York,
but busy, dirty, noisy, crowded, glorious Rome, as well as the beauty
and variety of the Italian coast and countryside, had captured his
imagination. Two years after a second trip in 1865, Italy's legendary
spell claimed another willing victim when Haseltine settled in Rome.
Although we cannot know if, in 1867, Haseltine envisioned staying for
most of the next thirty years, we may examine some of the features of
the Roman art community that held him there.

Rome undoubtedly appealed in part to Haseltine as a refuge from
the sweeping changes that affected the New York art world after the
Civil War. While it is unlikely, had he stayed in America, that he could
have sustained the kind of success he had experienced in the early
1860s, by painting the tourist spots and countryside of Italy Haseltine
could continue to attract patronage for his work after images of the
American landscape ceased to be of primary interest to collectors.[3]
By the time of Haseltine's move to Europe, the midcentury commit-
ment to establishing and patronizing the impossible ideal of a purely
national art – American artists, untainted by foreign training, painting
native scenery – gave way to a new vogue for refinement and cosmo-
politanism that Europe seemed to represent.

Critical attitudes in America about European influence were gradu-
ally shifting from one extreme to the other, and the cultural isolation-
ism of the middle decades of the century was replaced by the wholesale
appropriation of foreign, primarily French, aesthetics. The teachings
of the École des Beaux-Arts, where landscape composition was not
even offered, created a fashion for figure painting and contributed to
a growing disdain for pure landscape painting. At the same time, for
those who continued to paint landscapes, the blurring or sublimation
of detail associated with the work of the French Barbizon painters
made the topographical accuracy of traditional American landscape
painters like Haseltine seem woefully literal and old-fashioned, illus-
trative rather than emotionally expressive.

Although Haseltine shared the experience of European training
and travel with the new generation of American painters, the meticu-
lous accuracy associated with the Düsseldorf school had little in com-
mon with the technical bravura of the Paris- and Munich-trained
"new men." The objective realism of Haseltine's style and his choice
of subjects linked him more strongly to the old guard, who found
themselves under attack by New York art writers sympathetic with the
younger painters. Haseltine and his contemporaries – Albert Bierstadt,
Worthington Whittredge, and Frederic Church among them – were
increasingly savaged in the press for what critics saw as the repetitive
and retrogressive nature of their work.[4] For many of Haseltine's gener-
ation of landscape painters, the shift in taste that began in the late 1860s
brought on critical neglect or rejection, disadvantageous placement of
their work in exhibitions, and dwindling patronage. As American col-
lectors began to buy European, chiefly French, art in bulk, artists could
choose to emulate the French manner and compete with European
artists for patronage, or to continue to paint in their own styles the
resorts and *beau-monde* haunts of wealthy tourists, for which the
demand continued.[5]

The latter alternative meant that, for American landscape painters

in Rome, their canvases became, in effect, souvenirs of European travel – esoteric and costly forerunners of the postcard. This was the route chosen by Haseltine, who never developed a taste for the exoticism, sentiment, or full-blown stylistic sophistication that permeated much of the art of the later nineteenth century. His faithful, detailed representations of the light and landscape of Venice, Capri, Sicily, and the Roman Campagna assured him of commissions, and accounts of his work rarely failed to mention his fidelity to the poetry of Italy. For generations landscape painters had come to Italy for the beauty and variety of the countryside; in the later years of the nineteenth century the American mania for all things foreign assured them of support for their work.

Another related attraction of Rome for Haseltine was that, unlike in Paris, Düsseldorf, and, to some degree, New York, in Rome there was no "school" of art, no predominant official style in which artists came to be indoctrinated and against which powerful critics judged all work. There was, of course, the ancient Accademia di San Luca, but it did not maintain the kind of dictatorial stranglehold on artists of Paris's École des Beaux-Arts, for example.[6] After the response he received from New York critics in the mid- sixties for the traces of Düsseldorf in his work,[7] Haseltine was unlikely to want to become a follower of another academic style, or by extension, to practice his craft in a city that demanded artists adhere to certain stylistic prescriptions.

For an American artist seeking aesthetic and critical independence and already schooled in the language of art, Rome proved the perfect place to work. The art colony was large, established, and congenial, and an artist was free to work in his own style, to "follow the tranquil studio-life he can obtain here [in Rome] better than anywhere, enough to stimulate him without hurry and confusion . . . [and] progress in the development of his powers. . . ."[8]

Nor were artists hampered by social conventions: "Nowhere else as in Rome is artist-life so free and easy, and uninterrupted by the whims and exactions of fashionable society."[9] Religion and art were said to be the only two callings existing in Rome, and both were held in equal esteem. Because it was possible to live grandly for little money, many found the prosperity in Rome that eluded them at home. As one writer observed shortly after Haseltine settled in Rome,

some of [our artists] live in palaces, and others are moving so rapidly on the road to fortune, as to have a prospect of being lodged with not less comfort and dignity. The pleasures of social life they do not undervalue, and some of them contribute in a liberal manner to the enjoyment of their countrymen visiting Rome.[10]

In other words, artists were part of the entertainment for other Americans traveling abroad, so much so that their addresses were

given in guidebooks, posted in Roman book shops like Piale's, Monaldini's, and Spithöver's in the Piazza di Spagna, and listed in the local English-language newspapers.[11] A winter in Rome was considered a kind of extended shopping trip:

. . . [W]hen the dilettante came to Rome he remained during the winter season, and was as ambitious to be considered a patron of art as to supply himself with beautiful things. He rarely went away without some memorial picture or statue of his visit. Coming into immediate contact with the artist gave a zest to his transactions.[12]

One feature of artist life in Rome that had drawbacks as well as advantages was the studio system of patronage. Because hardly any contemporary art dealers operated in Rome, artists – both Italian and foreign – sold directly out of their studios to collectors. Those who could afford it generally had exhibition rooms attached to their studios where interested parties would either drop in at random or come on the days inscribed on the artist's calling card, according to the method the artist chose. Haseltine's reception days, as we know from his calling card (*fig.2*), were Tuesdays and Fridays. The disadvantage of accepting callers only on prescribed days was the possibility of lost business, but most found the lack of interruption by droppers-in to be compensation enough:

Visiting studios is a most agreeable occupation, but it is carried so far as to be an abuse in Rome; . . . I have often wondered how artists in Rome find time and patience for the fitting performance of their work: . . . the effect on the artist's nerves must be frightful. Just as he has a . . . composition developing, some various and conflicting passages of coloring to harmonize and study out, – tingle, tingle goes the bell, and in flock a host of tourists, who make fâde *remarks over pictures, turn over carelessly precious and delicate studies in portfeuilles [sic], and if they wish to buy – which is rare – they stop to haggle prices.*[13]

The advantage of the studio system was that no artist needed to worry about finding a dealer to represent his work, each artist having an equal chance of attracting buyers. The drawbacks were a lack of exposure and financial uncertainty.[14] The absence of an established network of dealers meant artists of all nationalities were more or less dependent upon the commissions promised by studio-visiting patrons during the brief Roman "season" – the time from November to April when the fashionable world came to Rome:

[T]he buying public is an ever shifting one in Rome, the season is short and very uncertain, . . . while of local patronage there is next to none, for the very good reason which any Italian artist will tell you – lack of quattrini, *i.e. the Italian gentry have no money to spend Meantime painters and sculptors [must look] to foreigners for substantial patronage, and [struggle] pleasantly enough through the uncertainties of a life, which,*

fig.2 William Stanley Haseltine's calling card, after 1874. Haseltine/Plowden Family Papers, private collection, England.

after all, in Rome has charms unknown to the artist life in any other city in the world.[15]

One result of the studio-cum-gallery arrangement was the obligatory comingling of art and business. Roman correspondent Anne Brewster reported that a French artist, in discussing the difficult access to studios in France, remarked that "Rome is a place of art commerce. Persons go to Roman studios to buy. We in Paris are pleased to sell, also; still, it is not the custom for buyers to come to our studios to make purchases." To which she responded:

But there is a serious difference between the positions of French and Italian artists, or, rather, the artists living in Rome of all nationalities.... In Rome the Italian government is too young and too poor to patronize art to any extent; therefore the native artist has little official encouragement. The artists of other nations (excepting always the French) who reside in Rome receive small aid from their governments. American artists have no national help, therefore all are obliged to open their studios to the public. There are no noted public exhibitions such as the spring "Salon" of Paris, to which all strangers flock and where the rich buy; – there is no outside help of any kind.... Picture dealers in Paris are the usual mediums between artists and purchasers, but this mode has two sides to it; artists are often great [financial] losers by the arrangement.... But on the other hand, a number of artists are brought into notice by picture dealers, and receive a share of public patronage, when they might not otherwise be heard or known of.[16]

For many painters in Rome, the system of selling directly from the studio led to a body of work based on theme-and-variation. As collectors and tourists filed through the studio rooms each season, the new works they commissioned were generally versions of other works, finished or in-progress, that they saw there. Haseltine's accounts, his extant works, as well as the reports of Roman correspondent Anne Brewster (see Chronology, this volume), reveal that in Europe, as had been the case in America, the artist's repertory was circumscribed by the steady demand for images of the most popular sites: Venice, Sicily, Capri, Amalfi, and the castle of Ostia near the pine forest of Castel Fusano, interspersed with the occasional depiction of Cannes or Blankenberg.

Another difficult feature of artist life in Rome was the infrequency and inadequacy of opportunities for public exhibition. The group that came to be known as the Società degli Amatori e Cultori delle Belle Arti had sponsored the only regular exhibitions in Rome since 1823 in the Dogana Vecchia (Old Customs House) at the Porta del Popolo, but most of the exhibitors were linked to the Accademia di San Luca, regional academies, or the Spanish-Roman school.[17] The general unwillingness of Italian artists to participate in exhibitions affected American artists in Rome, most of whom, like Haseltine, had exhibited their

work at home at the National Academy of Design or at other regular, respected venues, and now found themselves in a community with rather a different view. Exhibitions were not, as Anne Brewster reported in 1872,

what might be expected in such a city as Rome. Artists of reknown do not send their works In Rome the tendency is to isolation; there is no grouping together Each one has his little gallery in his studio. There is no general appeal made to the public; no attempt to produce an impression, no desire felt to compare their works even among native artists.[18]

This attitude prevailed for many years in Rome, as another American writer observed in 1876, "There seems to be a good deal of prejudice in the minds of many of the Italian artists against exhibitions in general."[19] Among the reasons for their lack of enthusiasm were concerns about damage during transport and the expenses involved, the fear of having their works copied by other artists while on view, and the questionable caliber of the other exhibitors.

The debate over exhibitions continued and escalated as plans developed for a national exhibition hall to be erected in Rome. Some artists opposed the plan on the grounds that Rome was not the codified center of the art world in Italy. In the view of foreign onlookers, however, the haphazard approach to exhibitions caused art and artists to suffer; as one English writer observed, "without a National Academy or a National Gallery for exhibition there is no emulation, no concourse, none of the motives or the rewards such as in other European capitals urge onwards the artist of the day."[20] Those artists favoring a grand and permanent hall for yearly national exhibitions evidently prevailed, and in January 1883 the Esposizione Internazionale di Belle Arti opened in the new palazzo in the Via Nazionale. To it Haseltine contributed several works and was mentioned in the press as one of the few foreigners to have been included in the purportedly international exhibition.[21]

Partly as a result of the difficulties of exhibiting in Rome, Haseltine showed his work sporadically after he left New York. He participated in only five major exhibitions in Europe – at the Paris Salon three times, in 1867, 1868, and 1877; at Munich in 1879; and for the last time at the Roman exposition in 1883. Although he became a *consigliere* (director) in 1886 of the Società degli Amatori e Cultori delle Belle Arti in Rome, he appears not to have shown works in the group's Promotrice exhibitions, either in their original location in the Piazza del Popolo, or after 1883 in the Palazzo di Belle Arti.[22]

The unstructured nature of the Roman artistic community set Haseltine adrift, like many of his American colleagues there. Cut off from the necessary underpinnings of dealers, regular exhibitions, reliable patronage, and frequent press coverage, it was imperative that artists and their spouses take an active role in their own publicity to keep from fading into oblivion. Personal temperament, disinterest, and comfortable financial circumstances evidently led Haseltine to neglect this obligation.[23] As a result, his reputation in America began to fade, and the effects of this erosion still linger today. Consequently, the European years of Haseltine's career have remained unexplored, limiting current awareness and appreciation of this lengthy and productive period.

No doubt propelled by the German fascination with Rome he encountered during his year in Düsseldorf, as well as the attraction that Americans, in emulation of English taste, felt for all things Italian, Haseltine made his first trip to Italy in 1856 and spent much of the next two years there.[24] American artists flocked to Rome for many of the same reasons as artists of other nationalities: the opportunity to study firsthand the classical past, the Roman associations of Claude and Poussin, the pleasant climate and abundant Mediterranean light, and the inexpensive living and picturesque surroundings. Bound up with the myth of Italy they also found a kind of spiritual ancestry, derived from the long and noble traditions of art that did not exist in America.

Stripped of puritan restraints and northern severity, life was lived more intensely in Italy, or so nineteenth-century Americans thought.[25] Vision was sharper, feelings were deeper, passions more extreme, and Haseltine's paintings of Italy were the visual counterpart of this intensification. Their brilliant lighting, strong sense of place, and vivid coloration invited viewers to feel part of the scene, allowing them to be transported back to the site and to the emotions it inspired. It is not surprising, given the widespread fascination with the sites described in classical literature, that one of Haseltine's earliest paintings of Italy, *The Bay of Naples* (*pl. 8*), is of a *locus classicus*. The stretch of coast embracing the Gulf of Naples was invested with historical interest by the poems of Homer, Horace, and Virgil, and the hill of Posillipo, from which Haseltine's view of Vesuvius was painted, was especially celebrated. Virgil's tomb, an attraction among Grand Tourists, was said to be in Posillipo, and it was at his villa here that he composed *The Aeneid*. *The Bay of Naples* reveals not only Haseltine's familiarity with the site's classical associations, but with the European pictorial traditions surrounding it (see, for example, *fig.3*, Turner's *Bay of Baiae, with Apollo and the Sybil*, based in turn on Claudian models).[26] The vertical composition, a rare format for Haseltine, was adopted in part to accommodate the dramatic stone pines that dominate the painting and dwarf the figures, and which would come to be a recurring motif in his paintings of Italy.[27]

Haseltine's early years in Italy were times of immense political and social upheaval. For centuries Italy had been divided into disjointed

provinces, some annexed and ruled by foreigners, primarily Austrian and French. In 1848, the discontent that had been brewing since the days of Napoleon boiled over into a fight for independence, a struggle that culminated in the creation of the Kingdom of Italy in 1861, with Venice added in 1866. When Haseltine arrived in Italy after a year in Paris[28] in December 1867, the Church was still trying to retain temporal power in Rome, which it eventually relinquished in 1870. When Pius IX finally withdrew to the Vatican, King Vittorio Emanuele II moved into the Quirinale Palace, and Rome became the capital of the newly united Italy.[29]

The community of artists in Rome before and after Unification was international in the extreme, the total number of foreigners seemingly outnumbering the Italians. Despite modern-day characterizations of the Roman artistic community as factionalized and insulated by nation, in Haseltine's day contemporary accounts told of much camaraderie, overlapping, and cross-fertilization among groups. Artists of all nationalities were familiar with their colleagues' work and traditions, and they streamed through each other's studios examining new works before they were shipped off to patrons: "Every day we are asked, 'Have you seen So-and-so's picture?' 'Don't forget to see So-and-so's statue before it goes off.' "[30] In addition to the Americans and English, there were the long-established French, the Germans and the Danes, and most significantly, the Spanish.

Among the foreign influences Haseltine encountered in Rome, the most powerful may have been the competing camps of the so-called Spanish-Roman school and the Italian opposition, led by Giovanni Costa (1823-1903). Although other countries maintained academies in Rome as well, the Spanish artist colony exerted the most influence on local Italian artists and on the community as a whole.[31] The Spanish-Roman school was epitomized by the chromatic bravura and facile handling of Mariano Fortuny y Marsal (1838-1874), who introduced the rococo manner of early Meissonier to Rome.

Specializing in the frothy, sugar-toned portrayal of interiors of excruciating refinement (see, for example, *fig.4*), Fortuny spent the last years of his short life in Italy – long enough to cultivate legions of imitators and to inspire many Italian artists to study in Paris, thus prolonging his influence after his death. Fortuny's

bizarre style might have been expected to die with him. But the modern Italians, of all people, have the trick of imitation; the manner of Fortuny … has proved a veritable feu follet *to the young southern artists…. Consequently, the market is deluged with gay pictures of frippery, with just enough incident to give a zest, or enough impudent suggestion to invite meretricious taste, and a kind of low school is set going.*[32]
Fortuny's effect upon artistic style in Rome was significant, and the

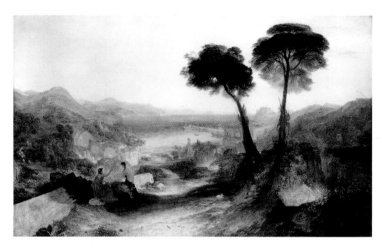

fig.3 J. M.W. Turner (1775-1851), *Bay of Baiae, with Apollo and the Sybil*, 1823. Oil on canvas, 57¼ x 94 in. Tate Gallery, London.

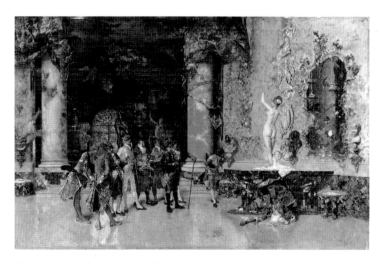

fig.4 Mariano Fortuny y Marsal (1838-1874), *Choice of a Model (Members of the Academy of Saint Luke at the Palazzo Colonna)*, 1874. Oil on panel, 21 x 32½ in. The Corcoran Gallery of Art, Washington, D.C. Gift of William A. Clark.

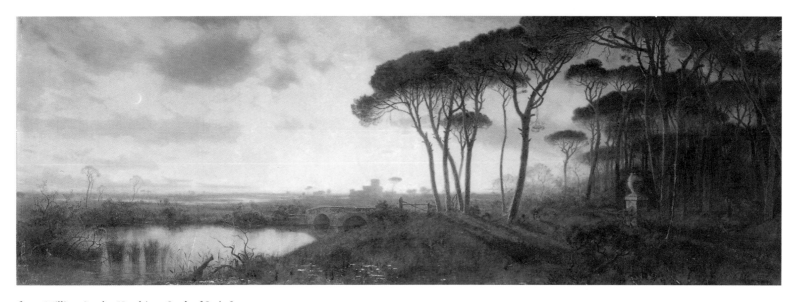

fig.5 William Stanley Haseltine, *Castle of Ostia Seen from the Pine Forest of Castel Fusano*, 1881. Oil on canvas, 25½ x 71 in. Private collection.

broader chromaticism and looser handling of Haseltine's work after 1868 may be traced in part to their intimate association.[33]

Fortuny's phenomenal popularity, both before and after his death, was a source of resentment among some Roman artists, who thought the flamboyance of his technical virtuosity and the baroque over-ripeness of his rarefied genre scenes was artificial. Chief among these critics was Giovanni Costa, Italy's preeminent nineteenth-century landscape painter. He voiced the common contention that after the period of spirited political and cultural development during the Risorgimento, Italy lapsed into stagnation. Old traditions had been rejected without the introduction of anything in their place. Eager to establish an alternative to both *fortunysmo* and the academic traditions of San Luca, Costa devoted much of his time to organizing artists' groups and finding ways for them to exhibit.[34]

Although rooted in the landscape of fact, Costa imbued his paintings with mystical, symbolic overtones, enhanced by the suggestive light of dawn or sunset.[35] Works like Costa's *Le Rive dell'Arno alle Cascine, Sughereto,* and *Il Tevere a Castel Fusano*[36] show an unmistakable affinity with Haseltine's work in the marshy region of Castel Fusano west of Rome. In Haseltine's *Castle of Ostia Seen from the Pine Forest of Castel Fusano (fig.5),* for example, melancholy saturates the scene in a manner unlike his usual objective approach. His paintings of

this bleak site in the Tiber River delta fifteen miles southwest of Rome (see also *pl.39*) are the most emotionally expressive of his European landscapes, redolent of the "desolate sweetness" Henry James experienced there.[37] One cannot help but sense that the funerary amphora on the pedestal at right, the delicate broken branch hanging limply from the central tree, and the elegiac tone are related to the deaths of two more of the artist's children in 1875 and 1879. Together with the pervasive stillness and the isolation of the female wood-gatherer nearly obscured in the darkness of the forest, the whole speaks of the loneliness and marginality of human beings in Nature.[38]

Haseltine captures the transient moment between night and day in this work; the warm glow of the sun emanating from behind the medieval castle of Ostia throws the foreground trees into haunting silhouette and emphasizes the shadowy recesses of the pine grove at the right edge of the painting. Recurrent in nineteenth-century descriptions of Ostia and Castel Fusano are references to the hazards of the fever-laden water of this area and the "death-like stillness" that prevails.[39] Examining one of Haseltine's paintings of this site, a studio visitor observed: *A large picture of Ostia attracted our attention by the sense of desolation and picturesque death which hovers about it. What was once a flourishing town is now nearly destroyed, the swamps have covered the soil, and under the summer's sun exhale a fetid breath which is a prophecy of death to*

every human being who inhales it. Under this "terror that flies by night," towns have wasted, cities have decayed and life has yielded a reluctant obedience to the great destroyer. This picture of Ostia, well handled in a strong and interesting manner, presents to you the sentiment of the end of the world.[40]

That the beauties of Italy were somehow dangerous, or even deadly, was reflected in nineteenth-century American literature, as well. Confronted by the pleasures, visual and otherwise, of Italy, puritan Americans tended to flinch, as in the novels of Hawthorne and James, at what they perceived to be moral and physical impurities. Yet despite the dangers, real and imagined, of the region around Castel Fusano and Ostia, travelers still made the two-and-one-half hour journey from Rome to experience for themselves the landscape celebrated by Pliny and Virgil.[41]

Work in Watercolor

Haseltine devoted much of his time after his expatriation to the medium of watercolor. Nearly half, in fact, of the known works dating from his Roman period are watercolors. Haseltine's departure from New York coincided with the energetic development and growing critical acceptance of watercolor as a serious medium in America.[42] During this period of maturation Haseltine was based first in France, where the current generation of painters showed little interest in watercolor, and then in Italy. It was the stylistic and technical developments of watercolor in Italy that most influenced his own use of the medium.

Although the d'Atri brothers, Rome's most prominent and, for some years, only dealers in contemporary art, had sold watercolors to wealthy foreign travelers since midcentury, the real blossoming of watercolor in Rome was marked by the formation of the Società degli Acquarellisti in Rome in 1875. Not by coincidence, this is also the year of the first of Haseltine's dated "finished" watercolors – sheets no longer intended solely as preparatory drawings but as fully realized works.[43] The ten original members of the Acquarellisti society banded together to lift watercolorists from anonymity and promote the acceptance of their medium. Among the factors that bolstered their success, as well as that of expatriate artists working in watercolor like Haseltine, was the portability of watercolors: they were easy for tourists to collect in bulk while traveling and to gather into an album at home. Not surprisingly, landscapes of recognizable tourist destinations, genre scenes featuring regional costumes, and representations of famous antique sites and monuments were the most popular subjects for watercolors with the collecting travelers.[44] This new breed of patron – created by increased tourism among the middle class – was less likely to make acquisitions directly from artists' studios, prefer-

ring to buy out of the fledgling regional, national, and international expositions in Italy or from the few operating dealers. A factor related to the appearance of a new type of collector, then, was the change in the marketplace through the rise of auction houses and contemporary art dealers late in the century. No longer exclusively vendors of old masters, antiquities, Roman coins, tapestries, and other *objets*, the emerging commercial galleries actively supported contemporary artists and the legitimacy of watercolor.[45]

Lacking the funds to mount an independent exhibition, the Acquarellisti's first public showing was in 1876 on the walls of Dovizielli's, purveyors of photographs and artists' supplies in the Via Babuino.[46] Patronized by the entire Roman artistic community, foreign and Italian, Dovizielli's proved a more than satisfactory venue, and the ad hoc exhibition was noticed in the local and international press. In her *Art Journal* review, Clara L. Wells noted that "the spirit of the whole is completely Roman, for the subjects, with few exceptions, are inspired by the picturesque nature, life, ruins, or religion of the immediate locality."[47] Haseltine's account books contain frequent notations of trips to Dovizielli's, and he would no doubt have seen this exhibition since it coincided with his burgeoning interest in watercolor.

Another influence on the Roman painters in watercolor, of particular significance for Haseltine, was the prominence of the medium of tempera in Naples, especially among the so-called Scuola di Posillipo. A leading member of this group, Giacinto Gigante (1806-1876), developed a technique mixing watercolor and tempera that created the effects of gouache – an opaque, dense form of watercolor much like the one that Haseltine would employ a decade later.[48] Haseltine may well have been familiar with Gigante's work firsthand from his frequent trips to Naples to sketch and to attend the local Promotrice exhibitions, or at the least, with the Roman watercolorists' adaptation of this technique.

In either case, the effect upon his own style of painting in watercolor was profound. Just as his colleagues back in America were eschewing the practice of using body color, believing it tainted the fluidity and transparency of pure colored washes, Haseltine was developing a resonant, full-bodied style of painting in watercolor that relied heavily upon gouache for its richness.[49] His preference for the opacity of gouache, which was made by mixing Chinese white with transparent colored washes, gives these works a solidity uncommon in watercolor and approximates the effects of pastel.[50] Because of its thicker texture, gouache could be handled more like oil paint than pure watercolor, and its use was often necessitated by Haseltine's predilection for tinted paper, as in *Vahrn in Tyrol near Brixen* (fig. 6).

Throughout his career Haseltine had worked on paper, but unlike

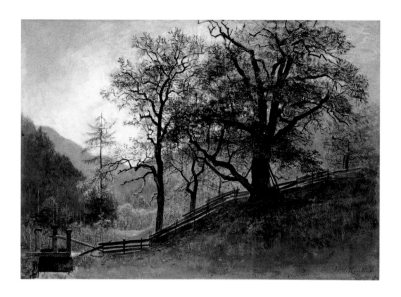

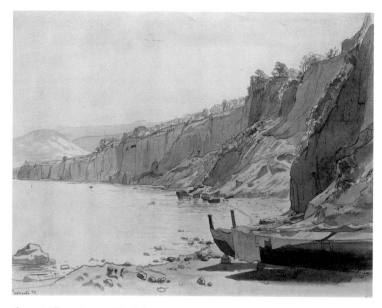

fig.6 William Stanley Haseltine, *Vahrn in Tyrol near Brixen*, ca. 1885. Watercolor and gouache on blue paper, 14⅞ x 22 in. The Metropolitan Museum of Art, New York. Gift of Mrs. Roger Plowden, 1967.

fig.7 William Stanley Haseltine, *Coast of Sorrento*, 1858. Ink, wash, and watercolor over graphite on paper, 17⅞ x 23 in. The Art Institite of Chicago. Gift of Mrs. R. H. Plowden.

the early works in pencil, ink, and monochromatic wash like *Coast of Sorrento* (*fig.7*) that were intended primarily as studies for future compositions or as private records of a given site, in Europe beginning in the seventies his work in watercolor changed in character and purpose and grew in importance.[51] An examination of Haseltine's technique in these years reveals that, in general, he set down the composition in graphite underdrawing, then built up the chief objects – usually boats, trees, or ruins – with layers of both wash and gouache, highlighted by touches of pure Chinese white. To ensure a knife-edged clarity of form, he drew crisp outlines in graphite or dark ink over the washes to reemphasize the linear definition of the primary subject (*fig.8*). Sky and sea were then brushed in loosely and suggestively in broader, less chromatically accurate strokes. Occasionally, tiny final details like tree bark or boat rigging were articulated in pen and ink. This technique of combining the richness of gouache with the precision of line enabled Haseltine to create on paper the vigorous contrasts of light and shadow and emphatic linear contours that marked his style in oil painting.

A Venetian watercolor dating from from the seventies, *Venetian Fishing Boats* (*pl.52*), exemplifies Haseltine's working method during this period. After ruling off the horizon line and outlining the fishing boats in a graphite and ink underlayer, brown, red, and orange washes thickened with body color were applied to create the wooden boats and

their sails. On the areas of sail canvas hit by direct sunlight, the colored wash is nearly saturated with white, and there are dabs of pure white highlight as well. The overall tonality of the sky and lagoon is dictated by the blue paper; in Venice, in particular, where sea and sky predominate, Haseltine's choice of colored paper was a shortcut of sorts allowing the artist to concentrate his efforts on the exploration of the rich colors and patterns of the boats' sails. Indeed, some of the washes in the sky are so pale it is difficult to distinguish areas of reserve paper from watercolor. The clouds and water are sketched in with rapid, freer strokes, indicating but not defining atmosphere and reflection and creating a contrast between the precisely drawn fishing boats and the more impressionistic background. This contrast of the hybrid styles of the boats and the water is intensified by the conspicuous juxtaposition of complimentary colors – blue for the sea and sky, orange for the sails – a technique Haseltine had exploited endlessly in his New England coastal paintings. In the final step, fine lines of ink detail the boats' rigging, masts, and hulls, as well as the fishermen's nets, draped like bunting from mast to mast.

Watercolors like this one were the products of working holidays and record Haseltine's travels, as was also the case for such American watercolorists as Winslow Homer, Childe Hassam, and John LaFarge. The portability of the tools of watercolor and quick-drying nature of

the medium enabled the artist to paint virtually anywhere. In Venice, for example, Haseltine sometimes painted in hired gondolas, making it difficult to identify precisely the vantage point from which he worked.[52]

While some sites attracted Haseltine's attention in both oil and watercolor[53] – Cannes, Venice, Sicily, and the coasts of Holland, Belgium, and the Netherlands – others must have seemed to him especially suited to watercolor. Bavaria and the Tyrol, where the family's summer holidays away from Rome's heat and fever were often spent in the eighties and nineties, rarely appear as subjects in Haseltine's paintings, but they are regions to which he frequently turned in his late watercolors. Haseltine's letters to his daughter from Traunstein in Bavaria reveal that the appeal of this area may have been first its superior trout streams and second its picturesque woods of birch, oak, and chestnut. In these years, fishing trips and sketching expeditions were often one and the same, conjuring an image of the artist heading into the woods with fishing gear in one rucksack and watercolor supplies in another. In October 1890 he wrote of "about a dozen ten pound grayling whose acquaintance I am very anxious to make" at Ubersee near Traunstein, one of his favorite sketching spots, and a number of years later he lamented from Traunstein, "I have done no fishing as yet, the weather being too clear + bright + as we leave next Saturday for Perugia I do not expect to get much of either fishing or sketching this season."[54]

Two watercolors of Bavaria and the Tyrol, *Torrent in Wood behind Mill Dam, Vahrn near Brixen, Tyrol* (*pl.69*) and *Mill Dam in Traunstein* (*fig.9*), illustrate the transition from the middle to late style in Haseltine's watercolors. From the mid-seventies to mid-eighties, at the height of his skill as a watercolorist, Haseltine produced bold and powerful works that frequently were more successful than his oil paintings of the same sites.[55] Although he never exploited the inherent fluidity and transparency of watercolor in the manner of an artist like Homer, in these middle years he conceived such radiant works as *View of Cannes with Parasol Pines* (*fig.10*), *Greek Theater at Taormina* (*pl.60*) and *Agrigento (Temple of Juno Lacinia)* (*pl.67*) in terms of outline, broad areas of light and shade, and forceful composition. By the nineties, however, Haseltine's approach in the European watercolors was almost miniaturistic; the sheets are nearly covered with an infinite number of tiny, animated brush strokes, his method now the antithesis of the fluency and spontaneity associated with the medium of watercolor. In part a reaction to the gentler landscape forms of Bavaria, his primary sketching ground in this decade, the numerous watercolors of Traunstein and Ubersee are delicate and feathery, quite different in style from the compelling works of the previous decades.[56]

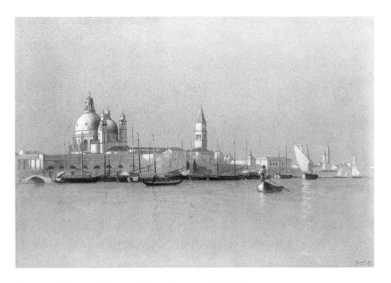

fig.8 William Stanley Haseltine, *The Lagoon behind Santa Maria della Salute (Santa Maria from the Giudecca)*, 1870s. Watercolor and gouache over graphite on blue paper, 13½ x 20 in. National Gallery of Art, Washington, D.C. Gift of Mrs. Roger H. Plowden, 1955.

fig.9 William Stanley Haseltine, *Mill Dam in Traunstein*, 1894. Watercolor and gouache on blue paper, 15⅛ x 22⅜ in. The Metropolitan Museum of Art, New York. Gift of Mrs. Roger Plowden, 1967.

fig.10 William Stanley Haseltine, *View of Cannes with Parasol Pines*, ca. 1875. Watercolor and gouache over graphite on blue-gray paper, 15⅜ x 22¼ in. Courtesy of Museum of Fine Arts, Boston. Bequest of Mrs. John Gardner Coolidge.

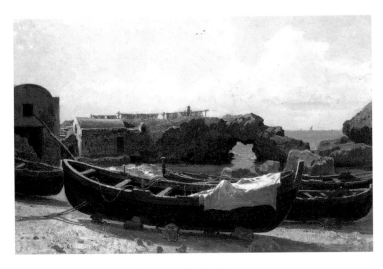

fig.11 William Stanley Haseltine, *Marina Piccola, Capri*, ca. 1858. Oil on paper mounted to canvas, 12 x 18½ in. National Gallery of Art, Washington, D.C. Gift of Mrs. Roger H. Plowden.

Haseltine at Capri

If the canvases of the landscape painters in Rome were valued chiefly as souvenirs of places visited, scenes of Capri were naturally among the most popular. And if the number of works Haseltine made of Capri may be taken as proof, this four-square-mile island in the Bay of Naples was among his favorite subjects in Italy (see, for example, *figs. 11 & 12* and *pls. 42 & 49*). He visited the island twice before his permanent move to Europe, in 1858 and 1865, and after his expatriation in the springs of 1868, 1870, and 1871.[57] To virtually all the European exhibitions in which he participated he sent paintings of Capri, as well as to the Philadelphia Centennial Exposition in 1876.[58] Images of the site were popular with patrons, as well, as exhibition and studio records reveal.[59]

Natural Arch at Capri (*pl. 43*)[60] pulls together a number of the chief attractions of Caprese scenery. Alternately obscured in shadow and bathed in the golden light of afternoon, the curious rock formations for which Capri was celebrated dominate the painting. As a contemporary writer observed, few places on earth "can rival the sublimity of the coast-line around Capri," whose jagged cliffs plunge precipitously down to the sea.[61] Haseltine's interest in coastal landscapes did not diminish after he left the rocky shores of New England; in the dramatic, craggy limestone of Capri, where "the geologist reads the secret of the past in its abruptly-tilted strata," he found much to occupy his brush.[62]

Haseltine referred to at least two on-site wash drawings in composing the painting – *Capri* (*fig.13*), for the distant coast of Sorrento, and *Natural Arch, Capri* (*pl. 41*), for the foreground arch. The fidelity of the painting to the second drawing in particular reveals Haseltine's interest in transferring to canvas the precision of sketches made on the spot. By maintaining the sharp focus, exact pattern of shadow on the arch, and scrupulous rendering of its rugged outline, he creates another of the arresting "rock-portraits" that so impressed Henry Tuckerman writing four years earlier of Haseltine's New England paintings.[63] Although the surface effects are richer here than in his works made on American soil, Haseltine's attention to the geological exactness of transcriptions of rock had not waned, and his reputation continued to rest upon this skill. In describing a work of this site in Haseltine's New York studio in 1874, a critic wrote:

Mr. Haseltine also exhibits a large picture of the famous "Natural Arch at Capri," with the Cape of Sorrento in the distance. This canvas is beautifully painted, and in the texture of the foreground and of the rock, and in the general details, bears the character of a study from nature.[64]

Although his record of the rocks may be exact, Haseltine took artistic liberties with the site as a whole, painting in elements that are not visible from this vantage point. From where he sat to sketch the *arco naturale* and the Sorrentine peninsula in the distance, it would have

been impossible to see the Faraglioni, the offshore rock group depicted at the right edge of the canvas (see *pl. 45*). By including these "rocky obelisks," as Ferdinand Gregorovius called them, Haseltine makes clear that the painting is a composite view and that his intent was to cluster together the rock formations and vistas most identified with Capri in a single composition in a way they do not actually appear.[65]

While the painting demonstrates Haseltine's continuing concern with the faithful rendering of rocky sites, it also points to his interest in traditional notions of the sublime in its abrupt shifts from light to dark, jagged forms, and exaggeration of scale. The artist plays with the scale of the *arco naturale* by obviously decreasing the actual size of the sailboats scattered in the bay and of the Villa Jovis on top of the far hill at the extreme left edge of the painting.[66] The fascination with phenomena like natural bridges and arches was part of the nineteenth-century obsession with geology and conjured images of divinity in nature.

The spiritual connotations of such geological wonders would have been clear to Haseltine's contemporaries, and were in fact manifest in the language of much of the travel literature about Capri. In the poet Bayard Taylor's description of a trip to Capri, he compares the arch to "the front of a shattered Gothic cathedral," emblematic of God's presence in nature.[67] At a time when landscape painting was often an explicit form of devotional art, viewers were accustomed to reading religious imagery in landscape. It would not have been lost on them, as it might be on twentieth-century viewers, that it was during the reign of Tiberius, and at the time of his residence at Villa Jovis, that the Crucifixion occurred.[68] A practicing Christian, Haseltine seems to engage in some quiet moralizing; that the imperial villa is dwarfed by the monumental arch reminds viewers that the constructions of even the mightiest men pale in comparison with divine creation.

Haseltine's distinctive effects of illumination carry a spiritual suggestiveness and give *Natural Arch at Capri* its power. The strikingly bold contrasts of light and shadow confer on the rocks a kind of iconic weight, magnifying their importance and dramatic force. By immersing the foreground in shade, the artist accentuates the crispness of their detail, while the unremarkable background – the still water and diffuse atmosphere – serves as a foil to further heighten the fantastic, almost surreal character of the crags and cliffs.

Sicily

Another of the popular tourist sites that captivated Haseltine's attention over a period of more than twenty years was Taormina, high above the eastern coast of Sicily. Although from our imperfect knowledge of his movements Haseltine appears to have visited Sicily only twice in the springs of 1871 and 1881,[69] he continued to mine studies

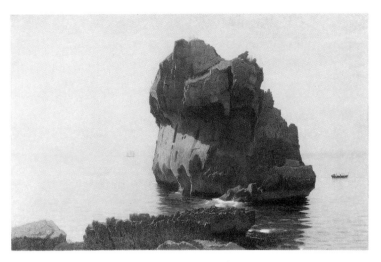

fig. 12 William Stanley Haseltine, *Capri*, 1869. Oil on canvas, 19⅞ x 31⅝ in. The Cleveland Museum of Art. Mr. and Mrs. William H. Marlatt Fund, 75.4.

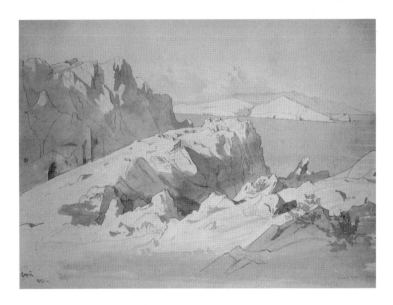

fig. 13 William Stanley Haseltine, *Capri*, 1858. Ink and wash over graphite on paper, 18⅛ x 23⅛ in. National Academy of Design, New York. Gift of Helen Haseltine Plowden.

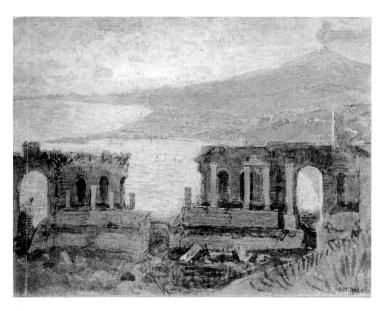

fig.14 William Stanley Haseltine, *Taormina*, 1881. Page from a sketchbook. Wash and gouache on blue paper, 4¹⁵⁄₁₆ x 6¾ in. Hirschl & Adler Galleries, New York.

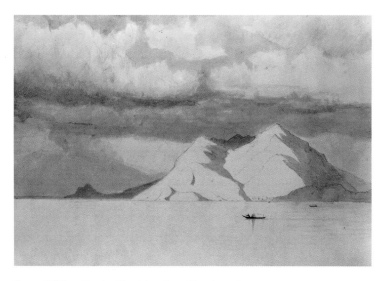

fig.15 William Stanley Haseltine, *Lago Maggiore*, 1867. Page from a sketchbook. Ink and wash on paper, 6½ x 9¾ in. Hirschl & Adler Galleries, New York.

made on-site for later studio compositions at least a decade after his last visit.[70] The largest and most forceful of the dozen or so works of the site is *Ruins of the Roman Theatre at Taormina, Sicily* (*pl. 61*), dated 1889.[71] Reconstructed in the studio from such studies as the 1871 monochromatic wash drawing *Roman Ruins at Taormina* (*pl. 58*), and, dating from 1881, a small gouache study in a sketchbook (*fig. 14*), and two large finished watercolors (private collection, Massachusetts, and *pl. 60*), the painting depicts the theater, of Greek origin but altered and restored in Roman times, at the eastern end of the ancient town of Tauromenium. Beyond, and framed by the openings of the posterior wall, lies the view to the southwest of the swagged bays of the Sicilian coast and the snowy summit of Mount Ætna.

The arduous trip up to the site, reached in Haseltine's day by foot or donkey, was rewarded by what was esteemed to be the finest view in Italy. A fellow American painter wrote that from its perch at a precipitous 420 feet above the sea, Taormina boasted the

most beautiful ruin in the world, the Greek Theatre. A few of its marble columns are still standing in front of the great amphitheatre, but its chief glory is the wonderful view seen through and beyond its gigantic red brick arches and walls, relieved against the turquoise sea and sky. The lovely coast-line of the straits of Messina winds away for miles; Point Naxos of the Greeks is in the foreground; and beyond lies the broad undulating plain, variegated with the many-tinted verdure of almond orchards and vineyards; and still beyond are the slopes and peaks of Mount Etna, rising ten thousand feet above the sea, shining white with snow like Mont Blanc, with wreaths of smoke from the crater drifting across the sky – altogether, one of the most entrancing and romantic views on earth, never the same, always changing, always beautiful.[72]

Haseltine captures this scene already made famous by American painters Thomas Cole and Thomas Hotchkiss with his distinctive blend of vehemently accurate detail and strong illumination.[73]

The power of *Ruins of the Roman Theatre at Taormina, Sicily*, lies in Haseltine's characteristically invigorating use of light.[74] He was no doubt attracted to the site for its celebrated light; even contemporary guide books noted that "those who make a prolonged stay at Taormina will have an opportunity of observing some marvellous effects of light and shade."[75] In this work the clear light of early morning cuts boldly across the scene in an irregular diagonal, drawing the viewer's attention from the shaded foreground vegetation to the brick and white-granite-columned wall, further accentuated by the hyperclarity of Haseltine's rendering of the architecture. After the eye makes the circuit from the theater, back to the brilliant blue Ionian sea, up the gentle slope to the top of Ætna, and down to the little modern town at the right, it is drawn forward again by the cactus cut off by the lower right

edge of the painting. Haseltine barely tickles the tips of its pads with light, a device that pulls the gaze two-dimensionally from the upper to the lower register of the painting and spatially from the back to the foreground, serving to balance the tug of Ætna.

The variations among the many works in different media of Taormina are slight, primarily alterations of the vantage point or the angle of light. Here, as in all of the series, Haseltine again strikes his favorite color chord, contrasting the orange-red of the bricks against the blue sea. He also diminishes the size of the theater, the largest in Sicily with seating capacity for forty thousand, making Ætna seem all the more imposing.

Unencumbered by such epoch-specific references as quaintly costumed figures, the painting's resultant openness allows us, as it allowed Haseltine's contemporaries, to feel part of the scene. This kind of pure landscape, with no traces of genre, combined with the crystalline rendering of detail, imbues the painting with a haunting sense of otherworldliness.

The recurrence of images of Taormina in Haseltine's oeuvre testifies to his and the public's interest, and one suspects that they were engaged not simply by the beauty of the site but by its deeper symbolic resonances. Americans, like the English before them, considered their own country the New Rome, and saw themselves as the inheritors of the greatness of the Empire. In Byronic nostalgia for faded and irrecoverable grandeur, many went to Italy to walk among the ruins in the gloried footsteps of the Romans. For them, what more appropriate image than an empty ancient theater to reinforce the common Anglo-American view of Italy as a stage deserted by the Romans upon which classically educated tourists could now strut?

Rising above the theater, Mount Ætna's gentle puffs of smoke belie the destructive force of Europe's largest volcano, which in Haseltine's lifetime erupted every four or five years. This was no docile, long-dormant set piece, but a fiery symbol of the pulsating life within. The snow-capped volcano was a tourist destination itself, the ascent to the brink of the crater appealing to the geological interest of nineteenth-century travelers. Regarded with mingled anticipation and fear, volcanos were, in their unpredictability and power, suggestive of death. The mutability of Ætna, which changed shape with each eruption, was a reminder of the living earth and stood in contrast to the crumbling ruins of a dead civilization.

Symbolically and spatially caught between these emblems of cataclysmic disaster and creeping decay, the contemporary town looks small and vulnerable, and turns the painting into a kind of panoramic memento mori of the inexorability of the end of life, be it immediate or gradual. In this light, the column fragments lying in the grass in the shadowy

foreground evoke the fallen Romans; the world is indeed a stage, from which not only the players but civilization itself eventually vanishes.

Whether viewed as reminders of mortality or as sun-drenched souvenirs of travel to Sicily, Haseltine and his patrons thought enough of his paintings of Taormina to include them frequently in exhibitions. The two most significant were those of 1874 at the National Academy of Design of the work commissioned the year before by prominent New York collector Marshall O. Roberts (see Chronology, 1873), and of 1876 at the Centennial Exposition in Philadelphia.[76] The reaction of a contemporary critic to the Roberts painting was that the "color was somewhat positive," the writer preferring "more subtle gradation of tint."[77] Of a different kind of image of Taormina,[78] another critic found the chief merit to be "one of sunlight craftily caught and cunningly handled,"[79] a sentiment echoed by a Boston reviewer during the same painting's May 1874 exhibition at the Williams & Everett Gallery:

[L]ooking at the painting of Taormina, a feeling of the warmth of that Sicilian sky comes over the beholder. It will repay an examination into its minutest details. The warm sunset tints, the rising moon, the ruins of the old Roman theatre, the mountains, the shore, and again below that far reach of azure Mediterranean.[80]

The same writer goes on to offer proof that many viewers thought of Haseltine's paintings as evocative postcards:

Old travelers in Italy will not miss such an opportunity to refresh their recollections of its scenery . . . while those to whom the Italian tour is still but a hope will visit them to gain new aids in filling out their mental pictures.[81]

American critics responded quickly to the changes in Haseltine's style after his move to Europe. By spring of 1873, one observer noticed that his works had

greatly gained in the qualities of breadth, refinement, and repose. A certain crude force of color, which unpleasantly characterized some of his earlier pictures, is now toned down into the proper harmony, and he shows less tendency toward what might be called the "dramatic" element in landscape painting.[82]

The following year a visitor to Haseltine's studio detected in his recent works a "marked improvement" over earlier pictures, which the writer found lacking in strength:

He had caught a trick from both French and German schools without giving himself to either, and it was said that he had no style. Something of the same eclecticism will be found in his fresher and maturer works, but the gain in conviction, in expression, in freedom, and fluency of utterance is unmistakable.[83]

By the 1870s, then, Haseltine's early emphasis on finish and precision had succumbed to more painterly considerations, characterized by

critics as increased "freedom" and "fluency." In the years since he had left New York, critical attitudes about style and subject matter had undergone a complete reversal, with suggestiveness and poetry eclipsing clarity and realism as touchstones. Although Haseltine preserved his fundamentally objective approach, he was not immune to the stylistic developments of the times, and his later work is marked by a softening of form, broader brushwork, and an increased colorism.[84] The tight handling, smooth surfaces, insistent blue/orange color chord, and geological accuracy of his New England coastal paintings gave way to richer textures and more evocative atmospherics in Europe, and the formulaic repetitiveness of his early pictorial design – made up of the unchanging trinity of rocks, water, and sky – grew more supple, able to adapt to his newly ambitious compositional demands. The constant in Haseltine's style and the principal link between his New England and European work was his overriding interest in the transformative nature of light on landscape. Reflected in his tireless experimentation with different angles and effects of illumination at the same handful of Italian sites, Haseltine never ceased to be fascinated by how the modulation of light could invigorate and metamorphose the emotional tone of his work.

Notes

I am indebted to a number of people for their help during the course of my work on William Stanley Haseltine over the last eight years. I want first to express my enormous gratitude to Haseltine's descendants, whose generosity, kindness, and hospitality during and after the time I was privileged to spend with them in Italy, France, and England are among my warmest memories. My thanks go to Contessa Helen Haseltine Toggenburg, Marshall Haseltine, Penelope Vaux, Lord Plowden, Carla Haseltine Browne, and, in particular, William Plowden, whose help in tracking down the artist's long-missing personal papers was essential.

I am also grateful to Barbara Novak, whose enthusiasm for Haseltine first stimulated my own at Columbia University. My final expression of thanks is reserved for the encouragement and inspiration of Howard Hibbard, my graduate advisor, to whose memory this essay is dedicated.

1. The names of the English Romantic poets associated with Italy appear with the lilting regularity of an incantation in the American and British travel literature, tourist diaries, and novels of Haseltine's day. It is not an insignificant point that nearly all of the Italian and European sites Haseltine chose to paint have Byronic associations, among them, Venice, Coppet and Chillon, Rome, and Spezia (where Shelley also met his death). Byron's *Childe Harold's Pilgrimage* more than any other nineteenth-century piece of writing created a new itinerary and a new focus in Italy for tourists and painters alike.

The influence of the poets permeated life in Italy: after-dinner entertainment at Roman dinner parties often consisted of readings of Byron (as Roman correspondent Anne Brewster noted of an evening at William Wetmore Story's house [Anne Brewster diary, Historical Society of Pennsylvania, 1 May 1872]); travelers never left Rome without a visit to the graves of Shelley and Keats, to the extent that some painters made a subspecialty of these graveside scenes (*Roman Times*, 14 December 1896); and the American consulate itself was in Keats's house at the base of the Spanish Steps. Even Ruskin allowed that his "Venice, like Turner's, had been chiefly created for us by Byron" (*The Works of John Ruskin* [*Praeterita*] [London: G. Allen, 1903-1912], 35: 295).

2. Angelico, "Italy," *New-York Times*, 3 February 1872 [dateline 2 January 1872].

3. By the time Haseltine left New York in 1866, his work was already beginning to generate negative reviews (see Chronology, this volume).

4. For critical commentary on the repetitiveness of Haseltine's New England rock paintings, see the *Albion* 42, no. 20 (14 May 1864): 237; *New-York Times*, 29 May 1865; and *Albion* 43, no. 22 (3 June 1865): 261, and the Chronology.

5. That the Haseltines' background and financial comfort allowed them to move in the same world in Rome as his patrons was no doubt an advantage, as it was for William Wetmore Story. Since the upper ranks of Roman society did not generally welcome visiting Americans into their circle, invitations to grand *palazzi* like Haseltine's Altieri and Story's Barberini were the next best thing, and the American travelers' only real chance of meeting the Italian *nobilità*.

6. Records in the archives of the Accademia di San Luca indicate that during these years not even the most prominent artists in the American colony – William Wetmore Story, Elihu Vedder, Haseltine, Charles Caryl Coleman, or George P.A. Healy – were members. Only after 1890, when such artists as

Richard Morris Hunt (1892), Daniel Chester French (1899), and John Singer Sargent (1918) were involved, was there any American participation at the Accademia.

7. See, for example, the *Crayon*'s April 1860 National Academy of Design review (Chronology, this volume).

Little is known about the nature of Haseltine's experience in Düsseldorf. As with most of the visiting American painters, there is no evidence that Haseltine was enrolled at the Academy, and his name does not appear on the student rolls for the landscape class, taught in those years by the Norwegian Hans Frederik Gude (records in Düsseldorf's Hauptstaatsarchiv; the most accurate published list of the enrollment is Rudolph Theilmann's "Die Schulerlisten der Landschafterklassen von Shirmer bis Brucker," in *Die Düsseldorfer Malerschule* [Düsseldorf: Kunstmuseum Düsseldorf, 1978], 144-148). What has remained unverifiable is whether he was actually a private student of Andreas Achenbach's, as Plowden claims (Helen Haseltine Plowden, *William Stanley Haseltine: Sea and Landscape Painter [1835- 1900]* [London: Frederick Muller, Ltd., 1947], 42).

Regardless of whether Haseltine's ties to the landscape painters of Düsseldorf were official or informal, the most significant and lasting impression from these years was his exposure to the on-site Italian studies of Johann Wilhelm Schirmer, the most celebrated landscapist associated with Düsseldorf. The first teacher of the Academy's course in landscape composition, Schirmer's style and methods influenced the entire local population of landscape painters through his vigorously naturalistic plein-air studies. The large studio-executed landscapes of Düsseldorf painters, however, were more mannered. In its exaggeratedly accurate detail, grand theatrical composition, extreme contrast of light and dark, and sharp effects of silhouette, Andreas Achenbach's *Sunset after a Storm, Coast of Sicily* (1853, Metropolitan Museum of Art, New York), for example, exhibits the operatic qualities commonly associated with landscape at the Academy, and traces of these stylistic devices can often be detected in Haseltine's later European work.

8. William Davies, "Artist Life in Rome, Past and Present," *Fortnightly Review* 45, no. 232 (April 1886): 571.

9. Frederick Daniel, "Models, and Artist-Life in Rome," *Appleton's Journal* 14, no. 332 (31 July 1875): 147.

10. Angelico, "Rome," *New-York Times*, 3 January 1870 [dateline 15 December 1869].

11. Among the many newpapers, mostly weekly, catering to the English-speaking tourist trade during the last third of the nineteenth century were the *Roman Times, Italian Times, Daily News, Roman Herald, Roman World, Roman News and Directory,* and *Tiber.*

In addition to providing artists' addresses, the papers published accounts of studio visits to artists of all nationalities; calendars of lectures on artistic and archaeological topics; guest lists of balls, receptions, and musical soirees; and a complete directory of such community services as The English and American Mutual Aid Society in Rome, the English, Scottish, and American churches, the Society for the Prevention of Cruelty to Animals, American doctors, English pharmacies, and the American banking establishments McQuay & Hooker's (also the post office), and Lowe's, both of which had art exhibition rooms on the premises, as well. These lists show us that it was possible to go to Rome, as many tourists did, and scarcely hear a word of Italian, so all-encompassing was the life of the Anglo-American community.

12. William Davies, "Artist Life in Rome, Past and Present," 572.

13. Anne Brewster, "Italy: American Artists in Rome . . . ," *Boston Daily Advertiser*, 16 June 1874, [dateline 30 April 1874].

14. For Haseltine, not having a dealer in Rome was less serious than for other artists because of his connections to his brother Charles Field Haseltine's Philadelphia gallery (see Mills essay, this volume).

15. "Art Gossip in Rome," *Architect* (London) 20 (6 July 1878): 2-4.

16. Anne Brewster, "Parisian Artists – Their Homes, Their Habits, Their Studios and Their Works," *Boston Daily Advertiser*, 8 November 1877 [dateline 20 October 1877].

17. Occasionally visiting foreign artists participated in the Promotrice exhibitions in the Piazza del Popolo, as did Bierstadt and two other Americans in March of 1857 (see Sanford R. Gifford Papers, European Letters, Archives of American Art, Smithsonian Institution, roll D21, 2:136- 138).

18. Anne Brewster, "Italian Gossip. Our Roman Letter," *Philadelphia Evening Bulletin*, 5 February 1872 [dateline Rome, 11 January 1872].

19. Clara L. Wells, "Art in Italy," *Art Journal* 2, no. 2 (May 1876): 154.

20. "Art Gossip in Rome," 2.

21. Among the other Americans represented were William Wetmore Story and his sons, Waldo and Julian, but most of the American art colony did not participate. See *Esposizione di Belle Arti in Roma 1883, Catalogo Generale Ufficiale* (Rome, 1883).

22. Although catalogues could not be found for every year Haseltine lived in Rome, all available catalogues were consulted, and Haseltine's name does not appear among the exhibitors, even in the years immediately preceeding and following his election to the board (catalogues, 1857-1901, *Società degli Amatori e Cultori in Roma* [Galleria Nazionale d'Arte Moderna, Rome]).

Similarly, although Haseltine was on the selection jury for the World's Columbian Exposition in Chicago in 1893, he did not exhibit work.

23. Part of the reason for Haseltine's obscurity in later years was that Mrs. Haseltine, born of wealth and preferring family and social to commercial life, lacked the impetus of financial need or the gift for promotion of Mrs. Elihu Vedder or Mrs. Story, respectively. On the roles of Vedder's and Story's wives, see the Vedder Papers, Archives of American Art, Smithsonian Institution, and Henry James, *William Wetmore Story and His Friends*, 2 vols. (1903; reprint, New York: Kennedy Galleries, 1969).

Haseltine's grandchildren have confirmed Helen Marshall Haseltine's mild distaste for the merchandising of pictures. While she was reportedly pleased with her husband's chosen profession and talent, she preferred to ignore the business aspects of artist life.

24. The American colony during Haseltine's first season in Rome was remarkable in both size and distinction. Among the American visitors and residents were Charles Eliot Norton, Herman Melville, Nathaniel Hawthorne, William Cullen Bryant, Bayard Taylor, George Ticknor, Harriet Beecher Stowe, and artists Thomas Buchanan Read, George Loring Brown, Peter Rothermel, John Rollin

Tilton, William Page, Luther Terry, James Freeman, John Linton Chapman, John Gadsby Chapman, Randolph Rogers, Chauncey Ives, Worthington Whittredge, Hamilton Wild, Abel Nichols, Joseph Mozier, Harriet Hosmer, William Wetmore Story, and the artist's brother, James Henry Haseltine.

25. Mario Praz, "Impressioni Italiane di Americani nell'Ottocento," *Studi Americani* 4 (1958): 85.

26. Haseltine was an admirer of J.M.W. Turner (1775-1851). Of the four illustrated books that Plowden mentions in her father's library in later years, two were of Turner's works – the edition of Samuel Rogers' poem *Italy*, illustrated with etchings after Turner, and "Turner's Views of England" (Plowden, *Haseltine*, 110). The latter probably refers to either Turner's *Picturesque Views of the Southern Coast of England* (1814-1826) or *Picturesque Views of England and Wales* (1826-1838).

We know from exhibition records that Haseltine also painted another work of the site of Turner's painting, specifically titled *Bay of Baiae* (see Chronology, June 1864). Baiae, where Aeneas disembarked in Book 6 of *The Aeneid* for his journey into the underworld, lies just around the cape from Posillipo. Nineteenth-century guidebooks never failed to inform travelers of the important classical associations of the site (see, for example, Karl Baedeker, *Southern Italy and Sicily* [London: Dulau and Co., 1890], 89 and 96).

27. A number of wash drawings and sketchbooks document Haseltine's activity on this first Italian trip. The composition of *The Bay of Naples*, for example, is based on three pages from a sketchbook dating from 1857/1859 (Museum of Fine Arts, Boston, 1978.366) and an 1858 drawing at the Cooper-Hewitt (1961.100.2). Single sheet drawings from this trip like *Sorrento* (*pl. 6*), can be identified by their dimensions, roughly 18 x 23 in., a paper size Haseltine used only during these years.

28. Haseltine's year in Paris, which began in May 1866 when he, his young son Stanley, and his second wife Helen Marshall sailed from New York, was a time of flux and travel for the thirty-one-year-old artist. He painted a number of significant works in this transitional year, some looking back to American roots, others pointing ahead to new compositional types. For example, *Lago Maggiore* (*pl. 35*), based on a page from an 1867 sketchbook (*fig. 15*), more closely resembles American luminist painting structure in its strong emphasis on horizon, planar definition of space, open foreground, unframed composition, and sense of suspended time and action than any works Haseltine made in America.

On the other hand, two paintings inscribed "Paris 1867" and dating from the first half of the year, *Amalfi Coast* (*pl. 33*) and *The Isle of Capri* (unlocated, based on the drawing *Capri and the Faraglioni, pl. 44*), reveal broader effects of light and color and a new panoramic ambitiousness, a direction Haseltine would explore in depth during his years in Europe. These two works also testify that even while in his Paris studio Haseltine's mind was drifting to the landscape of Italy.

29. The monarchy brought modernization and secularization, which was felt by many to diminish Rome's charm and to be responsible for reducing the number of tourists making Roman pilgrimages after 1870.

30. Anne Brewster, "Italy: Pradilla's Studio," *Boston Daily Advertiser*, 27 April 1877 [dateline 24 March 1877].

31. See Dwight Benton, "The Art Schools of Rome," *Art Amateur* 2, no. 5 (April 1880): 95.

32. "Art Gossip in Rome," 3.

33. That Haseltine served as a pallbearer at Fortuny's funeral attests to their closeness. See also Plowden, *Haseltine*, 57, 99-100, on Haseltine's friendship with Fortuny, as well with Francisco Pradilla y Ortiz and José Villegas y Cordero, successive presidents of the Spanish Academy. She also suggests that it was through Fortuny that Haseltine became interested in collecting art and exotic *objets*. Haseltine also owned five works by Fortuny (see Chronology for September 1875).

34. In his efforts to better the lot of artists in Rome, Costa established the Associazione Artistica Internazionale in 1870, the Gold Club in winter 1875/1876, and the Circolo Nazionale degli Italiani in 1879, the latter two to help Roman painters stand ground against the continued influence of the Spanish.

35. On Costa, see Paola Frandini, "Nino Costa e l'Ambiente Artistico Romano Tra il 1870 e il 1890," in *Aspetti dell'Arte a Roma dal 1870 al 1914* (Rome: De Luca Editore, 1972), xxiii.

36. Private collections, Italy, repr. *Il Secondo '800 Italiano: Le Poetiche del Vero*, exh. cat., Palazzo Reale (Milano: Mazzotta, 1988), 189 and 192.

37. Henry James, *Italian Hours* (1910; New York: Grove Press, 1979), 223.

38. The necropolis of Isola Sacra, whose graves are marked by amphorae, adjoins Ostia. The amphora included here no doubt serves as a reminder of the ancient burial ground (Augustus J. C. Hare, *Days near Rome* [London: Smith, Elder & Co., 1884], 2: 34.

See Chronology for 1875 and 1879 for the deaths of Charles Marshall and Stanley Lane Haseltine. Haseltine's daughter confirms that in later life Haseltine was affected by spells of sleeplessness and that life, "with the passing years, was becoming increasingly heavy" (Plowden, *Haseltine*, 122).

39. George L. Brown, quoted in "Artist Life in Europe," *Watson's Art Journal* 10, no. 6 (21 November 1868): 54.

40. Fred Hovey Allen, "Haseltine's Studio," *Boston Daily Standard*, 1 May 1896. This notion of "picturesque death" is redolent of the romanic interweaving of beauty and death in the art of Arnold Böcklin (1827-1901). Although Swiss-born, Böcklin trained under Schirmer at Düsseldorf a decade before Haseltine came to Germany, and the similarities between them may be traced in part to their experiences (see for example *Villa on the Sea*, 1878, Kunstverein, Winterthur). Böcklin's first journey to Rome in 1850 led to a lifetime of repeated trips and residence in Italy and an association with such "Deutsch-Romer" artists of these years as Anselm Feuerbach (1829-1880) and Hans von Marées (1837-1887). See *Arnold Böcklin e la Cultura Artistica in Toscana*, exh. cat., Palazzina Mangani (Fiesole: De Luca Editore, 1980).

41. The historical associations of the area rested primarily upon Pliny's description of his Laurentine villa and Aeneas' landing at Ostia. As a contemporary account related: "I had heard much of the beauty of the Pineta, or pine woods of Castel Fusano, and I wished also to see Ostia, out of reverence for its classical associations I can read Virgil as well as [the antiquarians], and I never will believe that Aeneas landed at Porto d'Anzio, or anywhere else than Ostia, where the localities so exactly tally with Virgil's description. So an excursion to Castel Fusano was arranged, which was to combine delights of luxuriant Nature and classic memories – food for the head and the heart . . . " (Frances M. Elliot, *Diary*

of an Idle Woman in Italy [London: Chapman & Hall, 1871], 2: 77).

42. Although New York artists had been interested and active in the medium throughout the previous decade, the first significant watercolor exhibition was held at the National Academy of Design in fall 1866, the year Haseltine and his family sailed for Paris. In December of that year, the American Society of Painters in Water Colors (later the American Water Color Society) was founded, holding its first exhibition at the Academy the following year.

43. Dated 1875 are *Pine Trees at Cannes* (private collection, England), *Blankenberg #2* (Kalamazoo Institute of Arts), and *Blankenberghe no. 3* (National Gallery of Art, Washington, D.C.).

44. See, for example, *Il Tevere a Castelfusano*, a site popular with Haseltine as well, by founding Società member Oronato Carlandi (1848-1939), repr. *Roma e Tivoli nelle Vedute dell'Ottocento*, exh. cat. (Rome: Galleria San Teodoro, 1980), 32.

45. Gian Francesco Lomonaco, *Acquerelli dell'Ottocento: La Società degli Acquarellisti a Roma* (Rome: Fratelli Palombi Editori, 1987), 5-18.

46. Lomonaco, *Acquerelli*, 5-18.

47. Clara L. Wells, "Notes. From Our Correspondent at Rome.," *Art Journal* (New York) 2, no. 6, (June 1876): 191.

Interestingly, Wells singled out the work of Vincenzo Cabianca (1807-1902) for special notice. Cabianca's oil paintings, in which the compositions are laid out principally in terms of starkly contrasted zones of light and shade, bear a stong relationship to Haseltine's later Italian paintings. See, for example, Cabianca's *Scene Medievale* (repr. *Il Secondo '800 Italiano*, 34). One of the principal landscape painters of the second half of the nineteenth century, Cabianca had been associated with the Macchiaioli painters in Florence before his move to Rome in 1870. It is likely that Haseltine was familiar with the Macchiaioli, whether through his fellow expatriate Elihu Vedder, whose contact with the Florentine circle dated back to the fifties, or through his own interest in contemporary Italian painting (Plowden, *Haseltine*, 164-165).

48. See for example Gigante's *Capri*, 1861, watercolor and tempera, Museo e Gallerie Nazionale di Capodimonte, repr. *Il Secondo '800 Italiano*, 147.

49. The use of gouache in America was associated with the Pre-Raphaelite painters, and the abandonment of opaque colors was a part of the backlash against their movement. Haseltine would surely have been familiar with their work in the medium from his years in New York. See Judith C. Walsh, "Observations on the Watercolor Techniques of Homer and Sargent," in *American Traditions in Watercolor*, exh. cat., Worcester Art Museum (New York: Abbeville Press, 1987), 47 and 62, note 7, and Kathleen A. Foster, "The Pre-Raphaelite Medium" in *The New Path: Ruskin and the American Pre- Raphaelites*, exh. cat., The Brooklyn Museum (New York: Schocken Books Inc., 1985), 88.

50. This frequently made observation about the pastel-like quality of Haseltine's European watercolors was first noted by Theodore E. Stebbins, Jr., in *American Master Drawings and Watercolors* (New York: Harper & Row, 1976), 235.

51. It was in the medium of watercolor that Haseltine felt most free to experiment with stylistic trends in Europe during the last quarter of the nineteenth century. Of these, the influences of *japonisme* and photography are perhaps most apparent in his work. We know from his account books that he purchased photographs on occasion, but whether or not he used landscape photographs in

addition to on-site drawings and sketches when painting in the studio is unclear (Haseltine/Plowden Family Papers, private collection, England).

52. Among Haseltine's accounts for June and July 1871, for example, are notations of frequent gondola rentals and the purchase of watercolor brushes (Haseltine/Plowden Family Papers). The polished nature of some of Haseltine's watercolors probably indicates that the artist finished or reworked them later in the studio.

53. Occasionally Haseltine based studio oil paintings on earlier watercolors made on-site. Among the subjects he repeated in both media were Taormina and Cannes (see, for example, *Greek Theater at Taormina, pl. 60*, and *Ruins of the Roman Theatre at Taormina, Sicily, pl. 61*, and *Cannes, pl. 62*, and *Stone Pines, Cannes*, 1870s, oil on canvas, Maryhill Museum, Goldendale, Washington). In shifting media Haseltine made few substantive changes, perhaps playing with the height of the vantage point or the proximity of the subject.

54. See letters of 1 October 1890 and 15 August 1898, Haseltine/Plowden Family Papers, and Plowden, *Haseltine*, 155-158.

55. This is particularly true of the works of Cannes and Blankenberg.

56. At the time of Haseltine's death in 1900 most of his work in watercolor from the previous quarter-century was still in the collection of the family. At a posthumous exhibition at the Palazzo Altieri, a reviewer familiar with Haseltine's work expressed surprise at the existence of an "unknown and wonderful mass" of watercolor sketches, underscoring their neglect during his lifetime (see Chronology for 19 April 1901).

Although we know he exhibited watercolors in important European exhibitions (in Munich in 1879 and Rome in 1883) and sold them to collectors (during an informal exhibition in Northeast Harbor in 1895), few outside the original family holdings have surfaced, leading one to wonder if they were painted primarily for pleasure or as studies for future oil compositions. That the works are all large scale, roughly 15 x 21 in., does not support the notion that they were intended as private documents; the rarity of those acquired by collectors while Haseltine was alive may simply be further evidence of his disinterest in the enterprise of selling.

57. It is possible, although undocumented, that he returned to Capri in June 1891 during a trip to nearby Sorrento. An undated watercolor (*Hillside Monastery*, private collection, France) executed in a style consistent with his later works on paper is a study for the Parrish Museum's *Anacapri* (1892, Southampton, New York), and may have been painted on-site in 1891.

58. His paintings of Capri appeared in the 1867 and 1868 Paris Salon exhibitions; the 1871 benefit exhibition for the American church in Rome; the 1874 Century and Lotus Club exhibitions; the Centennial; the 1879 Munich International Exposition; and the 1883 Roman International Exposition. (See Chronology).

59. Account records show that William Herriman, the preeminent American collector in Rome, bought a painting of Capri in 1868, and among the orders for winter 1872 were paintings of the site for Mr. T.A. Hamilton of New York and General Crocker of California (Haseltine/Plowden Family Papers).

60. This painting may have been one of those referred to by Anne Brewster when she reported that "Hazeltine's pictures of Capri and all that part of the

Mediterranean are exciting a great deal of attention" in Rome. See "Correspondence. Letter from Rome," *Philadelphia Evening Bulletin*, 14 March 1871 [dateline 24 February 1871].

61. "Capri," *Appleton's Journal* 9, no. 216 (10 May 1873): 631.

62. "Capri," 631.

63. Henry T. Tuckerman, *Book of the Artists: American Artist Life* (New York: G. P. Putnam & Sons, 1867), 556. See also Simpson essay, this volume.

64. "Mr. Haseltine's Studio," *Evening Post* (New York), 3 April 1874. This painting appears to have been exhibited the following month at the Williams & Everett Gallery in Boston, where it received effusive praise: "It is hardly possible to look at these pictures and not recognize marks of original genius of a high order. It was a bold stroke to choose such a point of view as that in the 'Natural Arch' (Capri), where cowering and fantastic rocks form a standpoint from which you look down on a vast expanse of calm sea, and far across the Bay of Salerno till fancy strains its eye for the solemn peristyles of Paestum" ("Haseltine's Pictures," *Boston Evening Transcript*, 19 May 1874).

65. The artist also eliminated a rock between the arch and the Faraglioni, the less picturesque Scoglio del Monacone.

66. The inclusion of the Villa Jovis, also called Villa Tiberio, serves as a reminder of the classical associations of Capri. A favorite retreat of Roman emperors beginning with Augustus, Capreae, as the island was known, was home to the twelve villas Tiberius built to honor as many deities between 27 and 37 A.D. when he lived on the island.

67. Bayard Taylor, "A Week on Capri," *Atlantic Monthly* 21, no. 128 (June 1868): 746. The article was later included in Taylor's *Byeways of Europe* (New York: G. P. Putnam & Sons, 1869), 349.

68. For those whose history might have been a little rusty, contemporary writers, like Haseltine's friend the celebrated historian Gregorovius, reminded readers that in the ruins of Villa Jovis could be seen the "ruins of the heathen world," and that "no place . . . [was] so adapted for self mortification as the ruins of this villa of Tiberius, under whose reign, and during whose life upon Capri, Christ was slain upon the cross" (Ferdinand Gregorovius, *The Island of Capri*, trans. Lillian Clarke [Boston: Lee and Shepard, 1879], 73; first published in the author's *Wanderjahre in Italien* [Leipzig: Brockhaus, 1864-1873]).

Apparently Christian martyrs were also thought in Haseltine's day to have been flung from this cliff (see Chronology for an April 1866 studio visit in which a work of this site is described).

69. In her biography Plowden appears to have thought mistakenly that the 1881 trip, documented by two dated watercolors, *Agrigento* (*Temple of Juno Lacinia*) (*pl.67*) and *Child in Arch, Taormina* (private collection, France), took place in 1883.

70. The last dated work of Taormina is the University of Pennsylvania's *Greek Theatre at Taormina* of 1891.

71. According to nineteenth-century exhibition records, Haseltine identified the ruins as Roman; works now bearing the title *Greek Theatre* were so labeled by the artist's daughter during her efforts to make order out of the contents of his studio.

72. D. Maitland Armstrong, *Day before Yesterday* (New York: Charles Scribner's Sons, 1920), 189-190.

73. Haseltine's work of this and other sites owes a debt, as does that of most foreign landscape painters active in Italy, to the panoramic vistas of the eighteenth- and nineteenth-century Italian *vedutisti*. Rooted in earlier traditions of topographical illustration and made for a mostly British market, the *vedute* paintings usually depicted Venice, Rome, or Naples, but the compositional type – a crisp, clear prospect from an elevated vantage point across a broad sweep of land or coastline – could be applied to other views, as here.

74. It is possible that this painting is the work mentioned in a studio inventory recorded in the December 1892 entry of the Chronology as having been bought by Mrs. Carstairs of Philadelphia, probably Haseltine's niece Esther or her mother-in-law, and of the family that owned Knoedler after 1927.

75. Baedeker, *Southern Italy and Sicily*, 342.

76. Because Haseltine's theme-and-variation working methods produced paintings of such remarkable similarity, it is impossible to identify positively either the Roberts or the Centennial paintings, but we may speculate that the former could be *Mount Ætna from Taormina* (private collection, New York), which is dated 1873. The Centennial painting is a riskier guess, but it may have been the work, now unlocated, that Haseltine exhibited in May 1874 at the Williams & Everett Gallery in Boston, which was described earlier that year by two writers in records of visits to his New York studio (see Chronology for 22 February 1874, 3 April 1874, and May 1874).

77. "National Academy of Design," *Evening Post* (New York), 4 May 1874.

78. This other image type of Taormina, in the May 1874 exhibition at Williams & Everett, is known in only three works: the University of Pennsylvania painting; an unlocated work reproduced in a William Doyle auction catalogue, 21 October 1987, lot 26; and a watercolor in an English private collection. See also note 77.

79. "Gallery and Studio," *New-York World*, 22 February 1874.

80. "Haseltine's Pictures," *Boston Evening Transcript*, 19 May 1874.

81. "Haseltine's Pictures."

82. B.T., "Art in Italy. Visits to Some American Studios," *New-York Daily Tribune*, 10 May 1873 [dateline 27 March 1873].

83. "Gallery and Studio," *New-York World*, 22 February 1874.

84. In many later works, the stylistic duality noticeable already in the 1860s – crisp definition of foreground details and broader rendering of background and atmosphere – becomes more polarized. In the European scenes, carefully delineated rocks, ruins, or architecture are set against a more loosely interpreted and coloristic sea and sky.

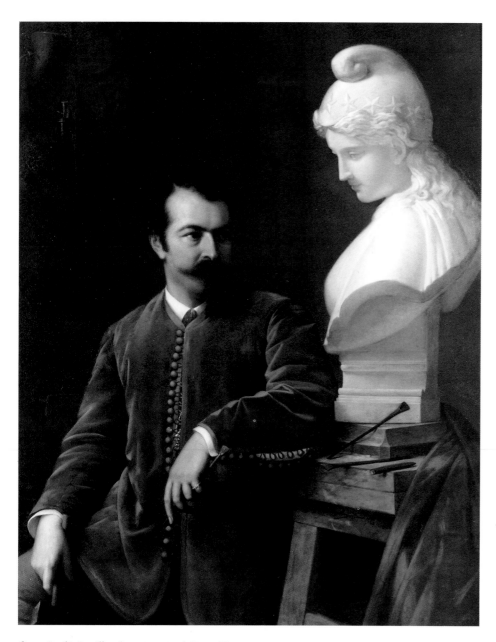

fig.3 Emilie Rouillon (act. 1868-1870), *James Henry
Haseltine*, 1868. The Historical Society of Pennsylvania.
Gift of Charles F. Haseltine, 1911.

Of Art and the Haseltines: A Family Affair

Sally Mills

"Strange," wrote Helen Haseltine Plowden, the daughter of William Stanley Haseltine, "how one special tendency or talent sometimes characterises a family for generations; all the children and grandchildren of John and Elizabeth Haseltine displayed artistic abilities, but only two sons, William and James Henry, took up Art as a career."[1] If Plowden thought it strange that only two sons took up the challenge of becoming professional artists, it is perhaps stranger to consider the ways in which the other children managed to work "artistic abilities" into other livelihoods. The variety of those livelihoods, moreover, reveals related shifts that occurred in the art world of the late nineteenth century, changes that saw the rise of a market system favoring art as commodity. Responsive to those changes, the five Haseltine brothers,[2] five sons of a merchant father, provide a view into the changing art world of the late nineteenth century, as well as a fascinating picture of family relationships centered around the profession of art.

So strong was the artistic inclination of the Haseltine family that in 1856 William felt compelled to redirect its manifestation in his youngest brother, encouraging Albert to apply his talented draftsmanship to the more lucrative profession of architecture, since "there are artists enough in our family."[3] Albert did not follow this particular advice, but he did find other ways to combine artistic leanings and financial necessity, just as his older brothers had. James Henry (1833-1907) became a sculptor; William Stanley (1835-1900) a painter; John White (1838-1925) a numismatist, antiquarian, and part-time agent for his brother Charles; Charles Field (1840-1915) an art dealer and, late in life, a painter; and Albert Chevalier (1843-1898) himself, another agent for Charles as well as for the French auction firm of Georges Petit. In one way or another, then, all the sons of John and Elizabeth Haseltine "took up Art as a career."

John Haseltine (1793-1871, *fig.1*) seems an unlikely patriarch for this brood of artistic sons. Born in Haverhill, Massachusetts, a town settled in the seventeenth century by his English forebears and famous in the nineteenth for its shoemaking industries, Haseltine began working at a young age for the firm of Moody, Wyman & Co., wholesale dealers in boots, shoes, and straw goods. In 1817 he moved to Philadelphia, at that time still the major port in the United States, as head representative of this lucrative firm.[4] Haseltine eventually assumed ownership of Moody & Wyman, changing its name to John Haseltine & Co. When he retired in 1839 at the age of forty-six, his eldest son was only six years old, and Haseltine turned the business over to a group of hand-picked associates from Haverhill, including his nephews Ward B. Haseltine, Daniel Haddock, Jr., and Stephen Kimball.[5] But he kept an eye on the firm (if not a hand in it) – Philadelphia city directories continued to list his occupation as "merchant" – with a business address identical to that of his nephews. Not until 1861 does Haseltine's occupation appear as "gentleman."[6]

Certainly, at least some of the sons of John Haseltine were expected or encouraged to work in the family business. James Henry (known principally as Henry) is listed in the 1850 Pennsylvania census as a clerk, age seventeen; John White first appears in the Philadelphia city directory in 1861, listed as a merchant. After attending college Charles went to work for "a dry goods commission house," and later entered into partnership with another agent. Albert graduated from Harvard College in 1863, but was back in Philadelphia by 1865, working as a salesman with Charles. William Stanley, a student at the time of the 1850 census and well on his way to a career in art by 1860, is not listed in any city directory until 1860, when his name appears in the New York pages as "artist, 15 Tenth." If he put in time at the family store or a related business, as evidence suggests his brothers all did, he managed to evade official notice or record of that experience.[7]

Yet even if John Haseltine expected from each of his sons some service in the family business, he also permitted their individual talents to develop. Three of his five sons attended college: William, the University of Pennsylvania and Harvard College; Charles, the University of Pennsylvania; and Albert, Harvard College. Haseltine was not keen on William's going abroad to study art in 1855, but allowed himself to be persuaded otherwise by means of a well-crafted and carefully reasoned letter from his son.[8] His two eldest sons (and, eventually, Charles) pursued their careers in art more or less single-mindedly, but the three younger sons sampled opportunities and pursued business ventures with greater irregularity. Still, their father apparently let them try what they would, and even supported such ventures. In his will, signed 4 November 1871, John Haseltine canceled "all debts or obligations due to me from all or any of my Sons" and directed his executors to "return to them for cancellation all such obligations in my possession."[9] For good reason, then, must Helen Haseltine Plowden have characterized

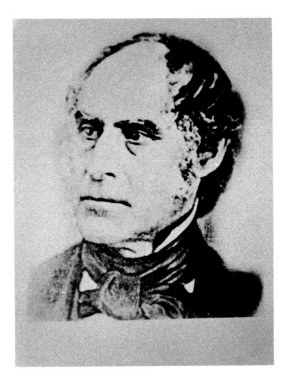

fig. 1 Unknown photographer, *John Haseltine*, ca. 1865. Haseltine/Plowden Family Papers, private collection, England.

her paternal grandfather (whom she never met) as "a silent, stern man, endowed with a big heart; generous to a fault ... [and] a tower of strength to those who needed him."[10]

One measure of John Haseltine's interest in art is his membership in the short-lived Art-Union of Philadelphia, a subscription organization designed, like the older American Art-Union in New York, to promote interest in and patronage of American art by offering each subscriber an engraving and a chance at an annual lottery.[11] Haseltine's interest may not have been substantial, since 1848 is the only year he was a member (his nephew Ward was a member in 1848 and 1851).[12] But in at least one instance the father made use of his sons' artistic talents when he invited (or permitted) one of them (we do not know who) to decorate the ceiling of a house in Haverhill that he had built for his widowed sisters, Mary West and Elizabeth Kimball.[13]

Elizabeth Stanley (Shinn) Haseltine (1811-1882), too, must have assisted her sons' advances in the field of art, although her role is harder to define. Her French heritage – she was descended from the Huguenot Peter Chevalier – seems to have been important in her children's upbringing: her oldest daughter married a French native, and her sons Henry, William, Charles, and Albert all lived at one time or had significant business in France.[14] Plowden suggests a stereotypical family dynamic whereby Elizabeth's sensitive, feminine nature mediated against her husband's more rigid, practical outlook to allow her sons' talents to flourish; she also notes that Elizabeth's "own tiny, white hands could embroider, sew to perfection, achieve a beautiful handwriting, and paint on china."[15] But Elizabeth was also familiar with the fine arts: in 1834 she sat for Philadelphia's premier portraitist, Thomas Sully (1783-1872), and by the 1860s she had tried her hand at painting and exhibited works at the Philadelphia Sketch Club and the Pennsylvania Academy of the Fine Arts. However, it is likely this later activity was encouraged by her sons' example, rather than vice versa.[16]

Whatever the source of the Haseltines' artistic bias, one may be certain that the extended family offered it support. Many of the first works that Henry and William displayed in Philadelphia were lent to the exhibitions by Haseltine cousins, brothers-in-law, and family friends.[17] When Charles became a member in the newly formed Philadelphia Sketch Club in 1862, one of his first acts was to establish a category of members who were not artists but who might "assist the reputation and prosperity of the Club." Among those Contributing Members (who in 1865 outnumbered artists thirty-eight to thirty-two) were Charles's wife Elizabeth; his father John; his cousins Daniel Haddock, Stephen Kimball, and Ward Haseltine; and Ward's son, Frank.[18]

Clearly, the children of John and Elizabeth Haseltine grew up in an environment of strong family ties and prosperous business dealings.

Parents, children, cousins, and brothers-in-law alike worked together and supported one another's ventures. Although three Haseltine sons, Henry, William, and Albert, chose to live the greater parts of their lives abroad, they remained tied to this supportive network of family. Art, in both its practical and creative aspects, presented one of the strongest bonds between these family members, and it is interesting to study how a family that built a fortune from shoes became distinguished for its devotion to art.

The oldest son and second child of John and Elizabeth Haseltine, Henry was listed among the members of his father's household in the 1850 census as a clerk, presumably with the family drygoods business, Haddock, Haseltine & Reed. But five years later his name appeared at the Pennsylvania Academy of the Fine Arts exhibition, attached to no. 509, the *Bust of a Lady*. How the young clerk in five years became a budding sculptor is unclear. He may have studied with Joseph Bailly (1825-1883), although that possibility was not suggested in Henry's life-time.[19] Bailly, a French émigré who settled in Philadelphia around 1850, first exhibited at the Pennsylvania Academy in 1851 and eventually became the Academy's professor of modeling. He was certainly one of the few artists or artisans practicing any type of sculptural work in Philadelphia in the 1850s. But if Bailly did instruct young Henry, his lessons probably involved more encouragement and inspiration than actual example – in the 1850s Bailly was still working out of the wood-carving tradition of his furniture-maker father.[20] Henry would have seen firsthand (if he were not told by Bailly himself) the limitations imposed on the career of an aspiring fine-arts sculptor. However it happened, Henry chose not to stay in Philadelphia and adapt his ambitions to practical reality. Some time around 1857, Henry joined the growing wave of American artists who sought in Europe the instruction and opportunities they could not find at home.

By 1861, the year he returned to Philadelphia to serve in the Union Army,[21] Henry had studied art in both Paris and Rome. He was in Rome by November 1857 when he and his brother William joined a group of artists and other friends of Thomas Crawford (1814-1857) to pay tribute to the late sculptor. Henry must have set up a studio around that same time, since it was reported in 1864 that he had "come [back to Philadelphia] from his studio at Rome at the opening of the war."[22] Henry's work in Paris is less easily documented. In 1869 he exhibited for his first and only time in the prestigious Paris Salon, listing his *maître* as "A. Toussaint." Armand Toussaint (1806-1862), a favorite student of David d'Angers (1788-1856), and who later ran an atelier espousing the noted sculptor's methods, died in May 1862, so Henry must have studied with him in the late fifties, before settling in Rome.[23] Toussaint's sculpture is not well known outside of France, so it is difficult to judge his effect on Henry's style. But it is certain that Henry maintained a tie

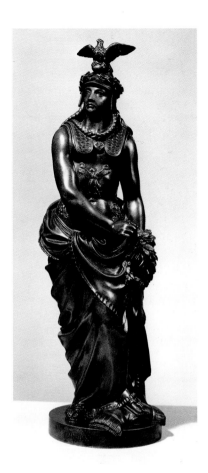

fig.2 James Henry Haseltine, *America Victorious*, ca. 1867. Bronze, medium brown patina, 16¾ in. Hirschl & Adler Galleries, New York.

fig.4 James Henry Haseltine, *America Mourning Her Fallen Brave*, 1867. Marble, 72 in. The Union League of Philadelphia. Commissioned by The Union League and presented by the artist.

to France even as he became immersed in the world of neoclassical Rome. Among his first exhibited works were copies after two equally famous but widely divergent marble sculptures in the Louvre: François Rude's naturalistic genre subject, *Neapolitan Fisherboy* (Salon 1833), and Antonio Canova's idealized yet chastely erotic *Amor and Psyche* (1787-1793).[24] Henry eventually chose the neoclassical realm of Canova, but there are indications that he remained aware of French precedents. For example, his bronze model for *America Victorious* (*fig.2*), gazing upward while bending to sheath her sword, seems to echo David d'Angers's *Philopoemen* (1837, Musée du Louvre, Paris), though her clothing and attributes tell a very different story from that of David's Greek hero.[25] It also seems that Henry realized the growing acceptance in France of bronze as an exhibition medium, since his sculpture *Excelsior*, exhibited at the 1869 Paris Salon, "attracted universal notice" as being "among the best bronzes."[26] It is interesting to note that one of the fullest critiques of Henry's sculpture appeared in the French *Gazette des Etrangers*, published in Naples, which commented that "the union of force, energy, nobility and elegance in Haseltine's works recall at once Rude, the bold sculptor of the Arc d'Etoile, David d'Angers and Pradier."[27]

A portrait of Henry from 1868, painted in Rome by a French woman, shows the sculptor as a comfortably successful gentleman, admiring his work and enjoying a cigar (*fig.3*). A still life of hunting paraphernalia in the top left corner makes further reference to leisure rather than livelihood. Henry sits alongside a bust from his important commission for the Union League of Philadelphia, *America Mourning Her Fallen Brave* (*fig.4*), underscoring his commitment to America in general and the Union cause in particular. Rouillon's portrait commemorates the Haseltine applauded by Samuel Osgood:

He is making good with his chisel the patriotism which he proved by his sword as officer in our army, and he is a fine specimen of a true American gentleman, who does not forget country and friends in the luxury of his Roman home.[28]

Many of the tourists who visited Henry's studio and sat for portrait busts were patriots of the same persuasion, whether J. Gillingham Fell, who later became president of Philadelphia's Union League; Frank M. Pixley (*fig.5*), a San Francisco politician, publisher and "staunch Republican"; or even General William T. Sherman himself.[29]

Portrait busts were standard fare for Henry Haseltine, as they were for most sculptors in Rome in the nineteenth century. But Henry's greater creative energies went into subjects drawn from literature (such as Henry Wadsworth Longfellow's *Excelsior*), recent history (such as Civil War themes), or pure fancy.[30] He was considered "quite unique among American artists in his tendency to work in couplets," and

fig.5 James Henry Haseltine, *Frank M. Pixley*, 1871.
Marble, 30¼ in. The Fine Arts Museums of
San Francisco. Gift of Miss Vera Pixley (42625).

among such paired groups, critics noted "Superstition" and "Religion,"
"Captivity" and "Liberty," "Spring Flowers" and "Autumn Leaves," as
well as "Grateful and Ungrateful Love."[31]

The last major exhibition of Henry's work seems to have been at the
1876 Centennial Exposition in his hometown of Philadelphia. There he
showed six ideal and literary subjects, all of them for sale, along with an
equestrian statuette owned by G. H. Schnieder.[32] But little is heard of
Henry Haseltine after this exhibition. As William Gerdts has pointed
out, "while [the Centennial] exposition represented the largest collec-
tion of neoclassical American sculpture ever brought together, it also
represented the swan song of that school of art."[33] Likewise, little is
known of Henry's work or livelihood after about 1880. In 1879, a writer
summarizing the state of American sculpture concluded that

There are other American sculptors deserving more than mere allusion,
like [Henry] Dexter, . . . [Charles] Calverly, and Haseltine, who in por-
traiture or the ideal have won a more than respectable position; but our
space limits us to a notice of several artists who . . . combine great natural
ability with traits distinctively American.[34]

Apparently Henry could claim neither professional distinction nor
native character sufficient to justify wider recognition.

But at just about this time, recognition seems not to have been on
Henry's mind. After 1880, he is no longer listed in the Rome directory,
and circumstances indicate a pull back to France where he had once
studied, and where, by that time, his brother Albert was living. In July
1881, at nearly forty-eight years of age, Henry married Nazzarena
Trombetti, a native of Terracina, Italy; their wedding was in Paris,
and in 1887 the couple was reported to be living in Nice. By 1903 the
Haseltines had moved back to Italy, living in Florence; four years later
Henry died in Rome.[35]

Henry's brother, William Stanley Haseltine, might have left simi-
larly indistinct signs and traces of his final year, had not the second son
of John and Elizabeth Haseltine married the daughter of a prominent
and well-connected American family[36] and paid what seems to be
greater attention to his career. Although he too spent the better por-
tion of his professional life in Europe, William, unlike his older
brother, saw that his work continued to appear in American exhibi-
tions, and is known to have visited his native country frequently.[37] As
a painter, William worked in a more portable and less labor-intensive
medium than sculpture, and was able to shift to the medium of water-
color when tastes and intentions changed in the later years of the cen-
tury (see Henderson essay, this volume). William also had the benefit
of a devoted daughter who in 1947 published a biography of her father
and for many years waged a campaign to ensure that galleries and
museums were aware of her father's work.

William's career as a painter needs no further elucidation in this essay. But his intersections with other Haseltines during the formation of that career are worth pointing out, especially since those connections were often overshadowed in later years by William's dealings with his second wife's more prominent family. Particularly during the earliest years of William's living abroad, family members in Philadelphia and New York helped him to attract and maintain contacts with American friends, patrons, and opportunities.

Another Haseltine brother, Charles, quite naturally provided many of those promotional links, because of the obvious sympathy between painting and art dealing. But Charles's business as a dealer dovetails in interesting ways with William's activities as a collector. Beyond his reputation as a painter, William eventually became known as an extraordinary collector of antiques and bric-a-brac;[38] he began this activity in the mid-1860s, buying paintings from New York colleagues – George Inness, Samuel Colman, and Aaron D. Shattuck. As well, he was dealing with Michael Knoedler's gallery (formerly Goupil & Co.), mostly for help in disposing pictures before traveling abroad. It may not be coincidental that Charles undertook a gallery soon after William moved to Paris. In January 1867, seven months after William left New York Charles, too, began dealing with Knoedler.[39]

Charles Field Haseltine, the fourth son and sixth child, bridges the gap between an enterprising father and his artistic sons. Like William, he attended the University of Pennsylvania, but unlike his older brother, did not finish a degree. In 1861 he is listed in Philadelphia city directories as a salesman and in 1864 as merchant and partner in the drygoods commission house of Haseltine & McCape. From 1865 to 1869 he was the partner of commission merchant John H. Williams. In 1869 he first appears in the city directory with the occupation that he would maintain the rest of his life: "paintings."[40]

Charles demonstrated a keen interest in applying business acumen to art long before he opened a picture gallery, however. In May 1862 he found his way into the still-young Philadelphia Sketch Club, where he not only suggested the topic for that evening's sketching activity (Undine), but also proposed that the "sketches be placed in an album at the Club's expense," which he would later sell (returning a share of the profits to the Club). Five months later Charles was "unanimously elected a member," and lost no time making changes and improvements – setting up a library, making donations, providing names of non-artist "contributing" members, and, in 1864, suggesting a system of prizes for members' drawings. In January 1865 he was elected president of the club. Charles immediately moved it into new, "palatial" rooms that he had taken and furnished at his own expense. He soon instituted policies to increase the club's money-making potential,

whether through exhibitions and publications geared to the public, or by zealously enforcing regulations; at one meeting in 1865 "all the members present were fined."[41]

Charles's biggest scheme for the club, however, was to organize a major exhibition devoted entirely to the work of American artists. Again, he announced a prize schedule, ranging from $1,000 on down, that he hoped would entice participation. Haseltine sent out hundreds of invitations in June 1865, enlisting the support, perhaps, of his brother William in New York, but certainly relying on Earl Shinn (who would later gain fame as a critic under the pseudonym Edward Strahan), to help spread word of his plans among friends and associates.[42] If an artist did not reply, Charles followed up with another letter. Emanuel Leutze (1816-1868) made a somewhat huffy response to this second inquiry, giving not only his refusal to compete or exhibit, but also his low opinion of competitions in general. Leutze objected to prizes that relegated non-award entries to rejected status; he also questioned the qualifications of the judges.[43] A critic who reviewed the Sketch Club show when it arrived in New York had similar concerns:

It is . . . a matter of doubt whether the true interests of Art can be subserved by such offers of tempting prizes. In the production of works of Art, either a disinterested love of beauty for its own sake, or, in addition to this, somewhat of creative genius are essential pre-requisites. The artist, animated by these impulses, works con amore, and will always do his best; he needs not the further incentive of a pecuniary reward.[44]

The conflict between "disinterested love" and "pecuniary reward" had been addressed a decade earlier by Asher B. Durand (1796-1886), the landscape painter who from 1845 to 1862 served as president of the National Academy of Design. "Seek not to rival or surpass a brother artist, and above all, let not the love of money overleap the love of Art," admonished Durand in 1855.[45] By the 1860s several voices had joined Durand's to decry the materialistic forces undermining true Art, their sheer number a sign that such forces were gaining general currency.[46] Charles, who in 1865 was still a partner in a drygoods commission agency, seems to have been among those whom Henry Tuckerman would disparage in 1867 for applying "the kind of arrangements which bespeak the mart and the stock company"[47] to the promotion of artistic endeavor. Extending principles of a market economy into the realm of creative "production," Charles was bound to offend an art world that aspired to fraternal community and enlightened patronage. He offered enticements not to potential buyers of art but rather to artists themselves; this effectively inverted those tactics of an older generation of art-union boosters, such as his father and cousin, whose efforts to develop patronage for American art assumed the existence of, or at least the desire to create, that art. When Charles showcased native

talent, he (perhaps over-optimistically) assumed the public's interest in it. Patriotically, he hoped to encourage the continued production of that talent; practically, he counted on sales:

This first exhibition of the Sketch Club of this city cannot fail to give an impetus to art and artists that will grow until our patrons of art will be convinced that the studios at home are more prolific of true genius than those abroad.[48]

Alas, while the exhibition brought fame to Charles Haseltine and the Sketch Club, it failed miserably from a financial standpoint. From admission receipts, catalogue sales, and commissions on pictures sold from the exhibition, Charles had expected to recoup the money he had offered for prizes. But sadly, "the Club realized nothing and Mr. Hazeltine lost a large sum of money."[49] And of the three hundred fifty works exhibited in Philadelphia, only fifty-six were entered for competition–Charles's prize incentive had not touched a responsive chord with many artists.

Charles was nominated president of the Sketch Club again in January 1867, but declined the honor. He retained his membership but withdrew from active participation, allowing the club to reclaim its original focus on social and artistic fellowship. He remained on good terms with the club and its members, some of whom later teased him for his imperial ambitions (*fig.6*).

But if plans for the Sketch Club were not fruitful, a commercial gallery was another matter. The ambition that Charles tested at the helm of the Sketch Club, his drive toward promoting the production and sale of art and receiving renumeration thereby, could be readily and appropriately satisfied through a private business.

Charles Haseltine had a natural advantage – brothers in the production end of the business. William's account books show that he received monies in from his brother Charles as early as 1865.[50] On 20 January 1867, Charles undertook the first of many dealings with Michael Knoedler, buying ten paintings including one by William, *Castle Chillon*. A painting called *Castle of Chillon* appeared at the spring exhibition of the Pennsylvania Academy of the Fine Arts; who knows but that Charles may have sold that painting to its owner, Jay Cooke?[51] Fewer documents exist relating to Henry's business dealings, but at least one instance points to Charles's involvement in those, too; Henry's sculpture *Reflecting Love* (ca. 1861, unlocated) was exhibited at the Pennsylvania Academy in 1868 with its owner listed as "C.F. Haseltine."[52]

Charles also dealt in European pictures, so his brothers, by living abroad, offered another advantageous connection. On 10 October 1868 the New York collector John Taylor Johnston recorded in his travel journal that after a visit to the Paris galleries of Goupil "we then went to [William] Haseltine's studio, met him by appointment & saw what he had been doing in Italy as well as what he had been buying for him

fig.6 Attributed to Augustus G. Heaton (1844-1931), *Charles F. Haseltine*, ca. 1867. Lithograph, 9½ x 13¹/₁₆ in. Philadelphia Sketch Club, Philadelphia.

self & relatives."[53] One may assume he was buying inventory for Charles's Philadelphia gallery, which opened in 1869; confirming that assumption is the fact that Charles soon had another agent:

It was in 1869-70 that [Albert Haseltine] appeared in Paris with the plan of selecting and buying paintings to be sent to his brother, who was an art dealer in Philadelphia at the time. He had also a brother who was a painter in Rome, Italy, and another, a sculptor in the same city, and I believe they were to help in the work.[54]

Charles eventually set up "foreign agencies" in Paris at 40 Rue Blanche and in Rome in 29 and 30 Via Babuino. It should be no surprise to learn that in the 1870s Henry Haseltine lived in 29 and 30 Via Babuino.[55] Charles visited these family and business connections frequently; in 1916 it was reported that he had "traveled through many countries in his search for paintings, and visited Europe 52 times for this purpose."[56]

Unfortunately, records from the Haseltine Gallery do not seem to exist. A disastrous gallery fire may have destroyed them all; in any case, there are presently no documents that reveal more about business relationships among the brothers. Nor is enough known about the individual artists and exhibitions showcased in the gallery itself, although it is known that Charles showed the work of Thomas Eakins (1844-1916), including his controversial portraits, *The Gross Clinic* (1875, Jefferson Medical College, Thomas Jefferson University, Philadelphia) and *The Agnew Clinic* (1889, University of Pennsylvania School of Medicine).[57] It also seems that Charles took good advantage of expositions in cities around the country, such as Industrial Fairs in Chicago and Cincinnati, to display his inventory and the work of individual artists. Paintings by his brother William were often included in such exhibitions; they also appear in auctions of "The Haseltine Collection."[58]

Even without full records, existing evidence of Charles's transactions with art dealers and auctioneers reveals much about his business. From March 1867 to December 1873, for example, Knoedler sales books record thirty-two transactions between the gallery and Charles Haseltine.[59] By comparison, during this same period, the prominent Boston galleries of Williams & Everett and Doll & Richards had, respectively, twenty-five and twenty-one transactions with Knoedler. Charles tended to buy in large quantity, not all of it the same quality. On 16 April 1867 he paid Knoedler $5,900 for forty-seven European paintings; the month before he had paid $1,000 for a single work by the American artist William Sonntag (1822-1900). Haseltine often paid Knoedler with prints by exchange, and records imply that credit terms were often and readily accepted.

In addition to sales from his gallery on Chestnut Street, in the 1870s and 1880s Charles held frequent auctions of "The Haseltine Collection" in Philadelphia and New York. While important items or impressive names might headline such sales, the bulk of these "collections" often consisted of minor and inexpensive European works. By the mid-1880s Montague Marks, editor of the New York journal *Art Amateur* and dedicated to exposing "art shams and dealers in art shams," had targeted Charles Haseltine:

One of the most respectable-looking of auctions is the perennial "Sale of the Hazleton Collection," which takes place in the most imposing rooms to be had, and always draws a large crowd and a good deal of money. The affair is in the hands of a very rich Philadelphia picture-dealer, who, I am told, does more business than any picture importer in this country. His method is very simple. Owning hundreds of valuable foreign paintings, he travels from city to city, exhibiting them together with inferior canvases, which, being in such good company, profit by the glamour of the association. When the "auction" takes place, the poor pictures are really sold, with the buyers of them; while most of the good ones may confidently be looked for in the next city on the route, where they will help to float a further lot of trash.[60]

Marks, whose magazine was devoted to "the cultivation of art in the household," often intervened on behalf of the smaller buyer, whom he accused Charles of treating "cavalierly." His major quarrel concerned the policy of a reserve, the idea that Charles might "protect" his investment in more valuable works by selling no pictures "unless the bids [were] satisfactory to their owner."[61] Charles was hardly the only dealer to engage in such practices; he seems only to have been the most visible.[62]

By 1887 Charles's business was extensive enough to support a gallery on Fifth Avenue in New York, which was conveniently managed by his brother, John.[63] Meanwhile, in the Philadelphia gallery, Charles was assisted by his son-in-law, Charles Stewart Carstairs, a relative not only through marriage but also by blood, since Carstairs was the grandson of Daniel Haddock, Jr.[64] Carstairs married Charles's daughter Esther in 1885, and worked for his father-in-law until 1893, when he moved to New York to join the firm of M. Knoedler and Co. Carstairs became the head of Knoedler's London branch and in 1928, upon the retirement of Roland F. Knoedler, bought out the business along with his son Carroll and two others. He was credited for much of the Knoedler Gallery's growth and prestige in the early twentieth century; among the collections he helped form were those of Henry Clay Frick in New York and P.A.B. Widener in Philadelphia. His career presents an interesting parallel to that of his grandfather-in-law, John Haseltine – beginning work in a local shop, moving on to the bigger city and larger market, and eventually buying out the firm with the assistance of sons/nephews. That Carstairs' father-in-law, Charles Haseltine, helped encourage and validate his career decisions cannot be doubted; Carstairs did not

come from a family of artists or art dealers, but by the time of his death in 1928 he was acknowledged as "a great art dealer whose name was known all over the world."[65]

Charles closed his New York gallery in 1889, apparently consolidating resources and concentrating on business in new quarters known as "The Haseltine Building" at 1416 Chestnut Street. On 2 February 1896 fire destroyed this gallery along with Haseltine's entire inventory and library of art books. The most expensive losses were European works by H. C. Selons, Louis Verboeckhoven, and William Bouguereau; among the American artists who lost works were Colin Campbell Cooper (1856-1937), Frank W. Stokes (b. 1858), and the dealer's brother William.[66] Charles, who took "his enormous loss very philosophically,"[67] moved into yet another address on Chestnut Street. But around and after this date his business activity seems more restrained, while his interests beyond art dealing multiplied. He devoted more and more time to genealogical research – work that his niece Helen Haseltine Plowden made good use of when writing the biography of her father.[68] Around the turn of the century, Thomas Eakins painted a portrait of Charles (*fig.7*), which counters the picture that members of the Sketch Club or the suspicious New York press might have drawn. Showing him in a circumspect pose with a brooding gaze, Eakins suggests a man in whom age, experience, and intelligence have contributed to a complex humanity.

Around 1905, Charles took up painting (*fig.8*), and described this new activity to his niece Helen:

Perhaps you have not heard that I have become an Artist & am painting Marines & landscapes with the greatest possible vigor. . . . The first one that I painted I sent to the jury of selection or rejection of the Art Club here . . . & it not only was accepted but it was placed on the line & since it has been sold. The fact of my painting it created considerable excitement & interest, for hardly any one believed at first that I had really painted it, but thought that I had taken a foreign picture & had put my name to it & had done all this as a joke. Now I have painted a considerable number & have received a great deal of praise from the Artists as well as Amateurs.[69]

But even while researching, painting, and traveling, Haseltine kept a hand in the gallery and dealer business, as correspondence with both the Knoedler and William Macbeth galleries attests.[70]

Charles played a natural role in promoting the work of his brothers William and (to a lesser extent) Henry. But he managed to involve his other brothers in the business as well. The middle and youngest sons of John and Elizabeth Haseltine did not follow the directed and disciplined career paths of their brothers. Even so, a survey of their activities reveals threads of art and family woven firmly into the fabric of their lives.

John White Haseltine, the middle of the five brothers and the longest-living of them, seems also to have been the most independent of

fig.7 Thomas Eakins (1844-1916), *Charles Field Haseltine*, ca. 1901. Oil on canvas, 24 x 20 in. Montclair Art Museum, Montclair, New Jersey. Museum purchase, Florence O.R. Lang Acquisition Fund (52.130).

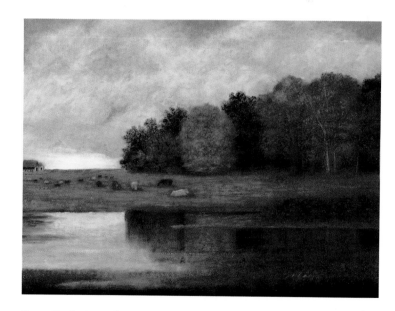

fig.8 Charles F. Haseltine, *A Summer Day*, 1905. Oil on canvas, 20⅜ x 26⅝ in. Scripps College, Claremont, California. Gift of Mr. and Mrs. Stephen I. Zetterberg, 1975.

them all. His business, too, seems furthest from the strictly fine arts, but it nonetheless provides links to family tradition as well as art market practice. Like Henry, John worked for at least one year as a merchant – presumably with Haddock, Reed & Co. – and he also joined the United States Army at the outbreak of the Civil War.[71] Following this service, John went into business with his cousin Ward Haseltine; he appears in Philadelphia city directories from 1867 to 1873 as the secretary and/or treasurer of various mining companies, including the Colorado Gold Mining Company and Pioneer Mining Company of Colorado, in which his cousin held a controlling interest.[72]

John's army service and mining concerns, however, seem to have only temporarily distracted him from his primary and true interest – curios, particularly coins, medals, and stamps. Before the war, he was engaged in some aspect of "the curio business" in New Orleans;[73] he resumed this as a full-time occupation in 1874. In that year he is listed in the Philadelphia directory with his business as "coins, 1343 Chestnut," and from that address he took orders for at least two auction sales of "Antiques & Bric-a-Brac" held in New York in 1874.[74] Concerned not only for the sale of these items, he indicated his interest in their study and collection by publishing a handsome and informative catalogue of colonial currency in 1872.[75] John was involved in several auction sales of coins and medals in the 1870s and 1880s, both as cataloguer and con-signor.[76] By 1876 his business had expanded from "coins" to "curios" and later "curiosities." This expertise and experience no doubt contributed to John's being installed in 1886 as the manager of his brother Charles's art gallery in New York.

After the Haseltine Gallery on New York's Fifth Avenue closed in 1889, John continued to sell pictures, as indicated by a listing in the 1890 New York directory for "Haseltine, John W., pictures." But he does not appear again in New York directories until 1895, when he is listed as a "broker, 60 B'way" in New York. He is listed as such through 1898, but in that year John W. Haseltine returned to the Philadelphia area, listed as a "collector." Subsequent Philadelphia directories list him with a business of "curios" or "curiosities" well into the twentieth century. One would like to know more about those "curios," although at the time of his death it was for his collection of stamps and coins, "one of the finest" in the United States, that John Haseltine was remembered.[77]

Considering the examples set by his brothers, one can easily imagine that the youngest Haseltine son, Albert Chevalier (*fig.9*), might have been alternately inspired and overwhelmed by family precedent. By the age of thirteen he was already displaying artistic inclinations, but seemed to be considering a career in the Navy. His brother William encouraged him to change his mind, but not to neglect his talent for draftsmanship. *I have heard very good accounts of . . . the way you are studying in school. . . I hear too that you are going into the Navy, if so – I hope that you will*

fig.9 Unknown photographer, *Albert C. Haseltine*, ca. 1867. National Academy of Design, New York.

not be all your life a midshipman. For my part, if I were in your place I would look for some pleasanter profession. An architect, (there are artists enough in the family) would do very well, and I think that you have some talent for drawing. It will be a splendid profession at some day in our country, & one that one can make a good deal of money by, much more than by painting. . . . P.S. Have you given up drawing entirely, if not try to draw something from Nature. You will find it difficult at first. . . .[78]
Instead of joining the navy, Albert followed William's example by attending Harvard College, graduating in 1863. He served briefly with the Landis Battery of the Pennsylvania volunteer militia; after the war he worked for two years with his brother Charles in Philadelphia before entering into a partnership with a classmate, Charles F. Fearing, as a stockbroker in New York.[79] During these years Albert apparently lived in William's studio in the Tenth Street Studio Building; his home address, like that of William's, is listed from 1867 to 1869 as "51 w. 10th." It may be that, by occupying the studio space, Albert kept open an option for his brother, should he ever want to return to New York and his prestigious address. Albert was certainly attending to some of his brother's business, as one of William's accounts with Knoedler was settled by making the payment of $937.33 to "Alb. C. Haseltine."[80] He was elected to the Century Club, and served his alma mater by setting up Harvard Clubs in Philadelphia and New York.[81]

But around 1870, as noted earlier, it seems that Albert decided to find a "pleasanter profession," and followed in the footsteps of his brother Charles. A Harvard classmate, Nathan Appleton, had recalled that "in 1869-70 [Albert] appeared in Paris with the plan of selecting and buying paintings to be sent to his brother"; he continued this train of thought by saying:
The Franco-Prussian War broke out before [the brothers] were more than started, and this really prevented the business from being undertaken later, though A. C. Haseltine was always more or less in touch with French artists, and for many years lived in Paris, and was associated with the house of Mons. George Petit.[82]
The Petit connection was mentioned by another classmate, Edward Darley Boit, who reminisced in 1899 that "It must have been ten years ago or thereabouts that Haseltine was called on to represent the interests of one of his brothers in the settlements of the affairs of George Petit – the well-known Paris picture dealer."[83] It appears that Charles was keeping an eye out for opportunities for Albert; for although Albert kept busy for the rest of his life, he seems to have followed no set occupation.

Classmates who visited Albert during these and later years recalled a man of charm and cultivation, one whose aesthetic and epicurean attentions veered toward dilettantism. He kept an apartment in Paris "which he occupied only when called to the capital by the exigencies of his brother's affairs,"[84] and spent most of his time in his home and gardens in Chartres, where he "lived almost the life of a hermit, cooking his meals and taking long walks in the country."[85] One classmate remembered Albert as a man whose
knowledge of French history, literature, and art was very wide. . . . He was of French Huguenot extraction, in appearance a Frenchman, with perfect command of the language, for which he had a fondness in his early days. He was a great reader of books, in several languages. Very fastidious in his tastes, he took a great interest in the French cuisine and became personally proficient in this art, as well an expert in judging of French wines.[86]
Others recalled Albert's unfulfilled projects and personal disappointments, for example, in plans in 1875-1876 to run telegraph cable from Portugal to the United States, or later, to erect "a business building on American principles, i.e., heat, elevators, many different offices, etc., etc., of which there was nothing of the kind in Paris" (suggesting that Albert at some point took seriously his brother William's suggestion that he try architecture as a profession). Neither of these projects came to fruition, nor did an application in 1897 for a place on the American Commission for the Paris Exposition of 1900.[87] These and other disappointments, along with failing health, seem to have marred Albert's final years. Boit, who visited Albert only a few months before his death in 1898, recalled that "there was undoubtedly a pathetic side to his last days." But he honored his classmate by concluding that "Under other circumstances, his noble tastes and wide cultivation might have made a mark in this puzzling world of ours."[88]

All members of that "puzzling world" of the late nineteenth century, the five Haseltine brothers present a window on its affairs of art, suggesting themes of nationalism and expatriation, the growing professionalism of artists and art dealers, and the rise of connoisseurship. Seen in simple outlines, the creative activities of Henry and William, the commercial dealings of Charles and John, and the tasteful cultivations of Albert suggest a circle of making, selling, and appreciating art. But this simple structure is enlarged and complicated by the painter William's collecting, which often brings him close to dealing; by the antique dealer John's briefly turning from selling "curios" to selling pictures; by the dealer Charles's taking up painting in his later years. All these activities suggest the complexity of the professional art world at the turn of the twentieth century, and the level to which the idealistic, "disinterested" pursuit of artistic goals had become entwined with the "kind of arrangements which bespeak the mart and the stock company." The individual accomplishments of each Haseltine brother are notable in their own right, but considered against the backdrop of family connections and intersections, as well as the changing world of the late nineteenth century, they become even richer and more remarkable.

Notes

An essay that incorporates biographical and genealogical minutiae necessarily condenses facts from several sources. Such information, if not otherwise noted, has been compiled from the following: Josiah H. Shinn, *The History of the Shinn Family in Europe and America* (Chicago: The Genealogical and Historical Publishing Company, 1903); *Vital Records of Haverhill, Massachusetts, to the End of the Year 1849*, 2 vols. (Topsfield, Mass.: Topsfield Historical Society, 1910-1911); and the [Charles F.] Haseltine Papers, Historical Society of Pennsylvania, Philadelphia. I would like to express special thanks to G. H. Laing, Special Collections Librarian at the Haverhill Public Library, for his generous assistance with and interest in details relating to the Haseltine family and the town of Haverhill, Massachusetts.

1. Helen Haseltine Plowden, *William Stanley Haseltine: Sea and Landscape Painter (1835-1900)* (London: Frederick Muller, Ltd., 1947), 19.

2. If the artistic mantle of the Haseltine family passed to any of the daughters, that fact remains unrecognized. Leonard Woodman Smith indicates that a sister became an artist ("Haseltine Family," clipping inscribed "15 January 1916" but otherwise unidentified, Haverhill Public Library), but to date neither confirmation nor exhibition records has been found for any of the three Haseltine daughters, Caroline Augusta (Mrs. Emile Marquéze), Elizabeth Stanley (Mrs. William Poultney Smith), or Marianne Lucy (Mrs. James Dumaresq).

3. William Stanley Haseltine to Albert Haseltine, Meyringen, Switzerland, 9 September [1856]. Haseltine/Plowden Family Papers, private collection, England.

4. "John Haseltine" [obituary], *Haverhill Gazette*, 22 December 1871. Other sources list the name of the original firm as "Moody & Co."

5. "John Haseltine," *Haverhill Gazette*; "John Haseltine of Philadelphia," Haseltine Papers (Ha14:3), Historical Society of Pennsylvania [hereafter HSP]. Upon Haseltine's retirement, the firm became Haddock, Haseltine & Reed, consisting of the partners Daniel Haddock, Jr., Hazen Haddock, Ward B. Haseltine, Stephen B. Kimball, and Charles Reed. Ward (1809-1886) was the son of John Haseltine's brother William, while Daniel (1806-1890) and Hazen Haddock (b. 1815) were sons of his sister Abigail. Stephen Kimball (b. 1807) was the son of John's sister Elizabeth. When Ward Haseltine retired around 1853, the firm became Haddock, Reed & Co. See also Helena L. Farr, *Farr, Haddock, and Allied Families* (New York: The American Historical Society, Inc., 1927), 31; and "Obituary: Death of Ward B. Haseltine of Philadelphia," *Haverhill Gazette*, 12 March 1886. One should note that by 1839 Daniel Haddock, Jr., was both nephew and brother-in-law to John Haseltine; in 1838 Daniel married Catherine Shinn, the younger sister of John's wife Elizabeth (Shinn) Haseltine.

6. This and many subsequent generalizations about occupation, residence, and business addresses have been compiled from information in city directories, including McElroy's Philadelphia Directory (1850-1867), Gopsill's Philadelphia City Directory (1867-1907), and Boyd's Philadelphia City Directory (1907-1923). New York and Boston directories were also consulted when relevant.

7. Pennsylvania census for 1850, National Archives, Washington, D.C.; "Obituary: Charles Field Haseltine," *American Art News* 14, no. 10 (11 December 1915): 3; city directories.

8. William's letter to his father is excerpted in the Chronology, this volume, and quoted in full in Plowden, *Haseltine*, 32-33.

9. "Last Will and Testament of John Haseltine, Philadelphia," signed 4 November 1871 and probated 19 December 1871; Wills Book 1873, 148-150, microfilm record at HSP.

10. Plowden, *Haseltine*, 19.

11. Philadelphia's Art-Union used a system similar to that of the London Art-Union, whereby, in addition to the distribution of a steel engraving to each member, a monetary prize (rather than an actual art work) was awarded by lottery: "The ART UNION of Philadelphia awards prizes in its own Certificates, with which original American works of Art may be puchased in any part of the United States, at the option and selection of the person who may obtain a prize at the ANNUAL DISTRIBUTION" (*Philadelphia Art Union Reporter* 1, no. 1 [January 1851]), cover). For a brief overview of art-unions in the United States, see William H. Gerdts, "American Art Exhibitions and Their Catalogues: From the Beginning through 1876," in James L. Yarnall and William H. Gerdts, comps., *The National Museum of American Art's Index to Exhibition Catalogues, from the Beginning through the 1876 Centennial Year*, 6 vols. (Boston: G. K. Hall & Co., 1986), 1: xxviii-xxix; see also Maybelle Mann, *The American Art-Union* (Otisville, N.Y.: ALM Associates, 1977). Like all other American art-unions, the Philadelphia Art-Union was dissolved by law in 1852.

12. *Transactions of the Art-Union of Philadelphia* (Philadelphia: Griggs & Adams, 1848); *Philadelphia Art Union Reporter* 1, nos. 1- 12 (January 1851-January 1852). In 1851 the Art-Union's honorary secretary for Haverhill, charged with promoting interest and receiving subscriptions for the Art-Union outside of Philadelphia, was Warner R. Whittier (1810-1897), a nephew of John Haseltine's brother-in-law and former business partner Warner Whittier (1780-1846). See "John Haseltine," *Haverhill Gazette*.

13. The Haverhill house, described as "a first class brick house . . . [on] the most desirable street" in town ("John Haseltine," *Haverhill Gazette*), still stands at 96 Summer Street. It has since been split up into a duplex and now houses doctors' offices. What remains of the fresco has been covered by a drop ceiling, but town residents recall it to show "putti and clouds." Attribution to a particular Haseltine son has not been made, but a likely candidate is William, who painted the doors of his Harvard room in 1853 or 1854 (see Chronology, this volume), and may have done similar work for his aunts on a trip from Cambridge to Haverhill. I am grateful to G. H. Laing for telling me about the Haseltine house and its ceiling.

14. Emile Marquéze (1820-1899), who married Caroline Augusta Haseltine in 1855, was born in Orthez, France (Haseltine Papers [Ha14:48], HSP). He is listed in the 1857 Boston city directory under "Marqueze, E & Co., boots and shoes, 52 Fulton," so it is likely that Caroline met him in connection with her father's business. Albert Haseltine, who was given the middle name Chevalier, seems to have cultivated a special affinity for France; see the discussion of him, this essay. For Elizabeth Haseltine's Huguenot background, see Plowden, *Haseltine*, 26-27; also Haseltine Papers (Ha14:36), HSP. Charles Haseltine, in his genealogical research, found no evidence that Pierre Chevalier's mother was Jeanne de Crequi, and so descended from the duc de Sully, as Plowden would later go on to state.

15. Plowden, *Haseltine*, 19, 73: "[William] consulted his mother and told her

he wanted to join his artist-friends who were working in New York; she, with her usual wisdom and selflessness, agreed and persuaded his father to let him go away again."

16. For Sully's portrait of Elizabeth Haseltine (1834, private collection), see Plowden, *Haseltine*, opp. 19. In 1865 Elizabeth Haseltine exhibited a *Water-Lilies* at the Philadelphia Sketch Club; she later showed five landscape subjects at the Pennsylvania Academy. See Anna Wells Rutledge, *Cumulative Record of Exhibition Catalogues: The Pennsylvania Academy of the Fine Arts, 1807-1870* . . . (1955; reprint, with revisions by Peter Hastings Falk, ed., Madison, Conn.: Sound View Press, 1988), 93, 458.

17. Ward Haseltine bought William's painting *View of the Siebengebirge* for $300 in 1858-1859, and displayed it at the Great Central Fair in June 1864. Daniel Haddock, Jr., bought a painting from William for $400 in 1858-1859, probably the *View from the Island of Capri, Near Naples*, that was exhibited in 1859 at the Academy; he also owned Henry's *Marble Bust of a Lady*, exhibited at the Academy in 1857. Stephen Kimball exhibited paintings by William at the Pennsylvania Academy in 1855 and 1860, having bought two from the artist in 1858-1859 for $230. William Poultney Smith and Emile Marquéze, brothers-in-law of Henry and William Haseltine, purchased paintings from William in 1858-1859 and 1860; Smith exhibited his *Old Tower in the Roman Campagna* at the 1861 Academy. Both Elizabeth and John Haseltine owned works by their son William, but apparently left big purchases to other family members. William's "List of Pictures Sold 1858-59," mentions John Haseltine at the very bottom as the purchaser of an unnamed painting for $30. See Yarnall and *Gerdts*, Index, 3: 1651; Rutledge, *Cumulative Record*, 93-94; Plowden, *Haseltine*, 73.

18. Sidney Lomas, "History of the [Philadelphia] Sketch Club, 1860-1935," typescript M S, 22, Philadelphia Sketch Club (microfilm copy in the Archives of American Art, Smithsonian Institution, roll 3664, frame 504); *Catalogue of the First Annual Prize Exhibition of the Philadelphia Sketch Club, held at the Pennsylvania Academy of the Fine Arts* (Philadelphia: Stein & Jones, Printers, 1865). Frank Haseltine (1838-1910), Ward's son, graduated from Harvard in 1860 and received an L.L.B. from the University of Pennsylvania in 1866. He practiced law for some years, but later indulged an interest in art. He exhibited at the Pennsylvania Academy and was a frequent sketching companion of Maitland Armstrong in Bar Harbor, Maine. See Peter Hastings Falk, comp. and ed., *The Annual Exhibition Record of the Pennsylvania Academy of the Fine Arts*, 3 vols. (Madison, Conn.: Sound View Press, 1989), 2: 239; also D. Maitland Armstrong, *Day before Yesterday* (New York: Charles Scribner's Sons, 1920), 297-298.

19. The earliest mention I have found of the oft-repeated claim that Henry Haseltine studied with Bailly appears in Adeline Adams's article for *The Dictionary of American Biography* (New York: Charles Scribner's Sons, 1932), an account that apparently depends on Lorado Taft's *History of American Sculpture* (New York: The MacMillan Company, 1930). Taft's brief discussion of Haseltine follows a long sentence that begins "Among the pupils of Bailly was Albert E. Harnisch," but Taft does not actually say that Haseltine, too, was a pupil of Bailly. *Appleton's Cyclopædia of American Biography*, published in 1887 and generally dependent upon subject-completed questionnaires for its information, says nothing at all about Haseltine studying in Philadelphia.

20. Bailly was not elected an Academician of the Pennsylvania Academy until 1860. His 1851 Academy contribution was a "Bouquet, carved out of one piece of American oak"; by 1855 he was in partnership with the German-born furniture-maker Charles Buschor (1823-1885), with whom he provided carved allegorical figures for the newly erected Masonic Hall in Philadelphia. See Henry Hawley, "American Furniture of the Mid-Nineteenth Century," *The Bulletin of the Cleveland Museum of Art* 74, no. 5 (May 1987): 209-211.

21. Henry was mustered into service on 18 September 1861, joining the 70th Regiment of the 6th Cavalry, United States Army, the famous unit known as "Rush's Lancers." He was promoted from captain to major on 1 March 1863, and discharged on 12 November 1863. See Samuel P. Bates, *History of Pennsylvania Volunteers, 1861-5*, 5 vols. (Harrisburg: B. Singerly, State Printer, 1869), 2: 753. A letter of January 1863 from Henry to his mother expresses regret over the dismissal of General Benjamin Franklin Butler and dismay at the politicization of the war effort: "I long to get out of this and go back to the quiet of my studio! I went into this war with good intentions; I have become disgusted in a cause where people allow themselves to be trampled upon by a few vulgar, selfish politicians. I want to go where I can surround myself with the beauty of the human form and live again in the admiration of the greatness of Nature and not with the contemptible selfishness of human meanness" (Henry Haseltine to Elizabeth Haseltine, Camp near White Oak Church, 28 January 1863; quoted in Plowden, *Haseltine*, 78-79).

22. Sylvia E. Crane, *White Silence: Greenough, Powers, and Crawford, American Sculptors in Nineteenth-Century Italy* (Coral Gables, Fla.: University of Miami Press, 1972), 401.; "Philadelphia Art Notes," *Round Table* 1, no. 25 (4 June 1864): 392. Crawford had died in London on 10 October 1857.

23. Toussaint's career has not been studied fully. For his relation to David d'Angers, see *La sculpture française au XIXe siècle*, exh. cat. (Paris: Editions de la Réunion des musées nationaux, 1986), 37. A short biography and list of works, including several sculptures for the west façade of Notre-Dame, appears in Stanislas Lami, *Dictionnaire des sculpteurs de l'école française au dix-neuvième siècle*, 4 vols. (Paris: Librarie ancienne Honoré Champion, 1921), 4: 312-315.

24. At the 1858 Pennsylvania Academy exhibition, Haseltine exhibited as no. 359 a *Statue – Italian Fisher Boy, after Rhude*; and in 1861 he exhibited as no. 407 *Cupid and Psyche after Canova*. See Rutledge, *Cumulative Record*, 93.

25. A bronze version of David's sculpture is reproduced in *The Romantics to Rodin: French Nineteenth-Century Sculpture from North American Collections*, exh. cat. (Los Angeles: Los Angeles County Museum of Art, in association with G. Braziller, Inc., 1980), 222, fig.101.

26. "The Exhibition of Fine Arts at the Palais de l'Industrie," *Watson's Art Journal* 11, no. 10 (10 July 1869): 125; the critic went on to say "There is sublimity in this work and remarkable aspiration, leaving matter far behind." The bronze *Excelsior* is unlocated today, as is the original marble that belonged to LeGrand Lockwood. Old photographs of the Lockwood Mansion show the marble sculpture installed in the central rotunda (some views include another Haseltine sculpture, *Kissing Cherubs*); see *LeGrand Lockwood (1820-1872)* (Norwalk, Conn.: Lockwood-Mathews Mansion Museum of Norwalk, Inc., 1969), 20, 22, 23. Both sculptures (along with the rest of Lockwood's art collection)

were sold by his widow in 1872.

27. Quoted in Anne Brewster, "Correspondence: Letter from Rome," *Philadelphia Evening Bulletin*, 3 November 1870 [dateline 14 October 1870].

28. [Samuel G. Osgood], "American Artists in Italy," *Harper's New Monthly Magazine* 41, no. 243 (August 1870): 422.

29. For Pixley, see Donald L. Stover, *American Sculpture: The Collection of The Fine Arts Museums of San Francisco* (San Francisco: The Fine Arts Museums of San Francisco, 1982), 24. The portrait of J. G. Fell is unlocated, but alluded to in a newspaper account: "Mr. Haseltine's busts of Mr. Fell, Mr. and Miss Abbott, of Philadelphia, excellent portraits, are now in the hands of the marble work-men" (Anne Brewster, "Letter from Rome: Chit-Chat About Literature, Art and Society," *Philadelphia Evening Bulletin*, 27 May 1869 [dateline, 4 April 1869]). For the portrait of Sherman, also unlocated, see "The Round of the Studios," *Roman Times* 1 (28 October 1871): 3: "The artist's bust of General Sherman is about to be executed in marble and will be sent to America as soon as it is finished. It will become the property of the General himself who favoured Mr. Haseltine with a sitting during his visit to Rome last winter."

30. Haseltine modeled a bust of Longfellow in 1869; in 1872 the poet saw the finished work in Boston and later wrote in his journal, "Saw Hazeltine's bust of me, made in Rome in 1869, – a clever piece of work, I should say" (quoted in Samuel Longfellow, ed., *The Life of Henry Wadsworth Longfellow*, 3 vols. [Boston: Houghton Mifflin and Company, 1891], 3: 199). Another version may still be in "a garden close to the road leading to the picturesque old cemetery of Mentone [on the French Riviera]." See John Joseph Conway, M.A., *Footprints of Famous Americans in Paris* (London: John Lane, 1912), 124.

31. Osgood, "American Artists in Italy," 422; Henry T. Tuckerman, *Book of the Artists: American Artist Life* (1867; New York: James F. Carr, 1967), 598. Like so much of Henry Haseltine's work, the paired sculptures mentioned by Tuckerman remain unlocated today.

32. International Exhibition. 1876. *Official Catalogue. Part II: Art Gallery, Annexes, and Out-Door Works of Art . . .* (Philadelphia: published for the Centennial Catalogue Company by John R. Nagle, 1876), 51. The seven works exhibited by Haseltine were: 1188, *Fortune*; 1198, *Spring Flowers*; 1199, *Lucretia*; 1200, *Captivity*; 1203, *Cleopatra*; 1210, *Duke of Leuchtenberg (Equestrian Statuette)*; and 1211, *Lucia di Lammermoor*.

33. William H. Gerdts, *American Neo-Classic Sculpture: The Marble Resurrection* (New York: The Viking Press, 1973), 49.

34. [Samuel G. W. Benjamin], "Sculpture in America", *Harper's New Monthly Magazine* 58, no. 347 (April 1869): 669.

35. Nazzarena Haseltine outlived her husband by twenty-five years; both she and Henry Haseltine are buried in the Protestant Cemetery of Rome. Cemetery records give Mrs. Haseltine's maiden name as Nenza; however, in Charles Haseltine's genealogical papers she is listed as "Nazarena Maria Filomena Trombetti . . . daughter of Luigi Trombetti." Shinn apparently anglicized this information when he published it in his book on the Shinn family, turning Nazzarena into "Marie N. F. Trombetti." See Revalee Renick Stevens and Robert Kim Stevens, *The Protestant Cemetery of Rome* (Baton Rouge, La.: Oracle Press, 1981), 68; Haseltine Papers (Ha14:48), HSP; Shinn, *The Shinn Family*, 225.

36. Helen Marshall, William's second wife, was the daughter of shipping magnate Charles Marshall (1822-1865), agent and part owner of the famous Black Ball line. Her sister, Mary Russell Marshall, married the lawyer and author William Allen Butler (1825-1902), thus aligning Haseltine with another of New York's most prominent families. Yet another Marshall sister, Elizabeth, married Charles Lamson, an importer of fine French fabrics; their granddaughter was the sculptor Malvina Hoffman (1885-1966). See Hoffman, *Yesterday is Tomorrow: A Personal History* (New York: Crown Publishers, Inc., 1965), 22-23.

37. See Chronology, this volume, for William's visits to the United States and exhibitions of his paintings in New York and elsewhere from the 1870s to the 1890s. Although he traveled frequently, there is little evidence for Plowden's state-ment that "Haseltine and his family re-visited America almost every summer or winter" (*Haseltine*, 104).

38. Plowden states that "[the artist Mariano] Fortuny was the first to encourage Haseltine in the collection of antiquities and works of Art. . . . Aided by Fortuny and the advice of his artist friends, Haseltine laid the foundation for that rare col-lection of pictures, furniture and '*objets de vertu*,' which, in late years, earned him the well-deserved reputation of a wise and experienced collector of ancient works of Art – especially of Hispano-Moresque and brass plates" (*Haseltine*, 100). The installation of this collection in the Palazzo Altieri earned Haseltine a place in Mary Eliza Haweis's *Beautiful Houses* (New York: Scribner & Wolford, 1882). William Haseltine's own records and Knoedler sales books indicate that the collecting urge began before he left New York.

39. See William Haseltine's accounts for 1864 and 1865, Haseltine/Plowden Family Papers; also Knoedler Sales Book 1: 139, 141, 144, 159. The works listed on page 141 under "Haseltine" appear in the *Catalogue of a Superb Collection of Fine Modern Pictures . . . to be sold at auction by Henry H. Leeds & Miner . . .* (New York, 15-16 February 1866); on page 144 is an account of the pictures actually sold, which, after commissions, netted Haseltine $227.90. Charles Haseltine's first transaction with Knoedler is recorded in Knoedler Sales Book 1: 206; Knoedler Gallery library, New York.

40. Charles entered the University of Pennsylvania in 1855 and left after completing his sophomore year. His business affiliations have been compiled from listings in *Gopsill's Philadelphia City Directory*.

41. Lomas, "History of the Sketch Club," 33-38.

42. Shinn wrote Charles Haseltine from Newport in July 1865, saying "I sit down to assure you of my warm interest in your scheme – S[amuel] P. Avery knows of your plan and will blow it about." Shinn later offered Haseltine cogent advice for successfully managing a second venue in New York. See Lomas, "History of the Sketch Club," 42-44.

43. Charles's second letter read in part, "I request that you will be polite enough to send me *an answer by return of mail* whether you will compete or exhibit, or whether you will not" (circular/letter from Haseltine, unaddressed, 8 September 1865; Philadelphia Sketch Club, Philadelphia). In framing his objec-tions to the prize exhibition, Leutze also revealed a preference for outright pur-chases: "Do you reflect that there may be more than one good picture, nay, many of equal merit, and you being able to give a prize but for one of a class, the rest will be *rejected condemned pictures* in the eyes of the world . . . and how does the

Philadelphia Sketch Club attain the high power to sit in judgment on works of art *publicly*. It would be very different if you would only desire a picture for yourselves as a club. You might exhibit it after your purchase of it to show your very kind good-will and taste in the selection" (Leutze to Haseltine, 11 September 1865; quoted in Lomas, "History of the Sketch Club," 44).

44. "Philadelphia Sketch Club Prize Exhibition," *Watson's Weekly Art Journal* n.s. 4, no. 15 (27 January 1866): 226.

45. "Letters on Landscape Painting, Letter IV" (1855), quoted in John McCoubrey, ed., *American Art, 1700-1960: Sources and Documents* (Englewood Cliffs, N.J.: Prentice-Hall, Inc., 1965), 114. Earlier in this same letter, Durand proclaimed that it would be "better to make shoes, or dig potatoes, or follow any other honest calling to secure a livelihood, than seek the pursuit of Art for the sake of gain.... [W]e cannot serve God and mammon, however specious our garb of hypocrisy; and I would sooner look for figs on thistles than for the higher attributes of Art from one whose ruling motive in its pursuit is money."

46. One such voice was James Jackson Jarves, who expressed concern in 1864 that money might be "a primary motive-power" for American artists: "Not that true artistic ambition does not here exist, but a sudden success, measured by pecuniary gain and sensational effect, is not the most wholesome stimulant for youthful art" (*Art-Idea* [1864; reprint, ed. Benjamin Rowland, Jr., Cambridge, Mass.: The Belknap Press of Harvard University Press, 1960], 190-191). Henry Tuckerman, who recognized America as an "externally prosperous, but socially material republic," complained in 1867 that "the kind of arrangements which bespeak the mart and the stock company ... are resorted to for the promotion of what, in its very nature, demands calm attention, gradual methods, a process and an impulse essentially thoughtful, earnest, and individual. These methods distribute and multiply pictures, but they lower the standard and vulgarize the taste" (*Book of the Artists*, 36-37).

47. Tuckerman, *Book of the Artists*, 36.

48. "City Intelligence. First Annual Prize Exhibition of the Philadelphia Sketch Club," *Philadelphia Inquirer*, 12 December 1865.

49. Lomas, "History of the Sketch Club," 40. To Charles's credit, it must be pointed out his schemes cost the club nothing, and that all deficits were paid from his own pockets.

50. William Haseltine recorded income from "C. F. Haseltine" in the amount of $150 on 3 January and $75 in November 1865 (Haseltine/Plowden Family Papers). At this early date, it is impossible to tell whether Charles purchased these paintings for himself or for resale. The latter sum, at least, may represent one or more of the three paintings by William that appeared for sale in the 1865 Sketch Club exhibition.

51. The very next day, 21 January, Charles bought eleven more paintings from Knoedler, all European, two of which later showed up in the Academy show. These were *Fisherman's Home*, by Camille-Leopold Cabaillot-Lassalle (no. 287), and Robert Schultze, *Surprised at Rest* (no. 37). See Rutledge, *Cumulative Record*, 41; Knoedler Sales Book 1: 206-207, Knoedler Gallery library, New York.

52. See Rutledge, *Cumulative Record*, 93. *Reflecting Love* was first exhibited at the Academy in 1861, its ownership listed as "J. H. Haseltine, For Sale." It continued to be listed as such from 1862-1867.

53. John Taylor Johnston, *Journal of a Trip to Europe with My Family in the Fall of 1868*, unpublished MS, 26. Metropolitan Museum of Art, New York.

54. Nathan Appleton to Arthur Lincoln, 21 July 1899, quoted in *Report of the Secretary of the Class of 1863 of Harvard College, June, 1893, to June, 1903* (Cambridge, Mass.: John Wilson and Son, 1903), 64-65. Appleton assumes that the idea of buying pictures in Europe and sending them to Philadelphia was Albert's, but it was probably Charles's (or maybe William's), since by 1869 William had moved from Paris to Rome, and Charles would have needed another agent in Paris.

55. Charles Haseltine's foreign agencies are listed in several auction catalogues of the 1870s; see, for example, *Catalogue of Mr. Charles F. Haseltine's Collection of Oil Paintings and Aquarelles...*, sales cat. (Philadelphia: The Haseltine Galleries, 17-23 December 1873). Henry Haseltine is listed in the Roman city directory *Guida Monaci* with the address of 30 Via Babuino in 1872, and 29 Via Babuino in 1874 and 1876 (with a studio address in the Vicolo degli Incurabili). On 13 September 1873 the American dealer Samuel P. Avery recorded in his diary a visit to Charles's agency in Paris: "[paid] 5045 f. to Haseltine Rue Blanche." See Madeleine Fidell-Beaufort, Herbert L. Kleinfield, and Jeanne K. Welcher, eds., *The Diaries, 1871-1882 of Samuel P. Avery, Art Dealer* (New York: Arno Press, 1979), 215.

56. Smith, "Haseltine Family."

57. See Lloyd Goodrich, *Thomas Eakins*, 2 vols. (Cambridge, Mass.: Published for the National Gallery of Art, Washington, D.C., by Harvard University Press, 1982), 1: 120, 133, 164; and 2: 47.

58. Yarnall and Gerdts's *Index* includes cross-references to at least four exhibitions to which Charles Haseltine was a major lender – the Chicago Interstate Industrial Exposition of 1874, and the Cincinnati Industrial Expositions of 1873, 1874, 1875. No doubt there were more. While Charles primarily contributed European paintings to these exhibitions, he also offered William's paintings at all of them. And from 1871 to 1887, paintings by William were included in at least eleven of Charles's auction sales. See Chronology, this volume.

59. The following discussion of Charles Haseltine's relations with the Knoedler Gallery depends on a careful review of its sales books from 1867 to 1915. For access to these records, as well as for her generous advice and assistance, I am grateful to Melissa De Medeiros, librarian at the Knoedler Gallery, New York.

60. Montezuma [Montague Marks], "My Note Book," *Art Amateur* 14, no. 6 (May 1886): 122. Marks announced in the first issue of his magazine that it would be his "intent to wage uncompromising war against all art shams and dealers in art shams, without respect to persons" (*Art Amateur* 1, no. 1 [June 1879]: 3). Between January 1885 and September 1887 Marks printed five reproving editorials about Haseltine in his "Note Book."

61. Montezuma [Montague Marks], "My Note Book," *Art Amateur* 16, no. 6 (May 1887): 123; and 17, no. 1 (June 1887): 3.

62. Haseltine was not the only dealer targeted by Marks; in August 1887 he accused several dealers of "winnowing" their holdings at auction: "The Sprague sale, we are told, was 'stuffed' by Vose, of Providence. Comparatively few of the canvases had been owned by Governor Sprague" ("Some New York Picture Sales," *Art Amateur* 17, no. 3 [August 1887]: 70). But Haseltine seems to have drawn particularly frequent and detailed criticism.

63. Charles Haseltine is also listed in the 1873 New York city directory with a

business address for "paintings" at 42 East 14th Street (an address curiously close to that of his brother William's late father-in-law, Charles H. Marshall, Sr., at 38 East 14th). He is listed at that address for only one year, and does not appear again in New York directories until 1887.

64. Daniel Haddock, Jr., it will be recalled, was both cousin and uncle to Charles Haseltine, being the son of Charles's aunt and having married the sister of Charles's mother. Haddock was thirty-four years older than Charles, and his eldest daughter, Mary White Haddock, was born in the same year as Charles (1840). This Mary Haddock married James Carstairs, Jr., and their son, Charles Stewart Carstairs (1865-1928), married Charles's daughter, Esther Holmes Haseltine (1864-1907), in 1885.

65. "C.S. Carstairs, Art Dealer, Dead," *New York Times*, 11 July 1928; Carstairs' obituary was condensed and published in *Art News* 24, no. 38 (14 July 1928): 10. Carstairs' own family was in the whiskey distilling business, so it would seem that, whatever distance might later appear between their social and professional circumstances, Carstairs owed his first break to Charles Haseltine. Carstairs' obituary states that Carstairs "was born in Philadelphia in 1865 and began his business career with a relative, Charles Hazeltine, an art dealer of that city," but provides no other indication of their relationship. Carstairs and Esther Haseltine eventually divorced, yet the Haseltine bond still followed into the next generation; Carroll Carstairs (born 1888) become a dealer for Herbert Haseltine (William's son, born 1877) and the two maintained a friendly relationship. See the Herbert Haseltine correspondence file, Knoedler Gallery library, New York.

66. "Art Treasures Swept by Flames," *Philadelphia Inquirer*, 3 February 1896; "Greatest Fire in Many Years," *Philadelphia Press*, 3 February 1896; "Fire Loss $1,487,450," *Philadelphia Press,* 4 February 1896. Although these accounts do not mention works by William Stanley Haseltine among Charles's inventory, one obituary of the painter indicates that he, too, lost "quite a number of his paintings" in the fire ("Obituary: William Stanley Haseltine," *Philadelphia Public Ledger,* 5 February 1900).

67. "Greatest Fire in Many Years," *Philadelphia Press,* 3 February 1896. Haseltine learned about the Sunday morning fire while he was teaching a Sunday school class, but, as he told the *Press* reporter, "I simply continued on teaching. I am not a fireman and could not do anything to help put the fire out."

68. Plowden, then Miss Haseltine, first availed herself of her uncle's research when she wanted to become a member of the Daughters of the American Revolution. See the letter from Charles Haseltine to Helen Haseltine, Philadelphia, 9 November 1896 (Haseltine/Plowden Family Papers). Charles's genealogical research notes today reside in Philadelphia at the Historical Society of Pennsylvania.

69. Haseltine to Helen Haseltine Plowden, Philadelphia, 8 May 1905; Haseltine/Plowden Family Papers. See also "Haseltine Found Dead in His Rooms," *Philadelphia Inquirer,* which includes a comment that "although [Charles Haseltine's paintings] were repudiated, and for the most part ridiculed, by the general art world, they found a ready sale, many of them, it is said, bringing high prices, from wealthy buyers." Another critic wrote in 1907 that "When [Charles Haseltine] took up the brush several years ago, many of his friends thought it was only a fad with him.... Not so; he seriously contemplated it as a profession....

He tried every subject, but marines and landscapes interested him most, and these have been the more numerous result of his work. I recently paid him a high compliment for the Exhibition of his works. Over 100 pictures were shown at his famous Art Galleries, and ... his versatility was remarkable" (Riter Fitzgerald, "Chas. F. Haseltine: His Masterpiece, 'The Golden Gate' is Now on Exhibition," *Philadelphia Item,* 2 July 1907; clipping filed in the Archives, The Corcoran Gallery of Art, Washington, D.C.). Charles indicates to his niece that he has just taken up painting, but one should note that in 1898 he is listed in the Philadelpia city directory as an "artist."

70. See, for example, letters from Charles Haseltine to William Macbeth dating from 1904 to 1915 (Macbeth Gallery Papers, Archives of American Art, Smithsonian Institution, roll NMC7, frame 350; and roll NMC51, frames 738-743); also the letter from Roland F. Knoedler to Haseltine, 18 March 1911, asking for help in locating the executor of an estate and offering to advance money to Haseltine if a creditor doesn't come up with the funds he owes; Domestic Letter Book, 20 February-April 24 1911, Knoedler Gallery library, New York.

71. Mustered into service in August 1861 with the rank of first lieutenant, John Haseltine was promoted to captain in October 1862. Plowden says that he "took part in twenty-five battles and was wounded at Deep Bottom after three horses had been shot from under him; he served as Chaplain of General Devos Cavalry Post, and it was through his efforts that Confederate graves were first decorated at the National Cemetery in Pettville" (*Haseltine,* 78). His obituary in the *Philadelphia Inquirer* (3 March 1925) says he "served as chaplain of General T. C. Devin Post, No. 363," and that the National Cemetery was "near Pittsville." For details of John Haseltine's military service, see Bates, *History of Pennsylvania Volunteers,* 2: 330.

72. In the 1868 Philadelphia directory, Ward B. Haseltine is listed as the president of two mining companies (Colorado Gold Mining and Pioneer Mining), but he also appears as the treasurer of three others (American Exploring, Monnier Metallurgical, and South Park Gold Mining and Exploring). John White Haseltine is listed as the secretary of those latter three companies; all five concerns shared the same address as 506 Walnut Street. Augustus Heaton, an artist who was Charles Field Haseltine's associate at the Philadelphia Sketch Club (see *fig.6*), served as treasurer of Ward Haseltine's Colorado Gold Mining Company.

73. "Capt. John W. Haseltine: Civil War Veteran and Curio Collector to Be Buried Today," *Philadelphia Inquirer,* 3 March 1925. This obituary states that Haseltine was "in the curio business in New Orleans at the outbreak of the Civil War [and] started North when Fort Sumter was fired upon," but this contradicts his listing in the 1861 Philadelphia city directory. See notes 6 and 7.

74. See *Catalogue of a Large Collection of Bric-a-Brac, Gems, Etc....,* sales cat. (New York: The Messrs. Leavitt, Auctioneers, 18-21 March 1874) and *Catalogue of Antiques & Bric-a-Brac, Consisting Largely of Etruscan Pottery and Statuary...,* sales cat. (New York: The Messrs. Leavitt, Auctioneers, 18-23 June 1874). It is probably not coincidental that these auctions were handled by Leavitt, who in the 1870s also transacted several sales of Charles's "Haseltine Collection."

75. *Description of the Paper Money Issued by the Continental Congress of the United States and the Several Colonies* (Philadelphia: John W. Haseltine, 1872).

Haseltine was assisted in this effort by John C. Browne, a member of a prominent Philadelphia banking family; the pamphlet includes reproductions in "photozincograph" by F. A. Wenderoth.

76. For example, the *Catalogue of Several Invoices of Coins, Medals, Colonials, etc.* . . . (Philadelphia: Messrs. T. Birch & Sons, February 1878), with its "catalogue by J. W. Haseltine"; or the *Catalogue of a . . . Collection of United States and Foreign Coins, Medals . . . , etc., gleaned from . . . cabinets purchased by J. W. Haseltine* (New York: Messrs. Bangs & Co., 24-25 June 1880).

77. "Capt. John W. Haseltine," *Philadelphia Inquirer*.

78. William Stanley Haseltine to Albert Haseltine, Meyringen, 9 September [1856]. Haseltine/Plowden Family Papers.

79. *Report of the Secretary of the Class of 1863 of Harvard College, June, 1863, to June 1888* (Cambridge, Mass.: John Wilson and Son, 1888), 101. New York city directories first list Albert C. Haseltine as a broker in 1867; the 1868 and 1869 directories also list "Fearing & Haseltine, brokers, 51 Exchange pl." Philadelphia directories for 1865 and 1866 list Albert as a salesman with the same business address as his brother Charles; the 1866 address (240 Chestnut) is that of the dry-goods commission merchant John H. Williams & Co., with whom Charles Haseltine had formed a partnership.

80. Knoedler Sales Book 1: 210 (4 February 1867); Knoedler Gallery library, New York. William's own account books record a payment of $2,500 received from "A.C.H." on 15 September 1868 (Haseltine/Plowden Family Papers).

81. [The Century Association], *The Century, 1847-1946* (New York: The Century Association, 1947), 382; a photograph of Albert is reproduced in *The Century*. For the Harvard Clubs, see Nathan Appleton to Arthur Lincoln, 21 July 1899; quoted in *Report of the Class of 1863, 1893-1903*, 64. Appleton recalled visiting the Harvard Club in New York "during the winter of 1865-66, or perhaps 1867-68, when the meetings were held way up in the building of Clark's restaurant, Broadway."

82. *Report of the Class of 1863, 1893-1903*, 65.

83. Boit to Arthur Lincoln, Vallombrosa, 13 July 1899; quoted in *Report of the Class of 1863, 1893-1903*, 62. A class report published in 1888 mentions that Charles "is now in Paris, associated with the house of M. Georges Petit," so Boit's estimate of "ten years ago or thereabouts" was accurate. See *Report of the Class of 1863, 1863-1888*, 101.

84. Boit, in *Report of the Class of 1863, 1893-1903*, 62.

85. Appleton, in *Report of the Class of 1863, 1893-1903*, 65.

86. Amos Lawrence Mason to Arthur Lincoln, [no date], quoted in *Report of the Class of 1863, 1893-1903*, 66.

87. See letters from Boit and Appleton, quoted in *Report of the Class of 1863, 1893-1903*, 62-66.

88. Boit, in *Report of the Class of 1863, 1893-1903*, 64.

Catalogue of the Exhibition

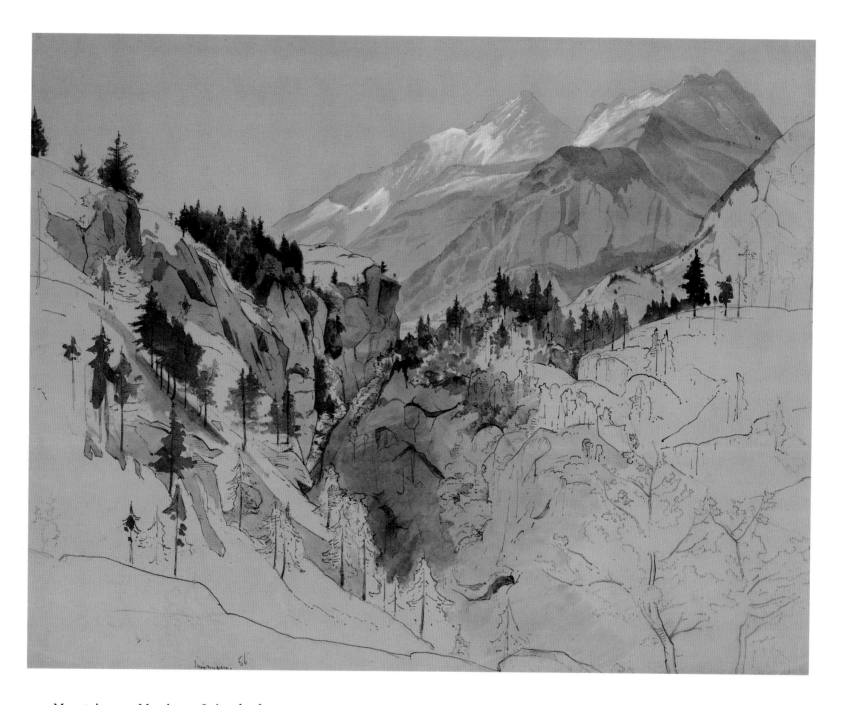

1 **Mountains near Meyringen, Switzerland,** 1856
Ink, wash, and gouache over graphite on brown paper, 17⅜ x 22¾ in.
Inscribed lower left: *Meyringen – 56*
Cooper-Hewitt, National Museum of Design, Smithsonian Institution
Given by Mrs. Roger H. Plowden (Mrs. Helen Haseltine Plowden) (1969-121-50)

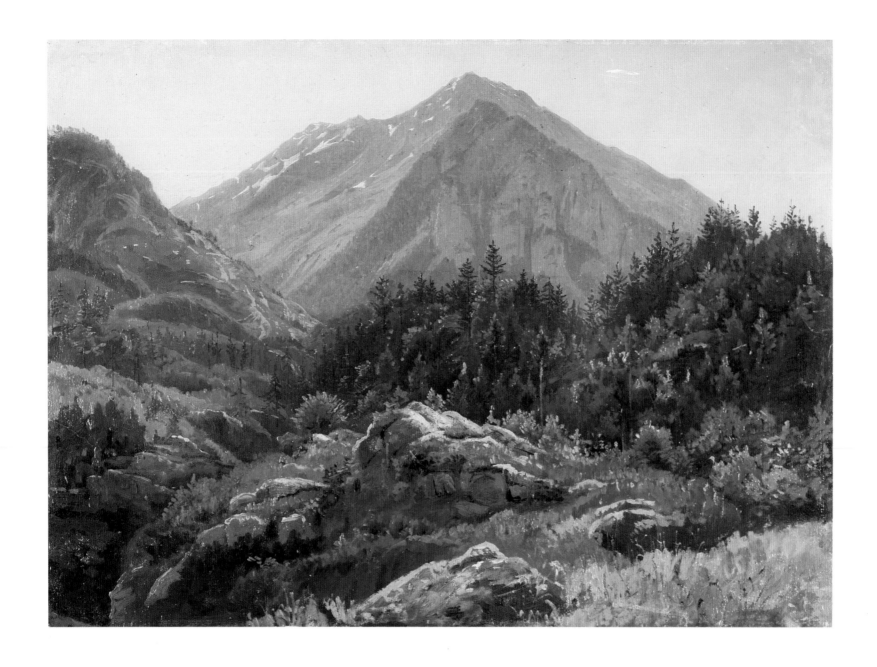

2 **Mountain Scenery, Switzerland**, ca. 1856
Oil on paper, mounted to canvas, 13½ x 19 in.
The William Benton Museum of Art,
The University of Connecticut, Storrs (1955.7)

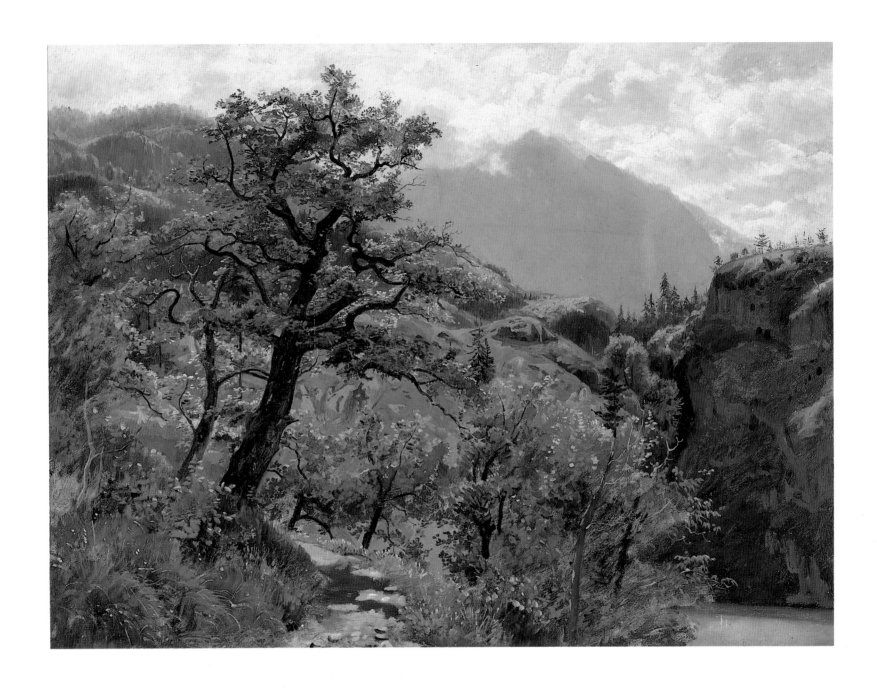

3 **Schwyz near Brunnen**, ca. 1856
Oil on paper, mounted to canvas, 16 7/16 x 22¼ in.
The Saint Louis Art Museum. Gift of Mrs. Helen Haseltine Plowden
through the National Academy of Design, New York (234:1961)

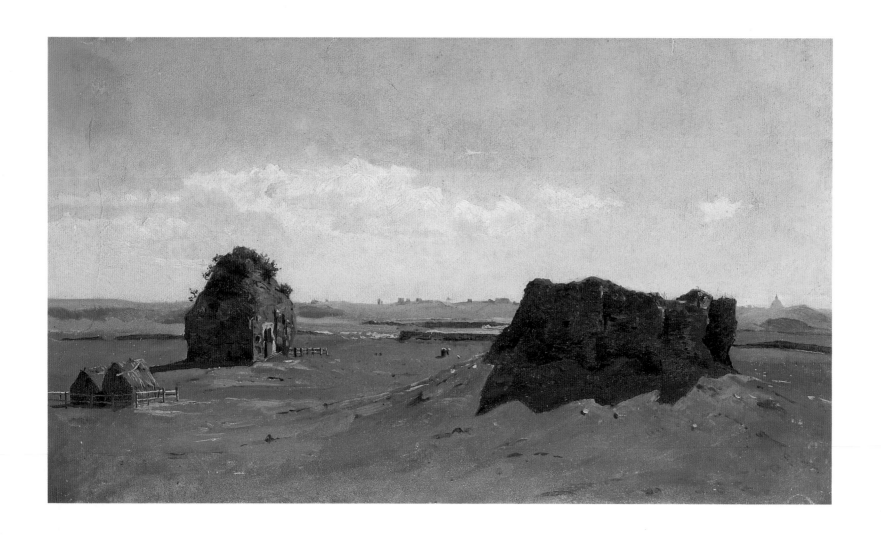

4 **Torre degli Schiavi, Campagna Romana**, ca. 1857/58
Oil on paper, mounted to canvas, 13¾ x 19½ in.
North Carolina Museum of Art, Raleigh
Gift of Helen Haseltine Plowden,
in memory of W.R.Valentiner (G59.16.1)

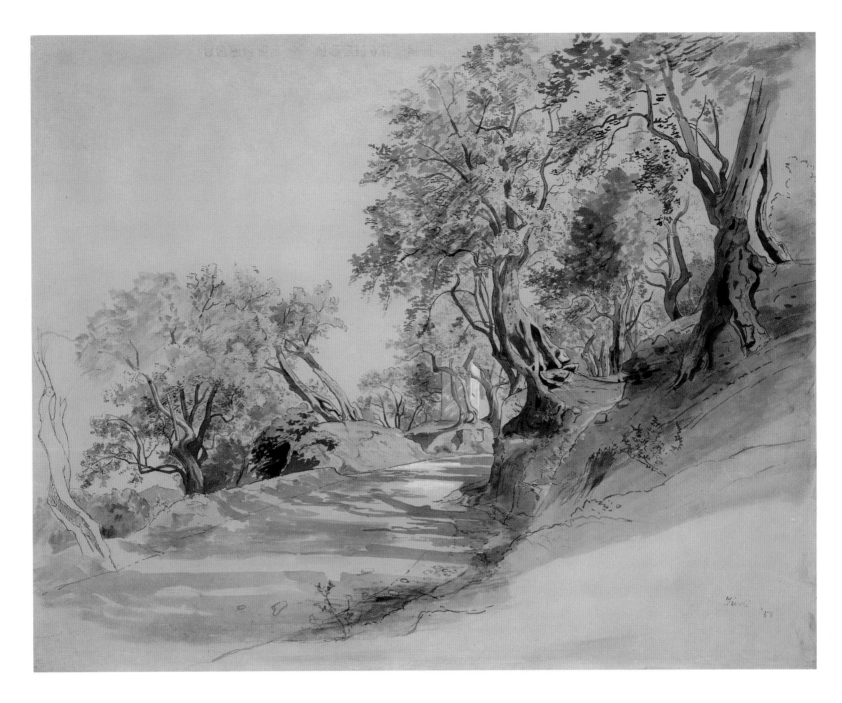

5 **Tivoli**, 1858
Watercolor, ink, wash, and gouache over graphite on beige paper, 18½ x 23¹¹⁄₁₆ in.
Inscribed lower right: *Tivoli/'58*
Lent by The Metropolitan Museum of Art, New York
Gift of Mrs. Roger Plowden, 1967 (67.173.3)

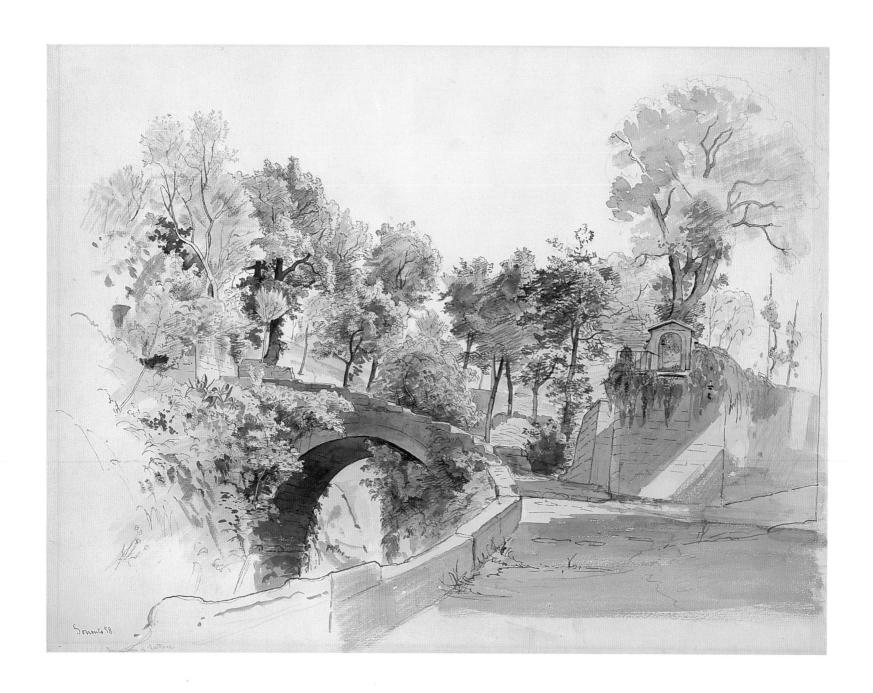

6 **Sorrento**, 1858
Watercolor, ink, and wash over graphite on paper, mounted to board, 18½ x 23½ in.
Inscribed lower left: *Sorrento 58/Mountains in distance*
Krannert Art Museum and Kinkead Pavilion, University of Illinois, Champaign
Gift of Mrs. Helen Haseltine Plowden, 1961 (61.16.1)

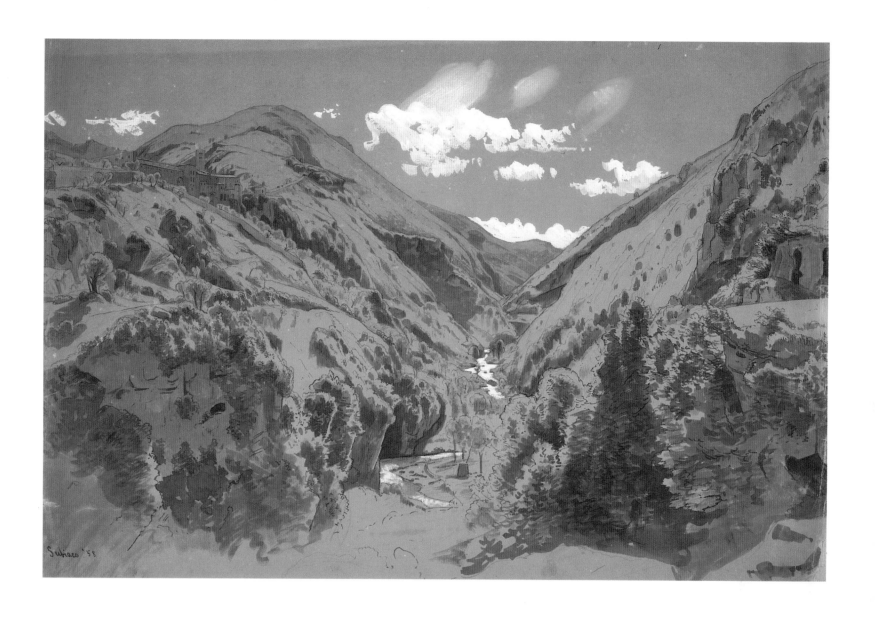

7 **Subiaco #2,** 1858
Ink, wash, and gouache over graphite on brown paper, 17½ x 26 in. (sight)
Inscribed lower left: *Subiaco '58*
Portsmouth Abbey, Portsmouth, Rhode Island
Gift of Helen Haseltine Plowden

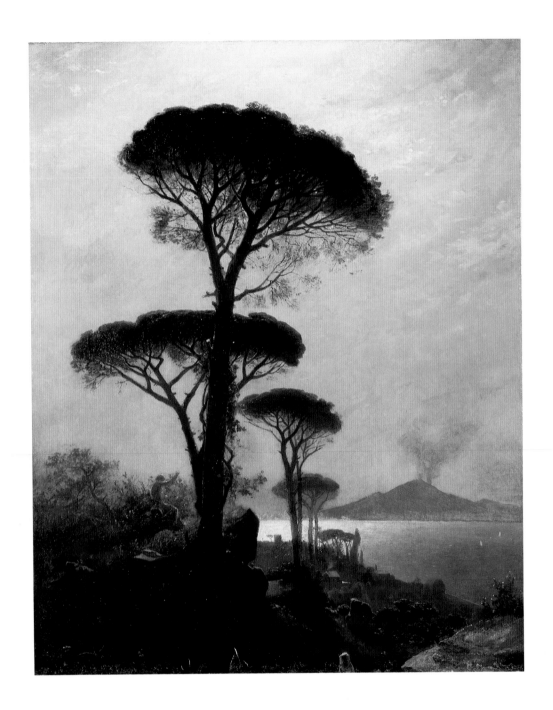

8 **The Bay of Naples**, ca. 1858
Oil on canvas, 30½ x 25½ in.
Inscribed lower left: *W.S.HASELTINE*
Davenport Museum of Art, Iowa
Gift of Charles August Ficke (25.131)

Along New England's Shore, 1859–1865

9 **New England Landscape**, ca. 1859

Ink, wash, and gouache over graphite on tan paper, 15 x 21½ in.

Inscribed lower right: *W.S.H.*

Ben Ali Haggin, New York

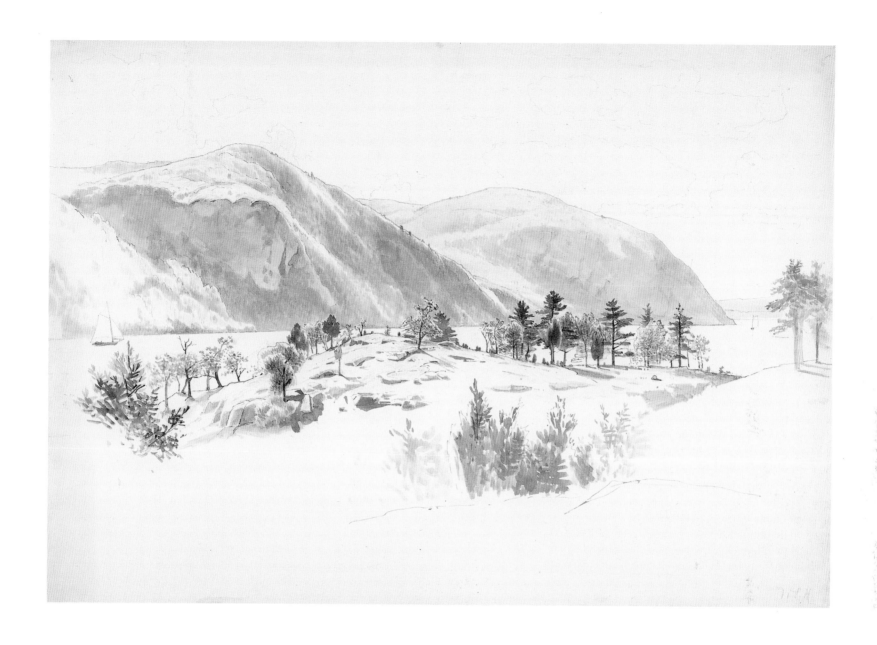

10 **Eagle Cliff from Northeast Harbor across Somes Sound**, ca. 1859
Ink and wash over graphite on gray-green paper, 15 x 21½ in.
Inscribed lower right: *W.S.H.*
The Art Museum, Princeton University. Museum purchase,
gift of Miss Dorothy Willard by exchange (x1988-138)

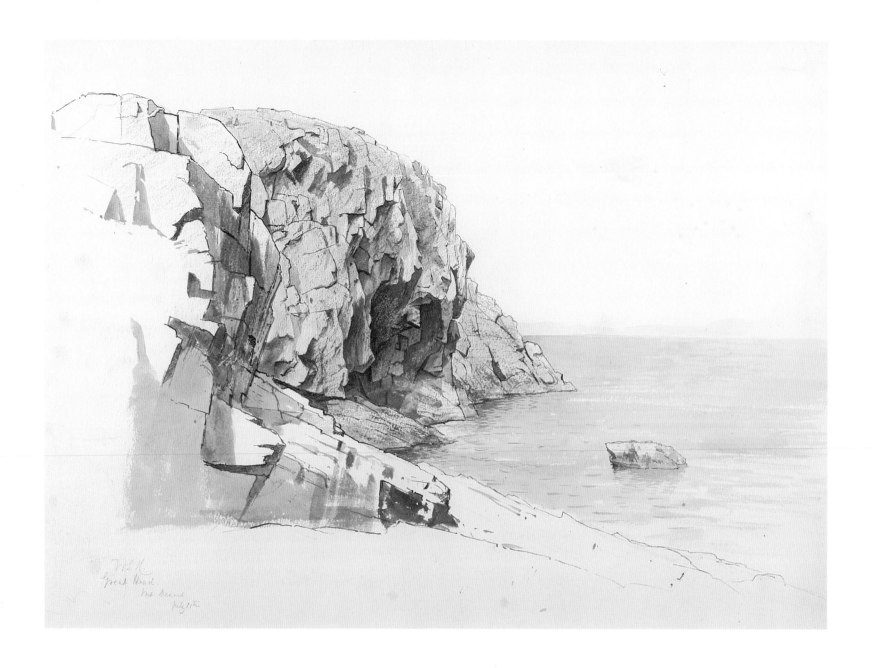

11 **Great Head, Mount Desert**, ca. 1859
Ink and wash over graphite on paper, 15 x 21¾ in.
Inscribed lower left: *W.S.H./Great Head/Mt Desert/July 11th*
Ben Ali Haggin, New York

84

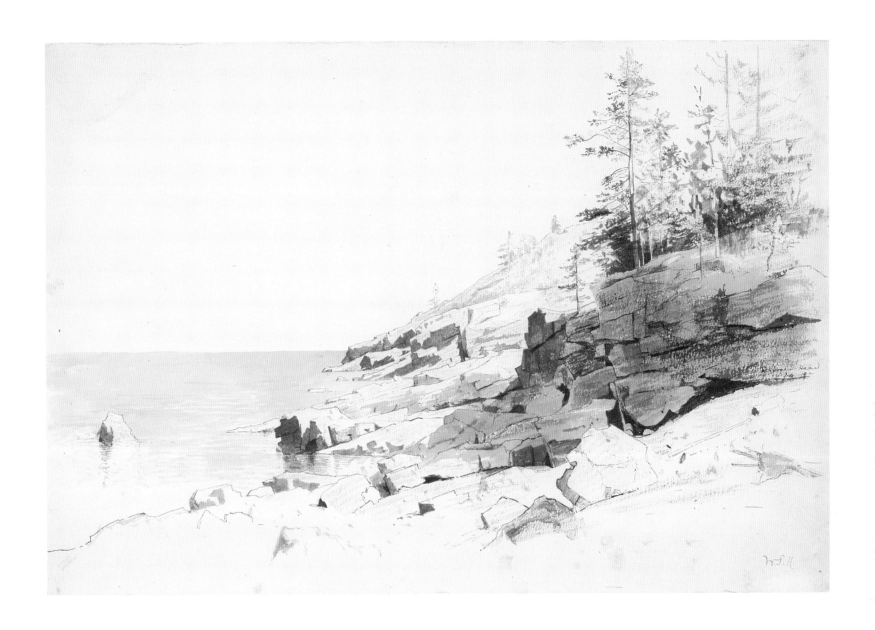

12 **Schooner Head, Mount Desert,** ca. 1859
Ink and wash over graphite on paper, 14⅞ x 22 in.
Inscribed lower right: *W.S.H.*; center right:
Schooner Head/July 19 [written-over *18*]
Private collection, New York

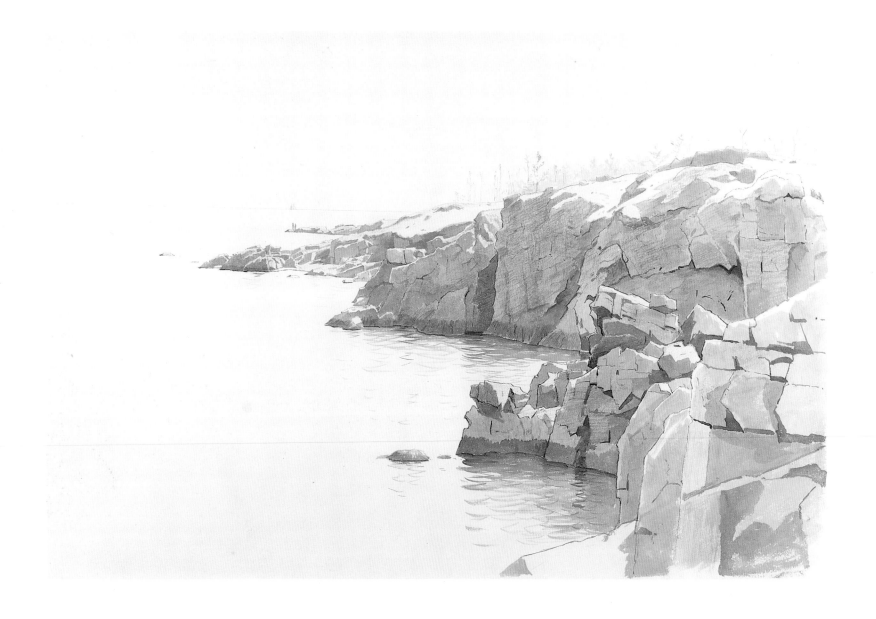

13 **Near Otter Cliffs, Mount Desert,** ca. 1859
Ink and wash over graphite on paper, 15¼ x 22⅛ in.
Inscribed lower right: *W.S.H.*
Ben Ali Haggin, New York

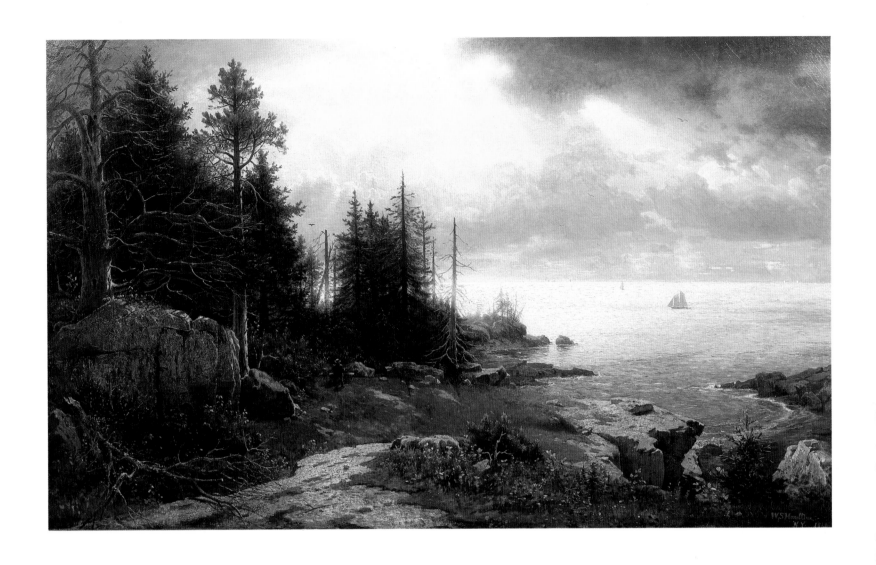

14 **A View from Mount Desert**, 1861
[originally shown as **Mt. Desert Island**]
Oil on canvas, 30 x 50 in.
Inscribed lower right: *W.S. Haseltine/N.Y. 1861*
Private collection

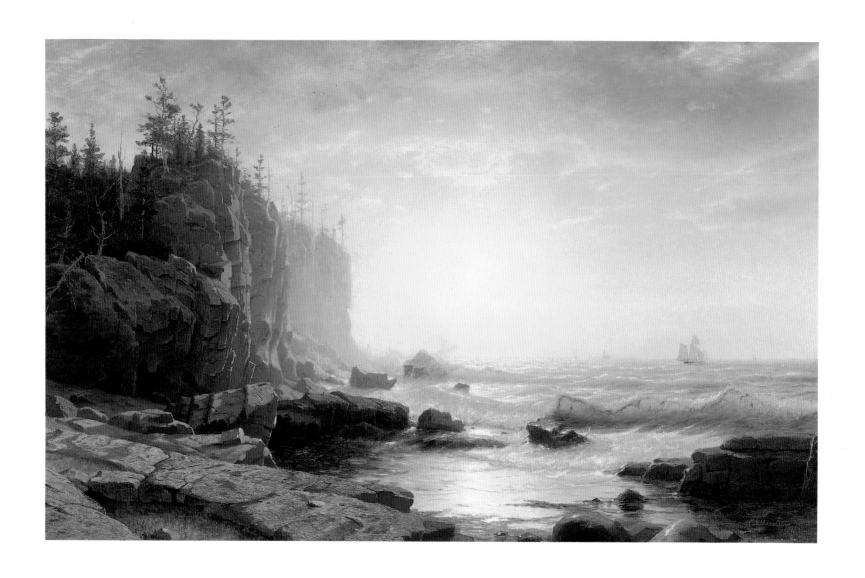

15 **Iron-Bound, Coast of Maine,** 1864
Oil on canvas, 20 x 32 in.
Inscribed lower right: *W.S. Haseltine/1864*
Private collection

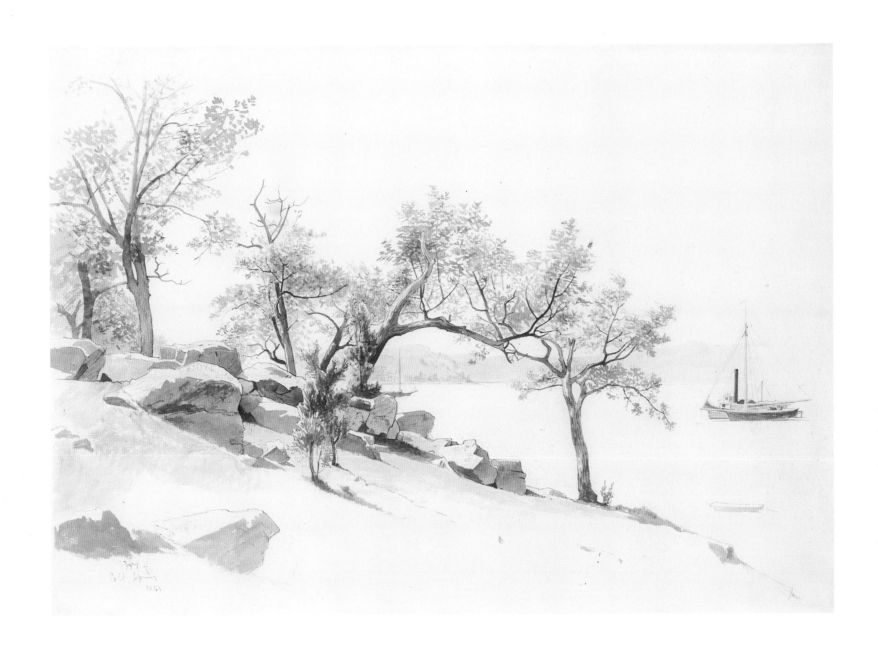

16 **Cold Spring,** 1861
Ink and wash over graphite on paper, 12½ x 21¼ in. (sight)
Inscribed lower left: *W.S.H./Cold Spring/1861*
David Nisinson

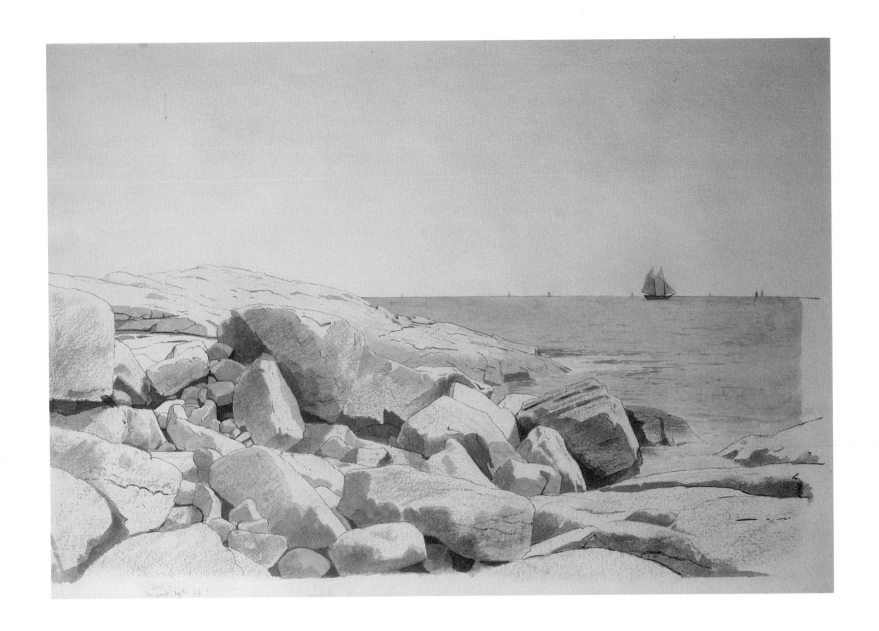

17　**Rocky Shore with Schooner in Distance**, 1862
Ink and wash over graphite on paper, 15¼ x 22¹⁄₁₆ in.
Inscribed lower left: *W.S.H./August 14th 62*
Private collection

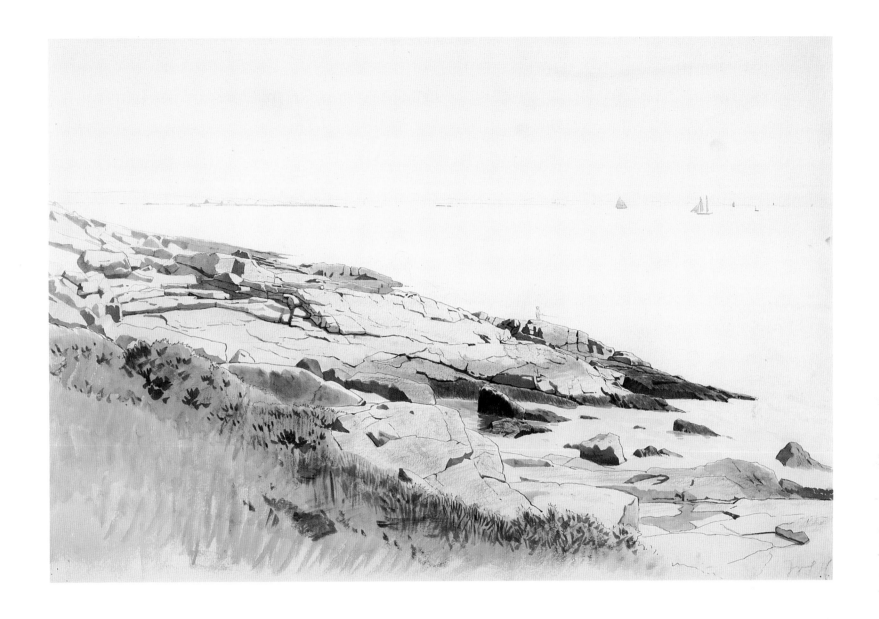

18 **Coastline, Narragansett, Rhode Island**, ca. 1862/63
Watercolor, ink, and wash over graphite on paper, 15⅛ x 22⅛ in.
Inscribed lower right: *WS.H.*
Daniel J. Terra Collection, Terra Museum of American Art, Chicago (16.1983)

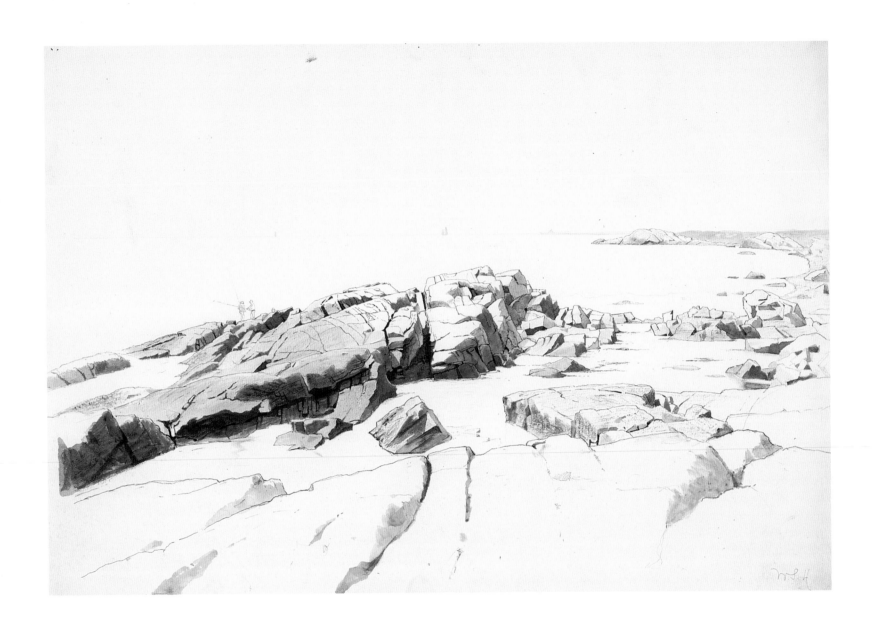

19 **Indian Rock, Narragansett Bay,** ca. 1862/63
Ink and wash over graphite on paper, 15⁵/₁₆ x 22 in.
Inscribed lower right: *W.S.H.*
Amon Carter Museum, Fort Worth, Texas (1983.133)

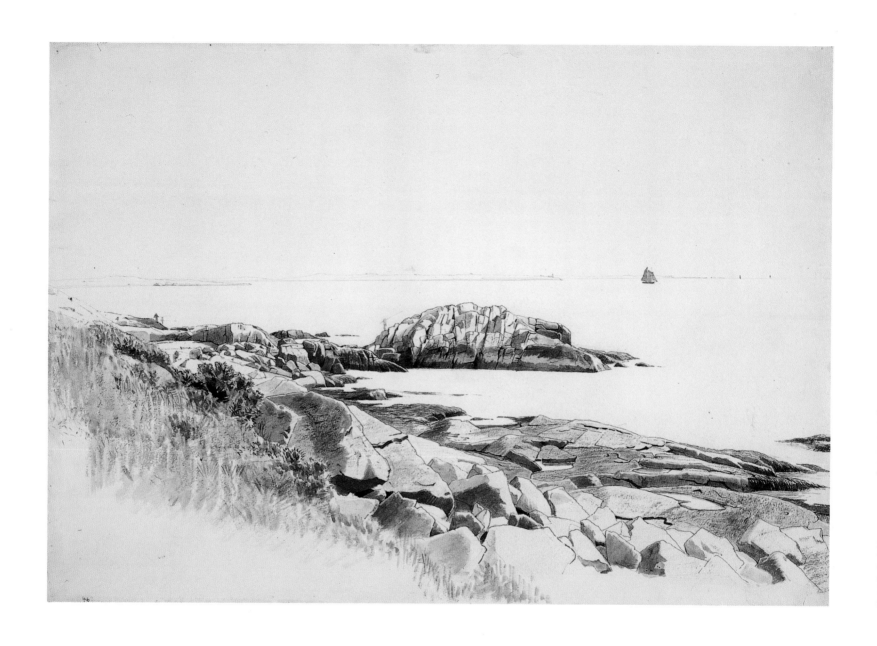

20 **Indian Rock, Narragansett,** ca. 1862/63
Ink and wash over graphite on paper, 15⅛ x 22⅛ in.
Museum of Fine Arts, Boston. M. and M. Karolik Collection (55.750)

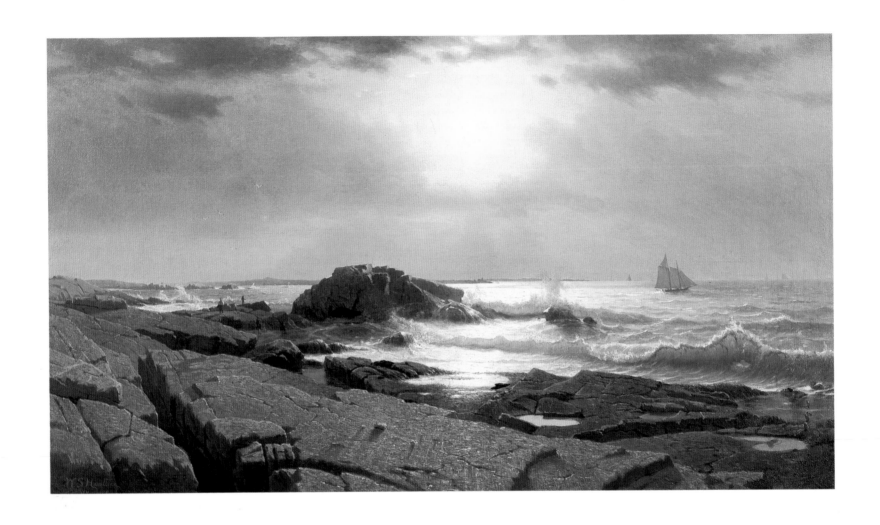

21 **Indian Rock, Narragansett**, 1863
[originally shown as **Indian Rock**]
Oil on canvas, 22 x 38 in.
Inscribed lower left: *W. S. Haseltine/NY 1863*
Private collection

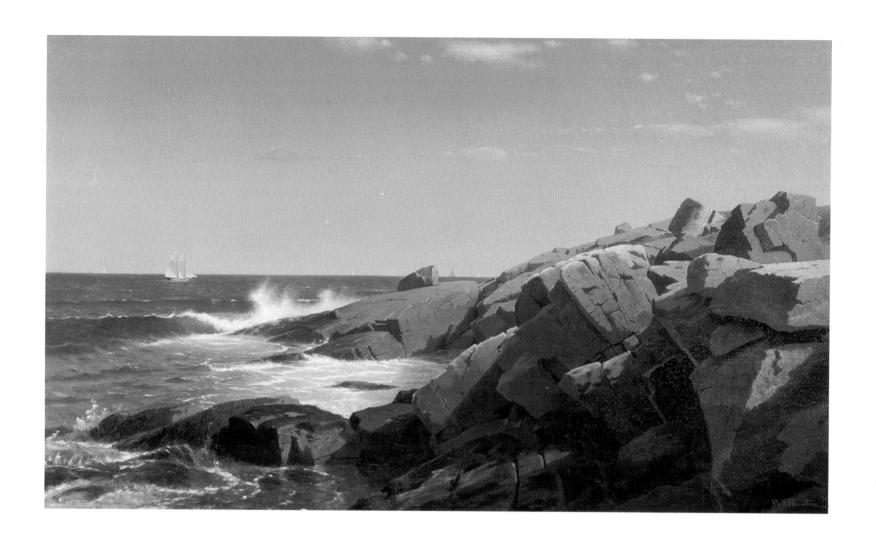

22 Indian Rock, Narragansett, Rhode Island, 1863
Oil on canvas, 22 x 38¼ in.
Inscribed lower right: *W.S. Haseltine N.Y/1863*
The Fine Arts Museums of San Francisco. Museum purchase,
Roscoe and Margaret Oakes Income Fund (1985.28)

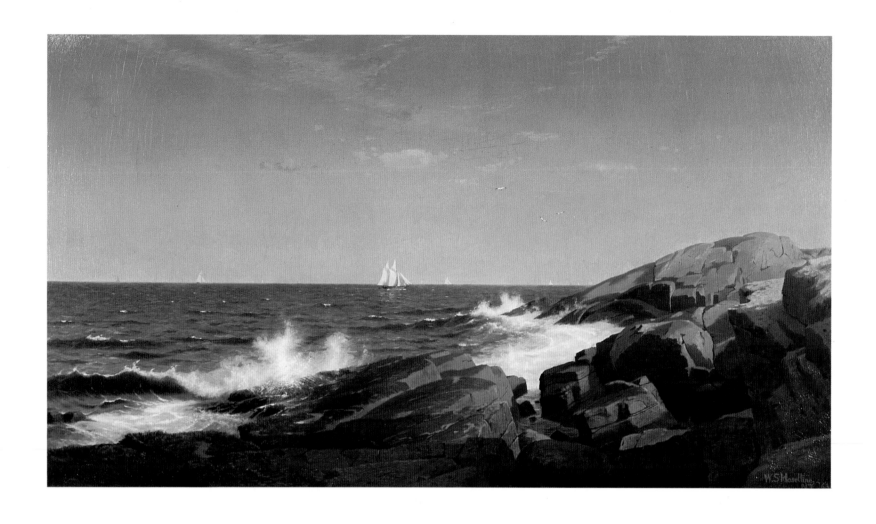

23 **Rocks at Narragansett**, 1863 [also known as **Rocks at Nahant**]
Oil on canvas, 21¾ x 39¾ in.
Inscribed lower right: *W.S. Haseltine/NY '63*
Henry Melville Fuller

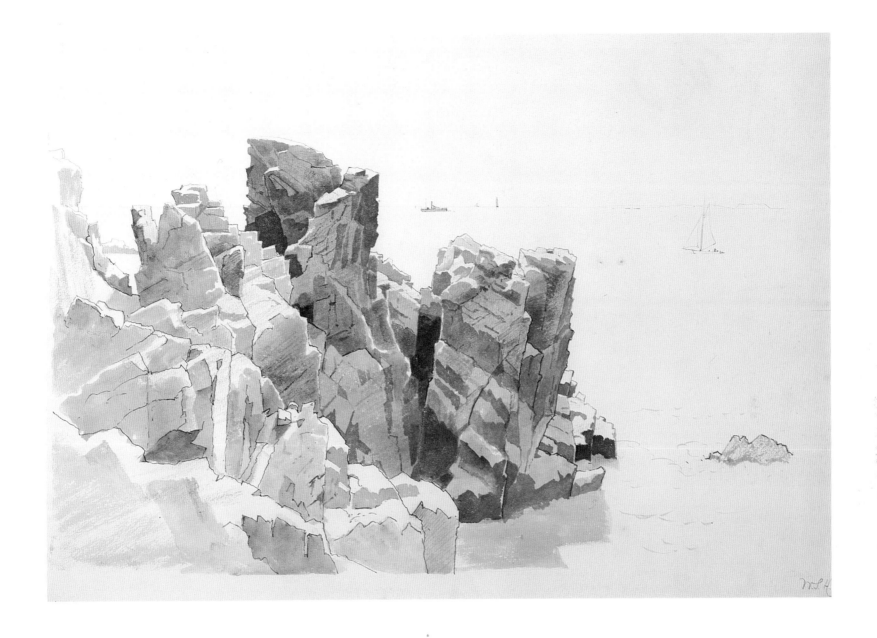

24 **Rocky Coastline, New England** [East Point, Nahant], ca. 1864
Ink and wash over graphite on paper, 15 x 22¼ in.
Inscribed lower right: *W.S.H.*
The Carnegie Museum of Art, Pittsburgh
Museum purchase, gift of the Robert S. Waters Charitable Trust (83.34)

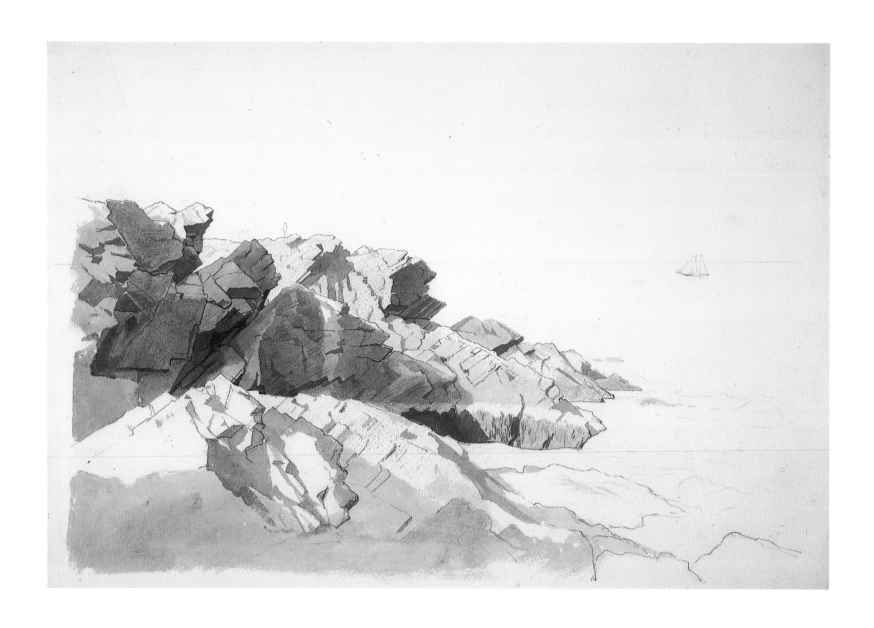

25 **New England Coast** [East Point, Nahant], ca. 1864
Ink and wash over graphite on paper, 14½ x 20½ in.
Walker Art Center, Minneapolis
Gift of Mrs. Helen Haseltine Plowden, 1961 (61.18)

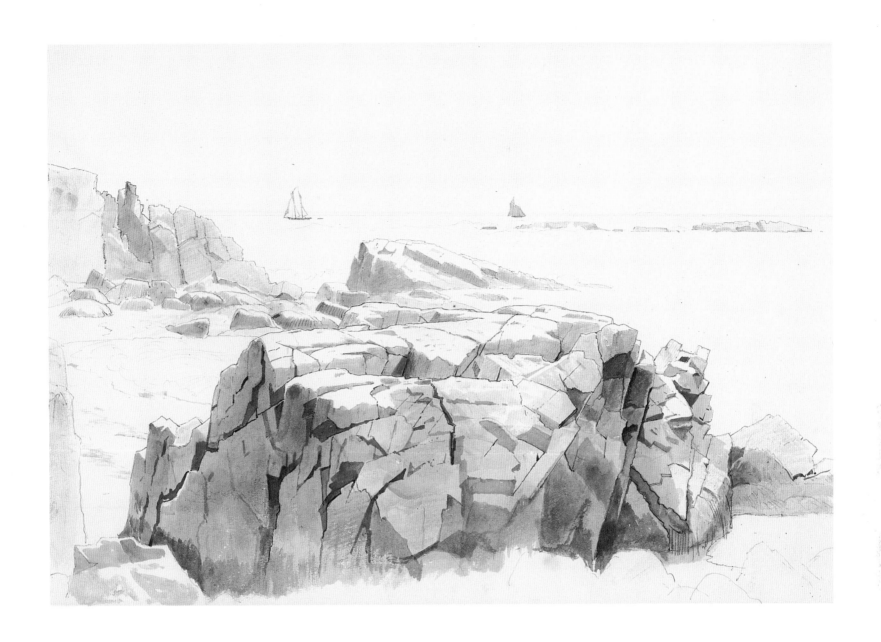

26 **Shag Rocks, Nahant,** ca. 1864
Ink and wash over graphite on paper, 15⅜ x 22¹³/₁₆ in.
The Corcoran Gallery of Art, Washington, D.C.
Gift of Helen Haseltine Plowden, daughter of the artist, 1954 (54.7)

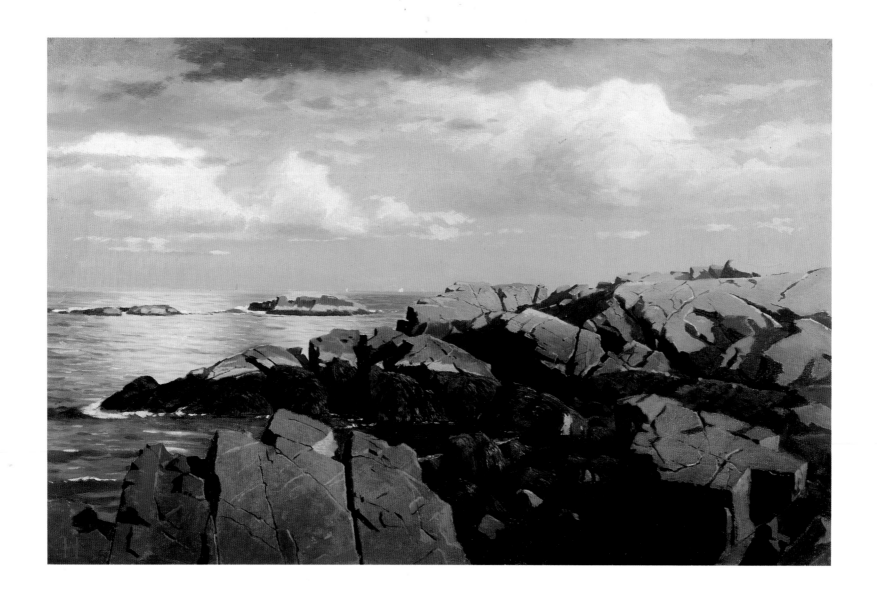

27 **After a Shower, Nahant, Massachusetts** [Shag Rocks], ca. 1864
Oil on canvas, 14⅞ x 23 in.
Inscribed lower left: *WSH* [in monogram]
The Brooklyn Museum. Gift of Mrs. Helen H. Plowden (48.197)

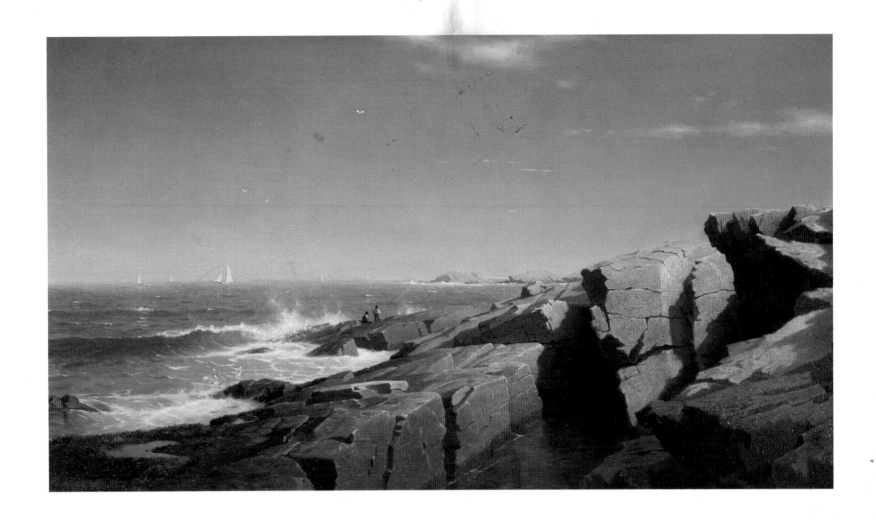

28 **Rocks at Nahant**, 1864
Oil on canvas, 22⅛ x 40⅛ in.
Inscribed lower left: *W.S. Haseltine 1864*
The Brooklyn Museum. Dick S. Ramsay Fund
and A. Augustus Healy Funds (82.86)

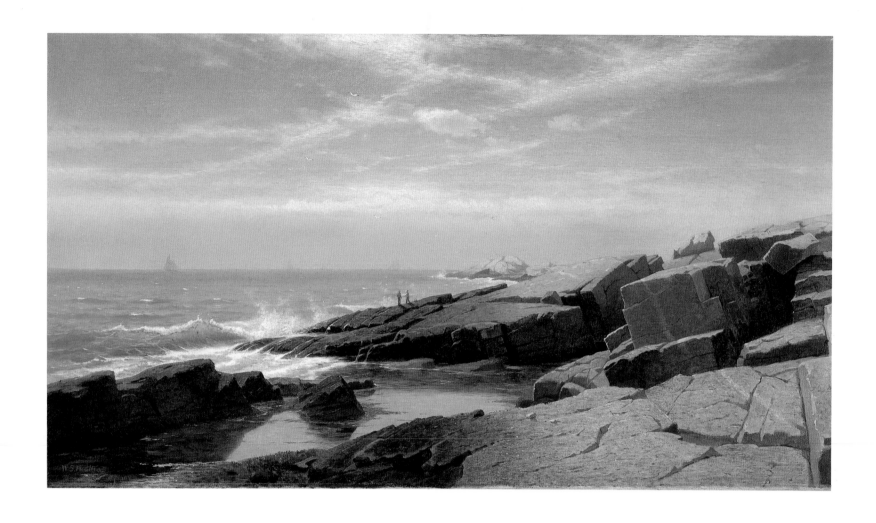

29 **Rocks at Nahant**, 1864
Oil on canvas, 22⅜ x 40½ in.
Inscribed lower left: *W.S. Haseltine/N.Y. 1864*
Daniel J. Terra Collection, Terra Museum of American Art,
Chicago (2.1983)

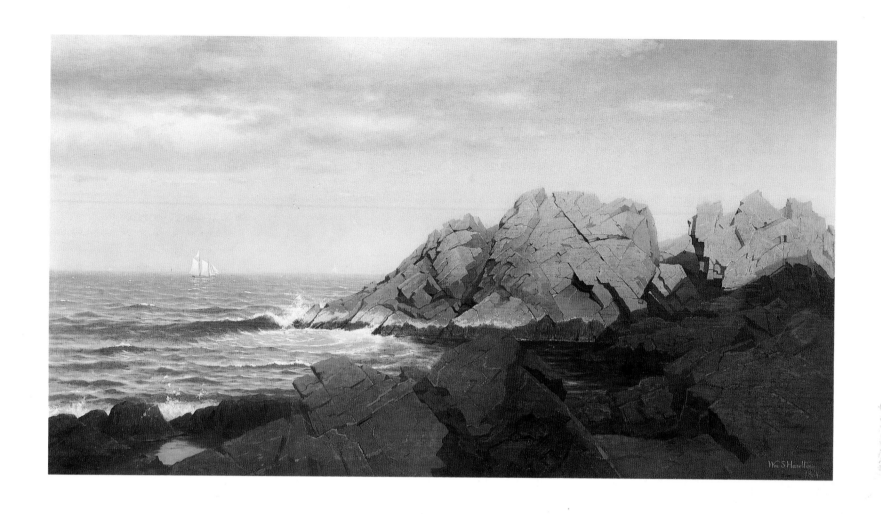

30 **Rocks at Nahant**, 1864
Oil on canvas, 23 x 40 in.
Inscribed lower right: *Wm S Haseltine/1864*
D. Wigmore Fine Art, Inc., New York

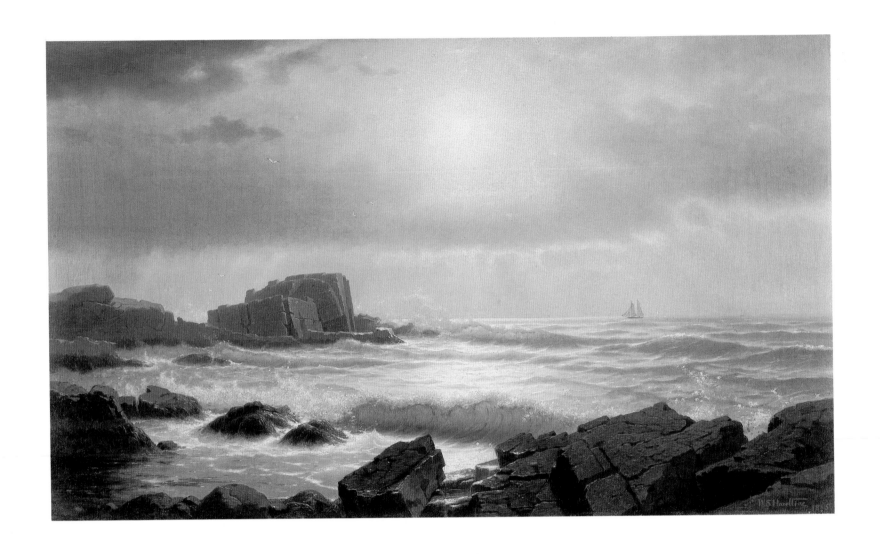

31 **Rocks at Nahant** [Castle Rock], 1865
Oil on canvas, 20½ x 34¼ in.
Inscribed lower right: *W.S. Haseltine/1865*
The Mariners' Museum, Newport News, Virginia

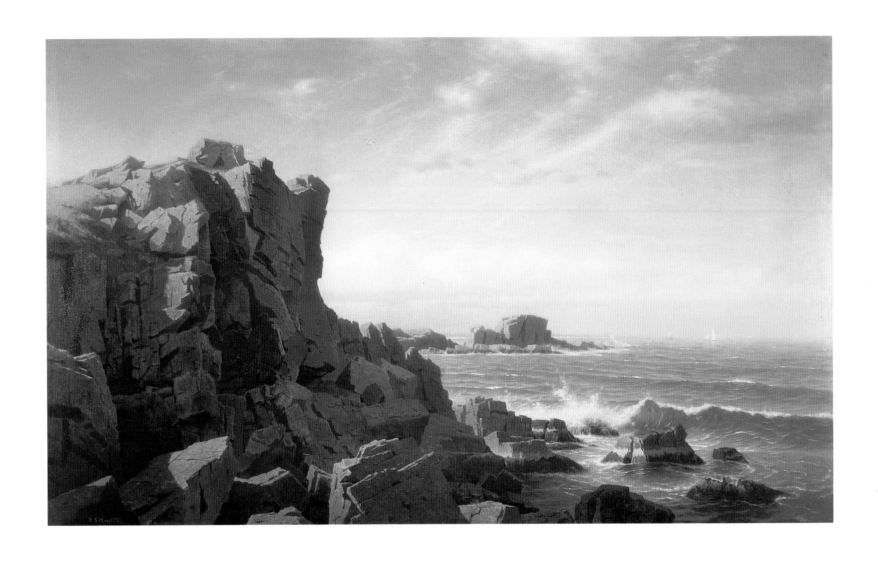

32 **Nahant Rocks**, 1865
[originally shown as **Castle Rock, Nahant**]
Oil on canvas, 36 x 60 in.
Inscribed lower left: *W.S. Haseltine/1865*
Julian Wencel Rymar

The Return to Europe
France, Holland, & Northern Italy, 1867–1883

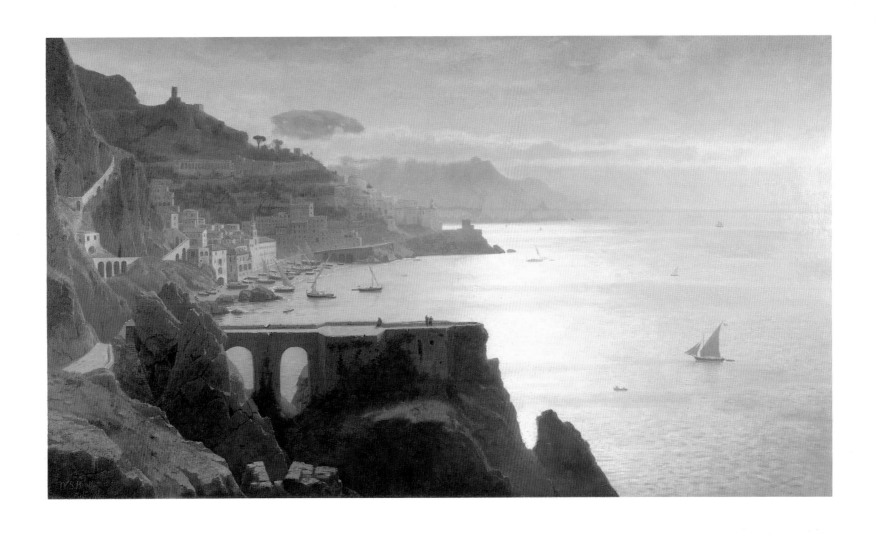

33 **Amalfi Coast,** 1867
Oil on canvas, 32 x 55 in.
Inscribed lower left: *W.S. Haseltine/Paris 1867*
Collection of the Mellon Bank Corporation, Pittsburgh

34 In the Appenines, ca. 1870
Watercolor and gouache over graphite on blue-gray paper, 15³⁄₁₆ x 22¹⁄₁₆ in.
Cincinnati Art Museum. Gift of Helen Haseltine Plowden (1952.190)

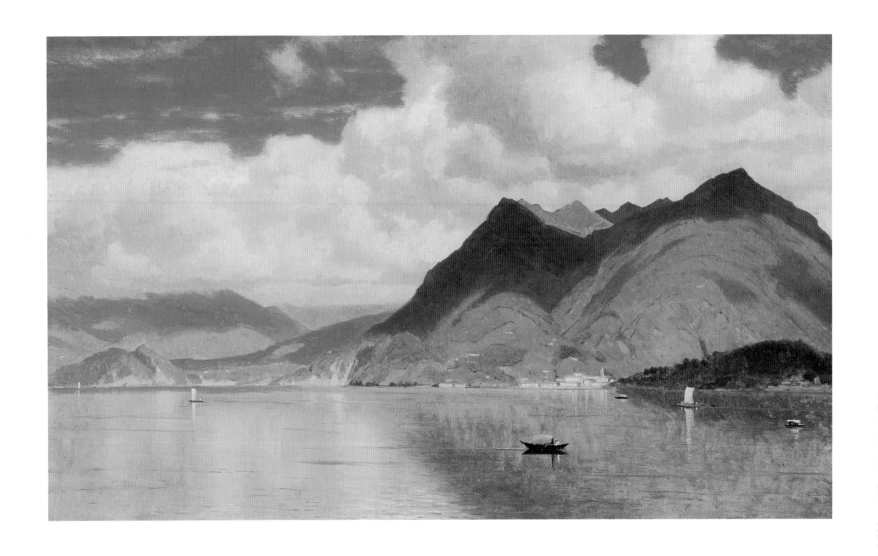

35 **Lago Maggiore,** ca. 1867
Oil on canvas, 13⅞x 22½ in.
National Museum of American Art, Smithsonian Institution
Gift of Mrs. Roger Plowden (1953.13)

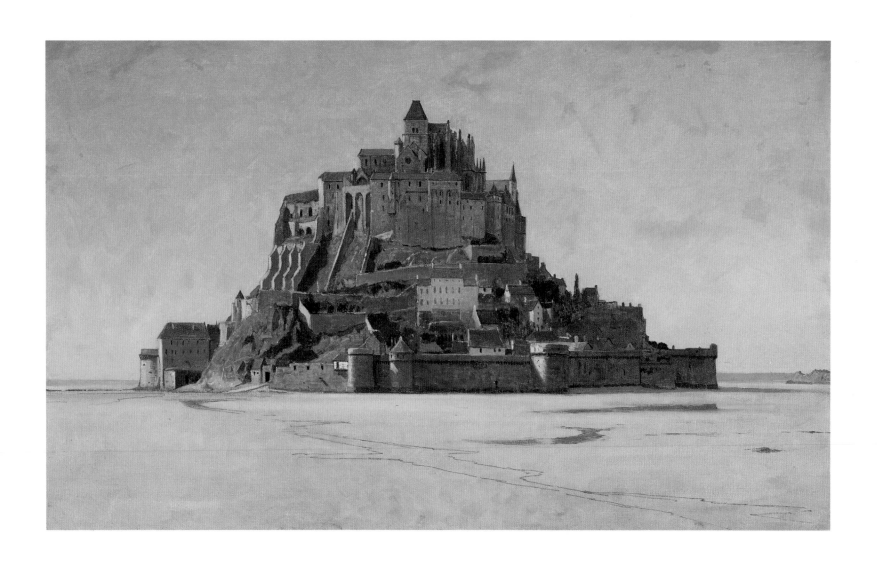

36 **Mont Saint Michel**, ca. 1868
Oil on canvas, 13¾ x 22¾ in.
The Fine Arts Museums of San Francisco
Mildred Anna Williams Collection (1964.1)

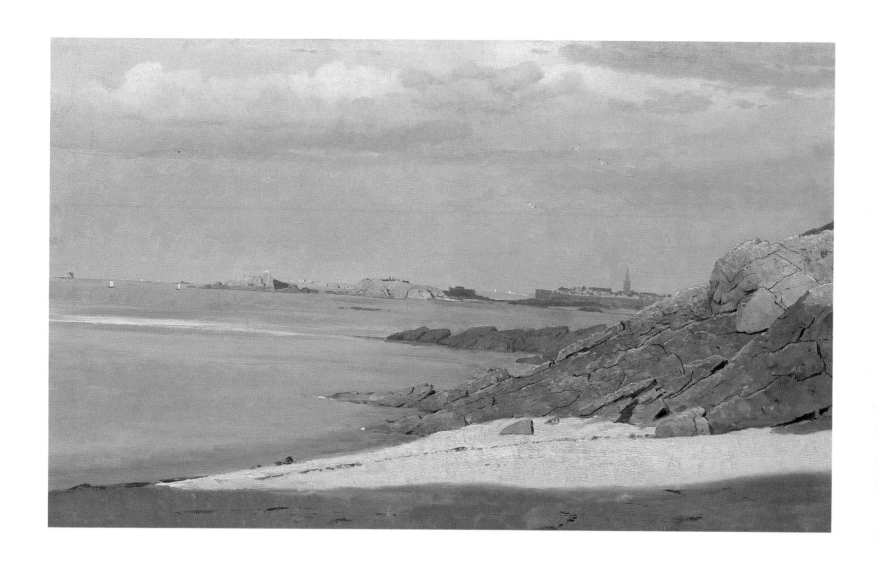

37 **Saint Mâlo, Brittany**, ca. 1868
Oil on canvas, 13¾ x 22⅞ in.
Lent by Mr. Graham Williford

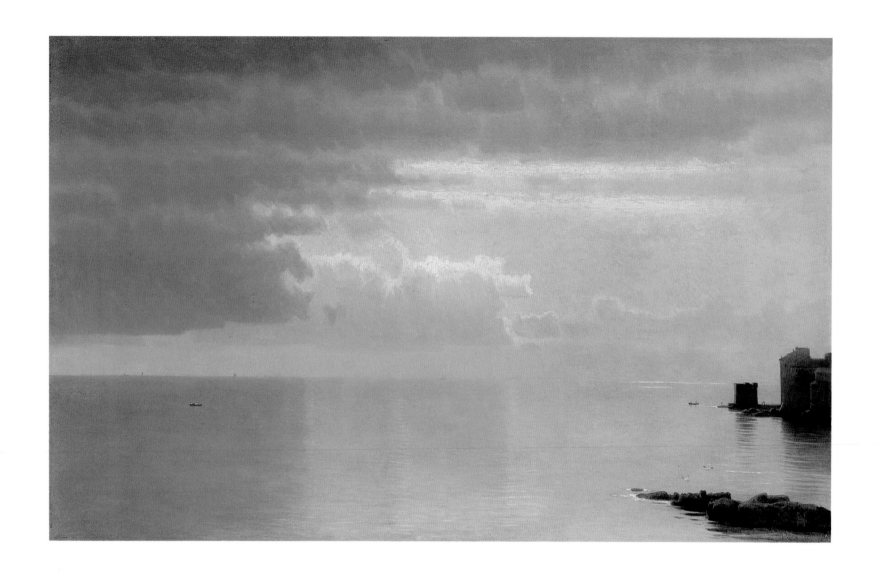

38 **A Calm Sea, Mentone**, ca. 1868
Oil on canvas, 20 x 32 in.
Inscribed lower right: *WSH* [in monogram]
Rob and Mary Joan Leith

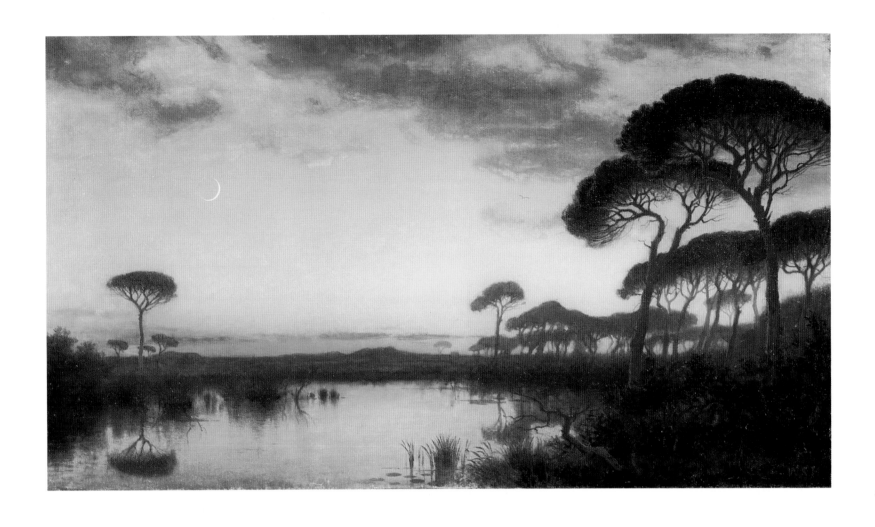

39 **Sunset Glow, Roman Campagna**, ca. 1875
Oil on canvas, 14 x 25 in.
Inscribed lower right: *W.S.H.*
American Express Company

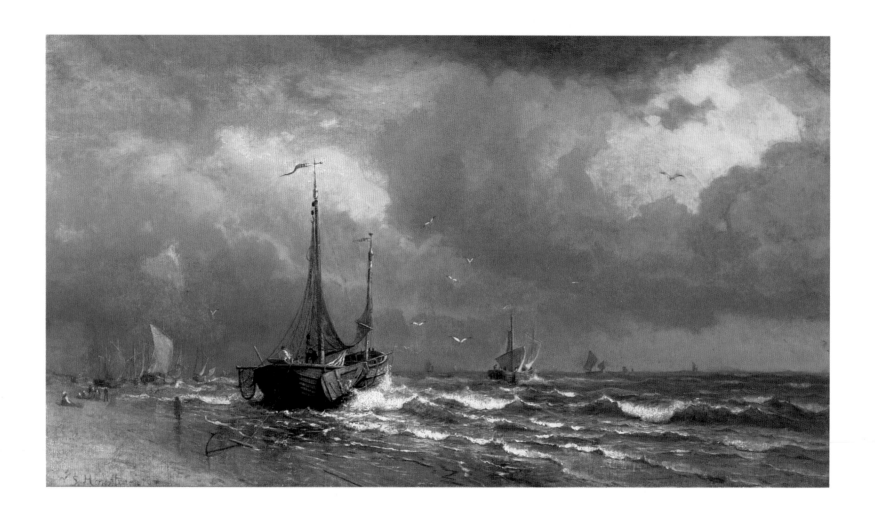

40 **Dutch Coast,** 1883
Oil on canvas, 14 x 25 in.
Inscribed lower left: *W.S. Haseltine 83*
The Currier Gallery of Art, Manchester, New Hampshire
Gift of Helen Haseltine Plowden (1953.1)

41 **Natural Arch, Capri**, ca. 1865
Watercolor, ink, and wash over graphite on paper, 14½ x 20½ in.
The Georgia Museum of Art, The University of Georgia, Athens
Gift of Mrs. Helen Plowden, courtesy of the National Academy of Design,
New York (61.767)

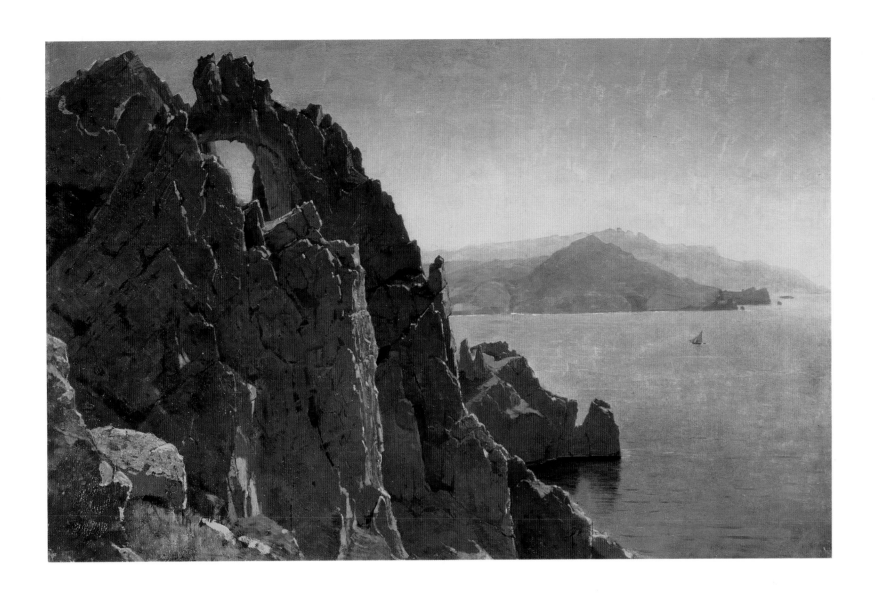

42 **Natural Arch, Capri,** ca. 1870
Oil on canvas, 15 x 23 in.
Smith College Museum of Art, Northampton, Massachusetts
Gift of Helen Haseltine Plowden (Mrs. Roger H. Plowden) (1952:4)

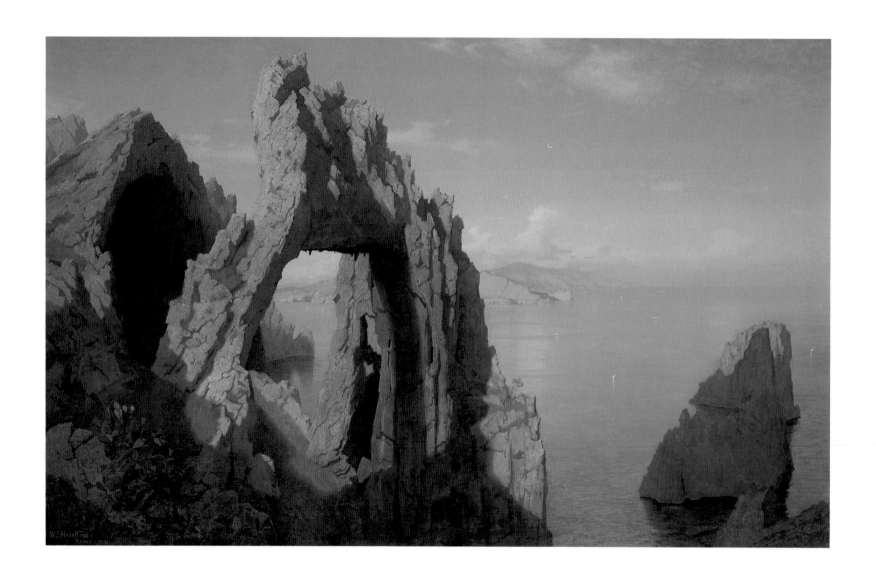

43 **Natural Arch at Capri,** 1871
Oil on canvas, 34 x 55 in.
Inscribed lower left: *W.S. Haseltine/Rome. 1871.*
National Gallery of Art, Washington, D.C.
Gift of Guest Services, Inc. (1989.13.1)

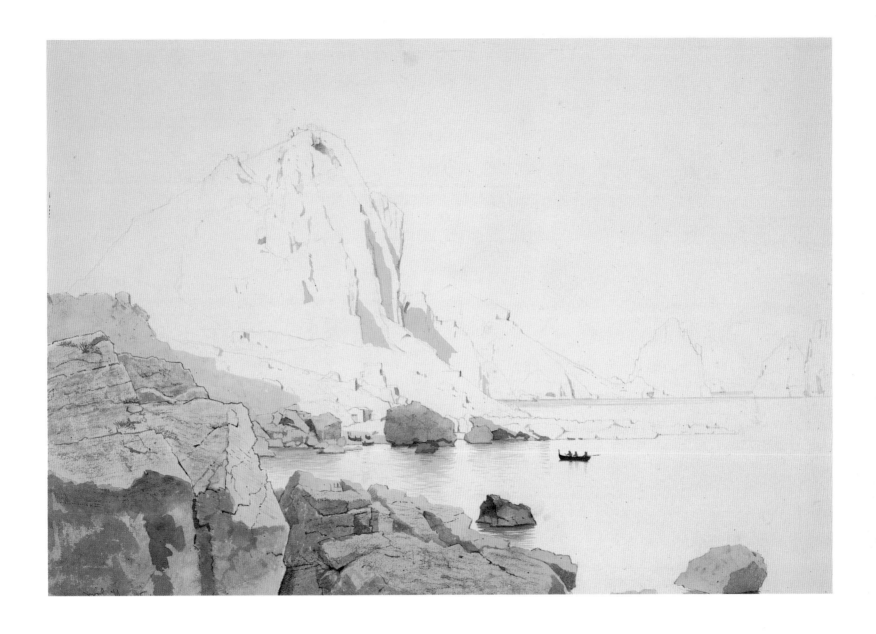

44 **Capri and the Faraglioni**, ca. 1865
Ink and wash over graphite on illustration board, 15⅛ x 21¾ in.
Cooper-Hewitt, National Museum of Design, Smithsonian Institution
Given by Mrs. Roger H. Plowden (Mrs. Helen Haseltine Plowden) (1953.155.1)

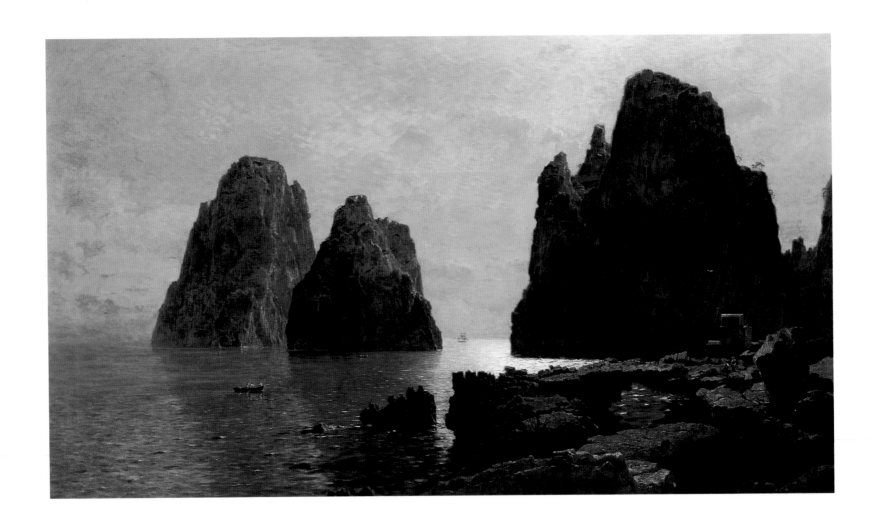

45 **The Faraglioni Rocks**, 1870s
Oil on canvas, 32¾ x 56¼ in.
Signed lower right: *W.S. Haseltine*
Princeton University, lent courtesy of The Art Museum
Gift of a member of the Butler Family (PP 303)

46 Ischia, 1870s
Watercolor, ink, and wash over graphite on paper, 15¼ x 22¼ in.
Montgomery Museum of Fine Arts, Montgomery, Alabama
Gift of Mrs. Roger H. Plowden (1952.3)

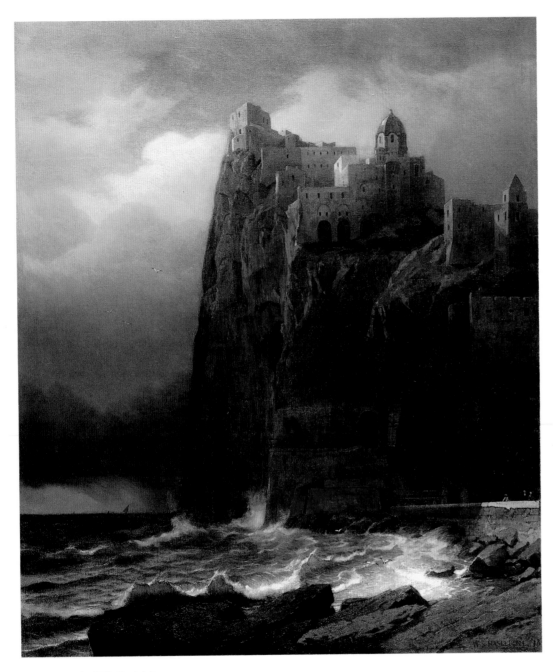

47 **Coastal Cliffs (Ischia)**, 1873
Oil on canvas, 32¼ x 26¼ in.
Inscribed lower right: *W.S. HASELTINE '73*
Bowdoin College Museum of Art, Brunswick, Maine
Gift of Mrs. Estelle K. Butler in memory of her husband,
Henry Franklin Butler (1964.37)

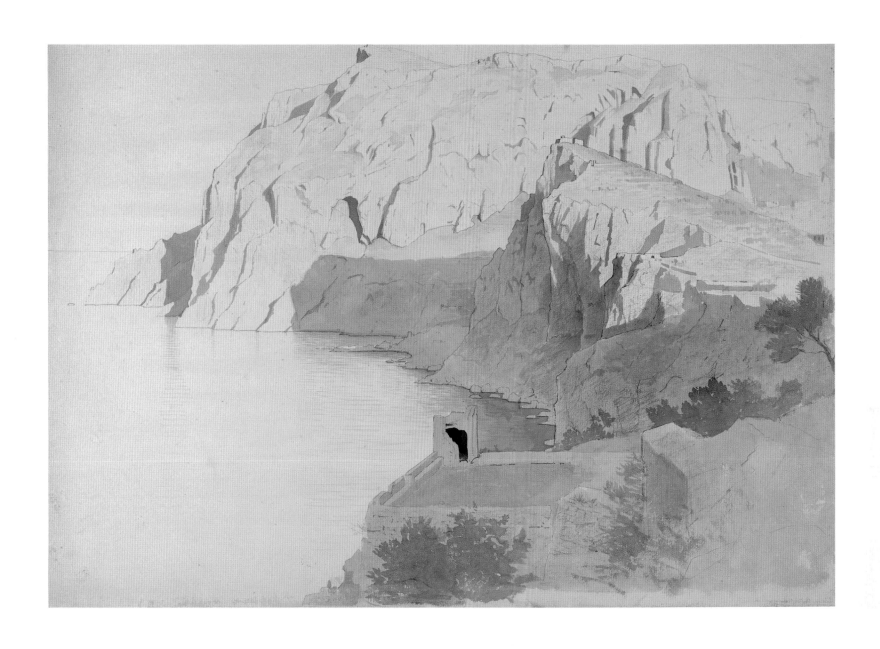

48 Study for View of Capri, ca. 1865
Ink and wash over graphite on paper, 14½ x 20⅜ in.
Collection The High Museum of Art, Atlanta
Gift of Mr. and Mrs. Peter A. Vogt (1984.90)

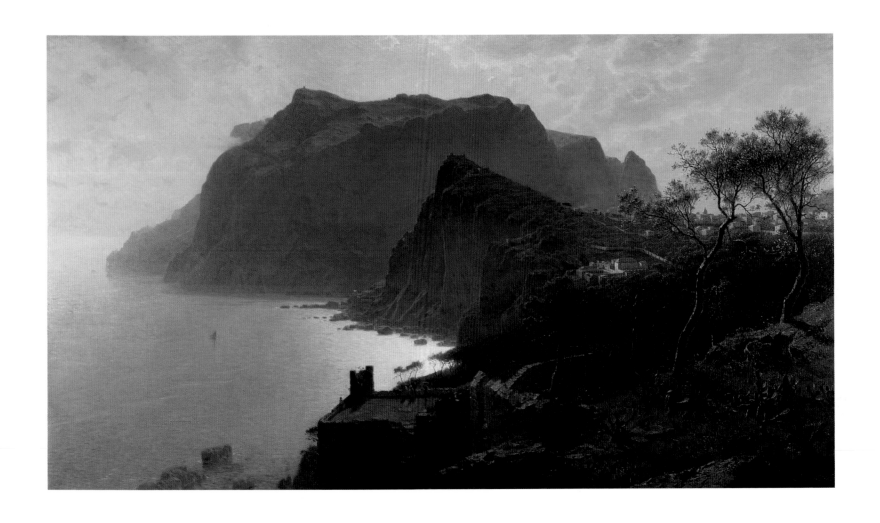

49 **The Sea from Capri,** 1875
Oil on canvas, 42 x 73 in.
Inscribed lower right: *W.S. Haseltine '75*
Collection The High Museum of Art, Atlanta. Purchased with funds from the
Members Guild in honor of Mrs. Wilbur Warner, President 1982-83 of the
Members Guild (1982.321)

Venetian Light, 1871–1885

50 **Venetian Lagoon,** early 1870s
Watercolor over graphite on paper, 14⅜ x 22 in.
Inscribed lower right: *W.S.H.*
National Gallery of Art, Washington, D.C.
Ailsa Mellon Bruce Fund (1968.12.1)

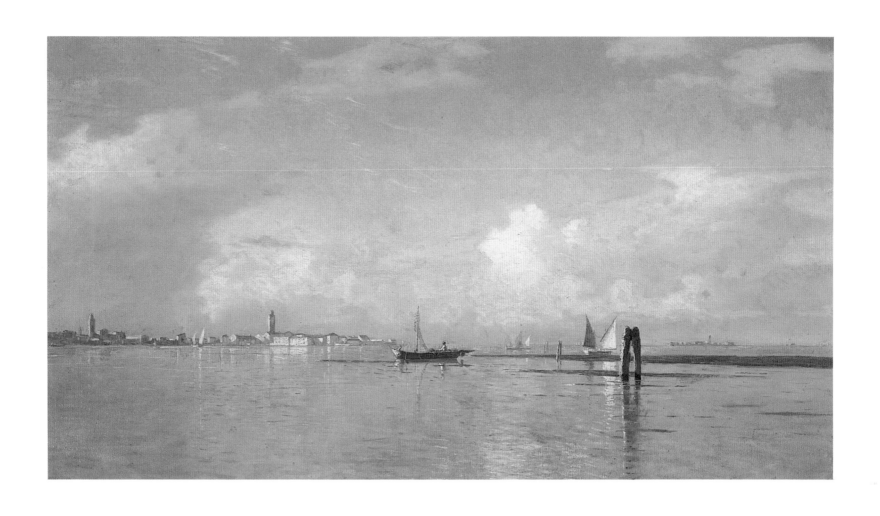

51 **Sunset on the Grand Canal, Venice,** early 1870s
Oil on canvas, 12 x 24½ in.
Cummer Gallery of Art, Jacksonville, Florida
Gift of Helen Haseltine Plowden (AG.61.7)

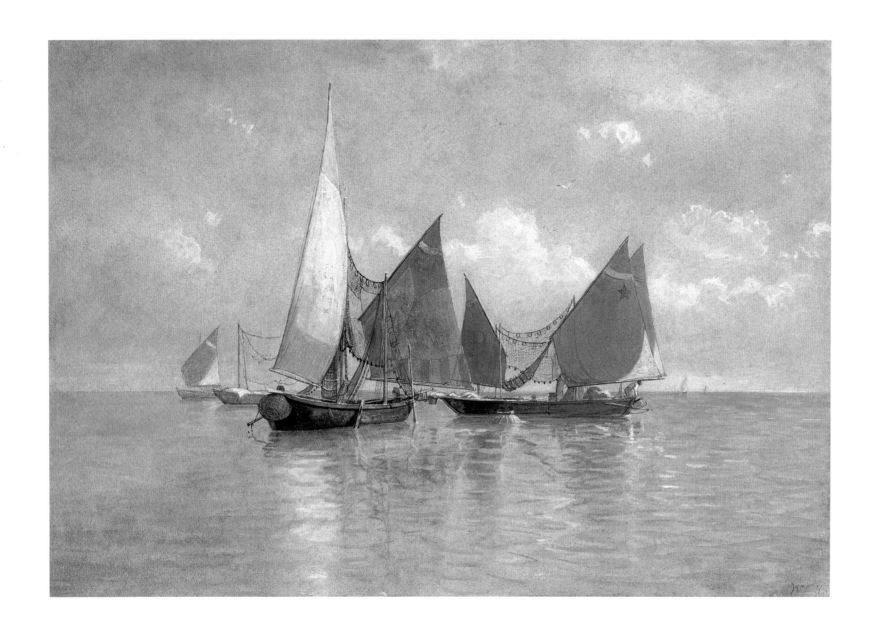

52 **Venetian Fishing Boats,** ca. 1875
Watercolor and gouache over graphite on blue paper, 13¾ x 20⅜ in.
Inscribed lower right: *Wm S.H.*
Private collection, New York

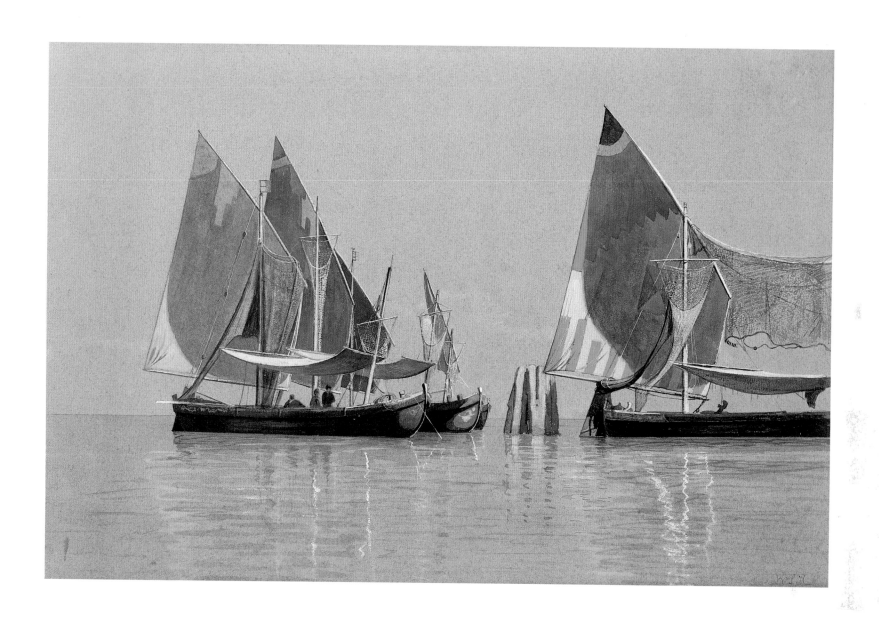

53 **Italian Boats, Venice**, ca. 1875
Watercolor and gouache over graphite on green-tan paper, 15 x 22³/₁₆ in.
Inscribed lower right: *WmS.H.*
Hirschl & Adler Galleries, New York

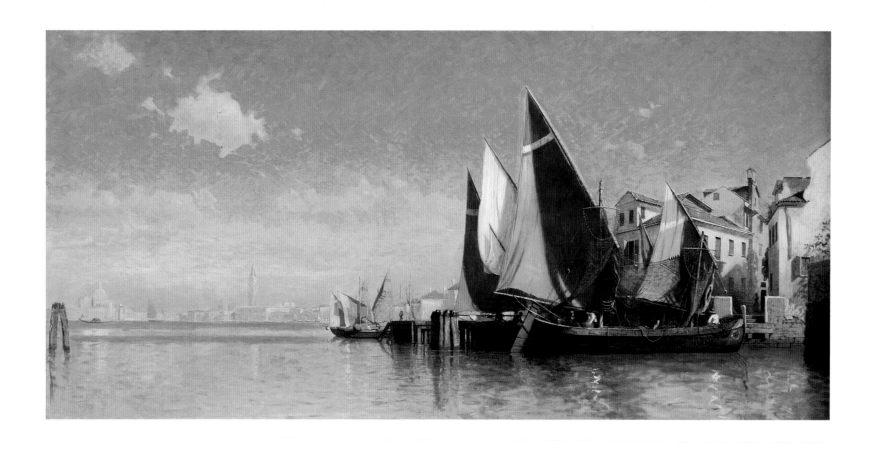

54 **Venice I**, ca. 1875
Oil on canvas, 23½ x 48½ in.
The Detroit Institute of Arts
Gift of Mrs. Roger H. Plowden,
the artist's daughter (51.253)

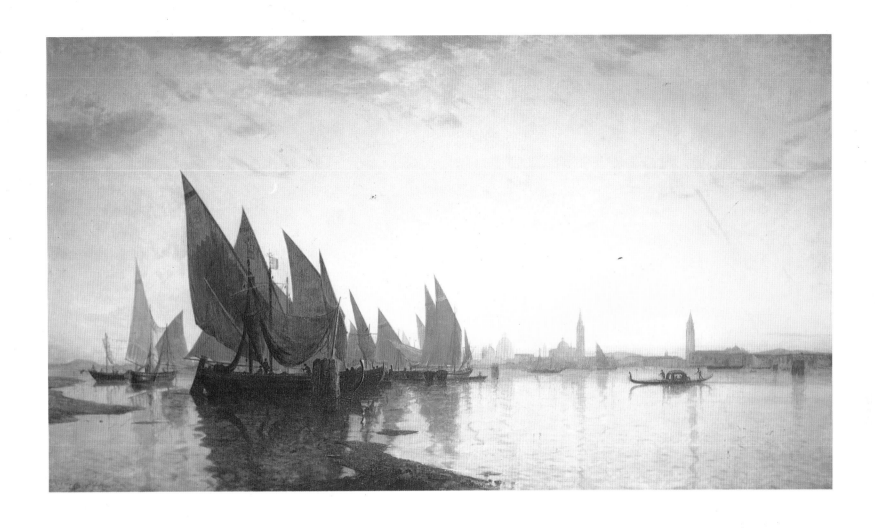

55 **Venice**, 1875
Oil on canvas, 32½ x 58½ in.
Inscribed lower left: W.*S. Haseltine/Roma 1875*
Dr. H.J. Smokler

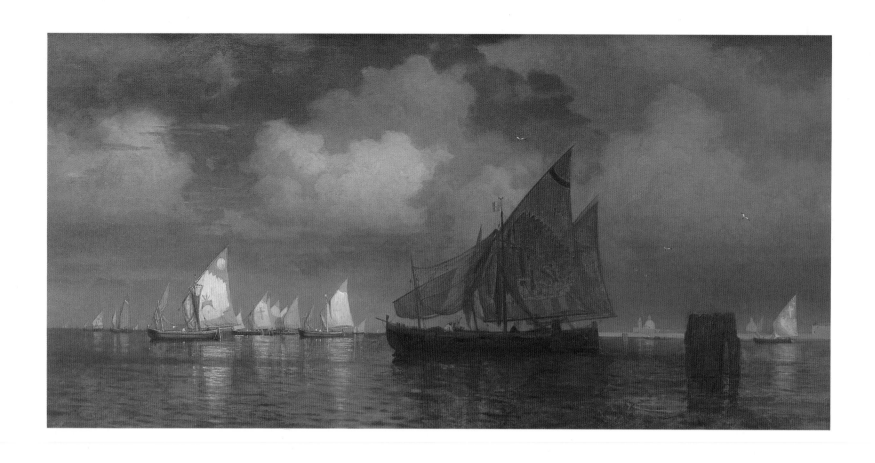

56 **The Lagoon at Venice,** ca. 1880
Oil on canvas, 17⅝ x 35⅞ in.
Inscribed lower right: *W.S. Haseltine*
Private collection. Courtesy Robert Miller Gallery, New York

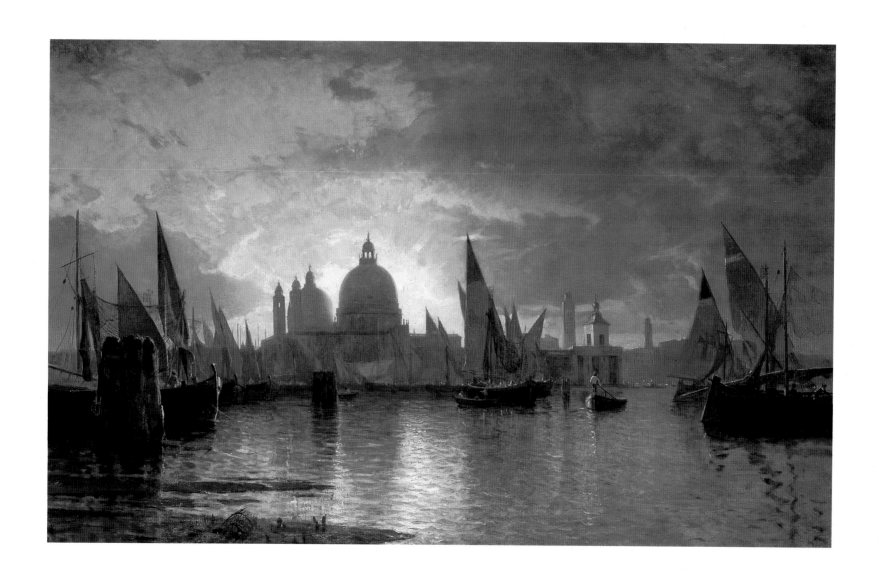

57 **Santa Maria della Salute, Sunset**, ca. 1880
Oil on canvas, 23 x 36 in.
The Metropolitan Museum of Art, New York
Gift of Helen Haseltine Plowden in memory of the artist, 1954 (54.100)

In the Shadow of Ætna, 1871–1889

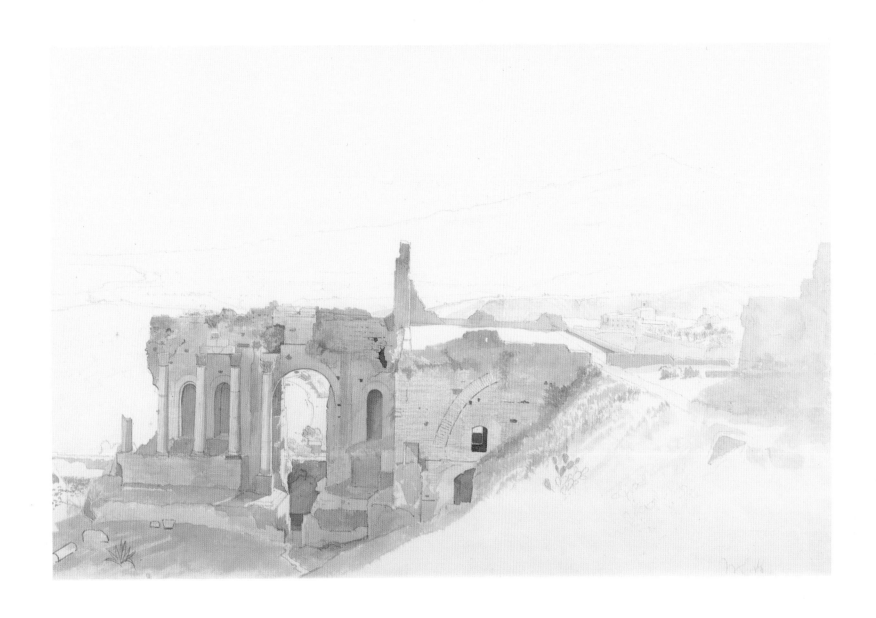

58 **Roman Ruins at Taormina**, ca. 1871
Ink and wash over graphite on paper, 14½ x 21¾ in.
Inscribed lower right: *WS.H.*
Ben Ali Haggin, New York

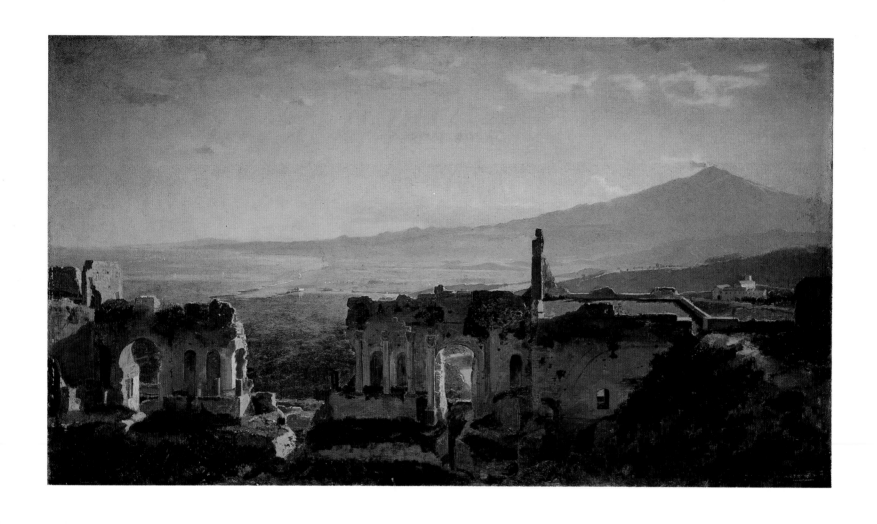

59 **Mt. Ætna from Taormina**, 1871
Oil on canvas, 14 x 24⅜ in.
Inscribed lower right: *W.S. Haseltine/Taormina – 71*
The Downtown Club, Birmingham, Alabama

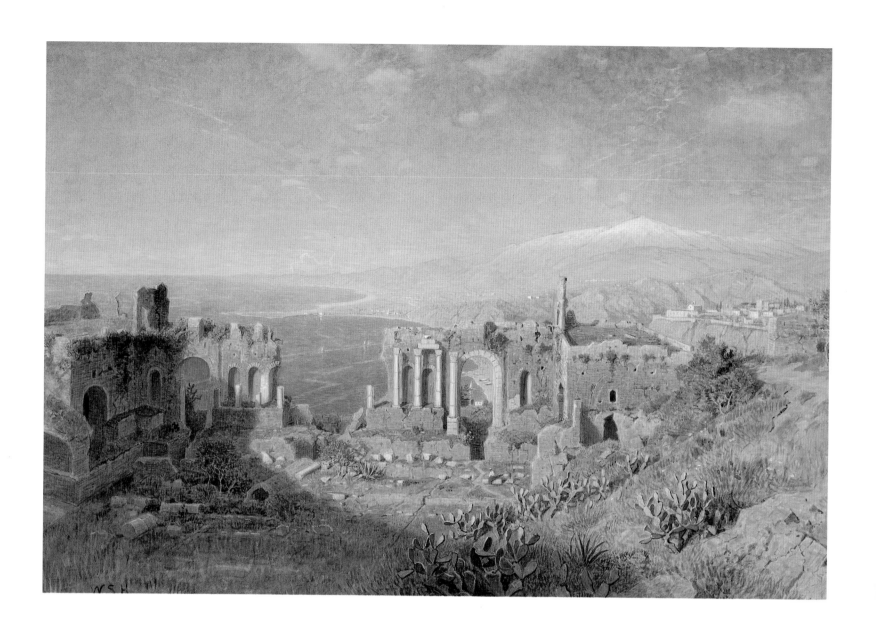

60 **Greek Theater at Taormina**, ca. 1881
Watercolor and gouache on paper, 14¾ x 21½ in. (sight)
Inscribed lower left: *W.S.H.*
Private collection

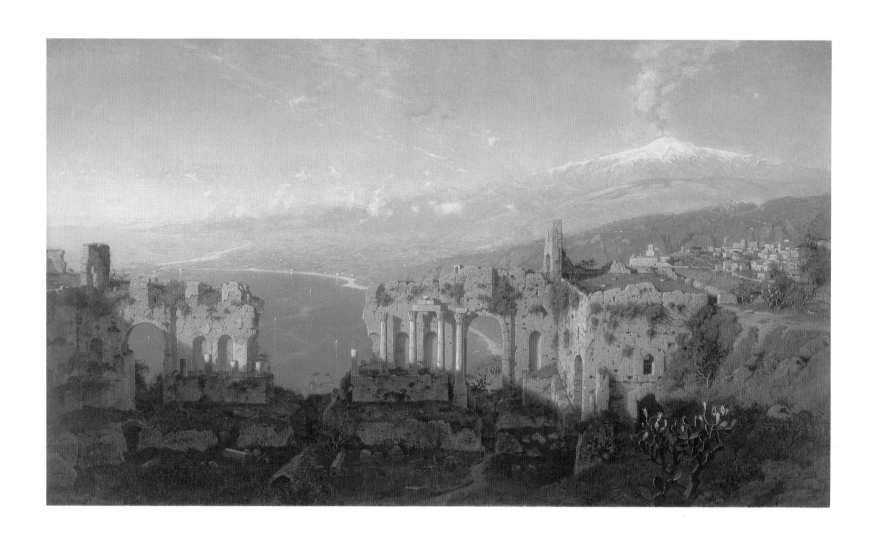

61 **Ruins of the Roman Theatre at Taormina, Sicily,** 1889

Oil on canvas, 32⅝ x 56½ in.

Inscribed lower left: *W.S. Haseltine./ROME 1889.*

The Fine Arts Museums of San Francisco

Gift of Peter McBean (1986.41)

62 **Cannes,** ca. 1875
Watercolor and gouache over graphite on blue paper, 15¼ x 22¾ in.
Inscribed lower right: *W.S. Haseltine*
Memphis Brooks Museum of Art, Memphis, Tennessee
Gift of Mrs. Helen Haseltine Plowden (51.22)

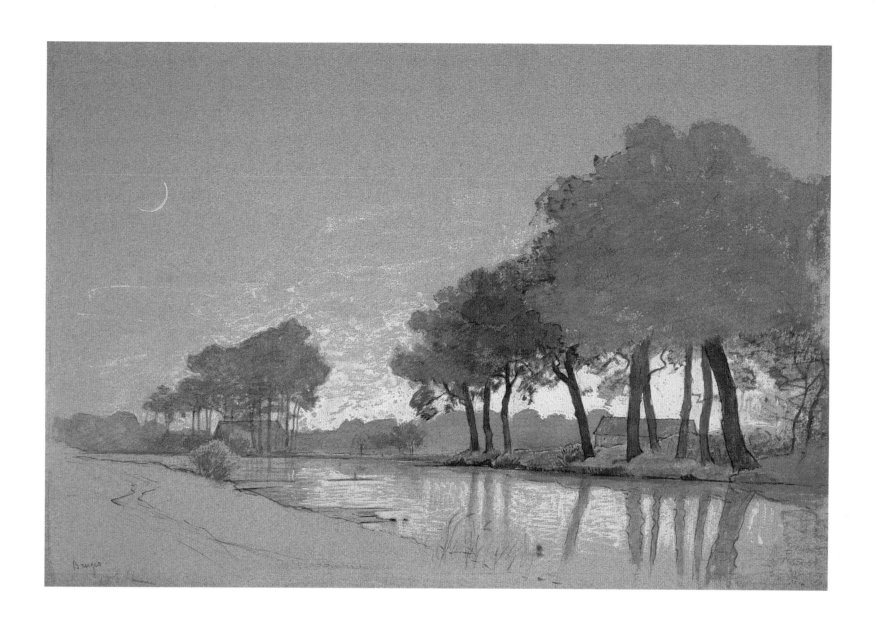

63 **Bruges,** ca. 1875-1880
Wash and gouache over graphite on blue-gray paper, 15 x 22⅛ in.
Inscribed lower left: *Bruges/W.S.H.*
Cooper-Hewitt, National Museum of Design, Smithsonian Institution
Given by Mrs. Roger H. Plowden (Mrs. Helen Haseltine Plowden) (1958-20-1)

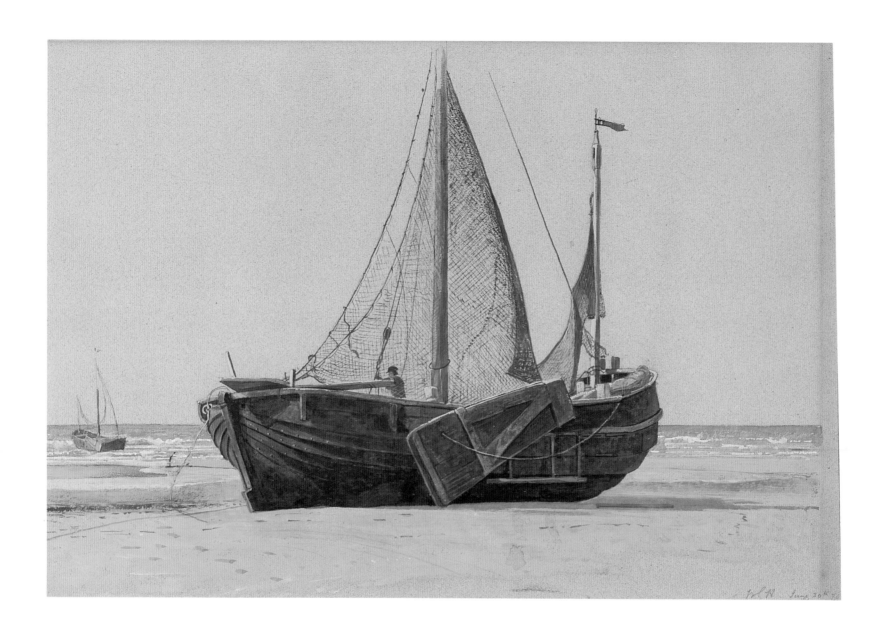

64 Blankenberg, 1876
Watercolor and gouache over graphite on blue paper, 14 x 20½ in.
Inscribed lower right: *WS.H. June 30th 76*
Wadsworth Atheneum, Hartford, Connecticut
Gift of Mrs. Helen Haseltine Plowden (1952.207)

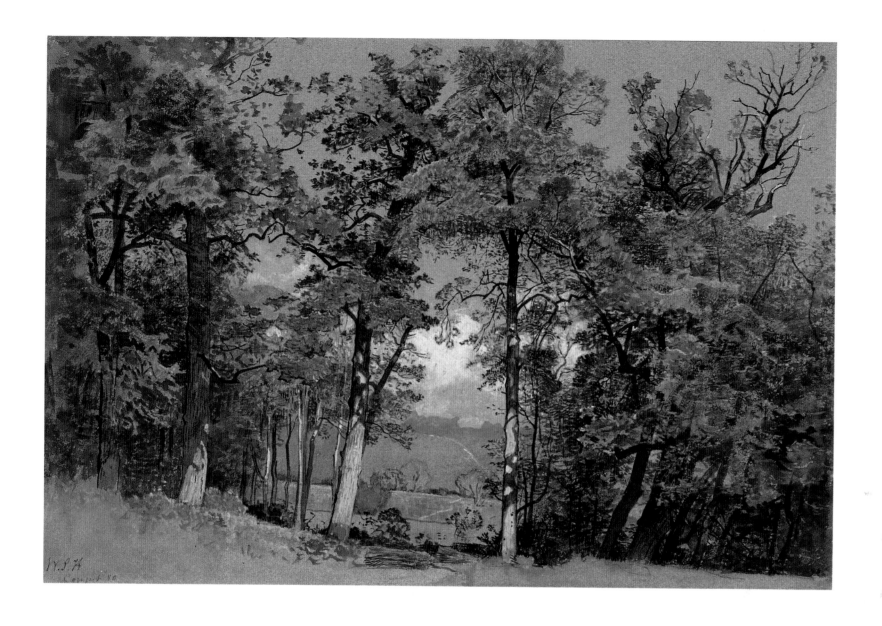

65 **Coppet, Lake Geneva,** 1880
Watercolor and gouache on blue paper, 14 x 22 in.
Inscribed lower left: *W.S.H./Coppet '80*
The Butler Institute of American Art, Youngstown, Ohio
Gift of Helen Haseltine Plowden, 1952

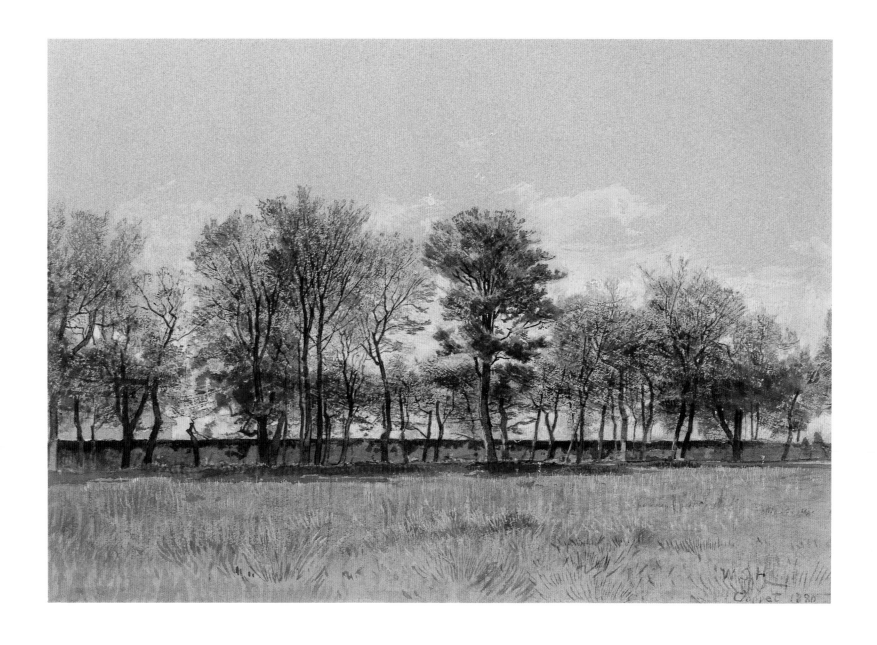

66 Coppet, Lake Geneva, 1880
Watercolor and gouache over graphite on blue paper, 14¹⁄₁₆ x 21 in. (sight)
Inscribed lower right: *W.S.H./Coppet 1880*
Hirschl & Adler Galleries, New York

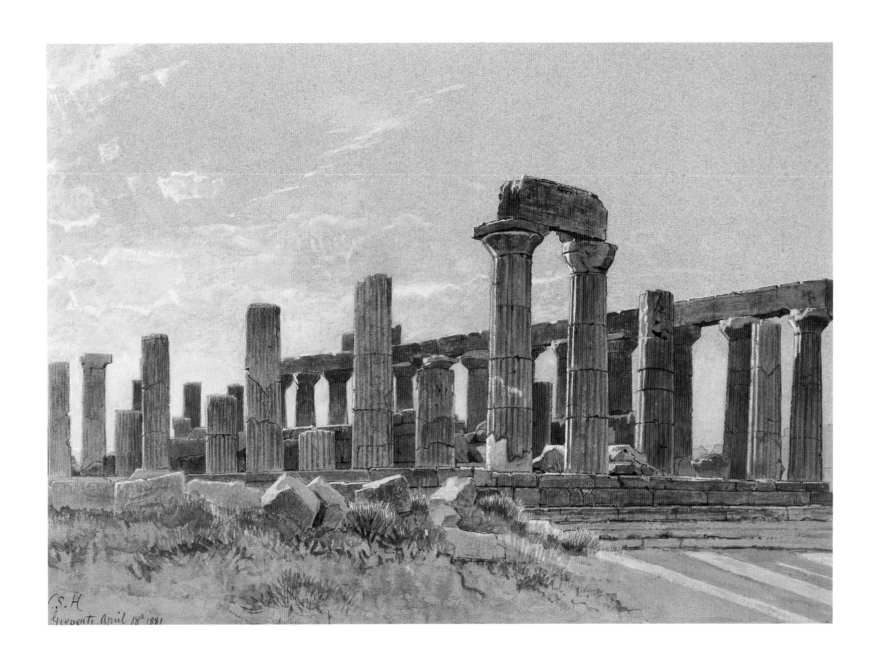

67 **Agrigento (Temple of Juno Lacinia)**, 1881
Watercolor and gouache over graphite on blue paper, 14½ x 20⁷⁄₁₆ in. (sight)
Inscribed lower left: *W.S.H./Girgenti April 18th 1881*
Hirschl & Adler Galleries, New York

68 **View from the Alhambra, Spain**, ca. 1882
Watercolor and gouache over graphite on blue paper, 14 x 21 in.
Inscribed lower left: *W.S.H.*
Hirschl & Adler Galleries, New York

69 Torrent in Wood behind Mill Dam, Vahrn near Brixen, Tyrol, ca. 1885
Watercolor, gouache, and ink on blue paper, mounted to cardboard, 22⅛ x 15⅛ in.
Inscribed lower right: *W.S. Haseltine*
Lent by Dr. Richard P. Wunder

70 **Wetterhorn from Grindelwald, Switzerland,** ca. 1885
Watercolor and gouache over graphite on blue paper,
mounted to cardboard, 14⅞ x 22¹³⁄₁₆ in.
Inscribed lower right: *Wm S.H.*
Milwaukee Art Museum. Gift of Mrs. Roger H. Plowden (M1952.14)

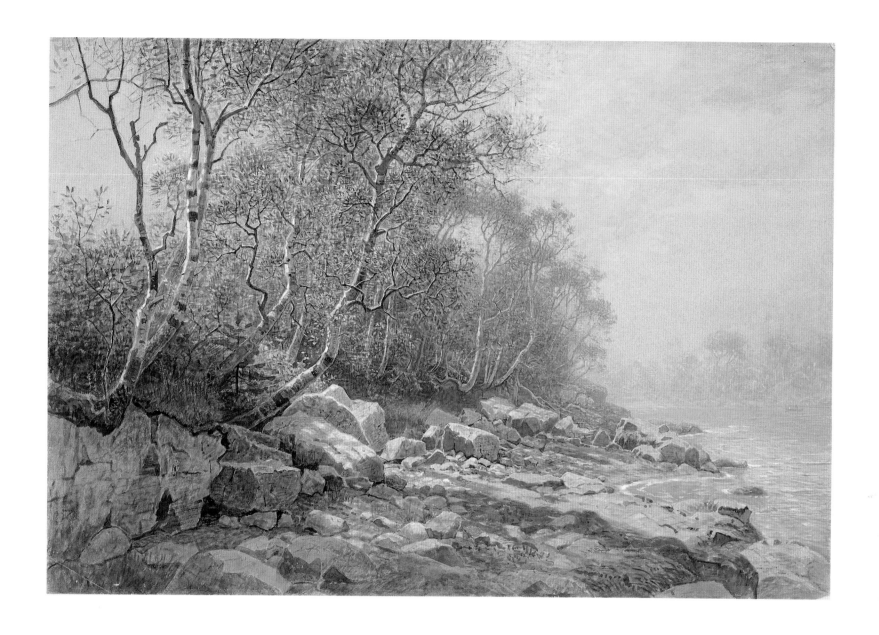

71 **Seal Harbor, Mount Desert, Maine**, ca. 1895
Watercolor and gouache over graphite on blue paper, 14¼ x 21½ in.
Inscribed lower left: *W.S.H.*
The Georgia Museum of Art, The University of Georgia, Athens
Gift of Mrs. Helen Plowden, courtesy of the National Academy of Design,
New York (61.766)

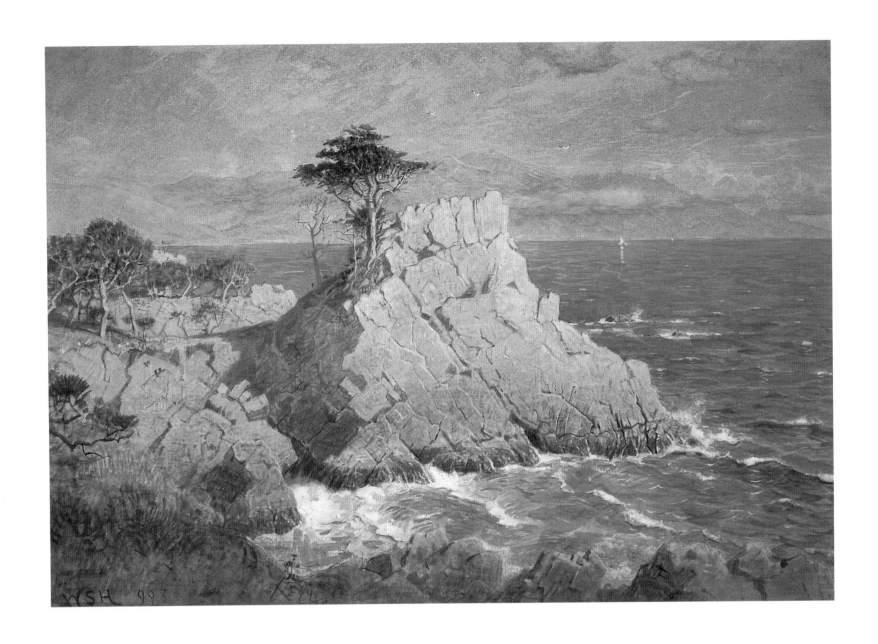

72 **Midway Point, California** [Cypress Point, near Monterey], 1899
Watercolor and gouache over graphite on blue paper, 15 x 21½ in.
Inscribed lower left: *WSH '99*
Phoenix Art Museum, Phoenix, Arizona. Gift of Mrs. Louis Cates (60.169)

73 Yosemite Valley. Yellowstone Park, 1899
Page from a sketchbook. Watercolor and gouache over graphite on
blue paper, 9 x 4¹⁵⁄₁₆ in.
Inscribed upper right: *Yosemite Valley. Yellowstone Park.*
Hirschl & Adler Galleries, New York

William Oliver Stone (1830-1875), *William Stanley Haseltine*, ca. 1861. Oil on canvas, 20 x 16 in. National Academy of Design, New York.

Chronology of William Stanley Haseltine's Life and Work

The principal source of information on Haseltine is the biography written by his daughter, Helen Haseltine Plowden, *William Stanley Haseltine: Sea and Landscape Painter (1835-1900)* (London: Frederick Muller, Ltd., 1947). This chronology depends heavily on that text's reconstruction of the painter's life and, more importantly, on the notes, transcriptions, and additional unpublished letters compiled by Plowden for her work. These latter, referred to hereafter as the Haseltine/Plowden Family Papers, have been made available through the great generosity of the Plowden family. A wealth of nineteenth-century documentation not readily accessible to Plowden has dictated, however, some significant departures from the overview she established.

Many of the Haseltine/Plowden Family Papers are recorded or transcribed in Plowden's hand. The chronology follows these texts as closely as possible, although some interpretation was required of the occasional indistinct word or abbreviation. Although Plowden lived most of her life in Europe, she seems to have recorded her father's financial transactions in dollars, which this chronology reflects.

The name *Haseltine* is spelled variously in documents from the nineteenth century: Haseltine, Hasletine, Hazeltine, etc. The use of the names and/or initials for "William" and "Stanley" also varies widely. This chronology follows the spelling of the original document without noting its variance from our standard. Similarly, the chronology neither notes nor corrects other variant spellings or apparent errors in quoted documents.

Many of the exhibition histories and titles are derived from Bartlett Cowdrey, *National Academy of Design Exhibition Record, 1826-1860* (New York: The New-York Historical Society, 1943); Lois Marie Fink, *American Art at the Nineteenth-Century Paris Salons* (Washington, D.C.: National Museum of American Art, 1990); Louis Lang, "Record of Works of Art Exhibited in the Century Room," in *Art History of the Century Association from 1847 through 1880* (MSS; microfilm in AAA, roll N431); Clark S. Marlor, *A History of the Brooklyn Art Association with an Index of Exhibitions* (New York: James F. Carr, 1970); Maria Naylor, *The National Academy of Design Exhibition Record, 1861-1900* (New York: Kennedy Galleries, Inc., 1973); Robert F. Perkins, Jr., and William J. Gavin III, comp. and ed., *The Boston Athenæum Art Exhibition Index* (Boston: The Library of the Boston Athenæum, 1980); Anna Wells Rutledge, *Cumulative Record of Exhibition Catalogues:*

The Pennsylvania Academy of the Fine Arts, 1807-1870; The Society of Artists, 1800-1814; The Artist's Fund Society, 1835-1845 (Philadelphia: The American Philosophical Society, 1955); and James L. Yarnall and William H. Gerdts, *The National Museum of American Art's Index to American Art Exhibition Catalogues, from the Beginning through the 1876 Centennial Year* (Boston: G. K. Hall & Co., 1986). The vast majority of histories and titles have been confirmed by checking against the original exhibition catalogues. In this chronology, the information following the title of a work indicates an owner or sale status.

Frequently cited references

PLOWDEN — Helen Haseltine Plowden, *William Stanley Haseltine: Sea and Landscape Painter (1835-1900)* (London: Frederick Muller, Ltd., 1947).

HASELTINE/PLOWDEN FAMILY PAPERS — Notes, transcriptions, and additional unpublished letters compiled by Helen Haseltine Plowden.

AAA — Archives of American Art, Smithsonian Institution.

CLASS BOOK — "Class Book, Class of 1854" (Harvard University Archives).

REPORT 1854 — *Harvard College, Report of Class of 1854* (Boston: Geo. H. Ellis, 1894).

People frequently referred to in this chronology

John Haseltine (1793-1871), the artist's father
Elizabeth Shinn Haseltine (1811-1882), the artist's mother
Helen Lane Haseltine (d. 1864), the artist's first wife
Helen Marshall Haseltine (1837-1926), the artist's second wife
Stanley Lane Haseltine (1861-1879), the artist's son
Helen Haseltine Plowden (1872-1977), the artist's daughter
Herbert Chevalier Haseltine (1877-1962), the artist's son
Sanford R. Gifford (1823-1880), artist and friend
Elihu Gifford, Sanford R. Gifford's father
Elihu Vedder (1836-1923), artist and friend
Dr. Elihu Vedder, Elihu Vedder's father
Carrie Vedder, Elihu Vedder's wife
Worthington Whittredge (1820-1910), artist and friend

Unknown photographer, *William Stanley Haseltine*, ca. 1854. National Academy of Design, New York.

Early Life

11 June 1835 Born in Philadelphia, second son of Elizabeth Shinn Haseltine and John Haseltine. By 1850 he was one of eight surviving children: Caroline H. Marquéze (1830-1899), James Henry (1833-1907), Elizabeth H. Poultney Smith (1837-after 1915), John White (1839-1925), Charles Field (1840-1915), Albert Chevalier (1842/3-1898), and Marianne Lucy Dumaresq (1846-1881). The Haseltine family had been among the earliest settlers of Haverhill, Massachusetts, where John, Sr., had been born and reared. The painter writes of the Shinn family that

My mothers family had resided in Phila almost from the time of its first settlement and it was from her side of my family that I inherited that affection & pride which I shall always entertain for my native city.

Haseltine's biographical statement, 25 July 1854, in Class Book, 137.

Throughout his youth, attends boarding schools in Princeton and Philadelphia, including "one kept by Prof Hart of the Phila High School." (Class Book, 137.)

Fall 1850 Enrolls at the University of Pennsylvania.

21 April 1852 Applies to Harvard College for admission to junior class: *Dear Sir – Could you inform me, if I could enter the Junior Class, next September with a certificate, having advanced as far as the third term Junior Class, of the Univ of Pennsylvania, I oblige your obediant servant. / Wm. S. Haseltine/ Adress. To the Care of / Haddock, Haseltine & Reed / 154 & 156 Market St Phila.*

Corporation papers, 2nd series, box 9 (1851- 1852), Harvard University Archives.

27 September 1852 Admitted to junior class at Harvard. Initially lives with a Mr. J. Porter. Among his classmates, who will graduate with him two years later, are John Chandler Bancroft and Horace Howard Furness. Becomes a member of the Harvard Natural History Society, the Hasty Pudding Club, and the "Med. Fac." Society. (*A Catalogue of the Officers and Members of the Harvard Natural History Society* [Cambridge: Metcalf and Company, 1855], 31; Faculty Records 14 [1850-1855], Harvard University Archives; Report 1854, 3-5, 60.)

College records document a series of minor infractions over the next two years, including breaking a chair (25 October 1852); making and continuing to make a disturbance in recitation room (10 January 1853); being absent without excuse from recitations and prayers (10 May 1853, 11 July 1853, 2 January 1854, 16 January 1854, 19 May 1854); and smoking in the yard (24 October 1853). Apparently ambitious in languages, he is

admitted to a special section of French, reciting to Professor Longfellow (19 September 1853), and studying German, Spanish, and Italian. ("List of Grades Received by Undergraduates," Harvard University Archives.)

Among extracurricular activities, he appears as the female lead in a number of Hasty Pudding Club productions: *Milliner's Holiday* (November 1853); *Who'll Lend Me a Wife?* and *Two Bonnycastles* (December 1853); *Lend Me Five Shillings* (January 1854). He is, as well, elected to the Class Day Committee, along with Benjamin Joy Jeffries and Furness, and as a vice president of the First Class Supper (March 1854). (Class of 1854, General Material, Harvard University Archives; also *An Illustrated History of the Hasty Pudding Club Theatricals*, 3rd ed. [Cambridge: Hasty Pudding Club, 1933].)

Haseltine's artistic endeavors include designing placards and materials for the Hasty Pudding Club, as well as completing paintings on the door panels of his senior-year room, 25 Stoughton Hall – *Dying Seagull* and *Tortoise Resting on a Log*:

[Haseltine] was a born artist, and showed his love of painting by decorating the walls and panels of his College Room. These pictures were preserved for many many years after he left College and were only obliterated when time had faded out the colours. He once drew so good a likeness of our Greek teacher, Professor Sophocles that we had it litographed ('twas before the days of photographs) and he was never weary of discussing any topic connected with art.

> Horace Howard Furness to Helen Haseltine [later Plowden],
> 23 September 1900, typescript in Haseltine Papers, AAA,
> roll D295, frame 453.

13 July 1854 Harvard faculty votes to grant degree. Haseltine writes:
I have always entertained a great longing for any thing connected with the fine arts. I have already painted several original pictures & intend going to Düsseldorf to prosecute the study of art as a profession.

> Class Book, 137.

Fall 1854 Returns to Philadelphia with the desire to go to Europe, but is encouraged by his father to remain in Philadelphia and work with the German-born landscape painter Paul Weber (1823-1916), while preparing work for the Pennsylvania Academy of the Fine Arts exhibition. Sketches on the Hudson River. Over the winter he paints at least nine pictures, hoping to gain his father's approval to travel abroad.

William Stanley Haseltine, *Dying Seagull*, 1853/54. Oil on wood door panel, 29 x 12¾ in. *Tortoise Resting on a Log*, 1853/54. Oil on wood door panel, 25¹/₁₆ x 12¾ in. The Harvard University Art Museums.

Early 1855 Writes to his father, imploring his approval to study in Europe:

Although you said the other morning that you could not allow me to go to Europe this summer, I think I can induce you to change your decision by stating the great advantages that I shall derive from such a visit. . . . If I am to adopt painting as a profession, I wish to be among the first in the rank. I would much rather never again touch a brush than sink to nothing but a third or fourth-rate painter. Although I have derived a great deal of advantage from Mr. Weber's instruction, I have nevertheless obtained a style which is not my own, a style which is a very tempting one and only to be got rid of by seeing other pictures – opportunities which I cannot here obtain. . . . I am certain that one more winter's instruction with Mr. Weber would ruin my style for life and strive as I would, I would never be able to lay it aside and paint a truly original picture. . . .

Another reason: I have too many friends; there are too many things to distract my attention here, and I consequently cannot help losing a great deal of time which is of the utmost importance to me. Now, in Düsseldorf I would be thrown entirely among those whose object would be, like mine, to lose as little time as possible. . . . I shall have the chance of seeing the finest collection of pictures in the world and of seeing and knowing some of the greatest artists.

There are three or four young men in the city who are beginners as well as myself. Two of these, who are very poor – and one of them no older than I am – are going to Europe this summer by subscription. . . . Last fall, when you and I spoke together of my going to Europe and when you told me to study with Mr. Weber this winter and try to paint an original picture for the Exhibition, I did it with the understanding that, if I succeeded, I would be allowed to go abroad this spring. Instead of one, I have painted nine original pictures, much better, I am sure, than you expected them to be. . . . As regards the expense, I will bind myself to spend not more than six or seven hundred dollars a year – which will be only four hundred more than you allow me now. I am certain that I will be able to keep within that allowance and I do not want it for more than two or three years; by then I will certainly be able to support myself.

Haseltine to John Haseltine, ca. 1855, in Plowden, 32-33.

April 1855 Represented at the Thirty-second Annual Exhibition of the Pennsylvania Academy of the Fine Arts, his first inclusion in a public art exhibition. Address given as 260 Spruce Street: "5. *Snow Scene.* For sale. . . 17. *Scene on the Juniata.* For sale. . . 41. *Scene on the Delaware.* S. Kimball. . . 382. *Scene on the Juniata.* E. Rogers."

European Study

Summer 1855 Departs for Düsseldorf. Writes from Paris to his mother:
I have been delayed thus far, partly by the advice of Dr. Sichell, who is attending to my eyes, and partly to witness the entrée of the Queen of England.

Haseltine to Elizabeth Shinn Haseltine, Paris, 30 August 1855, in Plowden, 34.

Fall 1855 Arrives in Düsseldorf. Plowden writes:
As soon as Andreas Achenbach returned [from his summer sketching tour], he took W.S.H. into his studio and work started in dead earnest. . . . Haseltine always talked of himself as a student of Andreas.

Plowden, 42.

There are no formal records of Achenbach, whom Sanford R. Gifford called "one of the best landscape painters living – nobody can paint water better," taking on Haseltine as a student. In an autobiographical statement written in 1900, Haseltine does not mention studying with Achenbach. It is clear, however, that the two men are acquainted. Both are members of the Malkasten Club, an artists' society. Along with Achenbach, Emanuel Leutze, and J. B. Irving, Jr., Haseltine signs a letter in support of Albert Bierstadt, correcting a somewhat libelous newspaper report dated from New Bedford, August 1855. (Sanford R. Gifford to Elihu Gifford, June 1856, European Letters, Gifford Papers, AAA, roll D21, 2:45; see also Gordon Hendricks, *Albert Bierstadt: Painter of the American West* [New York: Harry N. Abrams, in association with the Amon Carter Museum of Western Art, 1973], 32-34.)

Early summer 1856 Makes sketching tour down the Rhine and up the valleys of the Ahr and the Nahe rivers, before moving through Switzerland and Northern Italy. His companion, Worthington Whittredge, writes (apparently conflating trips of 1856 and 1857):
One more sketching trip in Germany and then I was to be off for the Eternal City. A goodly number of American students had foregathered at Düsseldorf and I had been conspicuous among them in finding out new places to go for summer sketching. I talked of a little village high up on the River Nahe, a tributary of the Rhine, emptying into that River at Bingen. . . . I soon had applications to take along with me a goodly number . . . and in a little while I found myself at the head of a band of jolly fellows guiding them to the region I had so enthusiastically described. Among them was Furness, the gentle and gifted painter of beautiful women; Perry, his dear friend; Haseltine, of Philadelphia; Irving, of South Carolina; Washington, a descendant of the family of the father of our country; and Lewis, the well known painter of the panorama of the

Mississippi River. . . . In the latter part of this month of July I started for Rome in company of Haseltine, a recent acquisition to the American colony in Düsseldorf. We were to go slowly, our sketch books at hand, up the Rhine into Switzerland over the Saint Gothard and thus to the Italian Lakes, Genoa, Leghorn, Florence and so on to Rome. We made the whole trip before it was cold weather and made many studies on the way.

Worthington Whittredge, *The Autobiography of Worthington Whittredge, 1820-1910,* ed., John I. H. Baur (1942; New York: Arno Press, 1969), 30-31.

27 July 1856 At Lake Lucerne in the company of Whittredge and Bierstadt. There meets Gifford:

Sunday, July 27th I was at Lucerne. . . . Walking in the evening on the fine promenade around the lake in front of the Schweitzer Hof, I met Whitridge of Düsseldorf and Haseltine and Bierstadt, two young American artists, whom I had expected to meet with W. at Kim [Kirn] near the Rhine [ca. 19 June], but which for want of time, I was unable to do. Spent a very pleasant evening with them at Gasthof Schneidem. They are going to spend several weeks on the lake.

Sanford R. Gifford to Elihu Gifford, Bellinzona, 10 August 1856, European Letters, Gifford Papers, AAA, roll D21, 2:79a-80a.

September 1856 Haseltine in Meyringen, Switzerland. He contemplates moving on to Northern Italy, although he implies that he would like to get back to work on pictures in Düsseldorf:

We are now settled in a little town named Meyringen, in one of the most attractive valleys in Switzerland. We first went to Brunnen, on the upper part of the Lac des Quatre Cantons, a place much frequented by artists from all countries. We adopted our usual custom of not going to a first-class hotel, but chose a good, comfortable country inn, das Weisse Rössl. . . . One of the first artists of Switzerland, M. Calamé, was there with four or five pupils. . . . Every morning, at early candle lighting, a procession headed by M. Calamé, pupils – paint-box and bottle carriers, started up a very steep mountain; by seven o'clock six white umbrellas were set and M. Calamé, by right of seniority, sat one to two hundred feet higher up than any of the others. . . . Next we went to a place called Lanstadt; we put up at a most shocking country tavern. The view of Mt. Pilatus was so fine, however, that we stood the discomforts for two whole days. From there we took the post for Meyringen We are stopping here, Meyringen, at a pension kept by Vater Roofam, and which is only meant for artists. We are eleven in all, including two professors, one from the Berlin Academy. . . . We go to the north of Italy for six weeks. I am anxious to get at my pictures again; I have plenty of subjects for new ones.

Haseltine to Elizabeth Shinn Haseltine, Meyringen, 3 September 1856, in Plowden, 47-49.

Unknown photographer, *Cascade Rosenlani, Switzerland,* ca. 1860. Haseltine/Plowden Family Papers.

I hear too that you are going in the Navy, if so I hope that you will not be all your life a midshipman. For my part, if I were in your place I would look for some pleasanter profession. An architect (there are artists enough in the family) would do very well, and I think that you have some talent for drawing. It will be a splendid profession at some day in our country & one that one can make a good deal of money by, much more than by painting. . . .

I am now in Switzerland probably one of the most beautiful countries in the world entirely different from anything in America, except in its being a republic, which it has been for many more years than we.

The scenery is very beautiful. I paint from morning till night and perhaps some of these days you may see a picture or two from here. . . . Have you given up drawing entirely, if not try to draw something from nature. You will find it difficult at first.

Haseltine to his brother, Albert Haseltine, Meyringen, 9 September 1856, in Haseltine/Plowden Family Papers.

Mid-September 1856 or later Travels to north of Italy, visiting the Lake Country, Genoa, and perhaps Venice.

January 1857 Journal reports that Haseltine is in Düsseldorf: *Of Philadelphian artists abroad, Rothermel is in Rome, Read in Florence, Perry in Venice, Lawrie and Hazeltine in Düsseldorf.*

"Sketchings. Domestic Art Gossip," *Crayon* 4, no. 1 (January 1857): 28.

28 April 1857 Represented at the Thirty-fourth Annual Exhibition of the Pennsylvania Academy of the Fine Arts. Address given as "now in Europe": "54. *Sunset, with a View of the Castle of Schomberg, on the Rhine.* For sale. W. S. Haseltine. . . 73. *Landscape: Sunday Morning on the Nater.* For sale. W. S. Haseltine. . . 104. *View among the Seven Mountains of the Rhine.* For sale. W. S. Haseltine. 105. *View of the Castle Strohwester.* W. S. Haseltine. . . 138. *View of an Old Castle near Cologne.* For sale. W. S. Haseltine. . . 157. *The Brothers: or, Leberstein and Steinfels on the Rhine.* For sale. W. S. Haseltine."

Mr. Hazeltine exhibits several landscapes of similar treatment and skill to those by Mr. Weber; they show power which only needs to be influenced by an untrammelled study of Nature.

"Sketchings. Domestic Art Gossip," *Crayon* 4, no. 6 (June 1857): 186.

Summer 1857 Again in Switzerland, apparently with Whittredge and Irving, takes up quarters at the Weisses Rössli in Brunnen. From there they branch off on various sketching expeditions including ones to Seelisberg, Lake Lucerne, Finster Aarhorn, and Mount Pilatus.

September 1857 With Whittredge at Baveno on Lago Maggiore.

4 November 1857 In Rome, where he attends "a meeting of artists and other friends" of the recently deceased Thomas Crawford; the group "unanimously adopted resolutions of deepest sympathy for the widow and family." Among this group of forty-five, in addition to Haseltine and his brother, James, are Luther Terry, James E. Freeman, John Gadsby Chapman, Cephas G. Thompson, George Loring Brown, P. T. Rothermel, J. O. Montalant, William Page, Joseph Ropes, J. Mozier, and Whittredge. (Sylvia E. Crane, *White Silence: Greenough, Powers, and Crawford, American Sculptors in Nineteenth-Century Italy* [Coral Gables, Florida: University of Miami Press, 1972], 401.)

T. B. Read, Rothermel, Whitridge, G. L. Brown, Tilton, Montelant, Hazeltine, and Page are now in Rome.

"Sketchings. Domestic Art Gossip," *Crayon* 4, no. 12 (December 1857): 379.

18 December 1857 Sketches at Ostia, outside Rome. During the season also sketches at Porto Salaro and Castel Fusano: *Haseltine's rooms overlooked the city, the Pincio and the Villa Medici, and he could view sunrise and sunset from his studio on the top floor of No. 107, Via Felice (now Via Sistina). It was let to him by Vincenzo Voltieri, the sculptor. . . . This house Palazzo Guglielmi, where he lived in '57-'58 was also the home of Gregorovius. . . . Freeman, the American painter, lived at 18, Trinità dei Monti, and Haseltine often looked him up in his studio.*

Plowden, 62.

Rome was gay one winter when we were there I think it was the winter of 1858. Your father was young and so was I. There were some very lovely American girls there that winter and we got all the fun out [of] them that we could. No end of bouquets were bought.

Worthington Whittredge to Helen Haseltine [later Plowden], 5 May 1900, typescript in Haseltine Papers, AAA, roll D295, frames 457- 458.

Also in 1857 Haseltine was represented at the Boston Athenaeum's Thirtieth Exhibition of Paintings and Statuary: "363. *The Drachenfels.*"

1858 Over the winter and spring he sketches in Olevano, Subiaco, Tivoli, Sorrento, Amalfi, and Capri.

March 1858 Still in Rome: *The season, so far, has been a very unfavorable one for the artists. . . .*

Among the students of landscape painting there is Loop, of New York; Montelant, Haseltine, and Wilson of Philadelphia; Ropes, of Hartford; and Williams, of Providence, Rhode Island.

"Foreign Correspondence, Items, etc.," *Crayon* 5, no. 6 (June 1858): 170 [dateline 27 March 1858].

20 April 1858 Represented at the Thirty-fifth Annual Exhibition of the Pennsylvania Academy of the Fine Arts. Address given as "now in Europe": "141. *Ruin of Castle Kern, on the Nahe*. W. S. Haseltine. . . 290. *Mount Pilatus from Neighborhood of Lucerne (Switzerland)*. W. S. Haseltine. . . 295. *Landscape View in the Neighborhood of Meyringen of the Vale of Hasle*. W. S. Haseltine."

Spring 1858 Represented at the Second Annual Exhibition of the Washington Art Association: "48. *View in the Seven Mountains (Near the Rhine)*. W. S. Hazeltine, Philadelphia 49. *The Two Brothers, (On the Rhine)*. W. S. Hazeltine, Philadelphia."

It is an undoubted improvement on the last exhibition; more varied and spirited as a whole. We hastily notice now a very few paintings of the most conspicuous merit, thus: . . . Hazeltine's 'View of the Mountains on the Rhine.'

"Washington Art Association Exhibition," *Cosmopolitan Art Journal* 2, nos. 2-3 (March- June 1958): 140.

May 1858 Sketching trip begins. During campaign visits Tivoli, Olevano, Subiaco, and south of Naples in Sorrento, Amalfi, and the island of Capri.

June 1858 In Sorrento, sketches Vesuvius.

Summer 1858 With Whittredge at Olevano. Haseltine suddenly leaves Olevano for home. Whittredge recalls:
The last I saw of Haseltine in Italy was in Olevano, I think in the month of June, in 1858; he received a letter and left me suddenly and sailed for home. I never knew much about it, but it was plain that he had something on his mind.

Plowden, 68.

Other accounts place his homecoming later in the year:
Spent the time between graduation and October 1858 (when he returned home) in studying art in different cities in Europe.

Class Book, 137.

Return to the United States

July 1858 Receives Master of Arts degree "out of course" from Harvard (although apparently did not attend graduation on 21 July), a degree conferred "in course on every Bachelor of Arts of three years' standing, on the payment of the usual fee, who shall, in the interval, have sustained a good moral character." (Class Book, 137; Faculty Records 14 [1850-1855], Harvard University Archives.)

March 1859 Established in Philadelphia at 1008 Chestnut Street; a studio visitor reports:
Philadelphia. – Hazeltine has made a great stride in his later works, having thrown off the peculiarities of his Dusseldorf training, and got a little more Italian warmth.

"Sketchings. Domestic Art Gossip," *Crayon* 6, no. 4 (April 1859): 126.

13 April 1859 Represented at the Thirty-fourth Annual Exhibition of National Academy of Design. Address given as Philadelphia: "712. *Landscape*."

And now, before leaving this penultimate room, stoop down once more – marvelling again at the strange perversity of the hanging Committee, which not only puts sight-worthy pictures entirely out of the line of sight, but neglects to project them at the foot, thus providing partial remedy for the evil – stoop, we say, and take an earnest look at no. 712, modestly registered as a Landscape, *by Mr. Hazeltine. It is just one of the most original landscapes of the year, and full of unusual beauty. It represents the outskirt of an Italian pine forest, with a stream thereby, receding from the spectator. The woods are dark; the sky is crimsoned with the flush of evening; the water reflects light without being a mere repetition of colours. There is furthermore a bold unconventional tracing of angular lines. The woods run in one line tolerably well defined; the waters in another; even the fleecy clouds are laid out as if they were a flight of birds, migrating to some happier shore. To be brief; there is as much poetry here, as in Mr. Cropsey's picture – and besides this, it is well painted." [Jasper Cropsey's* Sea-Coast of England *is no. 665.]*

"Fine Arts. National Academy of Design. Second Notice," *Albion* 37, no. 20 (14 May 1859): 237.

25 April 1859 Represented at the Thirty-sixth Annual Exhibition of the Pennsylvania Academy of the Fine Arts. Address given as 1008 Chestnut Street: "136. *View near Baveno (Lake Maggiore)*. For sale [$75.00]. W. S. Haseltine. . . 152. *After Sunset, Roman Campagnia*. Samuel Welsh. . . 219. *View on the Rhine*. For sale [$150.00]. W. S. Haseltine. . . 339. *View from the Island of Capri, near Naples*. D. Haddock, Jr."

June 1859 Seen as representative of the Philadelphia school:
The Philadelphia school (considered in relation to one branch of native Art – that of figures) is unquestionably taking precedence of other cities. A number of young men belonging to Philadelphia have enjoyed facilities for study in Europe, and are not the worse for European influences; they have come back in the possession of the resources of European skill and practice, but with minds free to contemplate and enjoy just those phases of beauty around them which their sympathies have led them to paint, and which the public can appreciate. And they have remained true to their sympathies. Walking around the galleries of the Pennsylvania Academy, one may take far more pride and pleasure in the originality of treatment, executive power, and in the ideas conveyed by the subjects of Lambdin, Perry, Furness, Craig, Lawrie, Haseltine, McClurg, Richards, and others, than in the immense canvas of Wittkamp, or in the unmeaning old masters that keep it company. We are quite aware that one "only paints children," another "only women and children," another "only grasses," another "only portraits," and so on; but we are also aware that what they do paint they paint conscientiously, and that if conscientiousness be adequately appreciated, grander ideas will come as the mind grows, by study and observation, to conceive them.

"Sketchings. Domestic Art Gossip," *Crayon* 6, no. 6 (June 1859): 193.

4 June 1859 Proposed and elected to membership in the Century Association (nominated by Frederick S. Cozzens).

July 1859 Sketching in Maine. On 9 July registers, along with Charles Temple Dix (1840-1873), at the Agamont House in Bar Harbor. At work on Mount Desert:
Of the remaining Philadelphia artists, Hazeltine is at Mount Desert.

"Sketchings. Domestic Art Gossip," *Crayon* 6, no. 8 (August 1859): 256; Agamont House register, Bar Harbor Historical Society.

Late Summer 1859 Represented at the Boston Athenaeum's Thirty-fourth Exhibition of Paintings and Statuary: "79. *Sorrento*. For sale... 82. *Paestum*. W. Dwight. [Possibly also catalogued as "311. *The Temples of Paestum*. Wilder Dwight"]... 92. *On the Roman Campagna*. For sale... 94. *On the Roman Campagna*. For sale... 186. *Old Castle, near Cologne*. For sale... 202. *Mount Pilatus, near Lucerne*. For sale... 278. *Roman Campagna*. For sale... 285. *View on the Rhine*. For sale... 314. *Castle Strohweiler*. For sale."

There are many exquisite landscapes by W. S. Haseltine, of German and Italian scenery showing the culture of the Düsseldorf school.

"Fine Arts. Athenaeum Exhibition," *Dwight's Journal of Music* 15, no. 23 (3 September 1859): 182; reprinted in "Sketchings. Domestic Art Gossip," *Crayon* 6, no. 10 (October 1859): 320.

New York Period

By November 1859 Moves to New York City. Takes a studio in the Tenth Street Building (along with Whittredge and Leutze). He quickly joins in active studio life and receptions; critics stop at his studio on their rounds:
Leutze, Hazeltine and Whitredge have taken studios in the Tenth st. building.

Philadelphia. – ... The younger men are hastening to New York. Hazeltine and Richards have already secured studios in New York; and Lambdin, junior, will probably follow in the course of a year.

"Sketchings. Domestic Art Gossip," *Crayon* 6, no. 11 (November 1859): 349.

Reporting somewhat after the fact, the same journal notes:
Philadelphia. – Little is stirring here between the men of the brush and their patrons. Rothermel, Weber, W. T. Richards, E. Moran, Schuessele, and G. C. Lambdin, are all busy. – W. S. Mason has departed to settle in your city; and if rumor plays not false, Hazeltine, Furness, Otter, Groustine, Dyke, Wilson, Howell, Wonderlich, Lawrie, and a host of other "professionals," contemplate an exodus to the all-absorbing metropolis.

"Sketchings. Domestic Art Gossip," *Crayon* 6, no. 12 (December 1859): 381.

December 1859 A visitor to Haseltine's Tenth Street studio finds that:
Hazeltine's studio is filled with souvenirs of European scenery. The walls are hung with sketches of the magnificent rocks and headlands on the bays of Naples and Salerno, added to which are Campagna and mountain views near Rome, and scenes in Venice, the whole forming a pictorial journey through the rare picturesque regions of Italy.

"Sketchings. Domestic Art Gossip," *Crayon* 6, no. 12 (December 1859): 379.

During the years 1858 and 1859, Haseltine sells ten paintings to his father; his cousins, Ward Haseltine and Daniel Haddock; his brother-in-law, Emile Marquéze, and future brother-in-law, William Poultney Smith; his father's business associate and nephew, Stephen Kimball; his Harvard classmates, Wilder Dwight and Atherton Blight; and others (including Messrs. Rose [of South Carolina] and Feltus). Prices for the works ranged from $125 to $400 (except for his father, who paid only $30), bringing in a total of $2,165. (Plowden, 73.)

1860 Listed in *Trow's New York City Directory* in the volumes from 1860 through 1865 as having his studio at 15 Tenth Street; listed in the volumes from 1861 through 1865 as residing at 7 University Place, the home of the parents of Helen Lane, whom he marries in October 1860.

10 January 1860 Represented at a reception of the Allston Association in Baltimore:
The most agreeable feature of the party was the presence of quite a considerable number of artists from New York and Philadelphia, who were in Baltimore en route for the convention at Washington, or staying here to attend the wedding of one of the brotherhood, which took place the next evening. Among our guests, no less than fourteen artists saw their works upon the walls. . . . – Shattuck, Hazeltine and Richards contributing the landscapes. . . . Dix also appeared in the adjoining room, the latter sending a noble marine, "Mt. Desert Island."

> G.B.C., letter from Baltimore in "Sketchings. Domestic Art Gossip,"
> *Crayon* 7, no. 3 (March 1860): 82-83.

19 January 1860 Represented at Studio Building reception:
We have also to chronicle a reception at the Studio Building on the evening of the 19th ult., as brilliant and as crowded as one could desire. Exhibition-room and studios overflowed with the beauties of art and nature. In the former . . . a Campagna scene by Haseltine, . . . and others, formed the principal attractions. The Light being shielded from the spectators by a screen under the gas-burners, the pictures appeared to great advantage. The studios were brilliantly illuminated, each one presenting a separate gallery.

> "Sketchings. Domestic Art Gossip," *Crayon* 7, no. 2 (February 1860): 56.

26 March 1860 Represented at Studio Building reception:
The artists of the Studio Building in Tenth street gave their second and last Reception for the season, last night. . . . The rooms of the artists were brilliantly lighted up, and a much finer exhibition of sketches and unfinished pictures was offered to their friends than will be ever seen by the public. . . . There were some striking landscapes by McEntee, Hubbard, Gifford, William Hart, Hazeltine, and Gignoux.

> "The Last Artists' Reception for the Season," *New-York Daily Tribune*,
> 27 March 1860.

Late March 1860 A studio visitor reports on works to be sent to upcoming National Academy of Design exhibition:
The exhibition of the National Academy will open as advertised, on the 12th inst. . . . We recapitulate the most important pictures produced during the winter, that are to grace the Academy walls, and first, the landscapes: Continuing the list begun in the notice of the above reception [at Dodworth's], we have to add Bierstadt's "Rocky Mountains," which promises to be one of the main attractions of the exhibition; J. M. Hart's "Placid Lake" and a "Summer Shower," Whitredge will be represented by a "View in Italy," and Hazeltine by "Rocks off the Coast of Capri."

> "Sketchings. Domestic Art Gossip," *Crayon* 7, no. 4 (April 1860): 113.

12 April 1860 Represented at the Thirty-fifth Annual Exhibition of the National Academy of Design. Address given as Philadelphia: "164. *The Faraglioni, Capri.* For sale. . . 177 *Coast of Naples.* H. A. Hurlbut. . . 267. *Villa – Lorrento.* For sale. . . 454. *Sunset near Naples.* For sale. . . 553. *Ostia.* E. Slosson. . . 572. *Claudian Acqueduct.* For Sale."

Hubbard, James Hart, Gifford, Shattuck, Coleman, Hope, Mignot, Gifford, Boughton, Nichols, Hazeltine, and McEntee, have all subjects characteristic of their styles.

> "The National Academy of Design. xxvth Exhibition.
> The Private View," *New-York Daily Tribune*, 12 April 1860.

We had nearly forgotten to say that Philadelphians need not be ashamed of their representatives in landscape either – Hazeltine, Moran, and Richards who exhibit there.

> "An American School of Art," *Philadelphia Inquirer*, 21 April 1860.

The Thirty-fifth Exhibition of the National Academy of Design, now open at the rooms corner of Tenth street and Fourth avenue, is attracting a large share of public attention. Opinions differ as to the relative merits of this collection, some maintaining that it is much inferior to that of last year, and others to the contrary, believing that it is superior. . . .

It may, however, be safely asserted that while the present exhibition contains a large number of pictures above mediocrity, the contributions of the acknowledged leaders of our artistic ranks – Durand, Leutze and others – are not what might have been expected from their reputations. Indeed, there are but few really striking pictures on exhibition this year. The number of pictures . . . is six hundred & sixty- eight. . . . Boston is represented by Walter Brackett and Wm. A. Gay; Philadelphia, by W. S. Haseltine.

> "Fine Arts," *Evening Post* (New York), 3 May 1860.

Haseltine contributes six works, of which the 'Coast of Naples' and 'Oetia' best express his powers. His pictures are well drawn, show good taste in composition and a delicate feeling, all of which rare merits would be more impressive if the Düsseldorf system of color did not interfere with them. The nullifying influence of color is again apparent in Sonntag's pictures.

> "Sketchings. National Academy of Design. First Notice," *Crayon* 7, no. 5
> (May 1860): 140.

23 April 1860 Represented at the Thirty-seventh Annual Exhibition of the Pennsylvania Academy of the Fine Arts. Address given as Studio Building, Tenth Street, New York: "87. *Mount Desert.* J. L. Claghorn. . . 100. *Old Roman Castle, Ostia.* S. Kimball. . . 152. *Landscape.* S. Kimball. . . 300. *View near Amalfi.* F. Rogers."

Hazeltine exhibits one of his best pictures in the "Castle at Ostia." He has strong natural ability, and renders his forms with considerable skill and ease, but greatly lacks delicacy and refinement in both form and color. This picture is well composed and very solemn.

"The Academy of Fine Arts," *Philadelphia Inquirer*, 3 May 1860.

April 1860 Sketches the coast of New Hampshire including Rye Beach (near Little Boar's Head, New Hampshire).

9 May 1860 Along with Whittredge and others, elected to the National Academy of Design as Associate:
New York. – At the annual meeting of the National Academy of Design, Wednesday, May 9. . . .
The following artists were elected Associates: W. L. Sontag, W. Whitredge, Jervis McEntee, C. Barry, and W. S. Haseltine.

"Sketchings. Domestic Art Gossip," *Crayon* 7, no. 6 (June 1860): 176.

Summer and Fall 1860 Sketches along the Hudson River (in July), near Lenox, Massachusetts, and on the Delaware River in New Jersey. The latter two spots are picked out by a studio visitor:
The most interesting works offered by the landscapists at this season are their summer studies from nature. Of these we would mention . . . several effective drawings by Hazeltine made at Lenox, Mass., and on the Delaware River.

"Sketchings. Domestic Art Gossip," *Crayon* 7, no. 12 (December 1860): 353.

10 October 1860 Marries Helen Lane, daughter of Sarah and Josiah Lane of 7 University Place, New York:
All our artists are flocking back to the city in great numbers. The wedding of Mr. Haseltine, on Wednesday, brought a considerable number.

"Art Items," *New-York Daily Tribune*, 13 October 1860.

23 October 1860 Sketches at Belvidere, New Jersey, on the Delaware River.

Late Fall 1860 Represented at the First Annual Exhibition of the Artists' Fund Society of New York: "129. *On the Pequest*. The Artist. . . 143. *The Eel Weir*. The Artist."

During the years 1859 and 1860 Haseltine sells thirty-five paintings to collectors (among others, Mr. Hurlbut of New York, and Messrs. Clarke, Rogers, Claghorn, and Slosson of Philadelphia) and the dealers J. S. Earle and Williams & Everett. A group of twenty works is sold at an otherwise unidentified auction. Prices for the works ranged from $25 to $325, bringing in a total of $3,756. Sometime in 1860 he acquires Gifford's sketch for the *Bay of Fundy*. (Haseltine/Plowden Family Papers; Ila Weiss, *Poetic Landscape: The Art and Experience of Sanford R. Gifford* [Newark: University of Delaware Press, 1987], 87; Plowden, 74.)

Also in 1860 Haseltine was represented at the Third Annual Art Exhibition of the Young Men's Association in Troy, New York: "63. *Ostia*. For sale. . . 65. *Coast of Naples*. For Sale. . . 71. *Rome, from the Campagna*. For sale."

March 1861 Represented at the Boston Athenaeum's Thirty-seventh Exhibition of Paintings and Statuary: "351. *The Willow Swamp*. 352. *Coast Scene – Sunset*. 353. *Naples*."

Willow Swamp. – Hazeltine exhibited at the Athenaeum a few evenings since, a landscape entitled "Willow Swamp," which is considered to be one of the best works he ever painted. It is in a somewhat different style from that in which he usually indulges, and is worthy of the position assigned it at the exhibition.

"Art Gossip," *New-York Times*, 16 March 1861.

20 March 1861 Represented at the Thirty-sixth Annual Exhibition of the National Academy of Design. Address given as 15 Tenth Street, New York: "309. *Vesuvius, from Portici*. For Sale. . . 361. *View on the Pequest, N.J.* For Sale. . . 378. *Sunrise at Rye Beach, N.H.* For Sale. 379. *The Willow Swamp*. For Sale. . . 408. *View on Delaware, near Belvidere*. For Sale. . . 502. *Amalfi*. For Sale. . . 527. *View on the Delaware*. For Sale. . . 556. *Interior of a Wood in Switzerland*. For Sale."

[Referring to landscapes in the National Academy of Design exhibition:] . . . a lively, animated one, Mr. W. S. Haseltine's no. 309, Vesuvius from Portici.

"Fine Arts. National Academy of Design – Second Notice," *Albion* 39, no. 15 (13 April 1861): 177.

Our pencil has marked for approval . . . The Willow Swamp, no. 379, by Mr. Haseltine, which has in it a sense of coming storm and a well-sustained local keeping, though it be spotty in parts and spread out too much lengthwise for the material whereof it is composed; . . . Mr. Haseltine's Amalfi, no. 512, has the same welcome touch of individuality [as Mr. Wust's Sunset over Jersey Flats]. The sky is Italian, as is the shore, if the water be too coarsely rendered considering the small size of the canvas.

"Fine Arts. National Academy of Design Concluding Notice," *Albion* 39, no. 16 (20 April 1861): 189.

The 36th Annual exhibition of the National Academy opened on the 20th ult. The collection, numbering 576 works, is not quite so large as that of last year, nor is it so interesting, there being too few figure-subjects, which are always essential to render an exhibition effective. There are nevertheless many striking and excellent works – works that indicate a steady and vigorous growth of art. . . . Hazeltine's Vesuvius from Portici *strikes us as his best work, being a fine composition and more genial in color.*

"Sketchings. National Academy of Design," *Crayon* 8, no. 5 (April 1861): 94.

12 April 1861 Confederate fire on Fort Sumter signals the beginning of the Civil War.
William's three brothers, James Henry, Albert and John, all fought in the Civil War; William was precluded from joining up, owing to the condition of his eyes.

Plowden, 77.

23 April 1861 Represented at the Thirty-eighth Annual Exhibition of the Pennsylvania Academy of the Fine Arts. Address given as 15 Tenth Street, New York: "48. *The Faraglioni, Island of Capri.* W. S. Haseltine. . . 69. *Italian Landscape.* W. S. Haseltine. . . 76. *Old Tower in the Roman Campagna.* W. P. Smith, Jr. . . . 184. *Landscape.* For sale. W. S. Haseltine. . . 220. *Ruins of an Old City on the Campagna.* James E. Caldwell. . . 224. *Acqueduct on the Campagna after Sunset.* W. S. Haseltine. . . 519. *View near Naples.* Mrs. E. S. Haseltine."

J. R. Tilten, W. S. Hazeltine, [and others in the southeast gallery] have to be noticed more particularly when we regularly review the exhibition. . . . In this room [north gallery] we also noticed views of considerable merit by . . . W. S. Hazeltine, . . . [future review mentioned never appeared].

"The Fine Arts in Philadelphia," *Philadelphia Press*, 22 April 1861.

8 May 1861 Elected full Academician of National Academy of Design:
The annual meeting of the National Academy of Design took place on the 8th ult. . . .
The following Associates were made Academicians: A. F. Bellows, James Bogle, W. S. Haseltine, David Johnson, Henry A. Loop, Jervis McEntee, A. D. Shattuck, William L. Sontag, R. M. Staigg, W. Whittredge, S. W. Rowse and J. A. Suydam.

"Sketchings. Domestic Art Gossip," *Crayon* 8, no. 6 (June 1861): 133.

29 May 1861 Represented at the Artists Patriotic Fund auction, sold by Henry H. Leeds & Co. in the Rotunda of the Merchants' Exchange, New York: "2. *Wood – Interior.*"

If all the classes of our countrymen contribute as largely toward the Patriotic Fund, in proportion to their means and their numbers as our New-York artists have done. . . . Nearly all our artists have contributed an original work . . . with characteristic paintings from . . . Hazeltine, . . . There are about seventy pictures in all.

"Art Items," *New-York Daily Tribune*, 26 May 1861.

Summer 1861 Spends early summer with wife in Cold Spring, New York. Artist and friend James Suydam reports:
Hazeltine & his wife have gone to the city where they expect to remain until Mrs. H. sheds her first born. They did not like their abode here and I expect went with willing hearts.

James Suydam to John Frederick Kensett, Cold Spring, New York, 7 August 1861, Kensett Papers, AAA, roll N68-85, frame 307.

18 August 1861 First son, Stanley Lane Haseltine, born in New York City.

24 December 1861 Represented at Young Men's Association show in Buffalo, New York: "14. *View at Lennox, Mass.* $150.00. . . 51. *On the Delaware.* $75.00."

26 December 1861 Represented at the Third Reception of the Brooklyn Art Association: "60. *Landscape*, The Artist. . . 65. *Coast Scene*, For Sale. . . 67. *Landscape*, For Sale. . . 75. *Landscape*, The Artist."

During 1861 Haseltine sold paintings sufficient to net him $1,813.08. (Haseltine/Plowden Family Papers.)

Also in 1861 Haseltine was represented at the Fourth Annual Art Exhibition of the Young Men's Association in Troy, New York: "133. *Landscape.* For Sale."

7 January 1862 Reported as represented at the Artists' Reception at Dodworth Studio building:
The Association of New-York Artists who hold their receptions at Dodworth's academy gave their first annual soiree for the present season The works of art exhibited were not so numerous as they have been at some former receptions, being not more than a hundred in all; but we do not remember ever seeing a greater number of really fine pictures on any similar occasion. . . . There were landscapes by . . . Hazeltine [and others].

"Artists' Reception," *New-York Daily Tribune*, 7 January 1862.

20 March 1862 Represented at the Third Exhibition of the Brooklyn Art Association: "40. *Iron Bound Coast of Maine*, For Sale. . . 44. *Old Mill at Amalfi*, For Sale."

Hazeltine has a small picture – a forcible study on the coast of Maine.
 "Brooklyn Art Association," *Brooklyn Daily Eagle*, 20 March 1862.

14 April 1862 Represented at the Thirty-seventh Annual Exhibition of the National Academy of Design. Address given as Studio Building, 15 Tenth-Street: "21. *Amalfi, Coast of Naples* . . . 80. *Mt. Desert Island* . . . 433. *After a Shower*. . . 438. *Iron-bound – Coast of Maine*."

W. S. Haseltine sends two or three large pictures. His view of "Amalfi, on the coast of Naples," (No. 21,) is a brilliant, showy piece, which will attract attention rather than retain it; and a view of "Mount Desert Island," also chiefly noticeable for its redundancy of color. Haseltine, however, is a young artist who has an ambition to improve, and who is destined, we think, to make his mark in the meritorious school of landscape which is rapidly growing up among us.
 "The Academy of Design. Second Notice. The Large Room,"
 Evening Post (New York), 17 April 1862.

No. 438 is a small picture, by Hazeltine. There are few elements in its composition, but the effect is very fine.
 "The National Academy of Design. A Second Visit to the Gallery,"
 New-York Times, 27 April 1862.

No. 21 is Mr. Hazeltine's Amalfi, Coast of Naples. It is almost too dainty, if not too gorgeous, for the actual coast. But the patient skill with which the whole is wrought, and the poetic sensitiveness with which the scene is felt, instantly suggest that the painter is doubtless truer in his picture than the critic in his remembrance of that lovely shore. The dingy, briny luminousness of the rising wave is masterly. It is sea-water itself rolling up on the beach, with bits of floating sea-weed caught like flies in amber. The beach itself, the burnished, rainbow- glowing pavement of the sea, is resplendent, as in evanescent, glancing sweeps of sunlight the shore may be. This picture is the best we remember to have seen by a painter of evident power.
 "The Lounger. The National Academy. – No. 11," *Harper's Weekly* 6,
 no. 280 (10 May 1862): 290.

Take a seat. Shut out, if possible, what hangs above, below, and around; and surrender yourself to the charm of a very fine sea-shore piece by a young practitioner, who is rising rapidly to a high place in his profession. We allude to no. 21, Amalfi, Coast of Naples by Mr. W. S. Hazeltine, which has had recently put upon it that best sign of appreciation – the little word, sold. The purchaser may be envied. Nothing in the whole range of Italian scenery is better worth depicting than that glorious Northern coast of the Bay of Salerno; and very rarely do we find its spirit so truthfully caught and so deftly transferred to canvas. The composition, for such we presume it to be, is bold and characteristic. A lofty and jutting crag on the left is surmounted by the inevitable ruined castle, with a few arches of an aqueduct spanning a chasm; at the foot of the rocks a few cottages; a boat hauled up; figures here and there; in two-thirds of the middle distance an open sea, reaching to the horizon; a boat running in to shore; a foreground of sands and beach and marsh soil. The atmosphere is hot with the Sirocco heat; the sun, low down, is visible and white; it is windy – you feel the salt and tepid air upon your cheek. The sea beats moderately upon the shore; the water coursing off from the golden sands leaves their rich amber to diffuse a delicious glow upon what, else, would be grey and dull. The sea – wherein so many artists fumble – is admirable for drawing, colour, movement; the boat, foreshortened, will soon be lifted-in on the crest of one of those rolling breakers, and grate her keel upon the wet and shimmering sands. There is a sensation impressed upon you, as you sit and look; and saying this, we need say little more in praise. Nineteen landscapes out of twenty, and meritorious landscapes too, fail to reach this aim, and so are little better than copies from Nature, more or less accurate. Yet in the detail there are one or two points that jar slightly. Whence, when the sun is so white and hueless, that you can look him in the eye without blinking, whence, we ask, comes the tint that touches arch of aqueduct and topmost tower on the crag, as though Sol were sinking to his rest in a gorgeous crimson bed? Why too, in the nook behind the fishing hamlet, has Mr. Hazeltine thrown in a dab of green and a cluster of trees that remind you of an English apple-orchard, or of a peculiarity amounting to a weakness in the landscapes of an able American artist now in Europe? Also, why will these sea-shore draughtsmen follow each other conventionally, in falsifying the manner in which water breaks upon a beach? In an unhappy hour – unhappy, that is, for those who dislike to see Nature misrepresented – some one discovered that a bolt-upright wave, jumping up, as it were, straight from the surface (as it sometimes does in deep, but never in shallow water) – some one, we say, discovered that this afforded a magnificent chance for showing off translucent effects. No matter how calm the sea, how gradually shelving the shore; no matter that in reality the wave rounds itself from the instant when it begins to assume a definite form; no matter that, with but a moderate swell on, the crest of the combing wave is a mass of foam – transparency is so much admired, while yeasty froth so necessitates flakes of pigment, that you rarely now see breakers or surges any more. Instead of them, so surely as there is a stretch of beach, so surely is there a long, slightly crested, pellucid, vertical billow.

Mr. Hazeltine has it here, though it is only one small item in his composition. [Comments about Suydam's Spouting Rock Beach, Newport, *and Kensett's* Sunset on the Coast *] . . . And so we pass on from Mr. Hazeltine's* Amalfi *to his* Mount Desert Island, *no. 80, which has almost as much local characterization, or in other words is altogether a different affair, though also a coast scene. Pine trees and boulders, on a slope that edges away down to the sea, are combined with a wide ocean expanse which glitters in a very strong light peering forth from behind dark clouds. There is severity predominant and in keeping throughout, while the good drawing and the indescribable sense of air and space make this also an attractive picture. But let Mr. Hazeltine beware of mistaking white pigment for light. It is an easy substitute, but passable only where the spectator is remote perforce and where effect alone is consequently studied.*

"Fine Arts. National Academy of Design. Second Notice," *Albion* 40, no. 19 (10 May 1862).

Mr. Haseltine's Coast near Amalfi *is a gorgeous work. The peculiar glow of the moist, smooth sea-beach is so evanescent an effect that the spectator can hardly criticize it justly. But the long lift of sea-water about to fall and slide up the shore is very fine, and every part of the picture is thought and treated with subtle sympathy and appreciation.*

"Editor's Easy Chair," *Harper's New Monthly Magazine* 25, no. 145 (June 1862): 125.

28 April 1862 Represented at the Thirty-ninth Annual Exhibition of the Pennsylvania Academy of the Fine Arts. Address given as 15 Tenth Street, New York: "3. *The Willow Swamp*. For sale [$250.00] . . . 104. *Rye Beach, New Hampshire*. For sale [$75.00]."

Summer 1862 Sketches along the New England shore, notably at Narragansett.

16 July 1862 Attends reunion of his Harvard class. (Report 1854, 68.)

November 1862 Represented at Third Annual Exhibition of the Artists' Fund Society, New York: "68. *Schooner Head, Mount Desert, Maine*. C. S. Seyton."

23 December 1862 Represented at the Buffalo Fine Arts Academy exhibition: "67. *Italian Coast Scene*. W. S. Hazeltine. A good "HAZELTINE" and betokens talent of good order. . . 70. *Coast of Naples* . . . 74. *Coast Scene*." Buffalo acquires *Coast of Naples* and exhibits it frequently thereafter.

3 February 1863 Represented at the Artists' Reception at the Tenth Street Studio Building, showing two coast scenes:

Haseltine's painting of Narragansett was another instance of that fine feeling for bold coast and untamed water which has hitherto made him famous in "Amalfi" and his other sea scenes. The water-spout peculiarity of waves when they sharpen into a convergent crevice, is only one of the admirably faithful representations of delicate and too often unstudied water effect, which gave attraction to the present fine painting. Another coast scene by his hand gave the sea in rather a quieter but scarcely less spirited mood.

"Fine Arts. The Studio Pictures," *Evening Post* (New York), 5 February 1863.

3 March 1863 Represented at the Sixth Reception of the Brooklyn Art Association: "189. *Narragansett*, For Sale. 190. *Narragansett*, For Sale. 191. *Narragansett*, For Sale."

No. 190, A coast scene, Narragansett, by W. S. Hazeltine, is a remarkably fine picture, characterized by strength and vigor. The rocks in the foreground look as hard and solid as nature, while the sea and the ships in the distance show a rare fidelity to Nature.

"Brooklyn Art Association: Annual Reception at the Academy," *Brooklyn Daily Eagle*, 4 March 1863.

Hazeltine exhibited two American coast views, with the same evidence of filial study of nature, the same intelligent and spirited painting of water effects, and the same capital rock drawing, which have so often proved to us that he takes an interest in the formative laws no less than the external appearance of scenery. We need not now re-state our estimate of his artistic position; in the department of coast scenery especially – since the praise deserved here was asserted a few weeks ago in noticing the Tenth Street Reception.

"Fine Arts. The Brooklyn Artist's Reception," *Evening Post* (New York), 5 March 1863.

14 April 1863 Represented at the Thirty-eighth Annual Exhibition of the National Academy of Design. Address given as 15 10th Street, New York: "10. *Sunrise at Narragansett*. Wm. T. Blodget. . . 72. *Indian Rock*. C. E. Habicht."

In Sunrise at Narragansett, *no. 10, by Mr. Haseltine, you will note another – and an extremely good one – of the popular sea-side bits of the day, made up of a foreground of rock and beach, with a translucent wave of emerald about to break, a back of smooth sea, and a sun just hazed*

sufficiently to be endurable to the sight. Why don't some of these able 'long-shore-men' diversify the view a little, try water for their foreground, and take for the middle distance all the infinite modification of form whereof terra firma *is susceptible?*

"Fine Arts. National Academy of Design," *Albion* 41, no. 17 (25 April 1863): 201.

Haseltine has two coast scenes – "Sunrise at Narragansett" (10) and "Indian Rock (72) – both evidencing the fine use his sympathies with nature have during the past year made of his eyes and sketch book. He has lost none of the power his last Academy's "Amalfi" exhibited in striking light effects – and his mastery over rocks has doubled, whether as regards form or color. Every inch of his "Indian Rock" tells a story in the most idiomatic language of nature. The staircased mass of red granite bears reminiscences all over it of a fiery birth and trial through cycles under the Thor hammer of the sea. If the water were at its wildest we question whether more oceanic force could be suggested than speaks from that sharply fractured, chinked and squared-blocked mass of finely variegated stone. In drawing light and shade and color it is one of the truest and strongest pieces of rockwork in the exhibition. In the same picture the harmony between the dun sky and the deep-green sea in its shadow is quite admirable. The transparency of the combing rollers in "Narragansett" is an example of Haseltine's best wave painting – while for the sky and the general distribution of light this is rivalled by no master-piece from his hand.

"The National Academy of Design. Its Thirty-Eighth Annual Exhibition," *Evening Post* (New York), 13 May 1863.

7 May 1863 Represented at the Fortieth Annual Exhibition of the Pennsylvania Academy of the Fine Arts. Address given as Studio Building, Tenth Street, New York: "49. *River Delaware above the Water Gap.* George Whitney. . . 347. *Scene – Bay of Naples.* [W. S. Haseltine]."

Summer 1863 Sketches New England coast from Narragansett, Rhode Island, to Portland, Maine.

16 July 1863 Attends reunion of his Harvard class. (Report 1854, 68.)

31 October 1863 Reported as represented at Goupil exhibition:
Messrs. Goupil & Co. have on exhibition a fine collection of oil paintings of the French, Flemish and American Schools, embracing characteristic works by . . . Haseltine. . . .

"The Fine Arts," *New-York Daily Tribune,* 31 October 1863.

[Note: On 26 March 1857 Michael Knoedler bought out Goupil's, New York, and the gallery became known officially as "Formerly Goupil and Company, M. Knoedler, Successor." The popular press, however, continued to cite "Goupil's" in its reviews and write-ups, even after October 1870 when the gallery became "M. Knoedler & Co." – a practice followed in this chronology.]

December 1863 Represented at the Buffalo Fine Arts Academy exhibition: "33. *The Iron-Bound Coast of Maine.* W. S. Hazeltine. Owned by Buffalo Fine Arts Academy. 34. *Coast of Naples.* W. S. Hazeltine. Owned by Buffalo Fine Arts Academy."

3 December 1863 A studio visitor reports:
W. S. Haseltine has returned to his studio after a busy summer on the sea-shore, and is at work again upon those sunny red rocks and blue waters which render his pictures so attractive and characteristic. His new sketches embrace some of the most interesting scenery to be found on our Atlantic coast, particularly along the rocky shores of Narragansett Bay, in the vicinity of Point Judith. The success which has attended Hazeltine's efforts in this way has induced him to confine his brush for the present upon similar views. To those who have sailed or strayed along the sea-coast of Rhode Island, opposite to Newport, the striking character of the scenery and remarkable tint of the rocky ledges, particularly in the afternoon sunlight, must be peculiarly interesting. To others, not familiar with that bold and beautiful coast, the sketches of this artist will be none the less valuable as presenting a phrase of scenery not exceeded in nature's attractions anywhere in this country. The pictures are painted with great boldness of effect, and the sharp irregular angles of the rocky red ledges contrast forcibly and pleasingly with the bright blue waters which circle and spread around them, and the calm, cloudless azure which bends serenely above. From present appearances, Hazeltine's red rocks are likely to become as popular and as individualized as are the mottled and somber gray ones of Kensett, so well known to all lovers of marine paintings.

"Fine Arts," *Evening Post* (New York), 3 December 1863.

7 December 1863 Reported as represented at Century Club exhibition:
Haseltine's two or three pictures of coast scenes in the vicinity of Narragansett are quite equal to any of his former works, and give a correct idea of the red rocks found in that neighborhood. The water is liquid, and the sky expressive of atmosphere.

"Fine Arts. Pictures at the Century Club," *Evening Post* (New York), 7 December 1863.

16 December 1863 Reported as represented in the Sixth Exhibition of the Brooklyn Art Association: "108. *Narragansett Bay*. I. B. Wellington."

In reference to the production of art on exhibition we have to say that the collection includes many fine landscapes by such well known artists as Gignoux . . . Hazelton, De Haas, Martin, . . .

"The Brooklyn Art Association,"
Brooklyn Daily Eagle, 16 December 1863.

26 December 1863 Reported as represented at Goupil & Co.:
Mr. Hazeltine. – Mr. Hazeltine has just completed a picture of Newport rocks. It is remarkable in the force and truth with which the effect of sunlight on the rocks and water is rendered. It is also better in quality of color than most of Mr. Hazeltine's rock studies. We have seldom, if ever, seen a stronger piece of painting. It belongs to the class of work that the Germans call objective – that is, work unaffected by emotion or mental peculiarity. It is the strongest way of rendering the fact of the subject. The picture may be seen at the gallery of Goupil & Co.

"Artists' Studios," *Round Table* 1, no. 2 (26 December 1863): 27.

Also in 1863 Haseltine was represented at the Boston Athenaeum's Thirty-ninth Exhibition of Paintings and Statuary: "311. *The Shore*. T. Appleton."

January 1864 Noted as among the country's preeminent landscape painters:
What would you or I give, dear reader, to get hold of Kensett, Hart, Colman, Inness, Haseltine, Cropsey, Casilear, Gignoux, Bierstadt, or Church for a month or two, so as to have them take suitable sketches of the charmed spots about the old country home, and in due season enshrine them in gems of choice art that would make great Nature our household friend.

"Our Artists," *Harper's New Monthly Magazine* 28, no. 164
(January 1864): 242.

2 January 1864 Reported as represented at Schaus's Art Emporium:
At present in Schaus's we find . . . a very good marine by Hazeltine.

"Schaus's Art Emporium," *Round Table* 1, no. 3 (2 January 1864): 44.

7 January 1864 A studio visitor reports:
Haseltine is engaged on a coast scene at "Seconet" or, in the Indian dialect, "Sogconnet." The rocks are carefully studied and painted, and the sea and sky clearly portrayed.

"What Our Artists are Doing. The Tenth Street Studio.
New Works on Canvas," *Evening Post* (New York), 7 January 1864.

16 January 1864 Reported as represented at the Century Association:
Dana, Hazeltine, Lang, and Cropsey were represented by works of which we wrote in a former number of the Round Table.

"Art. Pictures at the Century Club," *Round Table* 1, no. 5
(16 January 1864): 77.

13 February 1864 Reported as represented at the Century Club:
Mr. Hazeltine. – Mr. Hazeltine's two pictures in the gallery of the "Century" are perhaps an advance in certain qualities; but they are so strong and marked in style, so unmistakably Mr. Hazeltine's work that a few words of criticism are called for. They are justly appreciated and well understood; so much so that Mr. Hazeltine is threatened with the same martyrdom to a specialty as that to which Geo. Boughton was subjected after having painted his first successful winter pictures. It is a great injustice to an artist to encourage him in one direction at the expense of versatility. Most of all so when a specialty is not one of sentiment, but of subject-matter – rocks, water, and sky. Mr. Hazeltine's Newport and Narragansett rocks are by this time familiar to all art lovers of New York. In the two pictures which are the occasion of our remarks, Mr. Hazeltine shows a strong and positive talent, and a capacity equal to the forcible presentation of the local color, and the structure, of the objects in his work. The sunlight is well rendered – the light and dark of his pictures is at all times successful. What we miss is tenderness of color and delicate rendering of parts. In the two pictures at the "Century" – pictures full of light and refreshingly forcible and true in effect – the water, though well drawn, and the movement of the waves well expressed, seemed to lack in quality of wetness or liquidity, while the sky, fresh and strong in color, wanted depth and quality. It is to be hoped that Mr. Hazeltine will not suffer preoccupation with the most salient characteristics of his subjects to prevent him from giving due attention to the more subtle and exquisite parts of nature. We always expect from him vigorous and objective art work. He is yet to show perception of, and feeling for, the antithesis of these.

"Art. Art and the Century Club," *Round Table* 1, no. 9
(13 February 1864): 139.

5 March 1864 Reported as represented at Williams & Everett Gallery in Boston:
A few lines back we were writing of a want of atmosphere. In a small canvas of Hazeltine's in these last rooms, Williams & Everett's, there is its very vitality – the clear, fresh, yes, even salt nature of spray-beaten air on the rocks at Nahant or Newport.

"Boston Art Notes," *Round Table* 1, no. 12 (5 March 1864): 185.

Mathew B. Brady (1823-1896), "View of the Art
Installation" from *Recollections of the Art Exhibition,
Metropolitan Fair, N.Y.*, 1864. Courtesy of
The New-York Historical Society. Haseltine's *Sunrise
from Indian Rock* is shown at the right, middle.

24 March 1864 Represented at artists' reception at Dodworth Studio Building:

The last of the artists' receptions for the season took place at Dodworth's Studio Building on Fifth avenue last evening. The display of pictures was not as good as on former occasions . . . although there was nothing there very remarkable, there were a number of works of merit. . . . T. A. Richards, McEntee, Shattuck, Owen, Hazeltine, Whittredge, Weuzler, Pratt, T. Hart, C. G. Thompson, Gignoux, D. Johnson, Brevoort, Loop, Kittell, Baker, Green, Hall, Hennessy, Yewell, Smillie, Lazarus, Feuchsel and Bristol were severally represented.

"The Artists' Reception," *Evening Post* (New York), 25 March 1864.

The fourth of these very agreeable assemblies, and, we believe, the last of the Winter, was held at Dodworth's building on Thursday evening. . . . Mr. Haseltine had a picture representing a passage of scenery on the coast of Maine, which attracted some attention. But the picture is very feeble and does no sort of justice to the grand character of the rocks, and the sea is most lamentably tame. We had hoped something from this artist's previous pictures, which seemed to us to show a sign of promise, but he must abandon this pretty, neat way of treating rocks and surf, if he wishes to associate his name with the much resounding sea. A rock is a solid body, capable of resisting the force of wind and water, it is not a semi-transparent structure of tissue paper, which the flirt of a fish's tail would knock over; and the dash of the breaker is something more, believe us, than the foam blown from a glass of weak beer. Why will artists who are just beginning to try their powers take subjects like this, which can hardly be successfully handled after years of patient labor.

"Fourth Artists' Reception," *New-York Daily Tribune*, 26 March 1864.

1 April 1864 Represented at New York's Metropolitan Sanitary Fair, for which he served on the "Art Committee" with prominent artists and collectors: "304. *Sunrise from Indian Rock.*"

On Saturday evening the Art Gallery of the Sanitary Fair was opened. . . . We regret that we have only space for a mere mention of works quite as strongly attracting our attention. Simply because we began at the north end we find no room for what we wish to say of works by Whittredge, Hubbard, Casilear, J. G. Brown, Hazeltine, Coleman, Lang, Hays and others, who have done most manly work for the Fair, not only with the brush, but with assumption of manifold cares and responsibilities.

"The Private View," *Evening Post* (New York), 4 April 1864.

15 April 1864 Represented at the Thirty-ninth Annual Exhibition of the National Academy of Design. Address given as Studio Building, 15 Tenth Street, New York: "153. *Iron-Bound, Coast of Maine.*"

No. 153, by Haseltine, is called the "Iron-Bound Coast of Maine," and is a luminous water-scape, boldly and yet delicately painted. The outlines of the rocks, the easy movement of the water, and the white moisture of the atmosphere, are particularly good.

"National Academy of Design. Notices of the Works on Exhibition," *New-York Times*, 5 May 1864.

No. 153. "Iron-Bound Coast of Maine." W. S. Haseltine, N. A. An unfortunate title, we venture to suggest, for it at once draws attention to the fact that the rocks are of a texture quite the opposite of iron; so slight and unsubstantial, in fact, that, if they had to bear the shock of a real ocean, Maine would be very badly off indeed. However, Mr. Haseltine, seeing her strait, has kindly provided an ocean of the most inoffensive character, one that would not so much as lift a knotted tassel of sea-weed, or provoke a barnacle to open his mouth, if the fate of the world depended on it. On such a civil, mild-spoken, bland ocean an iron-bound coast would be quite thrown away, as useless as an iron helmet for a lady's curls, and we are glad to record that the painter has regarded the fitness of things, and neither wasted his billows on rocks that could not stand their shock; nor his rocks on billows that all the east winds that ever blew could not rouse to the most vapid expression of an intention to do them any injury whatever.

Clarence Cook, "National Academy of Design. The Thirty-ninth Exhibition," *New-York Daily Tribune*, 7 May 1864.

In conclusion of our review of the most representative pictures of the Thirty-Ninth Annual Exhibition of the National Academy of Design, we would remark that Mr. C. G. Colman, Mr. Warren, Mr. Shattuck, Mr. Hazeltine, Mr. R. Swain Gifford, Mr. George Owen, Mr. Clinton Ogilvie, Mr. J. F. Weir, and Mr. J. S. Brown exhibit works interesting and meritorious.

"Art. Exhibition of the National Academy of Design. III," *Round Table* 1, no. 21 (7 May 1864): 237.

And now is any one curious to know why we have not found a word to say concerning Messrs. Huntington, . . . Haseltine, Hall, and other regular contributors? We can but answer that these various gentlemen's contributions, more or less meritorious, are so precisely, in style or subject or both, duplicates and triplicates and quadruplicates of originals familiar to the town, that to go over them again would be wearisome to the writer and reader.

"Fine Arts. The National Academy of Design. Second Notice," *Albion* 42, no. 20 (14 May 1864): 237.

18 April 1864 Represented at Baltimore's Maryland State Fair: "93. *Amalfi.* B. F. Gardner. . . 393. *Amalfi.* B. F. Gardner."

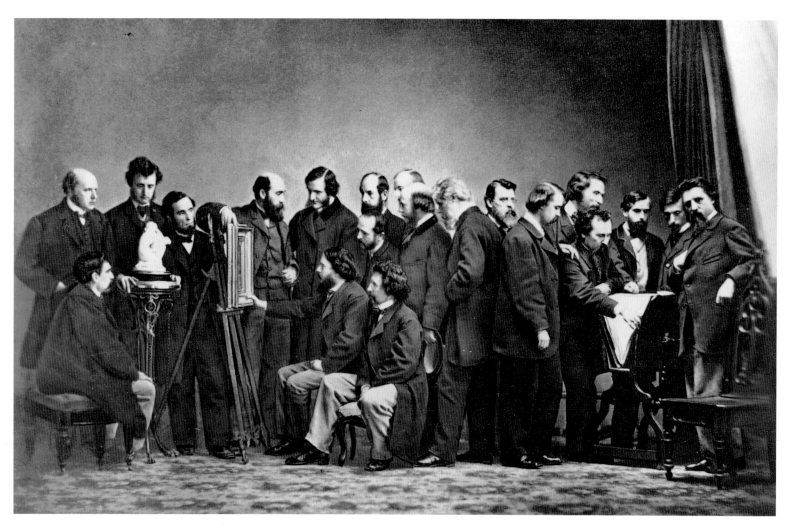

Mathew B. Brady (1823-1896), "The Art Committee"
from *Recollections of the Art Exhibition, Metropolitan Fair, N.Y.*, 1864. Courtesy of The New-York Historical Society. Haseltine is sixth from the right.

19 April 1864 At Metropolitan Fair auction *Sunrise from Indian Rock* (no. 147 in auction catalogue) is sold for $350. Haseltine also contributes two sketches that are included in the "Two Black Walnut Caskets, Each containing 55 sketches by American Artists, to be Sold, with other Works of Art, at Auction."

27 April 1864 Represented at the Forty-first Annual Exhibition of the Pennsylvania Academy of the Fine Arts. Address given as New York: "165. *Marine View near Newport*. T. Hilsen."

12 May 1864 Represented at the Seventh Exhibition of the Brooklyn Art Association: "13. *Marine*. S. B. Caldwell."

4 June 1864 Attends
the last regular monthly meeting, for this season, of the members of the Century Club. . . . We were surprised to find so many artists there. Kensett, Gifford, Bierstadt, Cranch, Hazeltine, Huntington, Gignoux, Hennessy, Suydam, Hicks, Hall, Hays, Lang, Thompson, and Johnson were present."
"Art and the 'Century,'" *Round Table* 1, no. 26 (11 June 1864): 407.

7 June 1864 Represented at Philadelphia's Great Central Fair: "9. *Amalfi*. Rogers, F., Prof. . . 183. *The Seven Mountains*. Ward B. Haseltine. . . 193. *Ruins of Nero's Villa*. E. W. Clark. . . 233. *Willow Swamp*. Miss Bohlen. . . 311. *Narragansett*. J. B. Wellington, Brooklyn. . . 593. T*he Bay of Baie*. Chas. Macalester."

10 June 1864 Travels from Philadelphia to New York.

11 June 1864 On his 29th birthday, his wife, Helen Lane Haseltine, dies in childbirth with a newborn son.

21 June 1864 Haseltine returns to Pennsylvania to sketch in the Lehigh Valley.

Summer 1864 Sketches in Massachusetts, especially Nahant, Lynn, Salem, and Gloucester:
Still southward, Haseltine divides his time between fashion and the sea at Nahant.
"Movements of Artists," *Watson's Weekly Art Journal* 1, no. 14 (30 July 1864): 213.

Haseltine, who passed the summer months at Nahant, has brought back many admirable studies of the scenery of that neighborhood. Many of his studies are as elaborate in their completeness as finished pictures – the rocks, water, and sky being painted with such a closeness and fidelity to nature as to leave little for the artist to add when he comes to use them in large works. It is within three years that Mr. Haseltine has come into notice as a painter of coast scenes, and so marked has been his success, that his prominence and superiority in the portrayal of the rocky shores of Nahant and Narragansett are by all fully acknowledged. Agassiz pronounces the rocks of Nahant to be the oldest on the globe, and that they are of volcanic origin. Mr. Haseltine fully conveys their character in his pictures, and no one who has wandered over those huge masses of rough red rock, and watched the waves breaking against them, could fail to locate, from his studies, the very spot he has delineated.
"Among the Studios," *Watson's Weekly Art Journal* 1, no. 24 (8 October 1864): 372.

Fall 1864 Goupil works on an engraving of *Indian Rock, Narragansett*; this will later appear in *Appleton's Journal* (1869) and *Picturesque America* (1872):
Goupil is about to issue an engraving of "Indian Rock, Narragansett," after a recently-painted picture by Haseltine. It will prove an acceptable companion to Kensett's "Noon on the Seashore," and Casilier's "Lake George."
"Fine Art Items," *Watson's Weekly Art Journal* 2, no. 1 (5 November 1864): 20.

Represented in Exhibition of a Private Collection [James L. Claghorn] of Works of Art for the Benefit of the United States Christian Commission, held at the Pennsylvania Academy of the Fine Arts: "134. *Near Mount Desert*."

5 November 1864 Represented at and participates in the Bryant Festival at the Century Club:
An elegant portfolio of red morocco, gotten up by Mr. Knoedler, destined to contain over forty sketches by the artist members of the "Century," was then presented to Mr. Bryant by the President. Of the sketches already finished we recall "An Autumn Day," by Cranch; a landscape, with lake and mountains, by Gifford; a Rocky Coast Scene, by Haseltine.
"The Bryant Festival at the Century Club," *Watson's Weekly Art Journal* 2, no. 3 (12 November 1864): 37.

Haseltine's Marine Views, of which there were several, bore, unmistakably, the signet of his hand, and in their moods of nature, were excellently rendered.
"Pictures at the Century Club," *Watson's Weekly Art Journal* 2, no. 3 (12 November 1864): 37.

Winter 1864 Represented at the Utica Art Exhibition of American and Foreign Paintings and Sculpture at the Mechanics' Hall, in Connection with the Twentieth Annual Fair of the Utica Mechanics' Association: "47. *Marine.*"

3 December 1864 A studio visitor reports:
Haseltine is occupied on a large marine picture, on the Nahant coast, being a view of the "Preacher's Rock" – the name given to a great mass of rock of a picturesque form, which rises above the shore and juts out over the water. The color of the rocks, with the sunlight falling full upon them, is warm and strong. The action of the waves is happily rendered.
 "Among the Studios," *Watson's Weekly Art Journal* 2, no. 6
 (3 December 1864): 83.

14 December 1864 Reported as represented at the Fall Exhibition of the Brooklyn Art Association: "106. *Marine.*"

Of course, in view of the fact of the crowded state of the gallery during the evening it was impossible to obtain any but a mere cursory glance at the pictures of the exhibition, but of the contributions sent in the following appeared to attract the most attention. No. 3, "In the Glen," by William Hart; . . . No. 106, "A Marine View," by W. V. Hazeltine; . . .
 "Brooklyn Art Association: Fall Exhibition at the Academy,"
 Brooklyn Daily Eagle, 14 December 1864.

Haseltine, Bradford, Kensett, and De Haas, were each represented by characteristic marines of Narragansett, Newport, Labrador and England, coast scenery.
 "Artists' Receptions," *Watson's Weekly Art Journal* 2, no. 8
 (17 December 1864): 116.

20 December 1864 Haseltine's name is among those of forty-eight artists on invitation to Samuel P. Avery's new Art Rooms at 694 Broadway, New York. (*The Diaries, 1871-1882, of Samuel P. Avery, Art Dealer*, ed. and intro. by Madeleine Fidell-Beaufort, Herbert L. Kleinfeld, and Jeanne K. Welcher [New York: Arno Press, 1979], xix.)

31 December 1864 A studio visitor reports:
Haseltine is engaged on a large picture of "Pulpit Rock," with heavy, fog-clouds in the sky, a stiff breeze blowing, and wind-tost waves. It promises to be a strong and effective work.
 "Fine Art Gossip," *Watson's Weekly Art Journal* 2, no. 10
 (31 December 1864): 147.

Throughout 1864 Haseltine sells twenty-four paintings to such collectors as R. M. Oliphant, Joseph Wharton, J. Pierpont Morgan, J. S. Warren, J. C. White, and Lydig Suydam, as well as to dealers M. Knoedler and Williams & Everett. Prices generally range from $100 to $525, netting $6,021. Haseltine himself acquires works by other artists, including Aaron Draper Shattuck and George Inness. (Haseltine/ Plowden Family Papers.)

14 January 1865 Represented at the Century Club:
The Bryant Album will be exhibited at the Century Club this [Saturday] evening. The collection of sketches by the artists who contribute is nearly completed, but few of the sketches promised being lacking.
 "Bryant Festival," *Watson's Weekly Art Journal* 2, no. 12
 (14 January 1865): 180.

21 January 1865 A studio visitor reports:
Hazeltine has completed his large picture of "Pulpit Rock." The fine form of the rock, the waves surging and dashing against it, the wide expanse of water reaching to the horizon, and the blue sky bending over all, form a picture of great beauty and excellence.
 "Among the Studios," *Watson's Weekly Art Journal* 2, no. 13
 (21 January 1865): 195.

24 January 1865 Represented at Dodworth Studio Building's artists' reception:
The first of the artists' receptions given in this city the present season, took place last Tuesday evening, at Dodworth's building on Fifth Avenue . . . Hart, Kenseth, Gifford, De Haas, Hazeltine, and Bradford, were represented by marines.
 "Artists' Reception," *Watson's Weekly Art Journal* 2, no. 14
 (28 January 1865): 213.

February 1865 Represented at the Buffalo Fine Arts Academy: "8. *The Iron Bound Coast of Maine. . . 137. Marine.* For Sale."

Goupil sells *Marine* for $355, taking an 11 percent commission of $39.05. (Knoedler Sales Book 1, 89; Knoedler Gallery library.)

4 February 1865 A studio visitor reports:
Haseltine is engaged on a large marine view, which gives promise of becoming one of his best and most effective works. . . . Haseltine is occupied on a large coast view.
 "Among the Studios," *Watson's Weekly Journal* 2, no. 15
 (4 February 1865): 227.

16 February 1865 A studio visitor reports:
Haseltine has a large marine view of a rocky coast near Nahant, with Castle Rock in the middle distance, jutting out into the water. A fine effect of sunlight and shadow on the rocks is obtained by the artist, and the character of the water and the sky is truthfully presented.

"A Visit to the Studios. What the Artists are Doing," *Evening Post* (New York), 16 February 1865.

18 February 1865 A studio visitor reports:
Haseltine is occupied on a large painting of "White Cliff, Portland Harbor," one of his best works. The sky, with its light clouds, is excellently well painted, and the rocks and water rendered with spirit and fidelity.

"Among the Studios," *Watson's Weekly Art Journal* 2, no. 17 (18 February 1865): 259.

27 February 1865 Represented at the Montreal Art Association exhibition: "161. *View at Nahant.* For sale. Owner: Unidentified, Boston."

March 1865 Represented at the Spring Exhibition of the Brooklyn Art Association: "78. *Narragansett Bay.* M. Snow."

[No.] 78. "Narragansett Bay," by Hazeltine would be a fine work of art, if it were a little more natural. The sea is too green and the cliffs too red.

"Brooklyn Art Association," *Brooklyn Daily Eagle*, 22 March 1865.

25 April 1865 Represented at the Forty-second Annual Exhibition of the Pennsylvania Academy of the Fine Arts. Address given as New York: "541. *Coast of Italy.* C. [F.] Haseltine... 592. *White Head, Portland Harbor, Me.* J. G. Fell."

No. 592, "White Head, Portland Harbor, Maine," is by Mr. Haseltine. In many respects this is a thoroughly excellent picture, although the rocks are somewhat too unmitigatedly square and hard in outline. The water is deliciously pencilled, although somewhat too brilliant in tone. It is a clever attempt to transcribe nature poetically, with a very free hand.

"Fine Arts," *Philadelphia Press*, 25 April 1865.

27 April 1865 Represented at the Fortieth Annual Exhibition of the National Academy of Design. Address given as 15 West 10th Street: "162. *Castle Rock, Nahant.* L. P. Morton... 212. *Pulpit Rock, Nahant.* R. Stuyvesant... 442. *Castle Rock, Nahant.* L. P. Morton."

This rock nuisance pursues us again in No. 212, by Mr. W. S. Haseltine, N. A., who gives us the peculiar formation of "Pulpit Rock, Nahant." The charm of such a hard transcript is unknown to us. We recognize the manual skill of the artist, and no more. It would be a relief if Mr. Haseltine would go to work at once and paint a quarry. He might in such wise get over it, and become as surfeited as the rest of the public.

"National Academy of Design, North Room," *New-York Times*, 29 May 1865.

Mr. Haseltine's Castle Rock, Nahant, *no. 442. is one of the best that we have seen of his many groups of bold, dark rocks, edged by a bright, blue sea. Admirable as this is, there is too much repetition of former things in the same line. But, as the young artist has gone to pass the summer at Capri, we may hope for some novelties from him anon.*

"Fine Arts. The National Academy of Design. Fourth Notice," *Albion* 43, no. 22 (3 June 1865): 261.

No. 442, "Castle Rock, Nahant," is another of Mr. W. S. Haseltine's carefully manufactured articles in stone-ware and water.

"National Academy of Design. South Room," *New-York Times*, 13 June 1865.

30 May 1865 Represented at Chicago's Northwestern Sanitary Fair: "109. *Nahant Rocks.* S. P. Avery, New York... 226. *Roman Champagna.* A drawing. Owner: North-Western Sanitary Fair, Chicago [exhibited under the heading "The Artists' Album" as one of fifty-two works donated to the Fair with a combined value of $5,000]."

By June 1865 Travels to Capri:
Charles Dix and Hazeltine are refreshing themselves and filling their portfolios with marine effects and coast scenery on the Isle of Capri. The last news of importance from them is that on the Fourth of July they gave a fete to the entire population of the island. It is reported to have been something quite extraordinary and to have cost – including fireworks, wine, banquets, etc. – nearly twenty francs.

"Art. Art Notes," *Round Table* n.s. 2, no. 1 (9 September 1865): 7.

September 1865 T. B. Aldrich's article on the Tenth Street Studio Building cites Haseltine:
On Tenth Street, between the Fifth and the Sixth Avenues, stands a large three-story building of red brick, with brown sandstone trimmings.... On the third story are Gifford, Hubbard, Suydam, Weir, Shattuck, Thorndike, Haseltine, De Haas, Brown, Casilear, and Martin. Here they are all together, – historical, figure, portrait, landscape, marine, animal,

S. Beer, *Haseltine's Tenth Street Studio*, ca. 1865.
Haseltine/Plowden Family Papers. A painting closely
related to the Cleveland Museum of Art's *Capri* is at
top right.

*fruit, and flower painters. It is not often that so many clever fellows are
found living under one roof. A community composed exclusively of gifted
men is unique, – a little colony of poets, for they are poets in their way, in
the midst of all the turmoil and crime and harsh reality of the great city!*
 "Among the Studios. No. 1," *Our Young Folks* 1, no. 9
 (September 1865): 595, 596.

November 1865 Receives negative review of work:
*Hazeltine has painted a number of pictures which have for subject ledges
of the siennite rock which seems to constitute the greater part of this
Gloucester coast. I do not know where he found the rocks he has painted,
but nature has evidently made them in a different mood from that in
which she built this shore. That is, supposing his pictures to be true. I find
at every step something new. I cannot find, as he appears to, square foot
after square foot of bare, smooth, clean-cleft, swept and garnished rock –
but the whole surface is scarred and broken with crack and cleavage, with
disintegration accomplished and in process, with marks of chemical and
of mechanical action; and the keener the eyes the more is to be seen. Let
Agassiz come and straightway a new world opens, new truths appear; the
rock is a palimpsest, and every student of nature sees through new layers
of obscurity and reads the clear, divine handwriting, the record of the life
of the globe. But, plain to be seen are many things which the half-looker
never sees. This rock has its vegetation, its animal life, its incidents of vari-
ous kinds, and not one of these has Hazeltine ever painted. I look across
the ledge, where I am lying, to the water – every crack and cranny has its
bit of grass, its waving weed, its tuft of golden-rod, and, given a golden-
rod, take for granted a butterfly! There he is, this minute! and will you
get a prettier story than that to put in your foreground; this yellow flower
with its yellow butterfly standing up against the blue sea?" Sept. 1865.*
 "Leaves from a Note-Book," *New Path: A Monthly Art-Journal* 2, no. 11
 (November 1865):181.

Late November 1865 Represented at the Sixth Annual Exhibition of
the Artists' Fund Society, New York: "239. *Coast Scene*. . . 303. *Indian Rock
Narragansett*. J. T. Johnston. . . 307. *Castle Rock Nahant*. J. T. Johnston."

*We have no space to write of certain beautiful works which, with pictures
that must be seen only to be forgotten, go to make up the collection of the
Artists' Fund Society. Messrs. Whittredge, Hubbard, Kensett, Church,
Gifford, Brown, Hennessy, Hazeltine, Ryder and Martin exhibit charac-
teristic pictures, and of an excellence of which the public are not ignorant.*
 Sordello, "On the Artists' Fund Exhibit," *Evening Post* (New York),
 29 November 1865.

S. Beer, *Haseltine's Tenth Street Studio*, ca. 1865.
Haseltine/Plowden Family Papers. A painting closely
related to the Cleveland Museum of Art's *Capri*
is at top right, above the Vulcan Material Company's
Rocks at Narragansett, before figures were added.

S. Beer, *Haseltine at Work in His Tenth Street Studio*,
ca. 1865. Haseltine/Plowden Family Papers.

5 December 1865 Represented in the Philadelphia Sketch Club exhibition. The exhibition later travels to New York: "33. *Clearing Up.* For sale. . . 87. *View Near Naples.* . . 121. *Coast of Capri.* For sale."

Mr. W. S. Haseltine's "Coast of Capri"! We have here a large, luminous picture of sea and shore, with piles of rock arching far out into the sparkling water, and picturesque peasants strolling along the sunny beach. A painting like this is sure to delight the general eye; and we think it will not be long before this brilliant painting will bear the words "for sale," on the catalogue opposite its title.

"The Philadelphia Sketch Club. Its Exhibition in New York,"
Evening Post (New York), 1 February 1866.

Throughout 1865 Haseltine sells paintings to such collectors as Rutherford Stuyvesant, J. G. Fell, the Hon. Levi P. Morton, Codman, J. T. Johnston, the artist John F. Kensett, and to dealers M. Knoedler, Snedecor, S. P. Avery, Williams & Everett, and his brother, Charles F. Haseltine. Prices generally range from $100 to $800, netting $9,825. (Haseltine/Plowden Family Papers.)

January 1866 Haseltine acquires Oswald Achenbach painting, *Early Morning on the Campagna*, from Goupil for the sum of $1000. (Knoedler Sales Book 1, 139; Knoedler Gallery library.)

February 1866 Consigns several paintings, by himself and others, to Goupil; these are sold through Leeds & Miner on 15-16 February, netting $227.90. (Knoedler Sales Book 1, 141; Knoedler Gallery library.)

28 February 1866 Marries Helen Marshall, daughter of Captain Charles Henry Marshall, owner of the Black Ball Line and president of the Union League Club. Helen Lane and Helen Marshall had been best friends.

March 1866 Receives artist William Sidney Mount as studio visitor. Mount later records:
W. Stanley Hazeltine N.A. Marine painter. 15 West 10th St – Water, if a clear day and a moderate breeze is painted darker than the sky, the surface of it has a purplish hue, and the dark waves are touched in with a tint of the dark blue sky over head, with reflected tints – Lastly, the foam of the waves is touched, in the right place rising or falling. Mr. Hazeltine paints a fine picture; colors well contrasted. His thoughts are evidently at the end of his brush.

William Sidney Mount Archival Collection, The Museums at
Stony Brook, New York.

21 March 1866 Represented at the Spring Exhibition of Brooklyn Art Association: "131. *Bay of Amalfi*, For Sale. . . 197. *Narragansett*, For Sale."

7 April 1866 A studio visitor reports:
Haseltine, whose studio is also in the Tenth St. building, is engaged upon a large picture, now nearly completed, which renders a view of a rocky promontory of the island of Capri, and stretching from its base, the bay of Salerno. This island is chiefly known in history as the residence of the Emperor Tiberius, who chose it from its difficulty of access. Here he erected twelve villas, which he named after the twelve chief deities of the old mythology. The ruins of the villa of Jove may still be seen, and surmount, as represented by the artist, the cliff looking towards Sorrento. From the cliff, which is 1300 feet high, the early Christian martyrs are said to have been flung. The rocks are of a limestone formation much displaced and broken by subterranean action, and present, therefore, shapes of which the picturesqueness verges upon the grotesque. Thus at foot of the great cliff here represented, which is known as Monte Tiberio, rises an arch-like and pinnacled formation of rocks, the Taraglione, 500 feet in height. In the distance the eye catches sight of the rocky elevations a little separated from the main-land, known as the island of the Sirens, famous in the songs of the poets from Homer to the present day. But Mr. Haseltine's studies are not all drawn from the coast of Italy. He acknowledges the fine opportunity for picturesque drawing which our own coast affords; his studio contains several views of Nahant and the Narragansett.

Mr. Haseltine has not confined himself to marine painting. We observed a view on the Pequod Creek, New Jersey, a picture which embraces a beautiful ensemble *enlivened by picturesque details. The eye catches a quiet expanse of water, bordered by meadows upon which a few trees are scattered; the time is autumn, and the picture is remarkable for the delicacy and individualization of color, neither lacking in warmth nor running into exaggeration, with which the artist has rendered the hues of this season; the careful drawing of the trees and of the grasses in the foreground is also worthy of remark, nor has this nicety of treatment interfered with the general effect of the whole. We have allowed ourselves, as the reader will perceive, to be betrayed into laudations, contrary to the custom of these notices, but our excuse is that this, together with other works of Mr. Haseltine, are soon to form a portion of a collection to be offered at public sale, in anticipation of which we may have no other opportunity than the present of characterizing the picture as we think it deserves; besides, we hope to see the artist encouraged in studies of nature displaying such closeness of eye and refinement of feeling. The sale we speak of is to consist of the works of Haseltine, H. Peters Gray, McEntee, Hennesey, Ehninger, Winslow Homer, Cranch, Bellows, Stone, Benson, and others. It will take place at the Gallery of Miner & Sommerville, No. 845 Broadway. The*

works are offered fresh from the artists' studios, and have never yet been submitted to the public.

"The Studios," *Watson's Weekly Art Journal* 4, no. 25 (7 April 1866): 387.

12 April 1866 Consigns eight paintings with Goupil "for auction"; the account is marked "Settled." (Knoedler Sales Book 1, 159; Knoedler Gallery library.)

14 April 1866 A studio visitor reports:
... others who, like Hazeltine, direct their study more particularly to the bold cliffs and jutting rocks against which the sea beats in vain.

"The Studios," *Watson's Weekly Art Journal*
4, no. 26 (14 April 1866): 403.

19 April 1866 Sells thirty-four works at the "American Artists' Sale," Miner & Somerville in anticipation of departure for Europe: "1. *West Island. Seconet Point... 6. Low Tide. Nahant... 10. Narragansett Rocks ... 13. Foggy Morning. Nahant... 16. Pea Island, Nahant. 17. Indian Rock, Narragansett... 22. Black Rock, Nahant... 24. East Point, Nahant ... 26. Flat Rock, Narragansett... 28. Evening. Narragansett... 30. Near Amalfi, Naples. 31. On the Pequod, New Jersey... 33. Narragansett Beach ... 35. Egg Rock, Nahant... 37. Prospect Rock, Nahant... 39. Castle Rock and Egg Rock, Nahant... 41. Summer Afternoon at Narragansett... 43. Capri... 46. Pulpit Rock, Nahant... 48. Morning Fog, Narragansett... 50. Claudian Aqueduct, Roman Campagna. 51. After a Shower. Nahant ... 55. Easterly Wind. Nahant... 58. Atrani, Coast of Naples... 60. Nahant... 62. Castle Rock, Nahant... 66. West Island, Seconet Point... 69. Nahant... 72. Foggy Morning... 78. Narragansett... 81. Indian Rock, Narragansett... 84. The Brothers, Nahant... 89. Nahant. Study from nature... 95. Narragansett."*

An auction sale of pictures by American artists will take place tonight, at Miner & Somerville's gallery. Hazeltine contributes a number of his best coast views – many of them studies from nature.

"Sale of Pictures," *Evening Post* (New York), 19 April 1866.

The collection of the works of Hazeltine and other distinguished artists of this city, put up by Sommerville & Miner, contained illustrations of their best work, fresh from the studios. We have not been able to get a report of this sale.

"The Recent Picture Sales," *Watson's American Art Journal* 5, no. 2 (April/June 1866): 28.

The auction sale of pictures by American artists took place last evening. The following named pictures brought one hundred dollars and upwards: Black Rock. Nahant, by Haseltine. $128 ... Pulpit Rock, by Hazeltine. $175 ... After a Shower, by Haseltine $100 ... Coast of Naples, by Hazeltine $650 ... Castle Rock, by Hazeltine $100 ... Indian Rock, by Haseltine $112

"Sale of Pictures by American Artists," *Evening Post* (New York) 64,
20 April 1866.

Years Abroad
May 1866 Travels to Europe; in Paris by 28 May:
W. S. Haseltine has just taken his departure for Europe, where he intends to remain for two years, at least.

"Addresses of Artists," *Round Table* 3, no. 37 (19 May 1866): 311.

June 1866 Establishes studio at no. 11, Boulevard de Clichy (rent paid 9 June, $265). Leaves immediately for Switzerland, arriving at Lucerne on 14 June. Acquires a landscape painting by Andreas Achenbach in Lucerne on 21 June, for which he pays $1,750. (Haseltine/Plowden Family Papers.)

Represented at the Chicago's Crosby Opera House Art Association: "24. *Narragansett Bay.* To be Distributed. A bright, blowing sea, rolling and dashing against solid rocks... 235. *The Bay of Naples.* To be Distributed. One of Haseltine's charming transcripts of European scenery, painted with even more than his usual precision."

14 July 1866 Reported as traveling throughout Switzerland:
W. S. Haseltine is traveling in Switzerland. From this excursion we may look for some novelty in his repertoire of studies. He has been giving us rather too much of Capri lately.

"Art Notes," *Round Table* 3, no. 45 (14 July 1866): 438.

22 August 1866 Reported as planning to settle in Paris:
As many of our artists are now studying in Europe, we have taken the trouble to find out who and where they are. A large number of them are in Paris. We give their names: Babcock, May, F. Howland, Thom, Inman, F. B. Mayer, Robbins, and Haseltine, of this city.

"Art Galleries and Gossip," *Watson's Art Journal* 5, no. 18
(22 August 1866): 278.

After 16 September 1866 Settles family at No. 22, Avenue Josephine (now the Avenue Marceau, 8th arrondisement).

Le Juene, photographer, *William Stanley Haseltine,* ca. 1867. Haseltine/Plowden Family Papers.

December 1866 Among 300 guests at banquet for General John Adams Dix (father of Charles Temple Dix), who has become the new Minister to France.

10 December 1866 Son, Charles Marshall Haseltine, is born in Paris.

Throughout 1866 Haseltine sells paintings to such collectors as H. W. Grey, William S. Doughty, C. S. Seyton, Mr. Vernon, D. Oliphant Vail, J. Cooper Lord, and Andrew Dickson White, who acquires a major Capri view. Haseltine himself acquires works by other artists including Andreas Achenbach and Alfred van Muyden. (Haseltine/Plowden Family Papers.)

Also in 1866 Haseltine is represented in at least two other American exhibitions –
Wellington Gallery, Brooklyn: "20. *Narragansett Bay.*"
First Annual Exhibition of the Utica Art Association: "57. *October Day, View on Pequod Creek, N.J.* . . 159. *East Point, Nahant.* For sale. . . 176. *Nahant Point.* For Sale. . . 235. *Newport Rocks.* For Sale."

4 February 1867 Goupil records an "account sale for W. S. Haseltine"; apparently they have bought from Haseltine two paintings by Hermann Herzog, and one by Haseltine (a Castle of Chillon), for $1,150; they deduct the cost of a frame for the Haseltine painting and freight from Paris, leaving a net of $937.33 which was "paid Jany 31 to Alb. C. Haseltine." (Knoedler Sales Book 1, 210; Knoedler Gallery library.)

February 1867 Represented at the Artists' Fund Society of Philadelphia: "19. *Sketch.* C. J. Price."

15 April 1867 Represented at the Paris Salon. Address given as "boulevard de Clichy, 11, et chez M. Munroe, rue Scribe": "726. *Capri.* 727. *Rochers à Capri.*"

22 April 1867 Represented at the Forty-fourth Annual Exhibition of the Pennsylvania Academy of the Fine Arts: "256. *Castle of Chillon.* Jay Cooke."

10 May 1867 Travels to Fontainebleau for the day.

June 1867 Travels to Switzerland and Italian Lake District.

October 1867 Travels along French and Italian Riviera.

November 1867 Travels in northern Italy.

3 December 1867 Travels to Rome where he settles in the Via Babuino, with studio near the Piazza del Popolo, where he stays through April.

1867 Henry T. Tuckerman's *Book of the Artists* mentions Haseltine favorably at length:

William S. Haseltine gives ample evidence of his Düsseldorf studies, whereof the correct drawing and patient elaboration are more desirable than the color – although herein also he has often notably excelled. Few of our artists have been more conscientious in the delineation of rocks; their form, superficial traits, and precise tone are given with remarkable accuracy. His pencil identifies coast scenery with emphatic beauty; the shores of Naples and Ostia, and those of Narragansett Bay, are full of minute individuality, wherein one familiar with both, and a good observer, will find rare pleasure; it is the same with "Amalfi" and "Indian Rock" – Italy and America are, as it were, embodied in the authentic tints of these rock-portraits set in the deep blue crystalline of the sea. The waves that roll in upon his Rhode Island crags look like old and cheery friends to the fond haunters of those shores in summer. The very sky looks like the identical one beneath which we have watched and wandered; while there is a history to the imagination in every brown angle-projecting slab, worn, broken, ocean-mined and sun-painted ledge of the brown and picturesquely-heaped rocks, at whose feet the clear, green waters plash: they speak to the eye of science of a volcanic birth and the antiquity of man, and with their surroundings, distinctly and, as it were, personally, appeal to the lover of nature for recognition or reminiscence.

One of Haseltine's best pictures of the Eastern coast belongs to Dorman Eaton, Esq., of New York; another to C. E. Habicht, Esq. "Indian Rock," Narragansett, and "Castle Rock," Nahant, are in the collection of J. Taylor Johnson, Esq., of New York; and "Seconet Point" belongs to R. M. Olyphant, Esq. Haseltine's Capri subjects, and those painted in Normandy, are very true to local atmospheric and geological traits.

> Henry T. Tuckerman, *Book of the Artists: American Artist Life* (1867; New York: James F. Carr, 1966), 556-557.

In the same volume, Tuckerman also mentions a number of works by Haseltine in his "Appendix: List of American Pictures in Public and Private Collections": *Narragansett Coast*, W. T. Blodgett, New York; *Indian Rock, Narragansett*, John Taylor Johnston, New York; *Castle Rock, Nahant*, John Taylor Johnston, New York; *Seconnet Point*, R. M. Olyphant, New York; *Coast Scene*, Marshall O. Roberts, New York; *Near Mount Desert*, James L. Claghorn, Philadelphia. (Henry T. Tuckerman, *Book of the Artists: American Artist Life*, 623-630.)

During 1867 Haseltine sells paintings to Mrs. Rose, his brother-in-law, Charles H. Marshall, and M. K. Jessup. The latter two acquire views of Capri, for which the artist receives $2,000 and $3,442.10, respectively, with a total income from his paintings for the year of $5,542.10. He also apparently has works on consignment with Goupil. He acquires paintings by Florent Willems and Alexandre Calame, as well as a group of bronzes. (Haseltine/Plowden Family Papers.)

9 March 1868 Travels to Tivoli for the day.

Early April 1868 Purchases five paintings from Elihu Vedder: *The Painter, Landscape, Cadiz, White Fort, Spanish Flag against Dark Sky*. (Elihu Vedder, *Digressions of V* [Boston: Houghton Mifflin, 1910], 466-67. See also Elihu Vedder to Dr. Elihu Vedder, his father, 14 April 1868; a list of works commissioned includes "Mr. Hazeltine [$100.00]." Vedder Papers, AAA, roll 516, frame 223.)

23 April 1868 Travels to Naples.

25 April 1868 Travels to Palermo, Sicily.

27 April 1868 Represented at the Forty-fifth Annual Exhibition of the Pennsylvania Academy of the Fine Arts: "132. *Amalfi, Gulf of Salerno*."

W. S. Haseltine, now of New York, whom we claim as a fellow-citizen by birth and culture, has an Italian view; "Amalfi" is the subject.

> "Fine Arts in Philadelphia," *Philadelphia Press*, 25 April 1868.

The Forty-fifth Annual Exhibition of the Pennsylvania Academy of the Fine Arts is now open. Its catalogue numbers three hundred and eighty-one works – paintings, drawings, and pieces of sculpture. The New York artists are well represented. . . . Haseltine . . . being [among the] exhibitors.

> *Watson's Art Journal* 9, no. 7 (6 June 1868): 84.

May 1868 Travels to Capri and Ischia.

1 May 1868 Represented at the Paris Salon. Address given as "chez M. Carpentier, boulevard Montmartre, 8": "1212. *Capri*. 1213. *Environs de Gênes*."

Three other American painters have exhibited also; Mr. Haseltine, a remarkable and much admired view of Capri.

> "Fine Arts Exhibition in Paris. What is to be Seen in the Salon d'Honneur, Champs Elysees," *Watson's Art Journal* 9, no. 11 (4 July 1868): 128.

Mr. W. S. Haseltine sent a brilliantly colored landscape.
"Exhibition of Fine Arts," *Watson's Art Journal* 9, no. 14
(25 July 1868): 165.

The French Salon of 1868. – It may interest some readers to know how many and which of their American countrymen were permitted to exhibit at the salon of the Palais de l'Industrie in the collection last spring. . . . William S. Haseltine, of N. Y., Capri, the Environs of Genoa. . . . There we have eleven exhibitors from this country, and only two landscape painters among them, Weber and Haseltine.
"Art Items," *Philadelphia Evening Bulletin*, 10 November 1868.

2 June 1868 Travels from Naples to Paris by way of Milan, Stresa, the Simplon Pass, and Geneva.

16 June 1868 Arrives in Paris, at least in part to see the Salon; he stays for approximately one week. He visits with Sanford R. Gifford. They dine together on 20 June. On 22 June Gifford visits Haseltine's studio:
Called on May and Staigg; met Hazeltine at May's. H. is here for a few days, having left his family in Savoie.
Sanford R. Gifford to Elihu Gifford, Paris, n.d., European Letters, Gifford Papers, AAA, roll D21, 3:7-8.

Called at Hazeltine's studio and examined his studies on the Corniche Road, where he was last winter. I was much disappointed. If they are like that and nothing more, I'd rather not go. However, I must go, I think, and see for myself. I intend first to go to the Val d'Aosta in Italy on the east side of Mt. Blanc.
Sanford R. Gifford to Elihu Gifford, Paris, n.d., European Letters, Gifford Papers, AAA, roll D21 3:8.

23 June 1868 Travels to Switzerland. Apparently Gifford and Haseltine plan to travel together, although they fail to meet:
[July] 5. Left G[eneva]. 7 a.m. by diligence for Sallenche, where I agreed to meet Hazeltine & make the tour of Mt. Blanc to the Val d'Aosta. Arrived at 12 M. H. not here. If he does not arrive by the diligence which is now due, I will go on to Chamounix.
Sanford R. Gifford to Elihu Gifford, Sallenche, 6 July 1868, European Letters, Gifford Papers, AAA, roll D21, 3:11.

I waited a day (6th) at Sallenche for Hazeltine to join me as we had agreed. As the diligence came without him, and brought no word, I left a note for him, in case he should come afterward, and moved on to Chamounix.
Sanford R. Gifford to Elihu Gifford, Aosta, 21 July 1868, European Letters, Gifford Papers, AAA, roll D21, 3:11.

13 July 1868 Travels to Saint Mâlo, where he and family stay for nearly a month, making an excursion to Mont Saint Michel on 7 August.

October 1868 In Paris, where he meets several times with the collectors John Taylor Johnston, William Hood Stewart, and art agent George A. Lucas. They visit collections together from 10 through 30 October. Johnston diaries record an appreciation not only of Haseltine's paintings but also of his collecting, including a "Fine specimen of wood carving which he had picked up for $50," and two paintings by Zamaçois, "one very fine," that Haseltine orders. (John Taylor Johnston, *Journal of a Trip to Europe with my Family in the Fall of 1868*, MSS, 25, 26, 40, 45, 50, and 51-52, Metropolitan Museum of Art Archives; *The Diary of George A. Lucas: An American Art Agent in Paris, 1857-1909*, transcribed and intro. Lillian C. Randall, 2 vols. [Princeton: Princeton University Press, 1979], 2:279.)

6 November 1868 Travels to Rome. Eventually settles in apartment in the Via della Croce, maintaining studio in the Via dei Greci, in the same building as Frederic Church and Jervis McEntee:
I am – we are – settled in Rome. . . . Healy is here – T. Buchanan Read – and several other American Artists. McEntee & Hazeltine have studios in the same building with me.
Frederic Church to Martin Johnson Heade, Rome, 16 November 1868, Church-Heade Correspondence, AAA, roll D5, frame 638.

17 November 1868 Represented at the Fall Exhibition of the Brooklyn Art Association: "173. *Indian Rock*, For Sale."

HASELTINE. – "Indian Rock, Narragansett Bay, R.I.," is the title given by Mr. W. S. Haseltine to the picture which he exhibits. The picture is a very blue one, blue water and blue sky, but the coloring is cleverly managed, and the [?] a very pleasing one.
"The Art Association," *Brooklyn Daily Eagle*, 16 November 1868.

We have also a tolerable specimen of Hazeltine's red rocks. Why, because a man paints one thing well, is he to go on painting nothing else all his life? Mr. Hazeltine has painted red rocks enough to build himself a very respectable monument, and it would be really refreshing to have him do something entirely different.
"The Art Association: The Pictures," *Brooklyn Daily Union*, 18 November 1868.

Late December 1868 Johnston and Haseltine continue their contacts in Rome, with social calls and studio visits on 23 and 24 December. (John Taylor Johnston, *Journal of a Trip to Europe with my Family in the Fall of 1868*, MSS, 125, Metropolitan Museum of Art Archives.)

Johnston notes that Rome "is swarming with Americans," which is confirmed by a journalist who remarks on the formation of an American artists' club in Rome:

The American artists, too, number here stronger than ever this Winter, for in addition to those who have of late years made Paris their home, we have Church, Gifford, McEntee, &c. . . . This increase in the number of our countrymen has led to – what was very much wanted – the formation of an American Club, which has been started under the auspices of the Hazeltines, Buchanan-Read, Randolph Rogers, Mozier, our Consul; Mr. Cushman and others. Spacious and comfortable apartments have been secured in the Palazzo Gregoria.

K., "Italy. Distinguished Travelers," *New-York Times*, 24 January 1869 [dateline 16 December 1868].

We will begin with Haseltine, the landscapist, *as the French say. We were lucky enough to find the artist in. He was engaged on a picture taken from his various studies of Capri. It represented the coast and a detached rock near the shore.*

The artist has caught a peculiarity in his picture which I have observed in volcanic rocks that jut up on this Mediterranean sea. I noticed it especially this autumn, when our vessel lay becalmed among the Lipari islands, just a half-mile off of flaming, thundering old Stromboli. The small rocks seemed as if they were floating on the surface of the water; some of them appeared almost tilting and swaying, and at a distance looked like ships. Mr. Haseltine's rock has this same appearance.

I cannot mention all the clever pictures we saw at Mr. Haseltine's and elsewhere, as I have not sufficient time. Mr. Haseltine is a Philadelphian by birth, and as our townsman, we have a right to be proud of him.

Anne Brewster, "Affairs in Rome," *Philadelphia Evening Bulletin*, 18 January 1869 [dateline December 1868].

Throughout 1868 Haseltine sells paintings to such collectors as William Herriman (a Capri subject), Mr. and Mrs. Gordon (a Spezia subject), A. Cleveland (a Genoa subject), and N. Appleton. His accounts list eight incoming payments for a total of $14,183. Haseltine himself acquires bronzes and crosses. (Haseltine/Plowden Family Papers.)

Also in 1868 Haseltine is represented at several American exhibitions –
Cincinnati Academy: "55. *East Point.*"
Derby Gallery: "35. *Point Judith.* To be Distributed."
Seventh Annual Exhibition of the Maryland Historical Society, Baltimore: "125. *Pulpit Rock, Nahant.* S. M. Shoemaker."

January 1869 John Taylor Johnston and the Haseltines are often together in Rome: they share informal visits (1 January), dinners (2 and 7 January – the latter hosted by Haseltine in honor of Henry Wadsworth Longfellow), studio visits (9 and 11 January), and church visits (7 February). (John Taylor Johnston, *Journal of a Trip to Europe with my Family in the Fall of 1868*, MSS, 130, 132, 136, 137, 139, 159, Metropolitan Museum of Art Archives.)

April or May 1869 Travels to United States, probably with son, Stanley:

Haseltine, the painter, left for the United States last week. You must not keep him there. His brother, Haseltine the sculptor, is very busy finishing work to be sent off.

Anne Brewster, "Letter from Rome," *Philadelphia Evening Bulletin*, 27 May 1869 [dateline 4 April]. Reprinted in "American Artists in Rome," *Evening Post* (New York), 30 May 1869.

8 May 1869 *Appleton's Journal* notes Haseltine as a contributor to an upcoming issue:

We have already in preparation plates from pictures by Church, Casilear, Durand, James Hart, Haseltine, Suydam, Fenn, and others. The collection, in due time, will become not only a varied series of illustrations of our mountain, river, and coast scenery, but a choice gallery of American art.

Appleton's Journal of Literature, Science & Art 1, no. 6 (8 May 1869): 185.

June 1869 *Appleton's* publishes a steel engraving by S. V. Hunt after Haseltine's *Indian Rock, Narragansett.* This is the engraving first published by Goupil in 1864 and later in *Picturesque America* (1872): "*Indian Rock.* The fifteen hundred visitors, who resort in the summer season to Narragansett Pier, as they cast their eyes upon the picture of Indian Rock in our present number, must have a fresh longing for the arrival of the day when they will find themselves once more drinking in the cool, bracing air of the ocean, and rambling over the sands and stones that line its shores. A few year ago, and only here and there a traveller had ever heard of the place. . . . Nobody dreamed that Flat Rock, and Foam Rock, and Indian Rock, would ever be painted and engraved on steel, and found "Accompanying Appleton's Journal." . . .*

But now how changed! Umbrella'd artists plant their easels here and there, and dash away with their ochres, and chromes, and bistres, and tell you that there are no rocks on our coasts so rich and varied in their coloring as these. . . .

But we are forgetting all about Indian Rock, and in fact there is not much to be said about it. Mr. Hazeltine shows us just how it looks in calm

and sunny weather; imagine how the sea dashing over the summit, thirty feet in the air, and you may know how it looks in the tempest.

Appleton's Journal of Literature, Science & Art 1, no. 12 (19 June 1869): 375

June or July 1869 Sees Elihu Vedder in New York. (Regina Soria, *Elihu Vedder: American Visionary Artist in Rome (1836-1923)* [Rutherford, New Jersey: Farleigh Dickinson University Press, 1970], 61.)

September 1869 Returns to Europe, passing through London to Paris.

1 October 1869 To south of France: Marseilles, Lyons, and Cannes.

28 October 1869 Travels to Rome. Establishes apartment in the Palazzo Carcano in the Via due Macelli; moves to new studio in the Via dei Greci, 32:

I visited some few studios on Saturday, and among others I went to those of your townsmen, the two brothers Haseltine. . . .

Mr. Stanley Haseltine, the painter, has moved into some handsome new studio rooms, No. 32 Via de' Greci. His exhibition room is one of the finest in Rome. It is a treat to see his tapestries and carvings. He has one bit of Flemish tapestry, for which he sent to Spain; it is the richest and loveliest work I ever saw. The story of Judith and Holofernes is told very quaintly upon it; but the conception of the faces and the rich folds of the draperies, the exquisite blending of the colors, are marvelously beautiful. Then there are the Arras and Beauvais specimens, which make the high walls of the studio very elegant. Mr. Haseltine has also a Medici wedding-chest, beautifully carved, and a variety of woodwork; but looking down in sublime pride upon all the would-be antiquities is one of those greatest marvels of all – a fine Etruscan vase, whose age counts by the thousands of years where the others only number hundreds.

The decoration of Mr. Haseltine's studios made me almost overlook his very beautiful pictures. One of his lovely Capri pictures, with the tilting rock islands, was on the ease[l] in the exhibition-room; and I thought it showed to good advantage surrounded by all these handsome tapestries and carvings. It is a good thing to see pictures in this way; you can then form some idea how they are going to look when hung in furnished drawing-rooms.

Anne Brewster, "Foreign Correspondence. Letter from Rome," *Philadelphia Evening Bulletin*, 31 December 1869 [dateline 10 December 1869].

22 November 1869 Represented in collection of paintings for sale in New York:

The collection of pictures of M.D'Huyvetter's importation, for some time on view at 845 Broadway, New York, was sold. . . .

The following prices, in order, down to $100, are from the list published by the Evening Post:
View near Rome, Wm. S. Haseltine, $122.50

"Art Items," *Philadelphia Evening Bulletin*, 22 November 1869.

1869 Represented in catalogue of James L. Claghorn's Philadelphia collection. Address given as New York: "19. *Near Mt. Desert Island.*"

During 1869 Haseltine sells paintings to J. S. Rogers, John Taylor Johnston, Martin Brimmer, and Messrs. Wright, Lawrence, and Tannatt, as well as the dealer Goupil. Eleven entries in his accounts yield a total of $28,263.90. He purchases works by, among others, Louis Hector Leroux, Scipione Vannutelli, probably Charles Caryl Coleman, and Eduardo Rosales Martinez (a portrait of Stanley), as well as a tapestry from the collection of Mariano Fortuny y Marsal. (Haseltine/ Plowden Family Papers.)

2 May 1870 Haseltine is appointed to committee to take charge of church property of St. Paul's within the Walls, Rome's American Episcopal church. For the next six years the artist plays an active role in the building of the church, which is consecrated 25 March 1876.

10 May 1870 Begins his summer travels, moving first to the south to Sorrento, Naples, and Capri. Moves to northern Italy on 2 June.

12 May 1870 Report on sale of Charles Haseltine's collection appears:
The concluding sale of the Haseltine collection took place last Friday. Having published the principal figures obtained on the first evening, we complete the report by giving some of the remaining prices . . . 138, Narragansett, by W. S. Haseltine, $105; . . .

"Art Items," *Philadelphia Evening Bulletin*, 12 May 1870.

20 June 1870 To Switzerland, where he stays until 1 October.

July 1870 Review of John Taylor Johnston's New York collection mentions Haseltine:
Most of our New York painters are represented in Mr. Johnston's gallery. . . . W. Hart, Hazeltine, Huntington . . . are represented by characteristic pictures.

Eugene Benson, "Pictures in the Private Galleries of New York. II. Gallery of John Taylor Johnston," *Putnam's Magazine* n.s. 6, no. 31 (July 1870): 86.

August 1870 A studio visitor reports on a visit of at least three months previous:
William Haseltine had not fully begun to work, but had just made his arrangements for his winter campaign, in which he will be sure to add to his well-won honors by land and sea.

> Dr. Samuel Osgood, "American Artists in Italy," *Harper's New Monthly Magazine* 41, no. 243 (August 1870): 424.

1 October 1870 To Italy, visiting Stresa, Milan, Florence, and Siena.

13 October 1870 To Rome.

26 October 1870 Daytrip to Torre dei Schiavi in the Campagna.

16 December 1870 In Rome. A studio visitor reports:
Haseltine the landscape painter of whom Philadelphians should be especially proud has some new pictures which rival the old in beauty. This artist's pictures depend on nature solely for their indescribable charm. No one can give you a more poetical version on canvas of this southern Italian sea shore than Haseltine. Solitary rocks of Capri with the Mediterranean dashing up in brilliancy against the reefs or lying in glassy stillness; not a sail or soul to be seen; as an Italian artist of much reputation says, the only living figure that would suit Haseltine's pictures would be a lovely Venus rising from the sea. One of his new paintings is especially fascinating; it is a corner of Ischia the citadel. The rocks rise up perpendicularly from the sea crested with fortifications, one rock looks like a grim old Moor or bedouin enveloped in his mantle. The sky a stormy one and the sea which is sullen is in perfect harmony of feeling with the rocky cliff. It is a picture that could make one sit for hours looking at it & thinking of those far off ages when man fled to rocks and heights to live, when the peoples put barriers between each other and strove to avoid their fellows with as much eagerness as now nations seek to be united.

> Anne Hampton Brewster Papers, Historical Society of Pennsylvania. Transcription of article for *Philadelphia Evening Bulletin* (MSS date, 16 December 1870).

Christmas 1870 Mrs. Haseltine gives a Christmas party for the children of the American colony and their friends. Costs of the "Christmas Tree": $102.80. (Carrie Vedder to Rose Sanford, Rome, Christmas 1870, Vedder Papers, AAA, roll 516, frames 447-456; Haseltine/Plowden Family Papers.)

31 December 1870 The Haseltines host "a very elegant" New Year's Eve dinner for fourteen; D. Maitland Armstrong and Robert Nevin are among the guests. (D. Maitland Armstrong, *Day Before Yesterday: Reminiscences of a Varied Life* [New York: C. Scribner's Sons, 1920], 209.)

During 1870 Haseltine receives $12,151.50 from the sale of six paintings to Messrs. Ogden, Blight, Laird, Gurnee, and William Allen Butler, husband of Helen Marshall Haseltine's sister, Mary. He acquires candelabra, a clock, and Murano glass, along with pictures by Scipione Vannutelli. (Haseltine/Plowden Family Papers.)

Also during 1870 Haseltine is represented at the Boston Athenaeum's Forty-sixth Exhibition of Paintings and Statuary:
"104. *View on the Coast of Capri.* Dr. Wright."

24 February 1871 In Rome, working on paintings:
Hazeltine's pictures of Capri and all that part of the Mediterranean are exciting a great deal of attention. He has one of a sunset on the sea, a little thing which would make "sunshine in a shady place."

> Anne Brewster, "Correspondence. Letter From Rome," *Philadelphia Evening Bulletin*, 14 March 1871 [dateline 24 February 1871].

3 March 1871 Summary of American artists in Rome mentions Haseltine:
Very little has been done by artists. Read and Healy have been painting some fine portraits, Rogers and Harnisch making some busts, and a few of the beautiful landscapes and interiors of Coleman, Vedder, Welsch, Hazeltine and others have been sold. But it has not been a good season.

> Anne Brewster, "Correspondence. Letter from Rome," *Philadelphia Evening Bulletin*, 24 March 1871 [dateline 3 March 1871].

19 April 1871 Represented at the Second Summer Exhibition of the National Academy of Design: "484. *Coast Scene.* R. Butler."

Late April Travels south to Naples, Messina, and Taormina on Sicily, and Capri.

26 April 1871 Represented at Philadelphia's Union League: "164. *Near Amalfi.* J. L. Claghorn."

20 May 1871 Returns to Rome from Naples.

1 June 1871 Travels north to Florence, Bologna, and Venice:
Haseltine returned from Sicily a fortnight ago, and has just left for Venice, where he remains a month to make some studies. His sketches he brought from Sicily, especially those from Taormina, are beautiful. The fine coast

outline, mountain distance and picturesque ruins of Taormina make it just the place for an artist like Stanley Haseltine. One of his sketches of Taormina represents Mount Ætna with its little mantle of snow, just as it looked when I saw it three years ago, when our ship lay becalmed off the coast of Sicily. Another gives Mount Ætna as it appeared when I saw it first. Vapory, gray and green to the summit was the grand old fire mountain, with the thin flame cloud hovering over it. During the night and the next day a sullen rain and lowering clouds came; when they passed away Ætna stood up against the beautiful blue Ionian sky, clothed like a bride in snowy white. One of these Taormina pictures of Haseltine's was ordered by Mr. Gurnee, of New York, last winter.

Anne Brewster, "Correspondence. Letter from Rome," *Philadelphia Evening Bulletin*, 21 June 1871 [dateline 3 June 1871].

Stanley Haseltine, who has been studying in Sicily all the spring, and returned to Rome a few weeks ago with some delicious studies, especially of Taormina, has gone for a month to Venice to make some studies; from thence he goes north into Switzerland.

Anne Brewster, "Rome," *Boston Daily Advertiser*, 27 June 1871 [dateline 6 June 1871].

6 July 1871 The artist John W. Casilear exhibits his Haseltine painting at the Yale School of Fine Arts: "59. *Afternoon.* J. W. Casilear."

12 July 1871 Travels north to Austria and Germany, visiting Innsbruck, Salzburg, and Munich.

By 7 August 1871 In Switzerland, visits Schaffhausen, Zürich, and Konstanz.

18 September 1871 In Germany, visits Frankfurt, Bad Homburg, Wiesbaden, and Cologne.

28 September 1871 Travels to Paris. Listed as resident of Rome:
Peintres
Haseltine, Stanley, Via dei Greci, 32
 Gazette des Etrangers [Rome] 3, 28 September 1871, 2.

1 October 1871 Travels to Germany, visiting Weisbaden, Bad Homburg, Strasbourg (now in France), and Frankfurt.

13 October 1871 Arrives in Italy, passing through Bologna, Padua, and Florence.

9 October 1871 Travels to Rome. Represented at Haseltine Galleries, Philadelphia: "83. *Scene on the Roman Campagna.* One of his finest."

11 November 1871 Noted in newspaper report of American artists in Italy:
There is a charming clique of young artists in Rome all united together in delightful clanship and brotherhood. Their names alone convey instantly, to the memory of the lucky American who has visited Rome, the most pleasant recollections of picturesque studios full of fine old furniture, Venetian glass, tapestries, rich old wood-carvings, and among all these treasures the beautiful modern pictures and suggestive sketches of these gifted young men. Vedder, Coleman, Crowninshield, Hazeltine, Welsch – why, the very list sounds as musical as poetry! They have returned to Rome from their summer's journeying, settled for the season in their charming, hospitable homes and attractive studios, with portfolios full of the most fascinating sketches. A visit to their studios is as exhilarating as a draught of golden Burgundy, and you come away feeling as if art was the only thing worth doing, worth living for. . . . When I write again I shall tell you of Hazeltine, the fine landscapist whose studies are among the choicest in Rome, and whose pictures are well known and admired by every American of cultivated taste.

Anne Brewster, "Art in Rome," *Boston Daily Advertiser*, 9 December 1871 [dateline 11 November 1871].

17 November 1871 In Rome, the Haseltines' movement in high social circles is noted:
Mr. and Mrs. William Haseltine gave a reception the other evening. The next day it was reported in the Fanfulla, *very much to the surprise of the host and hostess. The reception, however, was sufficiently brilliant and agreeable to be noticed. Mrs. Haseltine's salons, as well as her husband's studios, are furnished with such delicate taste that it is pleasure enough to see them On the walls are modern pictures such as only an artist of taste would select; the choicest works – one of Hamon's best-creations; one of Vaninteil's loveliest things; one of Coleman's monks reading in a cloister, &c.; and one of Haseltine's own most charming landscapes, a "procession of pines," with the rich sky and horizon he paints so well. Haseltine has brought from Venice some of the loveliest studies of the Venetian "butterfly boats," as Ruskin calls them, I ever saw. We all know how Haseltine paints water; what a poetry he throws into shores and sea, such a liquid sheen, such comprehension of nature's language of colors, and such a nice executive sense as he has. His Capri and Taormina pictures have shown all these qualities to us. Now he will add to his fame by some of the loveliest Venetian lagoon and Adriatic scenes ever artist painted.*

Anne Brewster, "Our letter from Rome," *Philadelphia Evening Bulletin*, 9 December 1871 [dateline 17 November 1871].

11 December 1871 Haseltine's father dies in Philadelphia.

During 1871 Haseltine sells paintings to Messrs. Bates, Ward, Loser, Wood, Spence, Scott, and Hamilton, as well as to his brother, Charles. For these works, which account for nine entries in his ledger, he receives $18,724.50. He commissions G. P. A. Healy to paint the portraits of his wife, Helen, and himself. (Haseltine/Plowden Family Papers.)

Also in 1871 Haseltine is represented by a painting of Capri at an auction/exhibition at National Academy of Design for the benefit of St. Paul's within the Walls, Rome.

February 1872 Represented at the Boston Athenaeum's Forty-eighth Exhibition of Paintings and Statuary: "75. *Italian Sea-View.*"

3 February 1872 Reported as represented at sale of of I.B. Wellington's collection, assembled for the Wellington Gallery, Brooklyn: "55. *Narragansett Bay.*"

Our limited space will not allow us to enter into detail with the many excellent pictures still unnoticed; but we propose to enumerate a few, in which a discriminating public will find no difficulty in recognizing beauty, artistic power, and great merit.... "No. 55. "Narragansett Bay," Haseltine, N. A.

 "Leavitt Art Rooms/Wellington Gallery/Messrs. Williams and Everett's Collection of Modern Paintings," *Watson's Art Journal* 16, no. 14 (3 February 1872): 165.

7 February 1872 Represented at sale of *Modern Paintings by Eminent American & Foreign Artists* held by Geo. A. Leavitt & Co.: "55. *Narragansett Bay.*"

30 March 1872 In Roman studio, a reviewer responds to a picture of Castle Fusano:
Hasletine's landscapes are undoubtedly very lovely and the last always seems the finest to me. This morning I spent some time in his studio. He has on the easel an unfinished picture that seems to me the best he has ever painted, "Castle Fusano." Any one who has been to Ostia will remember Castle Fusano and its beautiful stone pines, each one looking as if it held on the summit of its long tree stem a green cloud. Hasletine has caught the exact spirit of the place. It is a picture that will be forever fresh and enjoyable. Indeed, all his pictures wear well. You never tire of them. I own a small "Ischia" by him. From the sofa in my writing-room, I can see it where it hangs on the salon wall; and when I am tired I look at it for refresh-

ment; it is painted with such marvelous skill, the great fortress and steep precipitous rocky sides of that portion of the island, stand boldly against a stormy sky; down in the horizon is a fiery red glow, and in the foreground the Mediterranean plashes and foams up against the rocky shore.
 Anne Brewster, "Roman Gossip. Our Roman Letter,"
 Philadelphia Evening Bulletin, 23 April 1872 [dateline 30 March 1872].

April 1872 Noted in the collection of James L. Claghorn:
Stanley Haseltine shows at his very best in a coast-city of Italy, admirably painted.
 [Earl Shinn], "Private Art Collections of Philadelphia. –
 I. Mr. James L. Claghorn's Gallery," *Lippincott's Magazine* 9, no. 52 (April 1872): 442.

12 April 1872 Represented at the Forty-seventh Annual Exhibition of the National Academy of Design. Address given as Rome, Italy: "233. *Fisherman's Island, Lake Maggiore.* William Scott."

7 May 1872 Anne Brewster reports on Haseltine's success and activities:
And now about the "active" oils. Stanley Haseltine, as he merits, has been among the most successful artists of the season. As in the case of Rinehart, Haseltine is among those American artists on whose talents the approving opinion is international. These Spanish and German artists are apt to be pert about American genius. The famous Heilbuth is now in Rome – "Cardinal" Heilbuth, as he is called, because of several of his irreverential but clever pictures, in which our "Princes of the church" are represented in a mundane manner. Heilbuth chanced to see a picture of one of our most distinguished American landscapists this spring – one, too, that brought 10,000 francs. He asked saucily, "What amateur painted that?" When told it was by an artist of reputation, he cried: –
 "Oh, no, it is not by an artist! Don't tell me so. It is by an amateur," he persisted, "who has studied Turner closely. He is clever; but he can never be an artist," – and then pointed out the whys and wherefores of his sweeping opinion.
 But Heilbuth says Haseltine is an artist, as well he may. Haseltine's new picture of the "Pines at Castel Fusano" is worth – well – more than I am afraid he will ever ask for it. It is one of the best pictures of the season; indeed, one of those lucky bits that even a clever artist does not make every year; a bit of genuine inspiration. He has not finished it yet. "When it is exhibited in London or Paris," said a foreign artist to me, "there will be a furore." Such a beauty as it is! It makes one sick with envy to own it. On the left are grouped the beautiful stone pines, which are nowhere so light and picturesque as near and around Rome, especially at Castle Fusano, on the road to Ostia. The stately tree boles and delicate pine stems, which

hold up that "concentrated cloud of "olive verdure,"" are reflected in one of those dangerous but beautiful stagnant pools which you see around Ostia and Castle Fusano. From this pool rises the soft, subtle malaria haze which is as deadly as it is lovely. The picture then spreads off on the right to Castle Fusano and a solitary pine.

Haseltine's orders this winter, as well as I can remember, for I chanced in the studio as the pictures were being packed to send off, – are very numerous. A Capri and a Taormina go to Mr. T. A. Hamilton of New York; a beautiful Ostia and Sicily to Mrs. Jarret of England; two pictures from Sicily to Mr. Murray of England; two, a Venice and study of pine trees, to Mr. Julius Morgan of London; another Ostia and a Sorrento to Mr. Pierpont Morgan of New York; three, a Taormina, Lake Lucerne and Castle at Ostia, to Miss Wood of New York; a Venice, to Mr. Theo. Lyman of Boston; a Sorrento, to Mr. J. C. Lodge of Boston; a charming little Venice, to Mr. Wurts, the secretary of the American legation, residing at Rome; fishing-boats on the Adriatic, to Mr. Roosvelt of New York; a view in Sicily, to Mr. Gentil of Paris; a lovely water color, to Count d'Epinay; a Capri, to General Crocker of California; a Venice, to the Duke of Nassau; a commission from the King of Denmark, who said Haseltine's studio is one of the finest in Rome; and several other purchases and commissions I cannot now recall. I wish I had space to dwell on some of these pictures, which I have crowded together on this rich list, – the Taorminas, for example, in which Haseltine's artistic intelligence and nice judgment have selected just the finest points of that famous ruin, the Greek theatre, together with the picturesque outlines of the coast and Etna on the distant Calabrian shores.
 Anne Brewster, "American Artists in Rome," *Boston Daily Advertiser*,
 1 June 1872 [dateline 7 May 1872].

Anne Brewster summarizes her lengthy *Advertiser* report for the readers of the *Bulletin*:
I mentioned, in a previous letter to the Bulletin, *Stanley Haseltine's pictures and made especial notice of the "Pines at Castel Fusano, near Ostia." That was when it was first painted. Since then it has made quite a furore among the artists – German, French and Spanish. It is one of the best pictures of the season, and indeed an inspiration that rarely comes even to a gifted artist such as Haseltine. His orders have been very numerous this season, not only among Americans, but for England and from the Royalties that have visited Rome during the winter, Nassau, Denmark, &c. You may well be proud of your townsman. I have just sent a long account of his studio and commissions to the Boston* Advertiser, *otherwise I should dwell longer on him and his works.*
 Anne Brewster, "Art in Rome. Our Roman Letter,"
 Philadelphia Evening Bulletin, 27 May 1872 [dateline 7 May 1872].

Spring 1872 Returns to New York following death of his first father-in-law, Josiah Lane.

26 June 1872 Attends reunion of his Harvard class. (Report 1854, 68.)

July 1872 Is expected in Venice in early July:
Haseltine, who was to have come to Venice, had not yet made his appearance when I left [i.e., 9 July].
 George H. Yewell to Elihu Vedder, 14 July 1872, Vedder Papers,
 AAA, roll 515, frame 1021.

Haseltine finally arrives, as Maitland Armstrong later recalls:
I started on the Fourth of July [1872] to spend the summer in Venice.... I stayed at Venturini's, a small hotel overlooking the harbor near the Bridge of Sighs....The Haseltines were at Venturini's, and so was George Yewell.... Haseltine and I spent a great deal of time in the antiquity shops, very keen about finding good things cheap.
 Armstrong, *Day Before Yesterday*, 241, 249.

8 September 1872 Listed as resident in Rome:
Haseltine, Wm. Stanley, peintre paysagist, via dei Greci, 32.
 Rome-Journal. Gazette des Etrangers, 8 September 1872.

22 October 1872 Daughter, Helen Haseltine, is born in Paris.

16 December 1872 Represented at Leavitt Gallery, New York:
A good collection of paintings by foreign and native artists is on view at the Leavitt gallery in Broadway. Among them we notice works by S. R. Gifford, Wm. Hart, the lamented Kensett, Shattuck, Wyant, Geo. Inness, Lazarus, S. Coleman, Vedder, A. B. Durand, Boughton, Casilear, Cranch, W. T. Richards, and Haseltine.
 "Picture Sale," *New-York Times*, 16 December 1872.

6 January 1873 Leads meeting of American artists in Rome to pay tribute to the recently deceased Kensett:
The artists of Rome have been much grieved at the loss of their former companion, Mr. Kensett, and held, upon the 6th, a meeting at the Hôtel d'Europa, to pay tribute to his memory. Resolutions were drawn up by Messrs. George A. Baker and W. S. Haseltine, expressing the sorrow of the American artists in Rome for their loss in the death of a painter, endeared to them by his "personal qualities as a [m]an, and by the grace and char[m] of his works," and tendering their sympathy to "his relatives and friends, as well as to their brother artists in New York."
 "American Society in Rome," *Boston Weekly Transcript*, 11 February 1873
 [dateline 11 January 1873].

25 February 1873 Marshall O. Roberts in Rome makes many acquisitions, including works by Haseltine:

There has been a good deal of activity among American artists in Rome the present Winter, and the season has been a very good one for the sale of their works. The painters have been more favored than usual, Mr. Marshall O. Roberts alone having expended more than $60,000 among them. . . . There are nearly forty American painters and sculptors resident here, and few of them, who have recognized ability, complain of neglect.

 Angelico, "Art Gossip," *New-York Times*, 20 March 1873
 [dateline 25 February 1873].

15 March 1873 A studio visitor reports:

Mr. Haseltine is painting scenes taken from the vicinity of Capri, Ostia, and Amalfi – mostly Mediterranean subjects.

 "Artist Life in Rome," *New-York Daily Tribune*, 12 April 1873
 [dateline 15 March 1873].

27 March 1873 A studio visitor reports:

Hazeltine has also been working with as much ardor as a young painter who has his reputation still to make. He has greatly gained in the qualities of breadth, refinement, and repose. A certain crude force of color, which unpleasantly characterized some of his earlier pictures, is now toned down into the proper harmony, and he shows less tendency toward what might be called the "dramatic" element in landscape painting. A picture of the Castle Ischia, on which he is now engaged, shows sound and excellent work, and will surely advance his reputation.

 B. T., "Art in Italy. Visits to some American Studios," *New-York Daily Tribune*, 10 May 1873 [dateline 27 March 1873].

1 April 1873 Roberts's contacts with Haseltine reported:

The American patron this year has been Mr. Marshall O. Roberts of New York. He has bought right and left and given any number of orders; it is said he has spent $70,000 in the good cause of art. Among other things he has several of Benson's pictures; Haseltine's beautiful pines at Castle Fusano, as well as several others.

 Anne Brewster, "Rome," *Boston Daily Advertiser*, 28 April 1873
 [dateline 1 April 1873].

10 April 1873 Haseltine leaves Rome:

This morning Mrs. Haseltine wrote to see if we [Vedders, Kitty Beach, and her husband] would all dine there tonight as her husband is going out of town tomorrow.

 Carrie Vedder to Rose Sanford, 9 April 1873, Vedder Papers, AAA,
 roll 515, frame 1404.

June 1873 Represented at the Century Association: "19. *The Adriatic.* Owner: Mr. Roosevelt."

June/July 1873 Represented at the Boston Athenaeum's Fiftieth Exhibition of Paintings: "137. *Rocks.* T. Wigglesworth."

July 1873 Haseltine reported as summering in Europe. ("The Summer Haunts of Our Artists," *Watson's Art Journal* 19, no. 10 [5 July 1873]: 117.)

An American Sojourn
Fall 1873 Rents a studio in New York (103 East 15th Street), close to the Century Association; lives at 7 University Place, home of the late Josiah Lane.

15 October 1873 Represented at the Haseltine Galleries, Philadelphia: "53. *View from the Island of Capri.*"

October 1873 Represented at the Century Association: "1. *Italian Scenery.* 2. *Italian Scenery.* 3. *Italian Scenery.* 4. *Italian Scenery.* 5. *Italian Scenery.*"

2 December 1873 Represented in the Charles F. Haseltine Collection, on display at the Leavitt Art Rooms, New York. Address given as New York: "116. *View from the Island of Capri.*"

17 December 1873 Represented at the Haseltine Galleries, Philadelphia: "366. *View from the Island of Capri.* A beautiful place at a beautiful time of the year, and also a beautiful time of the day. It is also a good representative picture of the artist."

27 December 1873 Listed as church member in the United States, along with Vedder, at vestry meeting. (Records, St. Paul's within the Walls, Rome.)

10 January 1874 Represented at the Century Association: "4. *Venice. . . 9. Ostia. . . 31. Pine Trees at Ostia.*"

7 February 1874 Represented at the Century Association: "1. *The Faraglione at Capri. . . 12. Ruins of Roman Theatre near Taormina, Sicily.*"

22 February 1874 Elected to membership in Rome's prestigious Circolo della Caccia, sponsored by members of the noble Odescalchi and Doria families. (Club records, Circolo della Caccia, Rome.)

A visitor to Haseltine's New York studio reports:

The return of Mr. William S. Haseltine from Rome, bringing with him a large collection of pictures and studies, the fruit of a most industrious season in Southern Europe, is something like an event in our otherwise dull art circles. The welcome that has already been extended to the artist by his numerous friends has been accompanied by a great deal of genuine surprise at the amount of good work he has done abroad and at the marked improvement discoverable both in the studies and finished pictures. The temporary studio, No. 103 East Fifteenth street, is literally choked with his pictures, and it is no small tribute to Mr. Haseltine to say that all of them are interesting and not a few of them admirable. Before he went abroad his work was chiefly noticeable for his versatility rather than for the strength of his style. He had caught a trick from both French and German schools without giving himself to either, and it was said that he had no style. Something of the same eclecticism will be found in his fresher and maturer works, but the gain in conviction, in expression, in freedom, and fluency of utterance is unmistakable.

In this collection there are eight or ten large canvases portraying Italian subjects with extraordinary fidelity and with great warmth and tenderness of color. One of the largest is a scene on the eastern coast of Sicily between Messina and Catania, depicting the ruins of a Roman theatre lit by the sunset. Its merit is one of sunlight craftily caught and cunningly handled. Less voluptuous but more realistic and, to our thinking, more impressive are the Campagna and cliff scenes, wherein Mr. Haseltine has wrought out of simpler materials the most charming effects of shadow without struggling after that enervating impossibility – an Italian sunset. The walls of this studio are covered with color transcriptions, which for their accuracy of form and detail, especially in the portrayal of rocks, show Mr. Haseltine's unchanged partiality for that subject. These studies are peculiarly valuable on account of their fidelity, not less perhaps on account of the rare good taste of selection which they betray. There is material enough in them for an endless supply of excellent pictures, and we trust that it is the artist's intention to remain here and work out what is in him without gathering fresh spoils. Doubtless one or more of the large pictures will be shown at the spring exhibition of the Academy of Design. Those who desire to see them before that time may visit the studio on Wednesdays.

"Gallery and Studio," *World* (New York), 22 February 1874.

7 March 1874 Represented at the Century Association: "6. *Capri*. . . 30. *Taormina, Sicily.*"

3 April 1874 A studio visitor reports:

Mr. W. Stanley Haseltine, who until a short time past was a distinguished member of the colony of American artists in Rome, is now spending a few months in this city, and has opened a studio at No. 103 East Fifteenth street, where he has a small but interesting collection of his pictures on view. These were all painted in Rome, and illustrate scenes near that city and on the coast and islands of the Mediterranean. Mr. Haseltine's pictures are carefully finished, and in his selection of subjects there is a refinement which is very attractive.

Among the views in the neighborhood of Rome are a "Sunset on the Campagna," with pools of water in the foreground reflecting the mellow light, and groups of weird stone-pines leading off into the perspective: and a picture of the celebrated ruin of the "Tower of the Slaves," also on the Campagna. This subject is painted under a noonday effect and is beautifully rendered. The distance, looking over the plain, is strongly given, and the old ruin, as well as the foreground herbage, is painted in a crisp and off-hand style. One of the largest works is an interesting view of the ruins of the "Theatre Taormina," in Sicily. The full moon comes up from behind the distant hills, while the ruins in the foreground are yet aglow with the last rays of the setting sun.

There are also a view of an old fishing hamlet as Capri (with some quaint fishing boats drawn up on the rocky beach in the foreground) in which the sun is just sinking below the horizon and sends its rays sparkling over the water; a wild coast scene at Amalfi, with a beautiful effect of light concentrated upon the whitewashed walls of a cottage hanging on the cliffs; and a number of cabinet pictures of the harbor of Venice with groups of picturesque fishing boats. One of the largest of the Venetian pictures gives a tenderly-toned early evening view, and is very poetical. Mr. Haseltine also exhibits a large picture of the famous "Natural Arch at Capri," with the Cape of Sorrento in the distance. This canvas is beautifully painted, and in the texture of the foreground and of the rock, and in general details, bears the character of a study from nature.

Mr. Haseltine's studio is open for the reception of visitors every Wednesday from 10 o'clock in the morning until 3 in the afternoon.

"Mr. Haseltine's Studio," *Evening Post* (New York), 3 April 1874.

4 April 1874 Represented at the Century Association: "10. *Fishing Boats at Venice*. . . 21. *Pines at Ostia.*"

9 April 1874 Represented at the Forty-ninth Annual Exhibition of the National Academy of Design. Address given as 103 E. 15th Street: "165. *Castle at Ischia*. M. O. Roberts. . . 263. *Castle at Ostia, from the Villa Fusano*. M. O. Roberts. . . 359. *Ruins of a Roman Theatre at Taormina, in Sicily*. M. O. Roberts."

W. S. Haseltine sends several of his recent works, which we have already noticed, although he has not selected the best of them.

"The Academy Exhibition," *World* (New York), 9 April 1874.

Mr. W. S. Haseltine, one of our best landscape painters, whose studies are prosecuted chiefly abroad, has three pictures in the exhibition. He is seen at his best, however, in "The Castle at Ostia, from the Villa Fusano," (No. 263.) In the foreground is a river or pool of mirror- like water, in which the stone pines that grow on its banks is reflected. Around is a dreary space of dark marsh land, and in the distance looms the castle, standing out against a warm-hued sky. The contrast is not too strong, and the sentiment of the theme is heightened by the skillful distribution of color, light, and shade. This is decidedly one of the best landscapes in the collection.

 "Fine Arts. The Academy of Design. Notice of Some of the
 Prominent Works – Comparison with Former Exhibitions,"
 New-York Times, 13 April 1874.

Mr. W. S. Haseltine's "Castle at Ostia" is not very happy as a composition, the stone-pines refusing to agree among themselves or to take on more dignity than would naturally belong to the overgrown toadstools they resemble. Von Schadow, the successor of Cornelius as Director of the Academy at Dusseldorf, was once remonstrating with a young landscape artist who was bent on going to Italy for studies. "Why will you go to Italy, you who can paint our Westphalian elms so beautifully! There are only two trees in Italy, and you can paint them both here at home from your sketching umbrella. Shut it, and you have the cypress. Open it and you have the stone-pine." This story is pure Dusseldorf, but it is true of the stone-pine, at least, that it is not a natural growth but an artificial production, the spreading head being the part that is spared by the peasants, who trim up the lower branches for firewood. There are situations in which the result is picturesque, but it is not always so, and it requires considerable skill so to manage the tree in composition that it shall not offend. Ruskin says that Turner was the only artist who knew how to paint a stone-pine, and certainly he did introduce it with striking effectiveness. What would the "Mercury and Argus" or the "Golden Bough" be without this tree! They seem so grand in Turner's portrayal that the hope of seeing them makes a portion of the desire every cultivated person has to see the landscape of Italy, and it is only fair to Mr. Haseltine to say that the actuality is often as disappointing as it is in his picture. We dare say that this picture shows us how Ostia looks to matter-of-fact people, but we ought to be able to thank Mr. Haseltine for showing us how it looks to the poet.

 "Fine Arts. National Academy of Design. Forty-Ninth Annual
 Exhibition," *New-York Daily Tribune*, 25 April 1874.

Mr. Haseltine contributes transcripts of foreign scenery painted with great vigor and thorough true perception of the picturesque. His "Castle at Ostia from the Villa Fusano," is a sunset scene near a grove of Italian pines. In "Ruins of Roman theatre at Taormina, Sicily," we have a view of

Mount Etna, in which, we will say in passing, we should like to see more subtle gradation of tint, the color being somewhat positive.

 "National Academy of Design," *Evening Post* (New York), 4 May 1874.

Mr. Haseltine's Italian scenes are rich and suave.

 "Fine Arts. The National Academy Exhibition," *Nation* 18, no. 463
 (14 May 1874): 321.

"Castle at Ischia" (165) by W. S. Haseltine, [and works by other artists] . . . are meritorious.

 "Exhibition of the National Academy of Design," *Watson's Art Journal* 21,
 no. 6 (6 June 1874): 53.

23 April 1874 Represented at auction at Somerville Gallery, New York: A "marine," by Haseltine, was bid up to $315.

 "Art Sale at the Somerville Gallery," *World* (New York), 23 April 1874.

27 April 1874 Represented at the Spring Exhibition of the Brooklyn Art Association: "239. *Italian Scene*. Artist. . . 330. *Coast Scene*. Artist."

2 May 1874 Represented at the Century Association: "16. *Fishing-boats at Venice*. . . 23. *Old Castle at Ostia*. . . 27. *Sunset on the Italian Coast*."

6 May 1874 Represented in the Charles F. Haseltine Collection at Clinton Hall Sale Rooms, Astor Place, New York. Address given as New York: "31. *Pine Trees at Ostia*. . . 126. *Fishing Boats at Ischia*."

7 May 1874 Reported as represented at an artist reception at the Lotos Club:
[T]here are so many admirable pictures that a fuller mention must be reserved for another day, with especial reference to the pictures contributed by Eastman Johnson, Miller, Hart, Haseltine, Whittredge.

 "The Lotos," *New-York Daily Tribune*, 7 May 1874.

Mr. Haseltine, two Italian scenes; one a rugged bit of coast at Capri, and the other a gorgeous sunset finely illustrated with Venetian sails.

 "Art at the Lotos," *New-York Daily Tribune*, 8 May 1874.

19 May 1874 Reported as represented at Williams & Everett Gallery in Boston:
William Stanley Haseltine, after a residence of nearly eight years in Italy, has returned for a brief visit, and about twenty of his pictures, recently painted, are now on exhibition at the gallery of Williams & Everett.

 A native of Philadelphia and a graduate of Harvard, class of 1854,

Mr. Haseltine is well known to a very large circle of friends in Boston. His marine views of scenes on our own coast exhibited in past years, and they may well rejoice in the display of ability and the marked proofs of progress given by the present collection. Old travelers in Italy will not miss such an opportunity to refresh their recollections of its scenery, represented under many different moods and in varied scenes, from the Northern Lakes and Venice to Capri and Sicily; while those to whom the Italian tour is still but a hope will visit them to gain new aids in filling out their mental pictures.

The artist's old skill in the delineation of waves and the sea is here seen improved and elevated. In the picture of a storm at Amalfi we have the dash and the motion –

> *"Withdrawn and uplifted, Sunk shattered and*
> *shifted, To and fro – "*

while in the two remarkable paintings, "Natural Arch at Capri," and "Taormina," we have revelations of blue stretches of sapphire water –

> *"Dolce color d'oriental zaffiro."*

It is that indescribable beauty of the southern Mediterranean, seeming rather ether than water.

It is hardly possible to look at these pictures and not recognize marks of original genius of a high order. It was a bold stroke to choose such a point of view as that in the "Natural Arch" (Capri), where cowering and fantastic rocks form a standpoint from which you look down on a vast expanse of calm sea, and far across the Bay of Salerno till fancy strains its eye for the solemn peristyles of Poestum.

Looking at the painting of Taormina, a feeling of the warmth of that Sicilian sky comes over the beholder. It will repay an examination into its minutest details. The warm sunset tints, the rising moon, the ruins of the old Roman theatre, the mountains, the shore, and again below that far reach of azure Mediterranean.

Those familiar with Italian scenery will recognize in these pictures wonderful accuracy of observation, and a rare truthfulness. The "sunny sky of Italy" is not always sunny; a fact which Mr. Haseltine has remembered in some of his scenes in Venice, where the atmosphere seems heavy with moisture from the canals and lagoons, which condenses into leaden clouds above.

The picturesque fishing boats, with their tall, lateen sails, gorgeous in color, and bearing huge religious emblems, have never been better depicted.

The views at Ostia, a desolate place, having little attraction to travellers, but where Mr. Haseltine has found materials for five of his pictures, are interesting from their novelty and the ability with which the famous "stone pines" are delineated.

In the picture of Amalfi is admirably shown the peculiar streaked appearance of the southern Mediterranean near shore in rough weather, where the puzzled beholder gazes upon broad stripes of brilliant colors –

green and purple traversing the tumbling waters and mingling with the white of the waves.

Mr. Haseltine returns immediately to Rome to continue the pursuit of a profession for which he is admirably fitted by natural endowment, and the unremitting labor and study of a score of years. It is a pleasure to be able to say of him that he is no imitator. His pictures do not suggest those of somebody else. His style is his own, his choice of subjects is his own, his manner of treatment is his own, and all are of such an order as to justify the very highest hopes of his future continued and enhanced success, and entitle him to a very high place among landscape painters.

"Haseltine's Pictures," *Boston Evening Transcript*, 19 May 1874.

Return to Europe – the Palazzo Altieri

Early Summer 1874 Returns to Europe. Stops in England; on 10 July Samuel P. Avery records from London:
To Royal Academy met Mr Haseltine. to Black & White Ex. Holman Hunts. Ex.

 Diaries, 1871-1882, of Samuel P. Avery, Art Dealer, 242.

August 1874 Sketching in Venice.

September 1874 In England, probably to investigate schools for son, Stanley. Returns to Italy via Paris in October.

2 September 1874 Represented at the Fifth Cincinnati Industrial Exposition. Address given as Rome: "18. *Pine Trees at Cannes.* For Sale, $650. C. F. Haseltine & Co., Philadelphia... 211. *Fishing Boats at Venice.* For Sale, $650. C. F. Haseltine & Co., Philadelphia... 232. *Pontine Marshes.* For Sale, $500. C. F. Haseltine & Co., Philadelphia."

9 September 1874 Represented at the Inter-State Industrial Exposition of Chicago. Address given as Rome: "298. *Fishing Boats at Ischia.* Charles F. Haseltine, Philadelphia. For Sale... 343. *Capri.* Charles F. Haseltine. For sale. Any one who has ever been to this lovely spot of earth, will recognize its faithful representation... 403. *Scene at Capri.* For Sale... 442. *Clearing Up After a Storm.* For Sale. Perhaps no picture by this artist will call forth higher praise than this example... 448. *Fishing Boats at Venice.* For Sale. 449. *Italian Sunset.* For Sale... 468. *Sunset at Venice.* Charles F. Haseltine. For Sale. 469. *Coming Storm at Ostia.* Charles F. Haseltine. For Sale. Two of the best pictures of this artist in America... 508. *Landscape on the Island of Capri.* For Sale."

Mid-Fall 1874 In Rome; moves with family into a full-floor apartment in the Palazzo Altieri. Rent in 1876 will be $10,000 per year.

29 October 1874 Listed as resident in Rome:
Ateliers & Galeries de Peinture
Haseltine, W. Stanley, peintre paysagiste, via dei Greci, 32.
La Saison. *Guide-Journal des Etrangers a Rome* 1, no. 1 (29 October 1874): 3.

23 November 1874 Attends vestry meeting, St. Paul's within the Walls, Rome.

24 November 1874 Serves as pallbearer in funeral of the Spanish painter Mariano Fortuny y Marsal:
Then came the bier carried on the shoulders of several gentlemen; among them I noticed our distinguished landscape painter, Stanley Hasletine. In the funeral procession were most of our American artists – Vedder, Coleman, Yewell, Story, &c.
Anne Brewster, "Italy. Fortuny, The Spanish Painter," *Boston Daily Advertiser*, 24 December 1874 [dateline 1 December 1874].

The bier was followed by a long array of artists of all nations, on foot, without music; many men were weeping; Vedder, Coleman, Story, Haseltine, and nearly all the American artists in Rome, were in the procession.
"Mariano Fortuny," *Watson's Art Journal* 22, no. 11 (9 January 1875): 122.

8 December 1874 Represented at Charles F. Haseltine's Collection at the Leavitt Art Rooms, New York. Address given as Rome: "38. *Maggiore.* 39. *Como.* . . 143. *Clearing Up After a Storm.* . . 168. *Sunrise at Capri.* . . 207. *Sunrise at Amalfi.* 208. *Sunrise at Ostia.* A choice pair of paintings."

Also in 1874 Haseltine exhibited at –
Louisville Industrial Exposition: address given as 103 East 15th St., New York: "20. *Narragansett.* $250.00. Owner: W. S. Haseltine. . . 91. *Castle at Ischia.* $250.00. Owner: W. S. Haseltine."
Massachusetts Charitable Mechanics Association, Boston: "149. *Off Point Judith.* Owner: A. B. Vannever."

8 February 1875 Represented at the Haseltine Galleries, Philadelphia. Address given as Rome: "149. *Sunrise at Amalfi.* 150. *Sunrise at Ostia.* A choice pair of paintings. . . 206. *Sunrise at Capri.* . . 212. *Sunset at Venice.* A splendid specimen by the artist. . . 241. *Maggiore.* 242. *Como.* . . 300. *Clearing Up after a Storm.* . . 308. *Natural Arch at Capri.* . . 374. *The View from Capri.* This is a faithful and literal representation of this beautiful view."

Unknown photographer, *St. Paul's within the Walls, Rome*, ca. 1900 Haseltine/Plowden Family Papers.

9 February 1875 A studio visitor reports:
The American who has the handsomest studio in Rome is Mr. Stanley Hazeltine of Philadelphia. It is in the Palazzo Altieri, Piazza del Gesu.
 "Art and Artists," *Boston Evening Transcript*, 9 February 1875.

Spring 1875 Son, Stanley Lane Haseltine, is sent to The Beacon School in Sevenoaks, England, in hopes that the northern climate will help his health.

1 July 1875 Son, Charles Marshall Haseltine, dies at age of eight years.

Summer 1875 To northern coasts via Lago Maggiore and St. Gotthard Pass. Sketches in Belgium and at Scheveningen, the Netherlands.

September 1875 Reported as acquiring five works from a set of eight watercolor drawings by Fortuny:
[Mr. Stewart secured three] . . . the rest were reserved to be shown to the Baron de Rothschild, who declined to take them, and they were afterwards sold to the American artist, William Haseltine.
 "Private American Art-Galleries in Paris. The Collection
 of William Stewart, Esq.," *Art Journal* (New York) 1, no. 9
 (September 1875): 283.

Represented at the Sixth Cincinnati Industrial Exposition. Address given as Rome: "87. *Sunset at Venice.* $1250.00. Chas. F. Haseltine, Philadelphia. . . 113. *Storm at Capri.* $850.00. Chas. F. Haseltine, Philadelphia. . . 123. *Nahant.* $250.00. Chas. F. Haseltine, Philadelphia. . . 272. *Castle at Ischia.* $275.00. Chas. F. Haseltine, Philadelphia."

September/October 1875 In Paris; stopped in Cannes and Genoa before returning to Rome:
They left yesterday for Cannes where they remain until they go to Rome. [The letter discusses Mrs. Haseltine's mood following death of son, Charles Marshall; also mentions that Haseltine] too is fearfully changed and we all feel we did him much injustice in always looking upon him as a man of not very much depth of feeling.
 Elizabeth Herriman to Carrie Vedder, [Paris], [2?] October 1875,
 Vedder Papers, AAA, roll 517, frames 74-75.

November 1875 Receives praise in an article on Alfred Bricher:
In 1858 [Bricher] gave up his clerkship and at once set up his easel as a landscape-painter. . . . His first sketching- season was passed on the island of Mount Desert, coast of Maine, and while there he fell in company with

William Stanley Haseltine and the late Charles Temple Dix. These artists were men of genius, and young Bricher derived great benefit from their kindly advice.
 "American Painters. – Alfred T. Bricher," *Art Journal* (New York) 1,
 no. 11 (November 1875): 340.

Also in 1875 Haseltine was represented at the Louisville Industrial Exposition: "275. *Entrance to the Bay of Spezzia.* $1500.00."

20 January 1876 Represented at "1876 Ladies' Reception, Union League Club" exhibition in New York: "15. *Ostia.* J. Pierpont Morgan."

21 April 1876 Elihu Vedder writes to disparage reports of ill-will between him and Haseltine:
I gather you reported my saying – I thought amateurs like Haseltine & Boit had no business to open studios here in Rome. As to Haseltine it is utterly impossible that I should have called him an amateur when I have known him for years as a professional artist who has studied indefatigably and formed his own individual style.
 Elihu Vedder to Ellen Sturgis Dixey, Rome, 21 April 1876, AAA,
 Vedder Papers, roll 517, frame 350.

10 May 1876 Represented at the International Exhibition of the Centennial Exposition, Philadelphia: "265. *Ruins of Roman Theatre, Sicily.* For Sale. W. S. Haseltine, Philadelphia. . . 1040. *Natural Arch at Capri.*"

Summer 1876 Represented at the Eighth Exhibition of the Chicago Academy of Design: "26. *Coming Storm at Ostia.* W. S. Hoseltine, Rome, N.A. For sale."

The Academy is not yet large enough to restrict its exhibitions to works never before exhibited; but this is the case with a number on view. With the exception of ten paintings loaned by Knoedler of New York, and a few loaned by citizens of Chicago, all the works are by Chicago artists; and nearly all are offered for sale. Among those sent by Knoedler . . . Winslow Homer, De Haas, William Hart, Haseltine and Bellows, are represented.
 "Picture Exhibitions in Chicago," *American Architect and Building News*
 1 (23 September 1876): 310.

3 June 1876 Travels to Como, Ville d'Este, Turin.

8 June 1876 Travels to Paris.

20 June 1876 Travels to Blankenberg, via Bruges and Lille. Still there on 17 July:
Stanly Hazletine and family are at a bathing place on the Belgian coast, Blankenburg.

Anne Brewster, "Rome. A Sudden and Shocking Loss of Three Prominent Men . . . The Artists, the King, and the Pope," *Boston Daily Advertiser*, 2 August 1876 [dateline 17 July 1876]; reprinted, "Art and Artists," *Boston Evening Transcript*, 10 August 1876.

23 June 1876 Represented at the New York Centennial-Loan Exhibition of Paintings Selected from the Private Art Galleries, at the Metropolitan Museum of Art: "From the Collection of Mr. J. Pierpont Morgan: 58. *Ostia*, W. S. Hazeltine, N.A., Rome. . . From the Collection of John Taylor Johnston, Esq.: 140. *Indian Rock, Narragansett*, W. S. Haseltine, N. A., Rome."

30 July 1876 Travels to London; visits Junius and Pierpont Morgan; visits son, Stanley, at The Beacon School in Sevenoaks; intends to leave London on Thursday, 3 August.

7 August 1876 Returns to Blankenberg.

6 September 1876 Represented at the Fourth Annual Inter-State Industrial Exposition of Chicago. Address given as Rome: "84. *Sunrise at Amalfi*. For Sale. 85. *Sunrise at Ostia*. For Sale. A choice pair of paintings. . . 183. *Maggiore*. For Sale. 184. *Como*. For Sale. . . 239. *Sunrise at Capri*."

18 September 1876 Travels to London, perhaps accompanying Stanley back to school from Blankenberg.

27 September 1876 In Paris.

2 October 1876 Travels to Cannes:
I have been hard at work at Cannes, sketching pine trees from early morning until sunset – & come home tired enough at night & am glad to get to bed by nine o'clock.

Haseltine to Stanley Lane Haseltine, Cannes, 10 October 1876.
Haseltine/Plowden Family Papers.

17 October 1876 Returns to Rome, via Genoa, Pisa, and Siena.

29 November 1876 John Taylor Johnston collection, including three works by Haseltine, is on view at the National Academy of Design.

21 December 1876 Represented at John Taylor Johnston sale where three Haseltine paintings are sold: *Indian Rock, Narragansett*, $280.00 to J. W. Garrett; *Castle Rock Nahant*, $160.00 to H. L. Young; *A Calm Sea, Mentone*, $310.00 to J. F. Pierson. ("The Sale of the Johnston Collection," *Evening Post* [New York], 20 December 1876; "The Johnston Collection," *Evening Post* [New York], 21 December 1876; "The Johnston Gallery," *New-York Daily Tribune*, 21 December 1876; "The Johnston Art Sale," *New-York Daily Tribune*, 22 December 1876.)

December 1876 The Haseltines host a large Christmas party that is written of in the international press, along with an extended description of Haseltine's studio:
Christmas to the American residents at Rome has passed as usual, a number of dinners were given, and any quantity of pretty gifts have been showered around with the proverbial generosity of our country people. Mrs. Stanley Haseltine, wife of the artist had her usual Christmas tree for the children, and it was, as we say every year, "unusually beautiful." Upwards of twenty little "tots" were present. There were nearly as many nurses, some of whom were gorgeous, as Roman nurses are; one had on a light-blue satin brocaded petticoat with a red cloth gold embroidered jacket, a fine, white lace kerchief a red satin frill around the glossy black knot of hair and a great silver pin with a silver flower head run through the braids. The mammas and papas numbered fifty – republican Americans, princely Romans and diplomatic Germans, Mr. and Mrs. Vedder and their children; Mrs. Tilton and her handsome youngest boy, Mrs. Charles Astor Bristed and her attractive little son, Mrs. Terry and her children, Mrs. Henry Winter Davis and her two young daughters; the Countess Barbiellini-Amadei, an American by birth, and her baby girl; the Marchesa San Vito, also an American and her little boy, &c. Then there were the Prince and Princess Baudini, the Princess Altieri and all the pretty Princepessini; the Princess Viano, a great granddaughter of the Empress Josephine and of the royal Wurtemburg family, and a number of other great and little titles, ambassadors' wives, &c., too tedious to name over. The handsome tree was placed in one of Mr. Haseltine's spacious studios. At 4 o'clock it was lighted and the doors thrown open. It was a blaze of splendor that first abashed the children and then put them into ecstacies. I saw some little toddlers that seemed as if their only desire was like that of the moth, to plunge into the middle of the dazzling mass of glittering tinsel and flaming candles. After the first view of the tree was over, there came the distribution of "Christmas boxes," as we used to say in my young days. Every child received a handsome present, every nurse a little gift, and every guest a memento from the splendid tree. The children grew important and delightfully loquacious over their new possessions. One bright little girl, daughter of Mrs. Rapallo, of New York, displayed to me

Unknown photographer, *Palazzo Altieri, Doorway*, ca. 1880. Haseltine/Plowden Family Papers.

her treasures and bonbons, and exclaimed with fascinating naivete: "Oh, I shall be forever glad that I came to this house!"

Then followed the supper, which was spread in Mrs. Hasletine's handsome dining room. All the children were seated. It was a pretty sight, I assure you. Their fine nurses stood behind them. The little queen of the feast was Mrs. Hasletine's daughter Helen, a lovely blonde of three years of age. Besides the numberless "goodies," the table had on it beautiful flowers and slender glass vases, over three feet high, filled with holly and twined with ivy. There was a full force of men-servants in attendance, who gave tea and egg-nogg, sandwiches and sweetmeats to mammas and papas. At 6:30 o'clock the pretty festa was ended; and the carriages went rumbling out of the great cortile of the Altieri Palace, in which is the Hasletine apartment, taking the delighted children home loaded with fine toys and bon-bons, to dream of Fairyland where life is as one brilliant Christmas tree; their mammas and papas to make toilets for the numberless Christmas dinners.

Mr. Hasletine's apartment in the Palazzo Altieri is one of the best appointed in Rome. It extends around the four sides of one of the great cortiles of that vast palace "isola," as they say in Rome. It has a large terrace that is like a hanging garden in which are not only numberless flowers, but orange and lemon trees. There is a fine suite of reception rooms. These salons are like galleries, for the walls are closely hung with valuable pictures by distinguished modern artists. One of the four sides of this truly palatial apartment is occupied by Mr. Hasletine's studios. The large second ante-camera, which leads on one side to the salons and on the other to the studios, is a picture in itself. In one corner near a great window, is a true Zamaçois grouping, an antique-carved wood bahut [chest]; a picture; old repoussee brasses; vases, and a mass of green – one tall date palm and other rich plants. The light streams in on this artistic arrangement with excellent effect. You turn and see in other parts of this ante-camera almost equally beautiful distributions of furniture, plants, vases, pictures and rich brasses. The studios are great palatial rooms, with fine old frescoed friezes running around the walls, and nut-wood sportelli or inside shutters, the warm brown coloring of which is very harmonious. There are superb old tapestries, ric[h] stuffs; Persian rugs; majoliche; fine old carved nut-bahuts and cabinets; Venetian glass, unique repoussee brasses; all those costly and lovely accessories and properties that artists delight in; but these accessories are kept down so well; the arrangement of them is in such perfect taste that they do not attract too much attention, nor injure the effect of the picture. They fall into their proper places as simple surroundings. You have to be very familiar with the studio to know how many valuable objects of bric-a-brac are collected unostentatiously in it.

Hasletine's pictures are well known. They are remarkable for that art treasure – light. The clouds and water are full of light, and the trees of

character and movement. His skies and seas and pines have all the especial characteristics of the countries to which they belong. There is all the difference in the world between the Venice lagoon water glitter, the blue Capri waves of the bay of Naples, and the gray white wash up of the sea on the Belgian coast. His Ostia *pineta* woods are quite unlike the Cannes pines. He catches the true physiognomy of a landscape. Then how well his pictures are painted; honestly and truly; no sham effects with glazings, nothing untrue! He is a skillful manipulator, understands his art thoroughly, and is an artist to the tips of his nails. He works with a passion too. In summer he finds his amusement in searching out new points of study. Last summer he was on the Belgian coast, and was out at early morning and late twilight, in sunshine and rain. The studies of clouds and sea-coast he has brought home are marvellously beautiful; gray, soft, vapory, misty, thoroughly imbued with light, even when wrapped over with stormy clouds. The summer previous he was in Holland.

This afternoon I went into Mr. Hasletine's studio; he was out sketching in the Campagna. So I had the place all to myself for an hour, and enjoyed fully his pictures and sketches, of which I never tire. It is one of the greatest luxuries to sit alone in a fine studio, a luxury that one seldom has when only an amateur. On one of the easels near a window stood a large picture of a scene on the Holland coast; a storm is coming on; you look far up the beach; a strange lurid light pours out beneath a cloud in the distant sky and spreads down on the watery sands over two sailors who are adjusting the anchors of a great boat, the sails of which are filled with wind. This lurid light breaks out again on the front sky, above the same heavy cloud and you see its fine fiery source running like an opal flame under the angry clouds at the water-line of the horizon. This is the keynote of the picture and gives a splendid tone to the dark, stormy clouds, dashing sea and mist. In the foreground is another great boat with the curious side-paddles that look like rough wing rudiments, peculiar to Holland boats; the sails are lowered and filmy fishing-nets are spread over the masts; a sailor is wading ashore with one of the anchors. There is a fine dash and rush of waves. One breaks up into mist against the side of the boat, and another wave stands up just cresting very transparent and liquid.

Below this angry picture stood to-day, leaning against the same easel, another picture that was a perfect contrast. It was a scene from the Pineta at Castle Fusano, near Ostia – a twilight, with a full moon rising out of the beautiful but treacherous mists, with a soft opalline sky of fading sunset and the grove of slow-moving tranquil Ostian pines at the side. In front of these two pictures, so unlike each other in character, on an easel stood a new acquisition of Mr. Hasletine's a genre picture by Rossi, an artist of the Fortuny school, if school it can be called. This new picture is Mr. Hasletine's latest hobby, and if you visit his studios within the next six weeks or so, ten chances to one that he will take more interest in showing

you this picture than any one of his own charming landscapes. Its subject is like the opening of a fast Feydean novel, or a "risky" high-colored description by Gautier. The scene is a vast library that looks like the Hall of the Maps at the Vatican. A handsome young professor in black velvet and stuffs, powdered hair and lace ruffles is attempting to lecture on anatomy to two incroyable *young women. He stands behind a great library table; the forefinger of his right hand rests tremblingly on a skull; he looks breathless, and in a state of ecstatic anguish, as if his thoughts were more on human female charms than science or *memento mori.* The two incroyables are in wonderful costumes and most audacious positions. One is on a chaise longue *half buried in a green satin cushion, and displays provokingly her pretty celestial silk stockings and pink slippers; her graceful body is hardly hidden by a gauzy filmy gown, and she leans her fascinating little head, that is powdered and has a mob-cap with scarlet ribbons, on a delicious arm and hand. The other damsel is seated in a great chair, holding a huge open book; she has on a large black Rubens hat and white feather over her full blonde hair, a black mantle lined with scarlet, white fichu, yellow over-gown and Pompadour silk petticoat; her pretty feet and ankles are stretched out on a Persian foot-stool, with blue silk stockings, black slippers and great brass buckles. Both look drowsy and demoralized. The finish of the picture is exquisite; you can look into it as on a miniature. The accessories are finely placed and well painted; columns and draperies, a Cordova leather screen, a rich Turkish table cover, great books and the map on the wall of Italia Antica. You front the picture as from a great open doorway which leads out into the open air. On the outside broad marble steps are leaves and all the fragrant litter of out-stretching tree branches. You can easily imagine that it is a summer morning with buzzing flies out in the hot air, and in this library are the drowsy pretty, audacious girls, the poor young victim of a professor, whose words are of as much value in their ears as the drone of the honey-bee on the outside flower-beds; and he, poor man, is like a gray moth, which they may catch and fasten for amusement with a pin on a scarlet-satin bow!

One of Hasletine's beautiful Venice pictures had a delicious light upon it this afternoon. It is a sunset with a young crescent moon in the rich Venice sky. There is San Georgio and the Saluta and St. Marco; all the familiar campanile and cupolas and Ruskin's butterfly boats with their bright sails pointed up spear-like, very gorgeous in coloring, and the lagoon water truly Venetian in character, glittering smooth and yet broken up into multitudinous ripples and gentle wavelets.

Anne Brewster, "Holiday Week at Rome. A Children's Party – Mr. Hasletine's Studio," *World* (New York), 15 January 1877 [dateline 27 December 1876]; see also Carrie Vedder to her mother, 30 December 1876, Vedder Papers, AAA, roll 517, frame 596.

During 1876 Haseltine sells at least two paintings, one to Daniel S. Appleton. For these he receives $5,949.95. (Haseltine/Plowden Family Papers.)

19 January 1877 Brewster's account of the Haseltine studio appears in amended form. ("Art and Artists," *Boston Evening Transcript*, 19 January 1877.)

10 April 1877 Son, Herbert Chevalier Haseltine, is born in Rome.

18 April 1877 Represented at sale of James L. Claghorn Collection, on exhibition at Kurtz Gallery, New York. Address given as Rome: "44. V*iew near Amalfi, Italy*. 49 1/2 x 28. [width before height]...132. *Landscape*. 19 x 13. [width before height]." No. 44 reported as sold for $417. ("Sale of Claghorn Paintings," unidentified newspaper clipping from 19 April, AAA, Claghorn Papers, no frame nos.)

1 May 1877 Represented at the Paris Salon. Address given as "A Rome, palazzo Altieri; et à Paris, chez M. Carpentier, rue Halévy, 6": "1037. *Aux environs de Cannes (Alpes-Maritimes)*."

May 1877 Spends a week in Albano, southwest of Rome.

13 June 1877 Travels to Siena, lodging at the Villa Torre Fiorentina: *Haseltine never worked so hard as he did in the summer of 1877, which he and his family spent in Siena at the Villa Torre Fiorentina.... The Pagets' villa was not far from the Torre Fiorentina, and the two families spent many afternoons together; the Chigis lived in their palazzo in Siena; the Frederick Crowninshields, Maria Dexter, Anne Brewster, ... the Marion Crawfords, all were passing the summer in that beautiful ancient Italian town and formed a pleasant and intimate circle of friends.*
 Plowden, 105

9 July 1877 Arrives in Paris.

By 20 July 1877 Arrives in London, probably to pick up Stanley and return with him to Siena.

13 September 1877 Travels with Stanley from Siena to Engadine Valley.

Winter 1877/Spring 1878 In Rome.

June 1878 Travels to Livorno.

July 1878 Travels to Val d'Aosta, then Paris, where he sees his mother.

12 July 1878 In Paris, Samuel P. Avery writes:
Called at Febvre [?] to see picture by Bellescour bought porcelain of Fournier pd. 238 f. met Haseltine . dinner at Duvals with boys....
 Diaries, 1871-1882, of Samuel P. Avery, Art Dealer, 487.

18 July 1878 Travels again to Italy, through Turin on way to Venice.

Also in 1878 Haseltine was represented in at least two American exhibitions:
Louisville Industrial Exposition. Address given as Rome, Italy: "103. *Coming Storm at Ostia* Price, $750...124. *Nahant* Price $200...176. *Fishing Boats and Castle of Ischia* Price, $750."
Thirteenth Exhibition of the Massachusetts Charitable Mechanics Association, Boston: "10. *Italian Sunset****...42. *Natural Arch at Capri****...183. *Pine Tree at Ostia****...425. *Old Roman Theatre at Taormina****" [*** = For sale.]

Winter 1878/Spring 1879 In Rome.

Mentioned in Morris K. Jessup's collection in *The Art Treasures of America*: "*Haseltine, W.S. – Coast of Capri*." Also notes:
Mr. Jessup has been a prominent patron of American landscape painters. F.E. Church's "Parthenon" (6 x 4 feet,) S.R. Gifford's "Vermont Mountains" (3 x 4 feet,) and Stanley Haseltine's "Capri" (6 x 3 feet) are instances of his enlightened encouragement of home art.
 Edward Strahan [Earl Shinn], ed., (Philadelphia, 1879),
 The Art Treasures of America, 2:142.

9 February 1879 Daughter, Mildred Stanley Haseltine, born in Rome.

5 March 1879 Mentioned as represented by *Mt. Aetna* and *The Pines of Ostia* in the Marshall O. Roberts Collection. (*Art Interchange* 2, no. 5 [5 March 1879]: 36, iii.)

10 April 1879 Son, Stanley Lane Haseltine, dies at age 17.
I have been obliged by my abundance of material to put off until now mentioning a death that occurred in Rome a few weeks ago which ought not to be passed by unnoticed to Philadelphians – of the eldest son of Mr. Haseltine, the well known and charming landscape and coast scene painter.
 Anne Hampton Brewster Papers, Historical Society of Pennsylvania.
 Transcription of article for *Philadelphia Evening Telegraph*
 (MSS date, 6 May 1879).

May 1879 Represented at Internationalen Kunst-Austellung zu München. In oil paintings section: "1004. *Jacaglioni auf Capri.*" In watercolors and drawings section: "2222. *In Cannes.* 2223. *Val d'Aosta.* 2224. *Barke in Blankenberg.*" (Courtesy Michael Quick, Curator of American Art, Los Angeles County Museum of Art.)

Hasletine has sent off some of his fine coast and Italian pineta scenes to the Munich Exposition, also some of his beautiful Ravenna aquarelle studies.
 Anne Brewster, "The Roman Studios," *Boston Daily Advertiser,* 16 June 1879 [dateline 23 May 1879].

July 1879 In Lausanne, staying at the Hôtel du Faucon.

Fall 1879 In Rome.

15 September 1879 Represented at Haseltine Galleries, Philadelphia. Address given as Rome: "117. *Italian Sunset.* 118. *Castle of Ischia. . . 170. Coming Storm – Ostia. . . 211. Fishing Boats – Castle of Ischia.*"

4 October 1879 Represented at the Century Association: "1. *Castel Saladino – near Amalfi* Charles Marshall."

1 November 1879 Represented at the Century Association: "27. *Capri* Mr. Marshall."

24 November 1879 Represented at Haseltine Galleries, Philadelphia. Address given as Rome: "58. *Fishing Boats at Venice. . . 198. Natural Arch at Capri.* 199. *Moonrise – Ruins of a Roman Theatre at Taormina, Italy.*"

Winter 1879/Spring 1880 In Rome.

Summer 1880 Summers in Dordrecht, Holland, and St. Cergue and Coppet, Switzerland, on Lake Geneva:
I forgot to tell you after leaving Ouchy we went and passed two days at Berg with the Haseltines, who have been there the greater portion of the summer for the purpose of giving the saline baths to the children.
 Elizabeth Herriman to G.H. Yewell, 8 August 1880, Yewell Papers, AAA, roll 2428, frames 227-232.

Coppet – Made many sketches there.
 Haseltine/Plowden Family Papers.

Winter 1880/Spring 1881 In Rome:
The Haseltines are very gay and going much into society – Being up all

night does not seem to affect his frame of mind – for he seems to allow nothing to interfere with his painting up to four in the afternoon.*
 Elizabeth Herriman to G. H. Yewell, Rome, 6 January 1881, Yewell Papers, AAA, roll 2428, frames 236-241.

21 March 1881 Represented in Charles F. Haseltine Collection at Horticultural Hall, Boston. Address given as Rome: "354. *Sunset near Ostia.* 17 x 23."

April 1881 Visits Agrigento and Taormina in Sicily.

June 1881 Travels through Rapallo, Venice, and Ligurian coast on way to Switzerland (Hospenthal, Seelisberg, and Bex) for the summer.

August 1881 Visits Paris:
Je cause souvent de vous avec M. Haseltine, qui est à Paris depuis quelque temps et qui travaille dans l'atelier que vous connaissez.
 Luc-Olivier Merson to D. Maitland Armstrong, Paris, 4 September 1881; quoted in Armstrong, *Day Before Yesterday,* 313.

Winter 1881/Spring 1882 In Rome.

1882 Haseltine's apartment and studio is described:
Mr. Wm. Haseltine's apartments in the Palazzo Altieri *in Rome are worthy of the building. The Palazzo was built from* Giovanni Antonio Rossi's *designs by* Cardinal Altieri *in 1670; and it was formerly celebrated for the magnificent art collections and mss. which adorned the library. Now* Prince Altieri *occupies the first floor only of the vast old edifice, and above him dwells the artist whose collections demand a brief survey.*
 The entrance of the Palazzo *is similar to that of the* Borghese *and others – a great courtyard flanked with colonnades, decorated with sculptures. On the right we enter, and mount the lordly* Roman *staircase, with its wide, shallow, uncovered steps of stone, which eight abreast can almost run up or down without noticing that the level changes – a manifest improvement on the steep stairs of classic Rome, which* Renascence *architects may well be lauded for. The statues and busts which ornament the wide landings were mostly discovered in digging for the foundations of the palace. Double doors of oak, painted black, with lions' heads upon them, open into* Mr. Haseltine's *apartments, and we immediately recognize the habitat of an industrious and intelligent collector of all beautiful things. We enter a small corridor leading into a second which itself opens into the central room, or hall, as the* English *habit would call it, whence the living rooms run in three directions. On the right a pretty vista of four drawing-rooms (divided only by curtains, and throughout which is laid a pathway*

Unknown photographer, *Palazzo Altieri, Courtyard*,
ca. 1880. Haseltine/Plowden Family Papers.

of red and black cloth) lead to the dining room. Tall plants, palms, and tree ferns wave from the corners of the hall. Here an old cabinet of Swiss *wood and* Swiss *work, with its curious old locks intact, stands against the walls; there is a fine* scaldino *of* repoussé *copper, pierced into lace-like patterns; and beside the door a specimen of old hammered iron, forming flowers and coloured bosses, has been turned to account, and supports a brazen basin and ewer. From the centre of the carved ceiling hangs an antique brazen lamp. The form is pear-shaped, and small cupids support the chains. The walls are covered with pictures, specimens of silk,* Renascence *carving in wood and metal. The first of the vista of rooms, all lighted from the left side, is small, and panelled with fine* Gothic *carvings, pointed arches and tracery in high relief, catching the light from windows glazed in* Powell's *manner, with small circular panes. Antique silks break the masses of black wood, which might otherwise be too grim, and the carpets are of course chiefly* Oriental. *Here a tall credence bears statuettes in terra-cotta, there a cabinet stands out amongst green leaves. The* portières *are chiefly tapestry throughout, in which the colours, softened by time, not art, nor evanescent like colours made studiously to look like faded age, go well with every afterthought. The second room has a blue wall, and amongst many more modern conveniences, two or three cabinets of old* Neapolitan *work catch the instructed eye. These are broad and square with friezes of splendid wood relief by* Giovanni da Nola; *spirited figures, dogs and men modelled with all the force and knowledge of* Renascence *art, and full of fancy, move and breathe upon it. Below, drawers set with marble, onyx, and other precious stones in little* plaques, *supply the colouring needed.* Renascence *taste was bold, and even in the matter of keyholes dared to assert itself. Hence the* plaques *of stone, being five across the front, and too fine to drill through send the detail of the keyholes to the right-about; so these requisites stand aside on the alternate tiers of drawers, now to the right, now to the left, cut in the dark wood that frames the* plaques. *Of this kind of cabinet* Mr. Haseltine *possesses several very handsome specimens. On the walls a good many interesting old paintings are hung. Part of a triptych by* Van der Goes, *full of careful detail, and rich in harmonious colour, hangs on one side of the fire; on the other certain* Italian *works, dark-coloured like* Dutch *landscapes. A seventeenth-century mirror, made of pieces forming a wheatsheaf, charmed us much; also some curious old* Italian *pictures in silk stitchery.*

The next room has at present a wall of white and gold; but the owner projects carrying the tapestry, which now covers the mantelshelf wall, all round the room, which will be a vast improvement. The piece at present hung has a fine seventeenth-century design, with a capital border full of figures. The dining room is a well-proportioned, and handsome room; warm-coloured, being entirely covered with tapestry relieved by Hispano-Moresque *and brass plates.*

From the hall aforesaid the studio opens en face; two large and handsome rooms, coloured red, with fine old ceilings of the date of the Palazzo *itself, carved in wood and painted. The finest tapestry adorns the walls; the longest walls are almost covered by fifteenth-century single pieces, of great size and beauty, one of them a composition of more than one hundred figures, in costumes which recall* Van Eyck, *in capital condition. One of them is a very quaint picture of the "Last Judgment," and is equal to any of the famous pieces at* Berne.

Putting aside the charming modern works of art which crowd Mr. Haseltine's *easels, of which I cannot here speak, the walls present continual delights in the form of early metal work, ancient* Swiss *furniture, pots of majolica, fifteenth-century bronzes,* moorish *plates, and early painting. Among the latter, a curious little altar-piece, by* Albert Dürer's *master, painted on a gold ground, is a precious possession. A* Swiss *buffet of old inlaid wood, with its zinc lavatory, dolphin, and basin, is serviceable as well as handsome, standing within the door of the painting room.*

The furniture is of the time of Louis xv., *painted black and gold, with seats of imitation Gobelin.*

Mrs. [Mary Eliza] Haweis, *Beautiful Houses; Being a Description of Certain Well-Known Artistic Houses* (New York: Scribner & Welford, 1882), 84-89.

10 March 1882 Reported as serving as pallbearer in funeral of Richard Henry Dana:
The death of Mr. Richard Henry Dana, which occurred last month in Rome . . . The pall-bearers [included] . . . Mr. Haseltine.

Anne Hampton Brewster, "Rome: Ceremony of Presentation at the Court of Italy," *Boston Daily Advertiser*, 10 March 1882 [dateline 20 February 1882].

June 1882 Spends three weeks in Albano.

29 June 1882 Haseltine's mother dies in Boston.

July 1882 Travels to Rimini, with excursion to Torbole.

August 1882 In Recoaro.

6 September 1882 Represented at the Tenth Cincinnati Industrial Exposition: "197. *Castle at Ischia.* 200 W. S. Haseltine. [Described as "*Bay of Naples; Vesuvius in distance; rocky island crowned with castle; fishing boat on strand in foreground.*" Line drawing by Reid.] . . . 275. *Italian Sunset.* 250 W. S. Haseltine. [Described as "*Blue sky, purple clouds, deep blue sea in distance, sea green in middle distance, gray surf upon strand, yellow buildings to left, dark brown boats in foreground, figures in red.*" Line drawing by Reid.]"

18 September 1882 In Paris.

20 September 1882 In Biarritz, en route to Madrid.

21 September 1882 In Spain, travels with brother-in-law, Charles H. Marshall:
Here I am at last after so many years of expectation, & have just come home after seeing the famous gallery of Madrid. It is one of the few things that fully realized one's expectations. I never saw so many splendid pictures together – & the finest examples of Titian, Raphael, Velasquez, Murillo, &c &c that can be found in the world. We got here this morning after 20 hours journey from Biarriz which is just half way from Paris to Madrid. . . . At Biarriz it rained in torrents. We walked out however & saw the rocks & The Empress's villa. In Biarriz I was very much disappointed the rocks do not compare with those of Rapallo & of the two places I would much rather go to the latter to make sketches. So far I have seen nothing that tempts me to sketch, but I suppose that the finest scenery will come later on when we get to Grenada & Seville. We remain here until Monday night & then go on to Seville – & so on to Gibraltar & Grenada. . . I hope to be able to join you somewhere before the 15th of October.
Haseltine to Helen Marshall Haseltine, Madrid, 21 September 1882, Haseltine/Plowden Family Papers.

I am afraid that I shall not be back in time if you wish to leave [Pallanza, Italy] before the 15th. The distances are so great between the principal places – & the number of things to be seen so great that it will [be] almost impossible to accomplish anything unless I stay a little longer. Tomorrow we go to have a hurried look at Toledo. We are six hours in the train & six there & have of course only a glimpse at it. The next day the gallery in the morning & a bull fight in the afternoon. The next day we go to see the Escurial & the day after we go to Cordova for one day – then to Cadiz Gibraltar & we cant arrive at Grenada before the 6th of October – & I should want at least three days there & afterwards there are two or three other places I ought to see.
Haseltine to Helen Marshall Haseltine, Madrid, 22 September 1882, Haseltine/Plowden Family Papers.

3 October 1882 Writes from Malaga, having left Granada that morning. He and Charles go to Gibraltar (arriving on the 5th), Tangiers, Cadiz, Seville (by the 11th), Murcia, Vallencia, Tarragona, and Barcelona, returning to Rome about the 28th.

Among the paintings Haseltine sells in 1882 are a large view of the interior of a castle in Taormina (to Martin Brimmer of Boston) and a small

version of the work (to William H. Herriman of Rome). (Haseltine/Plowden Family Papers.)

Winter 1882/Spring 1883 In Rome.

21 January 1883 Represented at Roman International Exhibition. Address given as "Filadelfia": "Sala 1, Acquarelli . . . 52. *Studi dal Vero* (Divisi in tre parti). . . Sala V, Quadri a Olio . . . 34. *Capri*. 35. *Venezia*." (*Esposizione di Belle Arti in Roma, 1883, Catalogo Generale Ufficiale* [Rome: Bodoniana, 1883].)

The International Exhibition of Fine Arts was opened to-day by the King and Queen. . . . Among the works at the exhibition which are much admired are paintings by the American artists, Albert Bullin, William Scott, Stanley Haseltine.
"Opening of a Fine Arts Exhibition," *New-York Times*, 22 January 1883 [dateline 21 January 1883].

The Roman exhibition is not international, but Italian. Of the 1,500 works on view only a small proportion are foreign. Among them are pictures by Messrs. Stanley Haseltine and Dwight Benson, the American landscape painters.
"The Chronicle of Art. Art in March," *Magazine of Art* (London) 6 (March 1883): xxii.

Summer 1883 Summers in Vahrn near Brixen, Austria [now Varna, near Bressanone, Italy]. The Hotel zum Elefanten was the Haseltine's usual residence during their trips to Vahrn. (Plowden, 153.)

10 September 1883 Travels to London and Paris, which he reaches by 22 September.

Early October 1883 Rejoins family at Vahrn and returns with them to Rome.

Winter 1883/Spring 1884 In Rome.

Summer 1884 Vahrn, with excursions to Toblack, Vienna, Klausen, and Mühlback.

1 November 1884 Leaves Vahrn for Rome.

Winter 1884/Spring 1885 In Rome.

Unknown photographer, *Hotel zum Elephanten,*
ca. 1890. Haseltine/Plowden Family Papers.

Also in 1884 Haseltine is represented at the Twelfth Cincinnati
Industrial Exposition: "423. *Bay of Naples,* W. J. Brown, N.Y... 205.
Venetian Boats, The Haseltine Collection... 209. *Venice,* The Haseltine
Collection."

7 January 1885 Represented in the Charles F. Haseltine Collection
at Davis & Harvey's Galleries, Philadelphia. Address given as Rome:
"Pupil of A. Achenbach and Weber/Academician of the National
Academy of Design/Academician of the Pennsylvania Academy of
Fine Arts... 118. *Sunrise at Amalfi.* 119. *Sunset at Ostia.* 25 x 15."

6 April 1885 Represented at the Sixtieth Annual Exhibition of the
National Academy of Design. Address given as Palazzo Altieri, Rome,
Italy: "82. *Venice,* 500.00... 86. *Venetian Boats,* 500.00... 409. *Cannes,*
900.00."

30 April 1885 Goes with Anne Brewster "to Villegas's studio to see
his new picture, then to Villegas to see his majoliche and stuffs." (Anne
Brewster diary, 4 May 1885, Historical Society of Pennsylvania.)

11 June 1885 In Rome, fiftieth birthday party.

15 June 1885 In Rome, along with Worthington Whittredge, William
Wetmore Story, Charles Caryl Coleman, Randolph Rogers, Franklin
Simmons, Luther Terry, John Rollin Tilton, and Elihu Vedder, Haseltine
signs a petition urging the U.S. Congress to repeal the duty of thirty
percent imposed on works by foreign artists. (Mary E. Phillips, *Remin-
iscences of William Wetmore Story* [Chicago: Rand, McNally, 1897],
233-238.)

Summer 1885 Summers in Vahrn, with excursions to Matrei am
Brenner, Attersee, and around Bozen (now Bolzano, Italy).

Winter 1885/Spring 1886 In Rome:
*There were two Americans here to whom I feel under especial obligation –
Mr. [William] Herriman and Mr. Hazeltine. The former was a gentle-
man of wealth and culture, who made Rome his home; the other was an
artist of great merit, brother-in-law of my friend [Charles H.] Marshall.
Both of them were American gentlemen of the highest type, and both lived
in very handsome style. At the houses of these two Americans were assem-
bled, twice a week, a number of cultivated men, mostly of the Diplomatic
Corps, who would drop in after their dinner-parties, and pass the rest of
the evening playing whist, and in conversation, which was always bright
and interesting, for they had all seen a great deal, and were all men of the*

world. I attended some of these entertainments and the memory of them remains in my mind as amongst the most agreeable evenings I have every passed in any part of the world. They were always accompanied with something to cheer the passing hours and keep up our spirits until about two o'clock in the morning.

S[amuel] R[hoades] Franklin, *Memories of a Rear-Admiral*
(New York and London: Harper & Brothers, 1898), 325.

5 April 1886 Represented at the Sixty-first Annual Exhibition of the National Academy of Design. Address given as Rome, Italy: "504. *Fishing Boat at Venice, Sunset*, $350.00... 529. *Fishing Boat, at Blankenberg, Belgian Coast*, 300.00."

13 April 1886 Represented in the Charles F. Haseltine Collection at Moore's Art Gallery, New York. Address given as Rome: "Born at Philadelphia./Pupil of A. Achenbach and Weber./Academician of the National Academy of Design./Academician of the Pennsylvania Academy of Fine Arts... 50. *Narragansett*. 24 x 16... 90. *Sunrise at Amalfi*. [pencil annotation: 100]. 91. *Sunset at Ostia*. 25 x 15. [pencil annotation: 125]... 204. *Venetian Boats*. 25 x 14. [pencil annotation: 175]."

Summer 1886 Travels in the Tyrol, and to Innsbruck, Sterzing, and Salzburg.

September 1886 In Munich; Haseltine is elected as a member of the local Kunstverein. Anne Brewster visits Haseltine's Roman studio during his absence:
What a subtle power of delight is in a fine work of art! There is a certain picture which has been in my mind all summer. When the sun was scorching and the African scirocco resting heavily over Rome, this painting has been my refreshing comfort, it is a coast scene. Scheveningen, east Holland, one of Haseltine's pearls. During the summer I have gone to his beautiful studios and sat there alone visiting in my fancy the various places his lovely pictures represent, but the fresh sea waves and delicious sky of the Holland coast painting has always held me the longest.

Haseltine has been away from Rome all the season, first in the Tyrol, then in Bohemia, and now in Bavaria, but, not withstanding his absence, I have the privilege of going to his studios whenever I like. And a privilege it is indeed to sit undisturbed in those lofty rooms surrounded by fine paintings and all the numberless exquisite objects an artist of taste and easy means collects about him.

In one of the studios is a corner that would have fascinated Fortuny or Zamacois, and would have been immortalized by them as the background of a picture. I command it as I sit in a chair near one of the great

Unknown photographer, *Vahrn bei Brixon*, ca. 1890.
Haseltine/Plowden Family Papers.

windows, where I sit in front of Haseltine's superb Castle Fusano picture, in which the green summits of the trees seem like clouds massed together, as Hawthorne said of Italian stone pines. Back of this fine painting stretches out the picturesque corner I admire. On the walls to right and left are superb old tapestries; below are rare old cabinets, one inlaid with precious stones, an exquisite Marquise escritoire delicately inlaid with ivory; a soft odor of dried roseleaves and marechaie powder, spicy and fragrant, hangs around it. Who was the pretty Louis Quatorze woman that kept her love-letters and love tokens in those perfumed drawers? The side of a heavily carved nutwood chest stands out in rich relief, and old Cordova leather chairs strike in their sonorous notes of old-gold and nut-brown. In the very corner of this triangle against the wall is a brilliant panel, formed of precious irridiscent majoliche plates, reaching from surbace to the fresco-frieze of the lofty ceiling. They are hung on red silk damask and are dazzling as sunshine. The most brilliant pearl shell cannot surpass that mass of curious metallic luster which, centuries ago, the Spanish plate-makers put with such cunning skill on the surface of their clay. As the sun passes through scirocco mists it sends in by the window strange, broken lights, which are caught up quickly by these wonderful enamels and rendered back to my eye according to the character of each surface luster, for each one is individual – opaline gray, rosy blue, red, yellow – and so delicate is each dazzling tint as to make these color names sound too positive. The room is somber in hue on this scirocco day, and at times the rich objects and lovely pictures fall back into a shadow that is marvelous in color but all the while a deep shadow; rising up out of it is this broad panel of marvelous majoliche which –

Makes sunshine in a shady place.

My last look, however, is for the North sea Holland picture. It is in the adjoining studio, and there I go and sit my last half-hour. I said it is one of Haseltine's pearls. It is rather an opal. Along the sea and sky line is that far-off sun-glow of the evening which has an eye of fire in it, as the ground of Prospero's island had –

An eye of green in't.

Distant sails, filmy as soft-gray moths, are floating in that opaline distance; it seems as if they will slip over the horizon line and out of sight in an instant. Other ships are nearer the coast. Pearly green waves roll along grandly in broad, fine sea forms; near the coast they break up into cool, crisp foam. A crescent moon is shining and higher up in the sky are broken clouds; touched softly with the after-glow, they contrast well with the mass of gray clouds that rise up ghost-like above the horizon line. A stout, sturdy fisherwoman stands on the sands, her arms akimbo. You wonder if she is feeling hope or fear. Is she watching the ships in the offing anxiously or the ship coming in!

Outside in the Roman streets is a hot sun and oppressive air. The rumble of carriages and omnibuses sounds like the murmur of the North sea up in those stately, palatial rooms. I sit there looking at that Holland coast scene, enjoying "sweetness and light" and forget the heavy atmosphere which an hour or so ago had made "the weight of the grasshopper a burden." The well-tempered air of the spacious, hall-like studios seems like northern breezes; the far-off din of city bustle and rumor is as the soft dash of those invigorating sea waves. I forget it is a painted semblance that I am looking at, and I "hear mighty water rolling evermore."

Anne Hampton Brewster, "Art Beauties in Haseltine's Studio," *Chicago Daily News*, 20 October 1886 [dateline 26 September 1886]; see Brewster diary, 19 September 1886, Historical Society of Pennsylvania.

An undated note from Brewster further details Haseltine's studio: *The finest studios now in Rome since the Fortuny days are those of the distinguished landscape painter Stanley Haseltine. This fine artist has been several years living in Rome has travelled in Italy Sicily Holland & Spain and picked up in various places articles of great value that will some day very far off I hope bring a tremendous price. Not only his studios but every room in the whole handsome apt in P. Altieri where H lives contains rare and beautiful objects. His dining room is full of tapestries & majolica. Then there are valuable old and modern pictures by celebrated artists, rich bits of church embroidery on satin rare old stipi or cabinet brasses, porcelain, glass One of his tapestries in the first studio Gothic Flanders is a great beauty an Arras of 1420 that was taken to Spain. Fortuny found it at Barcelona and told H. of it The size is 21 feet by 15. The subject is Holofernes & Judith There are 4 scenes 1. Judith cutting off H's head 2. His officers discovering the act. The expression of their faces is very naive they accuse the guard who protests his innocence 4. Departure of the besieger Judith and High Priest look complacently over the walls watching the enemy march off. Wherever the principal actors are represented their names are worked beside them or over their heads. The costumes are most remarkable Judith is very rich. Another Flemish Arras which is in the 2 studio represents the Last Judgement Its date is 1480 and the size is 28 feet by 15. This tapestry came from the great Demidoff sale that took place in Florence a few years ago. It is also remarkable for costumes and fine old style. But Haseltine's land- and waterscapes are so beautiful that you are apt to forget the rich objects that cover the walls and stand about the rooms. His pictures of Castle Fusano and its pines are representations of that beautiful place as poetical as in nature – for nature is there a veritable poet. The artist may be as realistic as he pleases it is all lyric poetry and no prose. H's pictures of Capri and the Naples bay are well known and Ruskin's butterfly boats of Venice. There are pictures from Sicily and some from Holland each one telling what land or sea it represents in its coloring and style.*

Anne Hampton Brewster Papers, Historical Society of Pennsylvania, MSS notes, box 12, folder 2.

12 October 1886 The Haseltines are expected back in Rome from their summer travels:
Mass at San Carlino. Then I went to Haseltine's studio and looked at his lovely pictures. They do not return until the 12th of this month.
 Anne Brewster's diary, Historical Society of Pennsylvania,
 3 October 1886.

30 October 1886 Mrs. Haseltine gives Anne Brewster a birthday party. (Anne Brewster's diary, Historical Society of Pennsylvania, 31 October 1886.)

During 1886 Haseltine became a *consigliere* (director) of the Società degli Amatori e Cultori delle Belle Arti in Rome. (Società degli Amatori e Cultori delle Belle Arti, *Bilancio* 57 [1886] [budget and membership list].)

Winter 1886/Spring 1887 In Rome.

9 February 1887 Represented in the Charles F. Haseltine Collection at Moore's Art Gallery, New York. Address given as Rome: "Born at Philadelphia./Pupil of A. Achenbach and Weber./Academician of the National Academy of Design./Academician of the Pennsylvania Academy of Fine Arts. . .18. *Sunset near Ostia.* 17¼ x 21½."

Summer 1887 In Traunstein, Bavaria.

September 1887 Travels to Munich, then Venice, where he sold several works to Sir Henry Layard. In Venice through at least 25 October:
The weather is again very bad here, rainy & cold & I have had to give up making sketches & now spend my days in going to the galleries & looking at pictures & that after all is a very pleasant way of passing ones time. I went this morning to the Academia where are to be seen some of the finest pictures in the world & this afternoon I went with Count Middleton & his three daughters to see the modern exhibition which is also very fine in its way.
 Haseltine to Helen Haseltine [later Plowden], 25 October 1887, Venice,
 Haseltine/Plowden Family Papers.

Winter 1887/Spring 1888 In Rome.

Probably May 1888 Visits Subiaco and Perugia.

June 1888 Haseltine and family summer in Traunstein:
My friends the Haseltines leave to day. They go straight through to Innsprück en route to Traunstein.
 Anne Brewster diary, Historical Society of Pennsylvania, 23 June 1888.

August 1888 Goes with daughter, Helen, to Bayreuth for *Parsifal* performance. Stops in Nuremberg and Munich on return.

By 29 October 1888 Returns to Rome.
Mrs. Haseltine came to tea at 5.
 Anne Brewster diary, Historical Society of Pennsylvania, 29 October 1888.

Winter 1888/Spring 1889 In Rome.

Summer 1889 In Traunstein, with excursions to Salzburg (19 July and 1 August) and Marquartstein (22 August).

1 September 1889 Travels to Paris with daughter, Helen, to see 1889 International Exposition.

17 September 1889 Travels to Perugia.

Winter 1889/Spring 1890 In Rome.

June 1890 In Perugia, with excursions to Gubbio, Cortona, Assisi, and the Etruscan tombs in the plains. Fellow vacationers include Frederic, Lord Leighton.

July 1890 Travels to Salzburg.

August 1890 Summers in Traunstein, with excursions to Oberammergau, staying there through at least 1 October.

Winter 1890/Spring 1891 In Rome.

June 1891 Travels to Sorrento and Vesuvius.

July 1891 In Traunstein with excursion to Ubersee.

August 1891 Travels with daughter, Helen, to Bayreuth to see *Parsifal*, *Tannhäuser*, and *Tristan and Isolde*. According to Helen, Haseltine "enjoyed the music very much." (Haseltine/Plowden Family Papers.)

September 1891 Travels to Munich, visiting exhibition in Glaspalast, where Haseltine is particularly interested in paintings by Andreas Achenbach, Franz Courtens, Franz-Seraph von Lenbach, José Villegas y Cordero, Mario de Maria, and works from the Barbizon School.

Winter 1891/Spring 1892 In Rome.

June 1892 Travels to Vallombrosa, Italy.

Summer 1892 Summers in Traunstein.

By August 1892 Appointed to the selection jury for American paintings from Italy destined for the World's Columbian Exposition, along with Charles Caryl Coleman and Elihu Vedder (and "one painter from the Munich Advisory Board"). ("The World's Columbian Exposition," *Art Amateur* 27, no. 3 [August 1892]: 52.)

By November 1892 Haseltine prepares for the World's Columbian Exposition:
There is a good deal of dissatisfaction expressed among American Artists in Rome and Florence with regard to the uncertainty attending the shipment of their works for the Chicago exposition. It was announced a long time ago that a man-of-war should call in December at Naples and Genoa to ship these goods, but the man-of-war dwindled into a common steamer and now an old sailing vessel called the "Constellation" arrived on the 9th inst. at Naples, and there collected some of all the most valuable productions of American Artists in Italy, to carry them free to New York. In fact we have been informed that the "Constellation" was to leave Naples yesterday.
Most of the American Artists in Rome have been much put out; many of their works were not finished and most of these were not packed, as the Artists depended on the vessel not sailing before the end of December.
The young and distinguished sculptor Miss Hosmer forms part of the Advisory Committee and therefore there are hopes she will manage to instill some common sense into the minds of the Exposition Authorities. She has a beautiful "Isabella" in bronze nearly ready. Most of the American Painters, Mr. Haseltine at their head, are very busy finishing up their works.
 Roman Herald, 19 November 1892.

December 1892 At work on a painting of *Castel Fusano*, six by four feet, which
represents both banks of the river, on one, low, & almost destitute of vegetation, there is an old boat-house thatched with straw, & a white cottage flanking the road. The other bank is covered with a multitude of pine-trees – No figures.

In the studio:
1) picture of Venice filled with fishing boats of two kinds: the Chioggia & the Burano –
2) Coast of Taormina in Sicily on the Southern coast. Sold to Mrs. C. L. Haddock – Phila.
3) Another of Taormina – Sold to Mrs. Carstairs Phila. The former (No. 2) shows the ruins of the old Greek theatre; the other, the interior with the remnants of the stage, on the right the little modern town – Both No. 2 and No. 3 are sold & are going to Phila. –
4) View of the Castle of Alexander Farnese at Ostia showing a stormy sunset. In low tones – & Mr. WS.H. considers it one of the best he ever painted.
5) Picture of the sea breaking over some rocks near Marquis Spinola's Castle of Rapallo (Genova Riviera) – Features of the picture are: effects of light on water in motion –
6) Replicas of oil-sketches made at Narragansett in the sixties.
 List in Helen Haseltine Plowden's hand, Haseltine/Plowden Family Papers.

Winter 1892/Spring 1893 In Rome.

27 March 1893 Represented at the Sixty-eighth Annual Exhibition of the National Academy of Design. Address given as care of Butler, Stillman, & Hubbard, 54 Wall Street: "88. *Rapallo – Near Genoa*, 700. . . 93. *Evening – Scheveningen*, 600."

Transatlantic Travels
April 1893 Sails with family from Genoa to New York City; they stay for six weeks at the Bristol Hotel on Fifth Avenue at Forty-second Street.

28 June 1893 Attends reunion of his Harvard class. (Report 1854, 76.)

Early Summer 1893 Visits Chicago for World's Columbian Exposition. The Barbizon School collection in the art section holds particular interest for Haseltine, according to his daughter, Helen.

July 1893 Travels to Philadelphia, staying at the house of his brother, Charles F. Haseltine, on Spruce Street.

Late Summer 1893 Summers at Little Boar's Head and Rye Beach, New Hampshire. Travels with son, Herbert, to Mount Desert, Maine.

Fall 1893 Enrolls Herbert in the Westminster School in Simsbury, Connecticut.

October 1893 In New York. Reportedly represented at the Century Association, which "proved a great success and he sold many pictures." (Plowden, 177.)

November 1893 Returns to Europe.

4 December 1893 Represented at the National Academy of Design's "Loan Collection, 1893, including Twelfth Autumn Exhibition." Address given as Palazzo Altieri, Rome, Italy: "293. *Sunset at Cannes.* $600.00"

Winter 1893/Spring 1894 In Rome. Entertains Mr. and Mrs. John Hay in late January or early February. Visits with William Wetmore Story and family.

1 May 1894 Travels with daughter, Helen, to Venice, staying two weeks at the Hotel Bauer.

June 1894 With daughter, Helen, travels to England to meet son, Herbert. Wife ill with cholera and daughter, Mildred, with typhoid.

Summer 1894 Summers in Traunstein at Villa Wunder. Sees Herbert off from Bremen.

1 October 1894 Returns to Rome.

December 1894 Elected warden of St. Paul's within the Walls:
Last week the vestry held its first regular meeting[.] The official members are now as follows: Luther Terry, Mr. Haseltine, wardens.
 Roman Herald, 29 and 30 December 1894.

1894 Works toward establishment of American School of Architecture in Rome, along with Charles McKim, Samuel Abbott, Frank Crowinshield, and others; the school becomes the American Academy in Rome in 1897.

Winter 1894/Spring 1895 In Rome.

Late April 1895 Travels to United States.

24 June 1895 Earlier in the week attends Class Day at Harvard, with supper at the Porcellian Club. About to depart for Northeast Harbor, Mount Desert, Maine. (Haseltine to daughter, Helen, Somerset Club, Boston, postmarked 24 June 1895, Haseltine/Plowden Family Papers.)

Summer 1895 Summers at Northeast Harbor on Mount Desert, Maine. Sketches at Asticou, Seal Harbor, and Sutton Island. Holds private exhibition of watercolors, selling sixteen sketches. Prices of works, mainly European scenes, range from $75 to $125, and sell to collectors including Mrs. Frank Winthrop, J. H. Ludlow, and Mrs. Edgar Bass. (Haseltine/Plowden Family Papers.)

2 August 1895 Makes a three-day visit to William Bliss in Winter Harbor, Maine.

Fall 1895 In Boston, with studio in Pierce Buildings on Copley Square. Herbert enrolls in freshman class at Harvard. ("Haseltine's Studio," *Boston Daily Standard,* 1 May 1896 [quoted below].)

7 November 1895 Mr. and Mrs. Haseltine visit Isabella Stewart Gardner, signing her guest book (William Sturgis Bigelow is also a guest). (Courtesy Susan Sinclair, archivist, Isabella Stewart Gardner Museum.)

23 November 1895 In Boston, attends "Paderewski's First Piano-Forte Recital Here This Season."

December 1895 Spends Christmas in New York, returning to Boston by end of year.

February 1896 Represented at Museum of Fine Arts, Boston, in exhibition of Martin Brimmer's collection:
In the Fourth Picture Gallery are . . . hung W. S. Haseltine's "A Courtyard in Taormina" and "Looking Over the Sea from Taormina."
 "The Fine Arts. The Brimmer Collection of Pictures at the Museum of Fine Arts," *Boston Weekly Transcript,* 28 February 1896.

Late February 1896 Visits John La Farge's Exhibition and Private Sale of Paintings in Water Color and Oil Chiefly from South Sea Islands at Doll & Richards Galleries (14-26 February). (Plowden, 88.)

30 March 1896 Represented at the Seventy-first Annual Exhibition of the National Academy of Design. Address given as Pierce Building, Boston, Mass.: "57. *View on the Island of St. Honore, near Cannes, France.* 1,000 [illustrated on page 24; dimensions listed as 26 x 72 inches]."

The annual spring exhibition of the Academy of Design will be opened next week with 408 pictures . . . An Eastern scene with the new moon shedding a faint ray on the water is by W. S. Haseltine, No. 57.
 "The Academy Exhibition," *Evening Post* (New York), 26 March 1896.

1 May 1896 A studio visitor in Boston reports:
I recently called upon Mr. W. S. Haseltine at his studio in the Pierce Building, Copley square. For 28 years this artist has resided in Rome, and his temporary home in Boston for a year or more is in order that his son might enter and become pleasantly established in Harvard College.

Unlike several of our artists who have found a home in the old world, Mr. Haseltine remains a true American, and his son is being brought up as an American citizen. An education at Harvard was to the father in earlier days a beginning of life, which he has evidently appreciated, judging from the fact that he prefers to secure for his son the privileges and opportunities, which Harrvard can best give.

While chatting with Mr. Haseltine on his experiences in Rome, he showed us a large number of sketches which he has made there and in various parts of Italy. He has been an enthusiastic worker during all these years, and his success has been eminently deserved by the sincere and studious life which he has given to art. Haseltine's work is eminently characteristic, and belongs to what is known as the close method, yet the expressions of nature which he has been able to render are as subtle in tone, as vigorous in form and color as those by men who look upon this method as unworthy of respect. Wherever art is degenerating into a method, merely, it is necessary for the method to be one of force, but if art has no limitation to mere manner then any form by which the artist can secure the loveliest and most truthful expression of nature's varying moods, is worthy and successful.

I was greatly pleased with the quiet and forcible manner of this artist's work. There is nothing in the way in which a thing is said to call attention to its verbal expression, and therefore the mind of the observer is not diverted from the thought which the picture contains, to the way in which the thought is elaborated.

A striking painting of large size represented the island of Capri, where those jagged and picturesque rocks break into the air from the blue waters of the bay, and tower to a height of some hundreds of feet, their rough and jagged outlines almost startling by their bold and fearless contour. Upon the summit of the highest point of Capri, in years long gone, a monastery was erected near the famous cross, to reach which constitutes a penance – the ascent being so difficult. The walls of the monastery still stand, and a part of the buildings are in fair preservation. The tenacity to which it clings to these abrupt boulders is remarkable, and never have we seen this expression of man's handiwork in its relation to nature more faithfully delineated than by the hand of Mr. Haseltine, in the picture which he showed us of this rough but beautiful spot.

A large picture of Ostia attracted our attention by the sense of desolation and picturesque death which hovers about it. What was once a flourishing town is now nearly destroyed, the swamps have covered the soil, and under the summer's sun exhale a fetid breath which is a prophecy of death to every human being who inhales it. Under this "terror that flies by night," towns have wasted, cities have decayed and life has yielded a reluctant obedience to the great destroyer. This picture of Ostia, well handled in a strong and interesting manner, presents to you the sentiment of the end of the world.

A large number of the most interesting water color sketches were shown, covering with distinctly local qualities scenes from Southern Italy, Venice, Bavaria, and Mt. Desert in America; all intensely true to local quality, color tone and sentiment.

It is hoped that Mr. Haseltine will make an exhibition of these studies before he returns to Rome. They represent the diligent work of more than 20 years, and would fill a large gallery and invite a multitude of interested and delighted observers. We sincerely wish for Boston the privilege of seeing this wonderful collection of sketches, showing what one man has done in a quarter century.

Fred Hovey Allen, "Haseltine's Studio," *Boston Daily Standard*, 1 May 1896.

Early Summer 1896 Visits country home of Mr. and Mrs. William Allen Butler, Helen Marshall Haseltine's sister and brother-in-law, in Westport, New York, on Lake Champlain; joined by "a large party of cousins." (Plowden, 183.)

Late summer 1896 Haseltine reportedly visits "his oldest friend, Fairman Rogers, at his summer resort at Ochre Point, in Newport, R.I." (Plowden, 185.)

1 November 1896 Mr. and Mrs. Haseltine, and their daughter, Helen, visit Isabella Stewart Gardner and sign her guest book. Other guests that day were Elsie de Wolfe, Elizabeth Marbury, and T. R. Sullivan. (Courtesy of Susan Sinclair, archivist, Isabella Stewart Gardner Museum.)

23 November 1896 Represented at the Fifteenth Autumn Exhibition of the National Academy of Design. Address given as Palazzo Altieri, Rome: "92. *Public Garden, Venice*. . . 268. *The Faralioni – Capri*. . . 279. *Fishing-Boat, Venice*."

Winter 1896/Spring 1897 In Rome.

4 February 1897 Elected church warden at St. Paul's within the Walls. (Church records, St. Paul's within the Walls, Rome.)

February 1897 Guest at a dinner:
A dinner was given by Mr. Rhinelander of New York at the Hotel Royal

on Monday evening last. The guests were; Hon. Wayne McVeagh, Mr. Larz Anderson, Professor Lanciani, Rev. Dr. Nevin, Mr. Waldo Story, Mr. Wurtz, Mr. Durham and Mr. Hazeltine.

Roman Times, 21 February 1897.

June 1897 In Paris, visits the Salon de Champs de Mars with Edward Darley Boit, and there runs into his brother, Albert:
Again in the month of June (this time in the year 1897) I had arranged with William Haseltine – the artist, so long resident in Rome, – to go with him to the Salon of the Champs de Mars. We had reached our destination at an early hour of the morning, – say ten o'clock, – and were almost alone in the vast building, when we suddenly ran up against Albert Haseltine. The brothers had not yet met, and after the first surprise was over, we agreed to join forces, and when our visit to the Salon was over, both the Haseltines accepted my invitation to lunch with me.

Edward D. Boit to Arthur Lincoln, Vallambrosa, 13 July 1899; quoted in Report of the Secretary of the Class of 1863 of Harvard College (Cambridge: John Wilson and Son, 1903), 63-64.

August 1897 Travels to Brides-les-Bains (Savoy, France) via Chambéry; takes the spa treatment at the Hôtel des Thermes, but finds little to paint in the area:
I am going out this afternoon to make a sketch of an old mill, which I find rather a good subject, other wise there is not much here that tempts me.

Haseltine to Helen Marshall Haseltine, Brides-les-Bains, 11 August 1897, Haseltine/Plowden Family Papers.

September 1897 Travels to United States with son, Herbert, spending time in Boston with brief visits to New York and Philadelphia.

November 1897 Returns to Europe, passing through London and Paris on the way to Rome.

17 December 1897 Elected vestry warden at St. Paul's within the Walls. (Church records, St. Paul's within the Walls, Rome.)

Winter 1897/Spring 1898 In Rome.

June 1898 Summers in Perugia.

July 1898 Short visit to Paris; brother, Albert, dies there.
[T]his meeting of the two brothers [that occurred in June 1897] is not devoid of a certain melancholy interest in view of the fact that only one year later this same brother William was sent for in Albert's last illness,

and was with him when he died.

Edward D. Boit to Arthur Lincoln, Vallombrosa, 13 July 1899; quoted in Report of the Secretary of the Class of 1863 of Harvard College, 64.

15 August 1898 In Traunstein for first part of the month, then to Perugia.

September 1898 Returns to Rome.

Winter 1898/Spring 1899 In Rome.

April 1899 Sails for United States.

May 1899 In New York.

June 1899 Short visit to Philadelphia. Travels west through summer with Herbert, his son. By 8 June they are in Salt Lake City, Utah, having passed through the Arkansas Canyon (staying in the town of Salida), Colorado Springs, and Pike's Peak. By 13 June 1899 they are in San Francisco, staying at the California Hotel; they feel an earthquake. By 18 June they are in Yosemite, where he finds the scenery fine, but not extraordinary:
I felt it [the journey from San Francisco to Yosemite] was taking a great deal of trouble to see what certainly is a grand view – but no grander than others in Switzerland, except that the waterfalls are higher! However, I am very glad I went there and when I was asked if I did not think it the very finest view I had ever seen in my life, I answered – "Yes – of its kind!" But I said nothing about Capri and Taormina or even the Roman Campagna.

Haseltine to Helen Haseltine [later Plowden], 21 June 1899, typescript in Haseltine Papers, AAA, D295, frame 483.

23 June 1899 Travels to Monterey, staying at the Hotel del Monte:
For the first time on this trip, the reality exceeds the expectations! This is the most delightful place I have ever visited; like living in a magnificent park filled with splendid trees and beautiful flowers, brought to the very highest state of cultivation; I have seen no Italian villa to compare with it. Yesterday, we and the Van Nuxens drove to Cypress Point; the place is enchanting … for subjects of wild nature I have never known anything better.

Haseltine to Helen Marshall Haseltine, Monterey, 25 June 1899; in Plowden, 189.

7 July 1899 In Castle Crag, Shasta County; shows his sketches about and establishes "quite a reputation (!!)," including invitations to

exhibit his work at the San Francisco Art Association and the Bohemian Club. (Haseltine to Helen Marshall Haseltine, Castle Crag, 7 July 1899; quoted in Plowden, 189.)

13 July 1899 In Seattle, having arrived the night before from Portland. Haseltine writes that "the scenery on the [Columbia] river was grand, more imposing than the Hudson!" (Haseltine to Helen Marshall Haseltine, Seattle, 13 July 1899; quoted in Plowden, 190-191.)

22 July 1899 Haseltine writes that "adjectives fail to describe the wonder of our journey" to Alaska. (Haseltine to Helen Marshall Haseltine, aboard the *Queen*, 22 July 1899; quoted in Plowden, 191-192.)

26 July 1899 Back in Seattle, the Alaskan trip over after twelve days on the steamer:
The scenery was simply magnificent unlike anything else I have ever seen. On leaving Seattle we had a view of Mt. Tacoma, which stands quite alone – nearly fifteen thousand feet high & covered with snow. You could not see the base but only this ghost of a mountain, colored by the evening sun rising high into the sky – with most picturesque surroundings.
From Victoria northward:
[W]e had a succession of the grandest scenery in the world; great ranges of snow mountains succeeding each other & amid thousands of islands the water was filled with leaping salmon. . . . All the Swiss Italian & Austrian mountain lakes put in a line together would only make an atom in the scene. . . . [Near Douglas Island] we came upon what perhaps was the finest scene of our trip. We saw six enormous glaciers at once & for miles ranges in every direction of enormous snow mountains lighted up by the evening sun, the water filled with enormous blocks of floating ice, some of the most exquisite sapphire color. We remained watching them until after eleven o'clock at night & it was still quite light. In fact there was hardly any night at all.
 After that came the great Muir Glacier – 3-miles wide & two hundred & fifty feet high. While we were watching a piece as large as the Hotel Bristol in Rome heaved & fell with a roar like thunder, raising an immense wave. I wanted to make a sketch there but the cold was so intense I could not hold a pencil.
Plans to leave the next day for Banff, over Canadian Pacific Railroad, then back down the Arrow Lakes to Spokane and on to the Yellowstone Park.
 Haseltine to Helen Haseltine [later Plowden], Seattle, 26 July 1899, Haseltine/Plowden Family Papers.

Unknown photographer, *William Stanley Haseltine*, 1899. Haseltine/Plowden Family Papers.

Herbert Haseltine, *Midway Point, California*, 1899. Haseltine/Plowden Family Papers.

1 August 1899 In Banff, Alberta, "in a country that recalls Switzerland. The scenery is grand, but not tempting for sketching; maybe Italy has spoiled me." (Haseltine to Helen Marshall Haseltine, Banff, 1 August 1899; in Plowden, 192- 193.)

By 15 August 1899 In Yellowstone, having passed through – and sketched – Arrow Lake; writes from the Grand Canyon Hotel: *I have commenced a sketch; this afternoon Herbert and I went fishing and caught twenty pounds of trout, a very good afternoon's work; we were both laid up on arriving at the Mammoth Hot Springs and had to wait a day and see the military doctor, who cured us. I find the altitudes here, over 8,000 feet, very trying, and I cannot take long walks. We stay here until Saturday [19 August] and then go to Duluth, and from there by steamer over the Great Lakes to Buffalo.*

Haseltine to Helen Marshall Haseltine, Yellowstone National Park, 15 August 1899, typescript in Haseltine Papers, AAA, roll D295, frame 487.

25 August 1899 In Buffalo, having arrived from Duluth and a tour of the Great Lakes; will go on to Quebec and then "direct to Boston to see my sister Carrie, as we may never meet again." (Haseltine to Helen Marshall Haseltine, Buffalo, 25 August 1899; in Plowden, 193.)

12 September 1899 Sails for Europe.

October 1899 In Munich.

November 1899 Returns to Rome.

25 November 1899 W.S. Haseltine and family at the Palazzo Altieri listed among British and American residents in Rome in the newspaper, *Roman World*.

During 1899 Haseltine sells a small watercolor sketch of Castel Fusano, through William A. Butler, Jr.; a small-sized picture of Ostia to Mrs. Charles Plowden; and two sketches to Mme de Blumer. (Haseltine/Plowden Family Papers.)

Early January 1900 Writes an autobiographical statement for the publisher, James H. Lamb Co., in Boston:
Haseltine, William Stanley, painter, was born in Philadelphia Pa. Jan. 11th 1835, son of John & Elisabeth Stanley Haseltine, grandson of James Haseltine & Abigail Moores & a descendant of Robert Haseltine who was born in Lincolnshire England & arrived in Boston in 1637 with Revd. Ezekiel Rogers, formerly rector of Rowley, York, England. He was prepared for College at Phila. – was two years at the University of Pennsylvania; in 1852, went to Harvard University Cambridge Mass. & was graduated there A.B. in 1854 and in A.A. 1858. He then studied art under Paul Weber of Philadelphia until 1855 when he went abroad. After studying for two years in Düsseldorf he opened a studio in Rome. He returned to the U.S. in 1858 and settled in Phila. and in 1859 in New York. He was made a National Academician in 1861, having been elected Associate in 1860. Among his more notable paintings are: Capri, belonging to the Hon. A. J. White, U.S. Ambassador at Berlin, painted 1866 – Taormina, Martin Brimmer of Boston – & view of Venice bought by the Gr. Duke of Luxemburg & many pictures of Nahant & Narragansett painted between 1861 & 1867[.] Was married to Miss Helen Lane in 1860 & after her death to Miss Helen Marshall 1866. Spent the winter of 1866 & 1867 in Paris and has since then resided at the Palazzo Altieri in Rome where he has his studios & where he has painted a great many pictures mostly of Italian scenery. Passed the summer of 1899 in making the tour of the Western States including Alaska making sketches in Southern California & other places.
Other pictures wh you cd. add or substitute for any of the above – Ostia – belonging to J. Pierpont Morgan; Venice & Sorrento painted for the late J. S. Morgan of London; Castel Fusano – for Miss McGraw of Ithaca, N.Y.; Castel Fusano – Mr. Higginbotham of Chicago; Taormina – for Mrs. C. L. Haddock – Phila.; 'Riviera near Rapallo' – Mrs. Carstairs, Phila.; 'Amalfi' – for Mrs. Brown of Baltimore; Devil's Pulpit – Nahant for Rutherford Stuyvesant of New-York.

Haseltine/Plowden Family Papers.

3 January 1900 Attends vestry meeting at St. Paul's within the Walls. (Church records, St. Paul's within the Walls, Rome.)

23 January 1900 Ill with pneumonia.

3 February 1900 Dies in Rome. Buried on 5 February at Testaccio, the Protestant cemetery of Rome, after funeral service at St. Paul's within the Walls, Rome.

Obituary notices include:
The death of Mr. Haseltine, which occurred on February 3rd, was most unexpected by the American Colony in Rome, of which he had been a prominent member for more than thirty-three years. His disease was pneumonia complicated with influenza and lasted but eight days.
He was born in Philadelphia in 1835, graduated at Harvard College and followed the profession of landscape painting for which he manifested an exceptional talent.
He resided for the past twenty five years in the same apartment in the

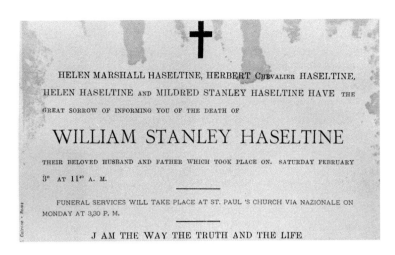

William Stanley Haseltine Death Announcement, 1900.
Haseltine/Plowden Family Papers.

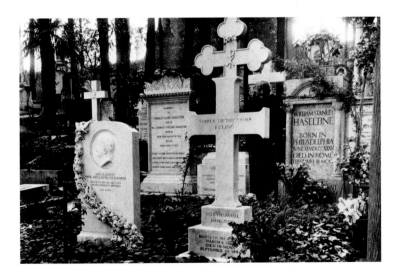

Unknown photographer, *Haseltine Family Graves*,
ca. 1930. Haseltine/Plowden Family Papers.

Altieri Palace. For thirty years he was a vestryman of Saint Paul's Church in the Via Nazionale, and at the time of his death its Senior Warden. He was married in 1866 to Helen Marshall, daughter of Charles Marshall of New York City, who with three children survive him.

The funeral took place Monday last, February 5th at St. Paul's Church, Rev. Dr. Nevin officiating. Dr. Nevin paid a warm and eloquent tribute to the memory of Mr. Haseltine in his sermon on the Sunday morning preceding the funeral, as the senior lay officer of the Church of Saint Paul, and a faithful co-worker for over thirty years. The funeral ceremony at the church closed with the singing of the Anthem "O, rest in the Lord."

The burial was at the Protestant cemetery on the same day. The pall-bearers were: the American Ambassador, the Belgian and Bavarian Ministers, Col Needham of the British Embassy, Mr. Abbott, Mr. Waldo Story, the Sculptor, Signor Murani, Mr. Winthrop and Mr. Erhardt. Besides a large contingent of the English and American colonies in Rome, there were present the Ambassadors of Austria and France and the Ministers of Belgium, Holland, Bavaria, Switzerland and Sweden, the Count Gianotti and many representatives of the Roman nobility.

Roman World, 10 February 1900.

William Stanley Haseltine, the landscape artist, died in Rome, Italy, on Saturday, after an illness of only two days. Mr. Haseltine was born in Philadelphia January 11, 1835, and was graduated from Harvard with the class of 1854. After studying art in Philadelphia under Weber and lately in Europe in Dusseldorf and Rome, he devoted most of his attention to landscape work. He was elected to membership in the National Academy in 1861, although he rarely contributed to its exhibitions. Mr. Haseltine lived for many years in Rome and Venice, and had a studio in the former city in the Altieri Palace. Among his pictures are "Indian Rock, Nahant," "Castle Rock, Nahant," "A Calm Sea, Mentone," "Bay of Naples," "Ischia," "Spezzia," "Ostia," "Pontine Marshes," and "Venice." He sent to the Centennial Exhibition of 1876 "Ruins of a Roman Theatre, Sicily," and "Natural Arch at Capri." He leaves a sister and three brothers, one of the latter being James Haseltine of Florence, Italy, a well-known sculptor.

Mr. Haseltine was twice married: first to Miss Helen Lane, daughter of the late Josiah Lane, a merchant of this city, and afterwards, in 1866, to Helen Marshall, youngest daughter of the late Charles H. Marshall, who survives him. The announcement of his death was received with great regret on Saturday evening at the monthly meeting of the Century Club, of which he was one of the oldest members.

"Obituary. William Stanley Haseltine," *Evening Post* (New York),
5 February 1900.

William Stanley Haseltine, an artist, whose home was in Boston, died of pneumonia in Rome, Italy, yesterday. He was sixty-five years old. He was a member of the Century Club and the National Academy of Design of this city.

Mr. Haseltine was born in Philadelphia, Jan. 11, 1835, and was graduated from Harvard in 1854. He then studied art in his native city under Weber, and later went to Europe, studying in Dusseldorf and Rome.

He was elected a member of the National Academy in 1861. His early works include "Indian Rock, Nahant," "Castle Rock, Nahant," and "A Calm Sea, Mentone."

Other pictures by his hand are "Bay of Naples," "Ischia," "Spezzia," "Ostia," "Pontine Marches," and "Venice." He sent to the Centennial Exhibition of 1876 "Ruins of a Roman Theatre, Sicily," and "Natural Arch at Capri."

"Death List of a Day. William Stanley Haseltine," *New-York Times*, 4 February 1900.

Friends in this city of William Stanley Haseltine, the well known landscape artist, were shocked to receive a cablegram yesterday announcing his death in Rome on Saturday. Mr. Haseltine had been sick but two days with pneumonia. He leaves a widow and three children.

Mr. Haseltine was born in Philadelphia, January 11, 1835, the son of John and Elizabeth Stanley Haseltine, with whom he made his home, at 706 Spruce street, while in this city. He attended the college of the University of Pennsylvania for two years, leaving at the close of his Sophomore year to enter Harvard University, from which institution he was graduated in 1854. He at once took up the study of art in Philadelphia, under Paul Weber, later going to Europe, where he studied in Dusseldorf and in Rome.

At an early period in his studies he began to devote most of his attention to landscape painting, some of his earlier works being "Indian Rock, Nahant," "Castle Rock, Nahant," and "A Calm Sea, Mentone," which were in the collection of John Taylor Johnston. To the Philadelphia Exposition of 1876 he sent "Ruins of Roman Theatre, Sicily," and "Natural Arch at Capri." He rarely exhibited in the National Academy, of which he was made a full member in 1861.

Many of his pictures have been sold to royal families in Europe, and nearly all of the more prominent private galleries in this city contain his productions. Quite a number of his paintings were destroyed in the fire at his brother's galleries in this city, some five years ago [1896].

For many years Mr. Haseltine lived in Rome and Venice, where he devoted himself particularly to Italian and Normandy landscape scenes. His studio in Rome, in the Altieri Palace, is one of the sights of the Italian city which attracts American travellers on the Continent. He paid a visit to this country last summer, spending most of his time in this city, where

resides his sister, Mrs. W. P. Smith, Jr., and his brothers, Charles and John Haseltine, the former conducting the well known Haseltine Art Galleries. His other living brother, now residing in Florence is the celebrated sculptor, James Henry Haseltine. Charles F. Haseltine left Philadelphia only ten days ago on an eight months' tour of the Holy Lands, and it will be some time before he can be communicated with.

"Obituary. William Stanley Haseltine," *Philadelphia Public Ledger*, 5 February 1900.

To the Editor of The Evening Post:
Sir: The following notice of Mr. William Stanley Haseltine has been translated from a Roman Newspaper, Il Giorno, in which it appeared last February. It is written by the art critic Diego Angelis, who has just been invited to lecture at the Sorbonne in Paris:

The landscape painter, William S. Haseltine, has just died here in Rome, and the collection of drawings, water-colors, and paintings, which he has left in his beautiful studio, filled with tapestries, cabinets, and majolica, are evidence of his genius. He had many warm friends, here and elsewhere, who were drawn to him because of certain traits in his character, charm of manner, and never-failing cordiality, but very few recognized his importance as an artist – probably because he worked solely for the sake of his work – invited no criticisms, and asked for no praise. Had it not been for his thorough knowledge of drawing and sense of color, one might have called him an "amateur," but an amateur in the literal sense of the word – a man who pursues art for the love of it. He was not hampered by the necessity of making money, and painted pictures to satisfy his own standard about them; he was master of his time and chose to devote it to realizing the ideal of beauty vouchsafed to him.

He came from Philadelphia, U. S. A., but for the last thirty-five years had lived in Rome with his family, in an apartment of the Palazzo Altieri which he gradually converted into a veritable museum. He belonged to that set of American artists, who, although they pass the greater part of their life "abroad," still preserve to the end the characteristics of their race; rapid conception of ideas, accurate reproduction of what they see, and a thorough knowledge of what they undertake.

Haseltine was graduated from Harvard College in 1854, and shortly afterwards went to Dusseldorf in Germany, and for several years studied painting with Paul Weber. The effects of this school, a subtle romantic sentiment, peculiar to those times and the artists who lived in it, is noticeable in all Haseltine's work. From Dusseldorf he went to Paris and arrived there about the time when the school of 1830 was approaching a glorious end, and making place for the naturalism in art which found expression first in Courbet and later in Manet. In 1860-'61 he returned to his country and devoted himself chiefly to the study of shore scenery, and soon became

well known for his sketches of Nahant rocks, the coast of Mount Desert, and Narragansett, but pictures of Italian skies and Italian waters, as he had seen them on visiting Italy in 1857 with Whittridge and Bierstadt, were in his heart, and three years later he returned there. In 1866 he came to Rome with the intention of making it his home, and never left it again.

As a consequence of these experiences, we find three elements in the character of Haseltine's paintings: Anglo-Saxon precision, French love of atmosphere and light, and German romanticism. Through all the phases of his art-life, in every variety of his many productions, these elements form an unchanging basis and give the chief character to his work. The work extends from 1850 to the last day he was in his studio, and consists of drawings, water colors, rapid impressions of landscapes, broad visions of the sea, memories of travel, impressions of forms, colors, shadows, reflections. Some are only a few lines drawn on a background, of blue-gray Turner paper; delicate Swiss birch-trees trembling before a spring breeze, Chioggia boats lighted up by the morning sun; torpid Dutch "Hause" being dragged up a canal reflecting a sunset sky; arid cedar-trees of the American West beaten by the winds of a thousand years; funereal Roman pines seen through a fiery twilight. Other sketches are more finished and extensive, and others are pictures in the best sense of the word and in a measure the result of this noteworthy collection of sketches and studies. Two pictures are especially in my mind – one, a solitary landscape in which, between a castle and two cypress-trees, the twilight recedes before a rising moon, and the other a canal in Venice between two rows of brick houses, peopled with red and yellow sailboats and glowing like an opal in the light of sunset.

Just as Anglo-Saxon precision is most evident in the drawings, and French atmosphere in the water-colors, so German romanticism may be most seen in the oil paintings, but this only from a superficial point of view, for, as I said before, the three above-named elements are rarely separate in his work.

One of the secrets of Haseltine's talent is the power to produce an effect with only a few lines and in the simplest manner. Master of technique, sure of what he wants, he never hesitates and never repeats; he knows the value of each stroke, and obtains effects he wants without any effort. For these reasons his collection of drawings acquires great importance, and without doubt will be an inspiration to many when once it is made known to the world. The reason why it has not been known in the artist's lifetime can be found in his indifference to public opinion and tenacity in pursuing his work. His pictures tell us this, and they also tell us that he was a man of gentle moods and lover of all that is beautiful; that all his life he maintained a serene and truth-loving spirit; that he drew infinite joy from his artistic talent. In this joy of reproduction and simplicity of spirit is hidden the true life of an artist. I understood this best a few days ago, when I went into the house where Death had suddenly entered, and saw the artist lying in his studio, covered with the flowers he loved so well, and surrounded by his works which he had left to the world, and I realized with sorrow that a great talent and a dear friend had gone from us.

"The Late Mr. William Stanley Haseltine," *Evening Post* (New York), 28 April 1900; originally published in *Il Giorno*, 11 February 1900.

19 April 1901 Four rooms of the Palazzo Altieri are converted into public galleries for the display of Haseltine's works:
On Friday, April 19th, a new gallery for the exhibition of the works of the late William Stanley Haseltine, the celebrated American landscape painter, was opened in his former studio. It occupies four halls in the Palazzo Altieri, two of which contain oil pictures, two others pictures and sketches in water colours. Haseltine's works are too widely known and appreciated on either side of the Atlantic to require a special notice, but I acknowledge that the exhibition of this unknown and wonderful mass of original sketches has taken us all by surprise. We are amazed at his power in interpreting and rendering the feeling of such different lights and landscapes as those of Sicily, Spain, Holland, Tyrol, Capri, and Venice. As a Roman I rejoice in the fact that Haseltine's favourite subjects were the Campagna and the pine-groves of the Maremma coast.

Rodolfo Lanciani, *Notes from Rome*, Anthony L. Cubberley, ed. (Rome: British School at Rome, 1988), 342; originally published in *Athenaeum* 111, no. 3839 (25 May 1901).

Index

The titles of works in this exhibition are marked by asterisks. Bold page numbers indicate works illustrated in this catalog.

Photo Credits

Reproductions of works in the exhibition are by permission of the lenders. Photographs for these and other images are courtesy of the following: Plates 1, 44, 63 – Ken Pelka; 7 – Dwight Primiano; 16, 17, 69 – Karin L. Willis; 18 – Michael Tropea; 22, 36, 61 – Joseph MacDonald; 38 – Museum of Fine Arts, Boston; 29 – Henderson Photography; 30 – Sotheby's; 42 – Stephen Petegorsky; 56 – Zindman/ Fremont; 71 – Michael McKelvey. Helga Photo Studio – Simpson essay, fig. 12; Henderson essay, fig.15; Mills essay, fig.2. David Allison – Chronology, p.152.

Frontispiece

Mathew B. Brady (1823-1896), *William Stanley Haseltine*. ca. 1865. Courtesy, collection of Susan Herzig and Paul Hertzmann.

Expressions of Place: The Art of William Stanley Haseltine is produced by the Publications Department of The Fine Arts Museums of San Francisco. Ann Heath Karlstrom, Director of Publications, and Karen Kevorkian, Editor.

The book is designed by Jack W. Stauffacher, The Greenwood Press, San Francisco. The display and text type is Minion. Photocomposition is by Kina Sullivan, Visual Strategies, San Francisco. The book is printed on 128 gsm White-A Japanese matte paper by C&C Offset Printing Co. Ltd., Hong Kong, through Overseas Printing Corporation, San Francisco.